ART TREASURES OF THE
Metropolitan

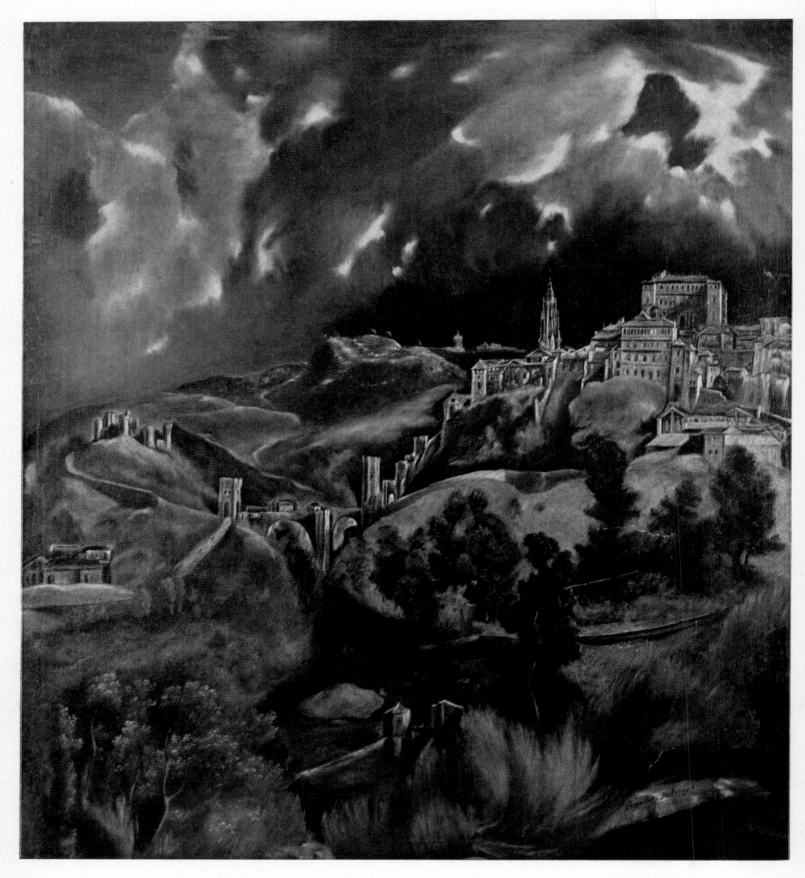

EL GRECO [1541-1614] *View of Toledo* · Spanish · Oil on canvas, 47¾ x 42¾″

ART TREASURES OF THE
Metropolitan

A Selection from the European and Asiatic Collections of
The Metropolitan Museum of Art

PRESENTED BY
The Curatorial Staff

Harry N. Abrams, Inc., *Publishers*, New York

FIRST EDITION

Edited by MARSHALL B. DAVIDSON, Editor of Publications, The Metropolitan Museum of Art

———————————

Supervision of color plates by WALTER NEURATH of Thames & Hudson, Inc.

Printing of color plates by ROGERS KELLOGG STILLSON, INC.

Printing of text in two-tone Optak process by EDWARD STERN & CO., INC.

Paper supplied by PERKINS & SQUIER CO.

———————————

TABLE OF CONTENTS

FOREWORD

THERE IS A CHARMING IDIOM of the French tongue—*prendre la parole*—which does not mean, as one might literally suppose, "to take the words out of another's mouth," but rather charges an individual with speaking in behalf of those of whom he is a part as their representative and peer. It is in this spirit, and at their urgency, that Miss Edith A. Standen, Associate Curator of Renaissance and Modern Art, *a pris la parole* for the curatorial staff of the Museum in the writing of this book. Her role has been more than that of editor but yet not quite that of ghost writer. She has been entrusted with the corporate knowledge and wisdom of the house and has produced a text which has more than justified their confidence in her felicity of expression and capacity for synthesis. In short, this splendid volume is proof positive that Lindbergh would have got to Paris even if he had been flown there by a committee.

The book also marks the eighty fruitful years which have brought these countless treasures to the Metropolitan, which first opened its doors on Washington's Birthday, 1872, at 681 Fifth Avenue. It is a tribute to American philanthropy and civic pride; it is an answer to propaganda from overseas that private enterprise, the public purse, and cultivation of the mind cannot work together for the betterment of mankind.

The Museum is proud of this book as it is proud of its collections. No greater monument to taste has been created in the short span of three generations. The museums and galleries of Europe are the accumulations of many centuries and the rewards of kings. The Metropolitan has been the work of common men filled with respect for the past and anticipation for the future. What is lacking from heredity is compensated for by a burning desire to do in this New World soil of ours what Lord Arundel's tutor, Henry Peacham, besought of him to do—"to transplant Olde Greece into England."

But any book about an art museum must stand or fall by its illustrations; chief credit for those in this volume is due to Charles K. Wilkinson, who, with the active assistance of the departmental curators concerned, selected the objects to be reproduced, determined the arrangement of the plates, and supervised the photography. For the painting section the choice was made by Theodore Rousseau, Jr. The making of choices is well known to be the most strenuous activity in which the human mind can engage; there is not a page in this book that does not have behind it a prolonged period of this activity. It is to be emphasized, however, that it is to the committee of the whole, the Staff, whose names appear at the back of the volume, that the book owes its richness of facts and ideas, its diversity and its unity.

The Trustees of the Museum wish to express their gratitude to Mr. Abrams for this courageous and beautiful accounting of their stewardship.

FRANCIS HENRY TAYLOR, *Director*

7

THE METROPOLITAN
AN INTRODUCTION

THE METROPOLITAN MUSEUM OF ART is a huge stone building, stretching over many acres, but low in comparison with the skyscrapers that, from their birthplace on the southern tip of the island, have crept uptown until they overlook it. The word "metropolitan" marks it as belonging to a great city, and it is defined as a "museum," that is, by derivation, a home of the Muses. Over five hundred people work in this building and more than two million visit it every year; on Sundays the crowds are as thick, though not as single-minded, as those in Grand Central Station. The visitors come to see paintings from Fra Angelico to Zaganelli, sculpture from Chinese Buddhas to Gothic Madonnas, furniture, pottery, laces, silver, costumes, glass, and a long list of categories it would be wearisome to enumerate; the small boys ask for the "guys in armor," the Ph.D student, on his way to the library, stops perhaps to look at a work of art which can, in Chesterton's phrase, "knock the most casual spectator into the middle of eternal life." In short, the Museum is about a million objects of incredible variety, some of which are illustrated in this book.

Behind every one of these million things lies a history, going back sometimes five thousand years into the past; in this history, were it written, we should read of the man who made each object, the uses to which it was put, the seas it traversed or the centuries it lay buried, the money that changed hands for it, the admirers who tinkered with it or treated it with love and reverence, and finally of the people who were responsible for its presence in its latest and, we trust, its last home. All this is summed up, more or less accurately, for that fraction of the million objects that are on public display, in a few lines of print on a label and, for all objects, exhibited or in storage, by an inconspicuous number, which is a clue to the same information on a catalogue card. This accumulation is, as it were, the raw material of a museum, but anyone who has seen it reverted to its random condition, as in the long, cool galleries of the German salt mines—paintings stacked in their hundreds and crates piled upon crates, preserved in safety while the buildings that had housed them were being smashed to pieces—knows that a museum is more than a building and its contents. It is organization, a web of balances and relationships between all its parts; it is this intangible thing that makes the museum an entity and a work of art in its own right. And like other works of art, it must be made with the mind and with the heart, with intelligence and with love.

Moreover, just as Michelangelo carved his David from a block of marble no other sculptor would attempt because of its flaws, the museum-maker must fashion his masterpiece from what comes to hand; he can never have precisely the raw material he would wish. Even the private collector of unlimited means must work with what is available on the market, and the museum, unlike other works of art (except great construc-

tions, such as cathedrals or gardens), is not the work of a single man, or even a single generation. (Its similarity to a garden can be embroidered upon; we can imagine the curators, each busy in his little plot, one setting out daffodils, another gardenias. Each plant must be placed where it will show to best advantage, but also where it will play its part in the bed as a whole. There must be balance; the sunflowers must not invade the rock garden nor the hot houses encroach upon the herbaceous borders. How much room should be left for annuals (temporary exhibitions)? How much money must be allotted for the upkeep of walks and walls and drainage? The gardeners take their trowels, so to speak, to the Alps or Andes and dig up precious specimens, which, with loving care, they transplant in an alien soil; they hear of a fresh species—works of a previously unknown period or an old technique revived in a modern style—discovered or evolved by a foreign botanist, and hasten to acquire an example. The weather bureau sends out storm warnings and the best loved flowers are removed to safety before the bombs rain down.) Moreover, there is a third factor that affects the museum considered as a unit, and that is the world outside. A museum is a process, a becoming; even if every object is pinned in place by the most unbreakable clause of a testamentary masterpiece, the changing climate outside will make the choice and the arrangements, first old-fashioned, then ludicrous, and finally historical, a period piece, which will become steadily more and more remote. More and more interesting, perhaps, for this reason, but the visitor will curse the chance that landed any overwhelming masterpiece in such a hodge-podge. As in every aspect of life, mutability for the museum is not a curse, but a necessity and a challenge.

GIVEN, THEN, THE OBJECTS, the men who have brought them together and tended them, and the outside world, the general public for whose use and delectation this garden, or world of art, was intended, what is the Metropolitan Museum today? Its present Director has described it as five museums in one, museums of ancient art, oriental art, European decorative art, American art, and a picture gallery; this organization is reflected in the sections of this book, with the omission of American art which will have a volume to itself.

The "museums" are divided into curatorial departments; Ancient Art has two, Egyptian, and Greek and Roman; Oriental Art, two, Far and Near Eastern; European Decorative Art, a whole flock: Medieval, Renaissance and Modern, Arms and Armor, Prints, the Costume Institute, and Music. The Paintings Department, naturally, looks after the picture gallery. American art has its own department, as it has its own wing in the building. The "museums" are, as it were, incorporeal divisions, ideal entities, and, to a very great extent, they are physically distinct; but in the last analysis it is the various departments which are the operating headquarters.

The Man from Mars (who, as an outsider, has taken the place, in our mythology, of the bland Persian or Chinaman conjured up by the eighteenth-century satirists to criticize the *mores* of Paris or London) might well express bewilderment. Why, he might say, are your "museums" based now on time and now on geography, with the picture gallery accepting only objects made of certain materials? The departments, now chronological, now geographical, and now concerned with certain types of objects only, would puzzle him still more, and it would be easy to drive him back to his flying saucer clutching what passes for his head by telling him of anomalies, or describing border-line cases. But to understand the divisions, and why they are satisfactory, he would have to learn a great deal of history: the history of the world, the history of museums everywhere, and the history of The Metropolitan Museum of Art in particular.

The reader, with a more than Martian knowledge of the history of our world, will not need to be told why Greek and Roman art are grouped together nor why they are separated from Egyptian. In the history of museums, the great problem has been whether to classify by material or by culture. In the analytical nineteenth century the first method prevailed; the Victoria and Albert Museum, with its departments of metalwork, woodwork, textiles, and the like, is the most uncompromising example. Our age has turned to synthesis; a rather close parallel to the development in museums is seen in the kind of books that are written on anthropology. The enormous accumulation of facts in such a work as the *Golden Bough,* arranged to show similarities in customs of all times and all over the world, has been re-

placed by studies of single cultures, viewed as co-
herent wholes. In the same spirit, the Victoria and
Albert, though retaining its organizational divi-
sions, replaced its greatest treasures, after the
war-time evacuation, in some of the most varied
and harmonious groupings to be seen in any mu-
seum today. Only paintings, that is, the paintings
of our Western civilization, have resisted this
tendency, and those who love them will justify
this on the grounds that, earnest as we are to
abolish the class distinctions of the kingdom of
art, there is finally a hierarchy. These paintings,
with architecture and music, are the best we have
done; hang the masterpiece, well framed, at the
right height, in a good light, on an unobjection-
able background, and let the visitor bring to it
the "careful attention, fixed with all patience and
humility," described by Roger Fry. He will need
no more, except perhaps a comfortable seat at
the right distance, for the flesh is weak.

But a more profound question is raised by this
problem of organization, since it concerns the
very purpose and function of the art museum. Is
it to instruct or delight? To be interesting or
beautiful? Again, the answer must be a com-
promise. Beauty is more nearly an absolute good
than knowledge; as Clive Bell has said, it
causes the "good state of mind," which he con-
siders absolute. For example, take a handful of
grains of sand and count them; you will have
more knowledge than before, but your "state of
mind" will not be improved. Call in the geologist
and have him tell you what rocks and shells were
pulverized to make the sand, how, when, and by
what they were made, and the knowledge will be
interesting. This word, "interesting," is certainly the
favorite adjective of approval of the modern age,
whether applied to cookery or to the fine arts. An
attempt to define it might well result in books as
long as those the eighteenth century devoted to
the words "sublime," "beautiful," or "picturesque."
But, without embarking on this undertaking, it
may be said that the quality so described seems
to depend on relationships, a thing or an idea
gaining in "interest" as it is seen linked in richer
and more complex ways. These links the museum
is supremely fitted to demonstrate—a natural his-
tory museum is primarily concerned with them.
Even the picture gallery will not be without this
kind of interest, for the experienced visitor knows
that standing and staring is not easy, and that

after a while he must fall back solely on dating or
identifying the artist, or naming the birds and
flowers, or other non-esthetic amusements, even
though he may have been doing this, as a side-
line, ever since he entered the gallery at opening
time with all his strength and wits about him.
There are departments, though, in which the in-
teresting and the beautiful come much closer to-
gether, indeed, can hardly be separated. It is not
possible to walk through a museum and say, "this
object is purely beautiful," "this object is beauti-
ful and interesting," "this object is merely inter-
esting." The sensation of esthetic delight is not a
chemical element that can be separated from the
other activities of the mind, as was implied by a
prominent collector who hung Pennsylvania door
hinges alongside his Renoirs, because the same
pure principles of art could be observed and en-
joyed in both. Even music, the least "interesting"
of the arts in the sense in which we are using the
word, sometimes (and in very great examples)
is enhanced by a relationship between its own
qualities and other intense emotions aroused by
words and their associations. Who would dare say
that none of the almost intolerable happiness that
sweeps over us when the choir breaks into the
Et Resurrexit of the *B minor Mass* arises from
the meaning of the words, or try to sieve out this
meaning from the glory of the music? So in the
museum, from the greatest work of art to the
slightest.

T HIS CONCEPTION of the co-existence of "the
beautiful" and "the interesting," has always
been part of the "communal intelligence or tradi-
tion" (Roger Fry's words again) of the Metropoli-
tan Museum, from the report of the policy commit-
tee in 1870 to statements by the present Director in
1945 and 1950. The committee wrote: "The Met-
ropolitan Museum of Art should be based on the
idea of a more or less complete collection of ob-
jects illustrative of the History of Art from the
earliest beginnings to the present time"; Mr. Tay-
lor has spoken of his five museums as each "a phil-
osophical entity in itself presenting as intelligently
as possible the evolution of the arts in the civi-
lizations with which it is specifically concerned,"
and described the sum of them as "a visual li-
brary for the course of history as a whole." The
committee's words of 1870 were bold indeed; the
Museum, in fact, at that time consisted of words,

but many of them were good ones and spoken by the right people.

The history of the Metropolitan Museum begins with a Fourth of July speech in Paris in 1866 by John Jay, in which he called for a "National Institution and Gallery of Art." His audience was fired to form a committee, which must have been made up of New York men, for they addressed themselves to the Union League Club of that city, urging the "foundation of a permanent national gallery of art and museum of historical relics, in which works of high character might be collected, properly displayed, and safely preserved." (The choice of the recipient of this plea, incidentally, is exceedingly interesting; characteristically American, and American of the period.) The Club took its time, but it had an Art Committee, which included painters, a sculptor, and a dealer and collector, and this reported in 1869; it concerned itself with organization, rejecting governmental support or control as "utterly incompetent" and that of any body of artists as not wise. It hinted that control must rest with "judicious friends of art" of ample means.

This suggestion became a concrete fact at a meeting called by the Art Committee for November 3rd, 1869, the true birthday of the Metropolitan Museum. To it were invited New York's men of wealth, brains, cultural interest, and public spirit, and they included those most important people, the Park Commissioners. If John Jay can be thought of as the father of the Metropolitan Museum, Andrew H. Green was its guardian angel, for, in a legislative act of 1869 concerned with his Central Park, he and the other Commissioners were authorized "to erect, establish, conduct and maintain in the Central Park in said City, a meteorological and astronomical observatory, and a museum of natural history and a gallery of art, and the buildings therefor, and to provide the necessary instruments, furniture, and equipments for the same." The Commissioners were authorized to receive "gifts, devises, or bequests," but there is no indication that adequate appropriations were voted for these stupendous undertakings. The chief speaker at the meeting was William Cullen Bryant, the poet. His speech still reads well and is occasionally wryly timely, as when he speaks of "men who seek public stations for their individual profit" and describes what a museum could be made with a tenth part of what is stolen from us in this

way. The passage on the sense of beauty—"in other words, the perception of order, symmetry, proportion of parts"—and his obvious sincerity and depth of feeling are quite exalting, until we, creatures of another age, come crashing to earth in his peroration. For he builds up to an example, a picture which can ennoble, instruct, and inspire—and it is a work by Ary Scheffer! This name will probably be unfamiliar, just as some of our present gods will certainly have sunk to nonentities eighty years hence. But the painter is one of those whom, with the blinkers of our century limiting our vision, we cannot see at all; Carlo Dolci is austere in comparison with Ary Scheffer, and Böcklin prosaic.

This is the kind of swift descent to which we become accustomed in reading about art in the nineteenth century. When the Central Park building was opened in 1880, the press complimented the Hanging Committee on their "remarkable and admirable work," their "system of bold or delicate or suggestive balancings"; these included "a Gérôme balancing an Eastman Johnson, a Troyon balancing a William Magrath, a Bouguereau balancing a Henry A. Loop." Now, we pride ourselves upon our tolerance and, indeed, there are few periods or artists that it is not fashionable or proper to admire today, from the cave paintings of Altamira to the photographs of Atget, but we have a (perhaps temporary) blind spot for certain artists of the nineteenth century; we cannot stomach (as yet) an Ary Scheffer, and only a specialist will have ever heard of Henry A. Loop. There is no question, however, but that our forefathers had minds as good as ours and looked at pictures with as much love. There are two, equally fatal, ways of reacting to this realization, the arrogant and the overhumble. The curator, making almost daily choices, walks his private tightrope between them.

No such problems faced the creators of the infant museum. They knew what they wanted and they knew they needed money to get it. In 1870 the State Legislature granted an act of incorporation to The Metropolitan Museum of Art, and the Trustees set out to raise $250,000. (This would cover the operating expenses of the Museum today for just over a month.) In 1871 the statute was passed that authorized the city to tax itself for $500,000 for the museum building,

which, it was then arranged, should be municipal property; the Annual Report of the Trustees represents the token rent. This principle, collections owned and controlled by Trustees in a building owned and maintained by the municipality, has proved viable, and the structure of many American museums is based upon it.

The Trustees ran their museum by themselves, in one temporary home after another, for ten years. At the beginning, one of them acted as superintendent for his incidental expenses only, with an assistant at $12.00 a week. When the glorious move was made to their own building in Central Park, the Trustees packed and unpacked the collections themselves. By this time, however, they had acquired a salaried Director, General di Cesnola, and, some years earlier, his collection. This purchase and this appointment were a first indication of what was to be for all time a main interest of the Museum, classical antiquity. The General was no carpet knight or Kentucky colonel; as an officer of the Sardinian army he had fought against Austria and Russia, and he did a great service to the United States when he ran a military training school in New York during the Civil War. (From this school grew the War College of the U. S. General Staff.) He later took part in several battles of this war and spent some months in a Southern prison. But his second and even more illustrious career began after the war, when he was appointed consul in Cyprus and spent eleven years there making archeological explorations and excavations. It was the result of this activity, some six thousand objects, that was bought by the Museum, and for many years constituted the bulk of its possessions. It was a truly extraordinary assemblage to find in an American museum at that date or, indeed, in any museum, at any time. The Metropolitan Museum was now, so soon after its foundation, in the position of owning something that had no parallel elsewhere, and which was of enormous interest to scholars everywhere. The collection had been sought for by the British Museum and the Louvre; its triumphant arrival in New York put the Metropolitan Museum, at one bound, on the map. But of course there were other things in the galleries; paintings and casts were there, naturally, for these were "Art" in most people's minds, but also, as an announcement of 1871 recommended, "objects of utility to which decorative art has been applied."

As the twig is bent. . . . These three categories, European painting, antiquity, and the decorative arts, are still the great branches of the Metropolitan Museum.

GENERAL DI CESNOLA reigned until his death in 1904. There had been bequests and gifts and a new wing on the building; the succeeding history can be told in the same terms, bequests, gifts, wings, purchases, and people. But it is people who make history and the new people who came in soon after the turn of the century were of such caliber that it is as if a new continent were rising from the sea. Take J. Pierpont Morgan, a contributor of 1870, Trustee from 1888, President from 1904 until his death in 1913; his is the first name, engraved in stone, that greets the visitor, and rightly, for in department after department, the most treasured masterpieces or the collection of the highest quality were his gift. Near his commemorative inscription are the lists of Benefactors, also cut into great slabs of stone. Here are many well-known names, some internationally famous, like J. Pierpont Morgan himself and Gertrude Stein, some a history in themselves, such as "Lord Duveen of Millbank." (We see here the well-deserved English title and remember the Tate Gallery on Thames-side and the name on the shop that carried the most expensive merchandise in the world.) The bearers of these famous names were very different types of human beings and of very varied accomplishments, but the action that placed a name on this list was always the same— a deed of splendid generosity, a contribution to the public good.

BUT THERE ARE obscure names also on the list, and one of them deserves a longer notice because he did his good deed for the Museum at such an extremely apposite moment. Jacob S. Rogers, a locomotive manufacturer, died in Paterson, N. J., in 1901 and left his residuary estate to the Metropolitan Museum, the income to be used for the purchase of rare and desirable art objects and books for the library. In 1883, he had become an Annual Member, paying his $10 yearly, as he would today. (Incidentally, the mind reels thinking what it would then have bought him at a butcher's shop.) Never had he indicated that he wished to provide more substantial support, but the bequest amounted to several million dollars,

13

very much more than had ever previously been given the Museum. To the Director and Staff (there were then three curators) it must have seemed as if the gates of heaven were opening. And the golden vintage began, the Boscoreale frescoes, the Dino armor collection, the Sagredo Room, Bruegel's *Harvesters.* Mr. Rogers' locomotives were surely turned to scrap many years ago, but if you wish to see his monument, read the last lines on the labels as you walk through the Museum. Subsequent bequests on the same munificent scale have included those of Harriette Matilda Arnold, Isaac D. Fletcher, Edward S. Harkness, John Stewart Kennedy, Frank A. Munsey, and Catherine W. Wentworth.

Some of these bequests were as unexpected as that of Mr. Rogers, but the majority of the donors had been active friends of the Museum during their lives. This has always been true of the Presidents, from John Taylor Johnson to the present holder of the office, Roland L. Redmond. Like them, the other incumbents, Henry G. Marquand, J. Pierpont Morgan, Robert W. de Forest, William Sloane Coffin, George Blumenthal, and William Church Osborn, have none of them been figureheads; all worked hard and well for the Museum. The names of many Vice-Presidents and Trustees stand with theirs on the engraved stone slabs; they will occur and recur in the succeeding pages of this book. A volume as large as this could be filled with nothing but names of donors and lists of their gifts; each section will include those of the most outstanding benefactors to the department with which it deals. Many were collectors and gave or bequeathed their accumulated treasures; all American museums have benefited from the unwritten American law that a man stands upon his own feet, not his father's, and that out of great wealth great gifts must be given. Some bought continuously and gave as they bought. Some were specialists, and worked closely with the curators of the departments that interested them; some co-operated with the Museum as a whole, giving what they understood was wanted. Some collections, such as that of Jules S. Bache, were small but exquisite museums during their owners' lifetimes; such groups of paintings and art objects, when they join their peers in the Museum, become, not only "more easily available for enjoyment by a wider public," as was said of Mr. Bache's masterpieces, but actually more valuable, as fitting participants in a noble progression. Then, though this book is not concerned with American art, it is impossible not to mention R. T. H. Halsey and the American Wing; of him it was said at the opening of the wing, "except for Mr. Halsey you might have had an American Wing, but you would never have had *this* American Wing." By no means to be forgotten, also, are the people never rich enough to become Benefactors, but who nevertheless gave an object, or the money to buy it, without which the Museum and everyone who visits it would be the poorer. Often pieces which seem comparatively insignificant at the time of their acquisition become exceedingly interesting and valuable as a result of increased knowledge in a particular field, or of a new conception of museum work. One Benefactor may be said to represent the great modern conception of the professional giver: John D. Rockefeller, Jr., who first investigated thoroughly and then gave lavishly when he had approved. The Cloisters is only the most conspicuous and magnificent result of his munificence. Every object illustrated in this book, whether gift or bequest or purchase from a fund, has behind it an act of generosity. Museum people take pleasure in recording this act on a caption or label, though they know how seldom it will be read. But for themselves and for the public they are saying, "Thank you."

However, as has been said before, accumulation does not make a museum, and the men who received the golden streams, often canalizing, purifying, and leading them into the great rivers of the Museum, deserve as much credit as the donors themselves. General di Cesnola (who had been allowed such a short sojourn in the Promised Land of ample purchase funds) was succeeded as Director by Sir Caspar Purdon Clarke, previously Art Director of the Victoria and Albert Museum. The Trustees had published their list of the qualifications needed for the post, which reads, a little curiously, (a) executive ability, (b) courtesy, (c) expert knowledge of art, (d) museum experience. But Sir Caspar, on all counts, was a great catch, a professional museum man long before the days of museum classes for post-graduate art historians. His experience at the Victoria and Albert was the best possible background as far as one great section of the Museum was concerned, the decorative arts; his architectural work (build-

ing museums in many lands) was invaluable, as the great structure stretched its wings into Central Park. With him, as Vice-Director, came Edward Robinson, a classical man, formerly Director of the Boston Museum of Fine Arts; he became Director on Sir Caspar's resignation (shortly before his death) in 1910. Antiquity was safe in his hands. He was succeeded in 1932 by Herbert E. Winlock, who had been curator of the Egyptian Department. After his retirement in 1939, on account of ill health, the present Director, Francis Henry Taylor, was appointed; he had previously been Director of the Worcester Art Museum. All this time the departments were becoming more and more coherent entities and the men who ran them as important to the Museum as the objects they tended, so that, where General di Cesnola, with the scanty assistance available to him, personally superintended and directed everything that went on in the Museum, Mr. Taylor has a professional staff adequate to the huge enterprise on which they are engaged.

THE PRESENT CURATORS, each man fighting for his own treasures, have played a great part in the selection of the illustrations that follow, but the works are not displayed as they are in the Museum. They approach more closely Malraux's *musée imaginaire*, the museum everyone can make for himself. It was not an easy museum to assemble; the extent of the incredible riches of the Metropolitan is not easy to grasp intellectually. Imagine a great globe with a pin-point of light shining out from it for the place of origin of every object in the Museum; the lights start in Portugal and stretch across Europe. They are clustered so thickly in France and Italy that the countries seem ablaze; so do Greece, Egypt, Mesopotamia. On through India to China and Japan (even Tibet has its sparkle of light), and the eye leaps the Pacific to the brilliance of the North American continent. Now a new star bursts out in an already crowded constellation at Florence; it is a Leonardo drawing. Now a pin-point twinkles in darkest Africa; it is a bronze cock from Benin. Imagine the globe as traversing the centuries; the light begins 5,000 years ago in the Near East, Egypt is all on fire, Greece begins to blaze in the last thousand years before Christ; when darkness falls on these lands, the lights are full on elsewhere. Of the other great museums of the world, none can show a sequence of lights representing such a variety of objects, beginning so early in history, and extending over so many millennia and so many square miles; in any other city, a combination of museums would be required to produce a globe as brilliant as the Metropolitan's. But who, in truth, can compare these lights? Shall Amsterdam in the seventeenth century (or its works in the Rijksmuseum) be said to outshine Florence in the fifteenth (or the Uffizi)? It is quite right and proper that curators should make comparisons and report to museum members where dark spots should be lightened; they take magnifying glasses to their little sections and, while they gloat over their own particular stars, they note that other museums have fewer interstices, in, perhaps, T'ang China. Sometimes these can be very exactly compared, and we learn that the museum is fourth in cross-bows but first in daggers, or that English decorative art is less well represented than it should be, but will be strengthened. To the museum visitor, or to the person who looks at the pictures in this book, all this is a quarrel between the iris and the rose, which is the fairer. Are two Vermeers really so much more valuable than one? There can be no addition of infinities. For, whether we conceive that the work of art gains its value because it tells us something of the nature of God, or because it expresses the true worth of Man, that value is a given fact, not to be disputed, and totally indescribable. For,

> *who in his own backyard*
> *Has not opened his heart to the smiling*
> *Secret he cannot quote?*
> *Which goes to show that the Bard*
> *Was sober when he wrote*
> *That this world of fact we love*
> *Is unsubstantial stuff:*
> *All the rest is silence*
> *On the other side of the wall;*
> *And the silence ripeness,*
> *And the ripeness, all.*

Only in another art, as in these lines of Auden's, can we receive the same message, and all our scribblings shrivel into nothing when we look at something that is, perhaps, a hole in the wall. "The words of Mercury are harsh after the songs of Apollo."

EDITH A. STANDEN

15

ANCIENT ART

OUR MEDIEVAL FOREFATHERS believed that the history of mankind ran in an unbroken line from the Garden of Eden to Judgment Day; with the Renaissance came the conception that it must at least be divided into two parts, Ancient and Modern, with some horrid Dark Ages lying between them. The nineteenth century may be said to have returned to the line, sometimes seen as rising gloriously and steadily from cave dwelling to Crystal Palace, but more often as jagged, the peaks and depressions varying in accordance with the predilections of the writer. Today we believe that history, from the moment when *Pithecanthropus* first became *erectus* until the events of today's newspapers, cannot be looked at as a single unit; we have widened our horizons, both historical and geographical, and the long sequence of world events must be broken down into what Toynbee has called "intelligible fields of historical study."

The sharpest cleavage is still the old one of Ancient and Modern; our perception of this is certainly heightened by our memories of a blank page and a new title between the Old and the New Testaments, but the consequences of the event that took place when B. C. changed to A. D. were sufficiently important over enough of the earth's surface to justify the heading of this sec-

tion. The world is wider than Christendom, however, and there is a great deal of equally ancient art, from China, from India, from Peru, that will not be found in the pages immediately following. We are dealing here with civilizations that are ancient and dead, but which are related, more or less closely, to our modern Western civilization and to the Mohammedan cultures, whose birth, on the kind of time scale we are here using, took place not so very long afterwards. (The tremendous length of time involved must be borne in mind throughout this section; the first B. C. dates in Egypt, if translated to A. D., would probably take us on to the Parliament of Man and the Federation of the World.)

Of all the civilizations that we now see as entities, rather than as rungs on a ladder with ourselves at the top, the Egyptian has, for everyone except the specialist, the most clearly defined individuality. The climate of Egypt and the burial customs of the people have combined to give us a picture of life on the Nile three, four, and five thousand years ago that cannot be paralleled in any other ancient civilization. But that we have this picture so clearly in our minds is due in very large measure to the museums; from the time when Napoleon's *savants*, abandoned in Egypt along with his army, finally returned with their

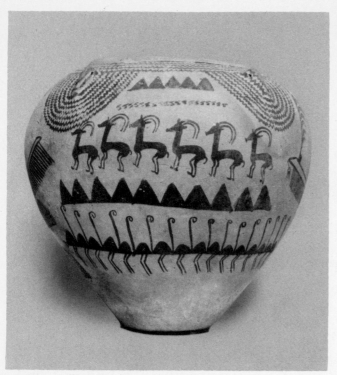

2. *Jar.* Painted pottery. Egyptian, Predynastic period, about 3400 B.C. 12″ high

exciting discoveries, museums have delighted in displaying the world of Egypt before us. The Stone Age archeologist, arranging loom-weights or fishhooks in a museum case, is often in the position of the paleontologist who constructs a dinosaur from a single bone; not so the Egyptologist, who has at his disposal a model of a loom with a perfectly comprehensible mechanism and figures of the women at work on it, or a boat with its crew, exactly adapted to the sporting pleasures of a royal chancellor of the XI dynasty. The character of Egyptian art, though alien, is familiar to us, and we can realize, once our eyes are accustomed to it, that it is based on the Egyptian's great desire to perpetuate the living world as he saw it and knew it.

The relation of the average museum visitor to the art of ancient Mesopotamia is very different. It is possible that the only memories he has of its art are of great man-headed bulls, innumerable deities endlessly fertilizing dates, and a man called Gudea who liked to see himself immortalized in stone. Owing to rainfall and floods and burial customs unlike those of Egypt, much less material has been preserved, and what there is—objects of metal, stone, pottery, and ivory—is far less easy to fit into a simply grasped pattern. Mesopotamia has seen many races living within

it and its art was complex; it was not frozen and static, as is suggested by Assyrian sculpture, but full of cross-currents, archaisms, and contradictions. There was no single development from naturalistic representation to severe stylization or vice versa; often naturalism and stylized convention existed side by side. There were periods in which exact symmetrical patterns were much used, a type of design not native to Egypt, which would, however, become characteristic of later cultures in this part of the world. In fact, the ancient art of the Near East is much more closely linked than the Egyptian with later ages and with other countries; in it may be observed traditions and subjects that reappear in somewhat different forms in the Middle Ages of Europe and in the art of Islam.

Greece and Rome, on the other hand, we feel we know. They are bone of our bone and flesh of our flesh; they had as much to do with our making as had Palestine. We read their books for pleasure and profit, our philosophers must tangle with Plato and Aristotle before they can come to grips

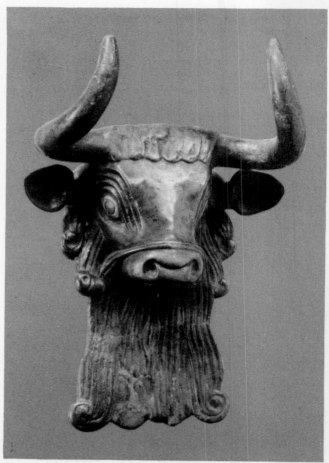

3. *Bull's Head.* Copper, with lapis lazuli eyes. Sumerian, III millennium B.C. 5¼″ high

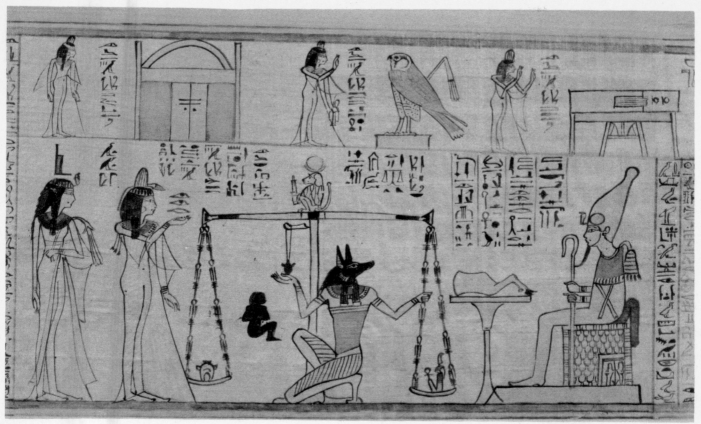

4. *Judgment Scene.* In the papyrus of Princess Entiu-ny. Egyptian, XXI Dynasty, 1085–950 B.C. From Thebes. 14¼″ high

with Leibnitz and Kant, and our artists, until very recently, all had to begin their training with drawing from the "antique." But here again, it is only since the museums and archeological insight began to bring order into the accumulations of the Renaissance princes, to distinguish among Greek and Roman and Etruscan, and to enlarge the horizons of appreciation from the *Laocoön* to Praxiteles to the Parthenon to the sixth century and beyond, that the art of this mother civilization of ours has been an "intelligible field of study." The material which museum men had to work with, though it included no wood or cloth, as in Egypt, was still abundant and varied, and, fortunately for us, there was a great deal of a substance, baked clay, that is practically imperishable, impossible to melt down, and of no value when crushed (that marble should burn to the humble but useful material, lime, is a tragedy of chemistry). Potter's clay was the basis for the painted vases, household utensils, which now form the great illustrative body of material by which insight into Greek life and graphic art is endlessly enriched. No two are duplicates, and each is an original creation from one of the mighty creative

epochs of art and observation. These vases, above all those of Attica, are the background of every modern collection, elucidating the subject matter of marbles, bronzes, jewelry, and intaglios. From Rome come marbles in abundance, sometimes reflecting the glories of Greek originals, sometimes giving us the Roman countenance as clearly as if the man were in the room.

All these civilizations rose, in ways for which there is no generally accepted explanation, from a vast background of primitive culture stretching behind them for unimaginable eons. They were never closed systems; we cannot picture history as a series of separate circles. Even Egyptian art was open to influences, especially at the beginning and at the end of its career. What succeeds these civilizations is not Dark Ages, a vacuum, from which a new Athena of a civilization will spring, adult and fully armed. It is rather a period in which the old ideas, or motifs, or ways of expression, combine, recombine, revert to archaism, or seek out strange alliances, while the new appear, disappear, copy feebly, or boldly initiate, journey splendidly into blind alleys or take timid first steps on paths that will lead to glory. These

19

centuries (from the catacombs, say, to the beginning of Islam) are the happy hunting ground, the *terra incognita,* for the scholar or the art historian, who is always keenest when the map is most nearly blank and when he feels he may be approaching the actual source of his particular Nile. The works of art from these misty years are a challenge to the museum man and a problem to the catalogue department; some of them are illustrated in this book. Their divided affinities are clearly seen, as in the blue faience mask (figure 27); here the glaze is characteristic of Egypt and Syria, but the style is Greek.

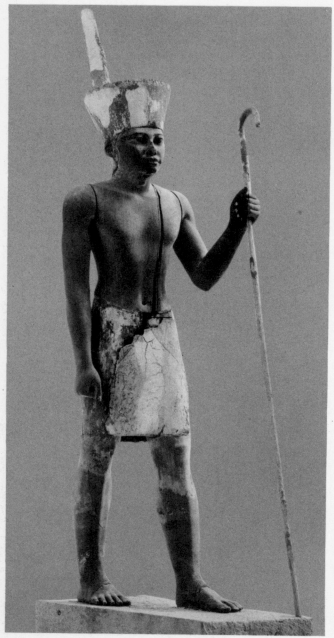

5. *King Se'n-Wosret I.* Wood. Egyptian, XII Dynasty, 1991–1778 B.C. From el Lisht. Statuette 23″ high

Curiously enough, the first important acquisition made by the Metropolitan Museum included a large number of such scholars' delights, though they were so more because they were made in an outlying region than because of the period of their manufacture. This acquisition was the Cesnola Collection, an unrivaled document, with thousands of objects in various materials, stretching in unbroken sequence from the Bronze Age to Byzantine times, and all from the one island of Cyprus. Hither the ships came through the centuries, from Greece, from Egypt, and from the East, bringing fashions as well as merchandise, and the artistic products of the island show the result of this traffic.

But to the Trustees and to the public in the nineteenth century, proud and happy as they were to have the Cesnola Collection, "Art" was primarily oil paintings on canvas and classical sculpture. The first gift to the Museum was a Roman sarcophagus, but sculpture was for the most part represented by casts; as the committee of 1870 reported, "there is a large class of objects of the highest beauty, and of inestimable value toward the formation of a sound taste in Art, which can be had in great completeness by a comparatively moderate expenditure, and with the smallest possible delay. These are the casts of statues and sculpture of all sorts, of architectural subjects and details. In this direction, with reasonable good judgment, it is impossible to go wrong." Casts, therefore, the Museum obtained and its halls, like those of other museums at the time, were sufficiently populated with this bleak and chalky company to justify the establishment of a Casts Department when the first organizational division was made in 1886; this department preserved its identity until 1906. Edward Robinson, Vice-Director in 1905 and Director from 1910 to 1931, well understood the value of casts; he had already started the classical collection of the Boston Museum of Fine Arts and he held the position of departmental curator in the Metropolitan Museum, in addition to his other duties, until 1925. But during this period the genuine articles had been acquired in sufficient numbers, so that the casts could be seen, not so much as "objects of the highest beauty" but as indispensable adjuncts to any classical department, on the same footing as, and even more useful than, photographs, slides, and architectural models. The gods

arrived, and the half-gods withdrew to the study rooms. Miss Gisela M. A. Richter, also an archeologist, was Mr. Robinson's co-worker and successor in the department, and John Marshall, for twenty-two years a purchasing agent in Europe, acted for them. The Rogers and Fletcher Funds, with other generous donations, made his work possible. Nor were splendid gifts lacking, such as the Gréau and Charvet collections of Roman glass, presented by J. Pierpont Morgan and Henry G. Marquand, which, with other gifts and purchases, make the Museum's antique glass collection one of the largest and finest in the world. The Metropolitan Museum was a latecomer to the field of classical antiquity, which had been harvested by collectors ever since the Roman millionaires turned their greedy eyes on Greece, but the disadvantages of this position have been in part offset by a striking advantage. Though it lacks the spoils of the eighteenth and early nineteenth centuries, the Museum lacks also their unwanted —and often haphazard—accumulations; it has a balanced collection.

The first few decades of the twentieth century took the classical collection, as it were, from plaster to marble; during the same period Albert M. Lythgoe made the Egyptian Department. Here the Museum, given the impetus by J. Pierpont Morgan and William M. Laffan, could do more than wait for gifts and scout around for purchases; it could go out and dig. Mr. Lythgoe's ambition was straightforward; he wanted "a series of objects which will thoroughly represent the civilization of ancient Egypt." Thirty years of excavations directed by him and his assistants, Herbert E. Winlock (his successor as curator from 1929 to 1939) and Arthur C. Mace, brought results beyond the dreams of the founders of the department. Mr. Lythgoe based his program for the development of the collection on material obtained through excavation on sites of various periods, supplemented by purchases. With its experts on the spot in Egypt, the Museum was in an extremely advantageous position to buy fine pieces as soon as they came on the market. But, from tiny ivories to the great tomb of Per-Neb (the largest Egyptian thing in America except the Central Park obelisk), the generous collector and donor has also played a major part; Edward S. Harkness, who gave the Carnarvon Collection, the tomb and other masterpieces, as well as supporting the excavations, was the donor *sans pareil* in this department.

The ancient Near East has been less well treated in the Museum until very recently. On the whole this art was not the sort of thing that private people collected for their personal pleasure and as public evidence of their intellectual and esthetic interests. The days when great stone bulls and lions moved by shiploads to the British Museum or the Louvre were past when the Metropolitan Museum was founded, though one

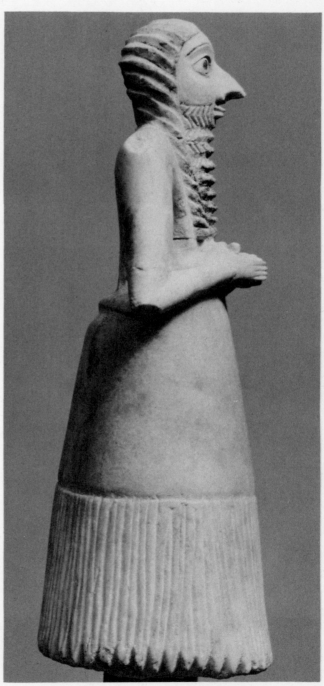

6. *Male Votive Figure.* White gypsum. Sumerian, about 2600 B.C. From Tell Asmar. 11¾" high

21

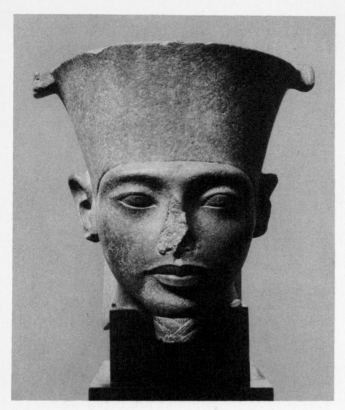

7. *The God Amūn*. Diorite. Egyptian, late XVIII Dynasty, about 1350 B.C. 16″ high

Striding towards him, from the opposite page, is a god in person, Se'n-Wosret I, of the XII dynasty—a god, as were all the rulers of Egypt, but how much more prosaically, though majestically, human than the worshipper from Mesopotamia!

We are still in the company of the gods when we look at the first head on this page. Not now incarnate as a king, but as his divine self, Amūn, in black granite (figure 7), is paired with a youth from archaic Greece (figure 10). The Egyptian sculptor has taken the intensely hard and difficult stone and worked it into forms that flow as easily, and look as simple, as a finger painting. This is the end of the road; nothing could be done to improve the curve of the headdress and the cheek, the planes of the eyebrows and the lips; Egypt could go no further. We turn to Greece and a whole new world opens up; there is in this young man a spark of life that the Egyptians never knew. It expresses itself as tension, like a spring coiled within the body, and it is stronger than the conventions of the sculptor—conventions which are an indirect inheritance of a thousand years of stone-carving in Egypt and the East, now the props and stays of an art just coming into being. But when this manifestation of life has fully permeated the marble, the divine will be

of each kind of animal, torn from its home in the late 1840's, eventually arrived as a gift from John D. Rockefeller, Jr., in 1931. It was then realized that a wide realm of art, closely connected with the Museum's properly cultivated fields, was most inadequately represented. Certain gifts, especially those made in 1917 by J. P. Morgan, were a good foundation, and, in succeeding years the Gedney Beatty bequest, the gift of Luristan bronzes and Phoenician ivories from George D. Pratt, the material from the excavations of H. D. Colt, with other gifts and bequests, and, in addition, purchases (notably from the Brummer Collection) have built up into a substantial group, large enough to make choosing the illustrations for this book no easy task. Here, from South Mesopotamia, is the little man (figure 6) who has been staring at an unseen god for over four thousand years; he already shows the contradictions characteristic of his place of origin. One can see the efforts made by his creator to bring him to life, the hair painted black and the eyes inlaid with shell and lapis lazuli. Yet the body is treated as if it were a geometrical shape and one of the fingers of the clasped hands would, were it uncurled, be twice as long as any of the others.

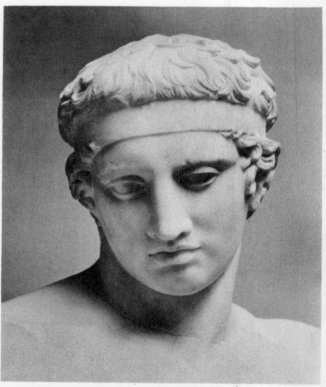

8. *Head of an Athlete*. Marble. Roman copy of a Greek statue by Polykleitos, about 430 B.C. Head about 10″ high

brought even closer to the human. The idealized *diadoumenos* of Polykleitos (shown in a Roman copy, figure 8) has heard the "still, sad music of humanity"; the Roman lady's eyes are fixed on something quite familiar and near at hand (figure 9).

All the illustrations in this book have been selected and arranged to suggest contrasts and parallels such as those just touched upon. Others may be found by turning a page or two; thus, the small, copper bull's head from Sumer (figure 3), made in the third millennium B. C., with its inlaid lapis lazuli eyes, full of life and strength, can be compared with the more precisely ornamental head of the same animal as carved by the Achaemenids on a stone capital from Persepolis two thousand years later (figure 14). Here is the Egyptian statement on a painted papyrus, in letters and figures (figure 4), of exactly what happened when the lady Entiu-ny was brought by the goddess Isis before Osiris, chief god of the dead, and Anubis superintended the weighing of her heart against the image of Truth; here, on the other hand (figure 20), is a snapshot, a single tense moment, in a battle of two bulls, expressed with an economy of line that Picasso might envy, made in Thebes, thirty centuries ago.

Egypt and Greece are contrasted again in the

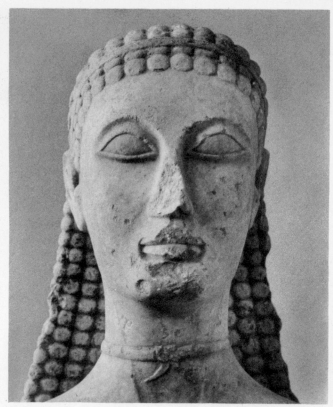

10. *Head of a Youth.* From a marble statue. Greek (Attic), about 600 B.C. Detail 12″ high

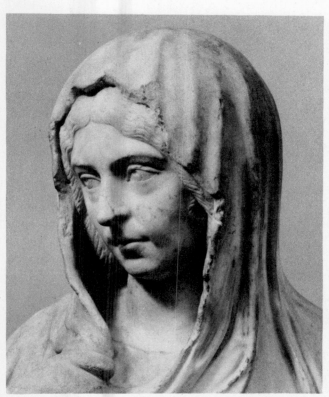

9. *Lady*. Portrait bust in marble. Roman, early third century A.D. Life size

kneeling and the seated figures: the Egyptian (figure 11), as always, utterly composed and self-confident, the folds of the voluminous garment falling without effort into inevitable and perfect curves, while it is perhaps not too fanciful to see in the young Greek woman (figure 12) a being who has conceived the terrifying, though liberating, idea of the possibility of Free Will. There are animals to be compared as well as human beings; stylized, realistic, decorative, idealized. The Greek vases take us from the pictorial shorthand of the "geometric" period, intense and decorative, through the gaiety and grandeur of the black-figured vases, to the miracles of the masters of the red-figure technique. What good fortune for later ages that the Greeks chose this medium for their drawings of men and women! What their paintings were, of which the Greeks thought so highly, can be guessed from the rare Roman examples, such as the two shown here, part of the most important series ever to leave Italy (figures 32 and 33); their perspective and realism are as overwhelming as the Baths of Caracalla. In fact, as we turn these pages we see that antiquity has given us an inexhaustible world of treasures to admire and to love.

23

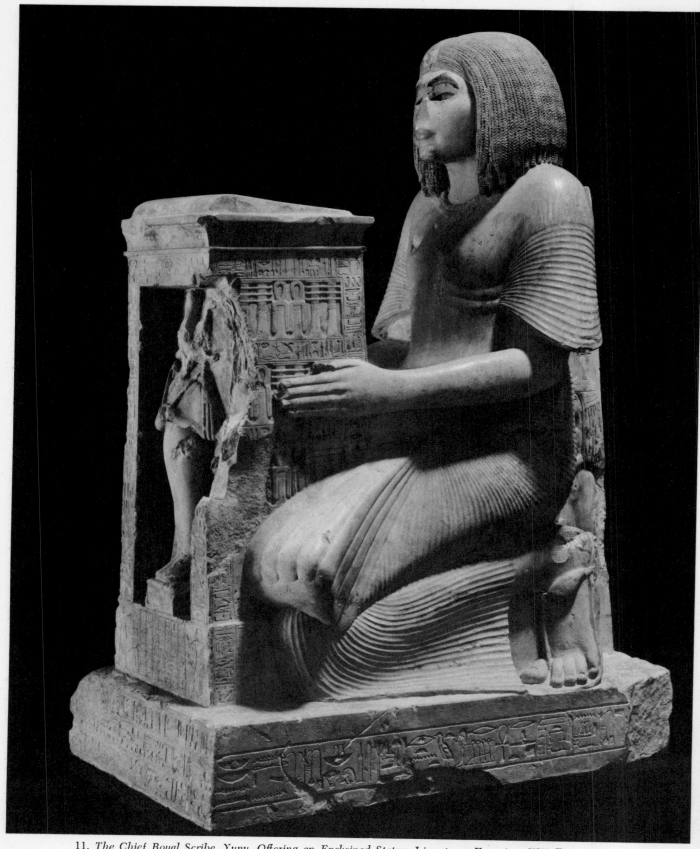

11. *The Chief Royal Scribe, Yuny, Offering an Enshrined Statue.* Limestone. Egyptian, XIX Dynasty, about 1300 B.C. From Asyût. 51″ high

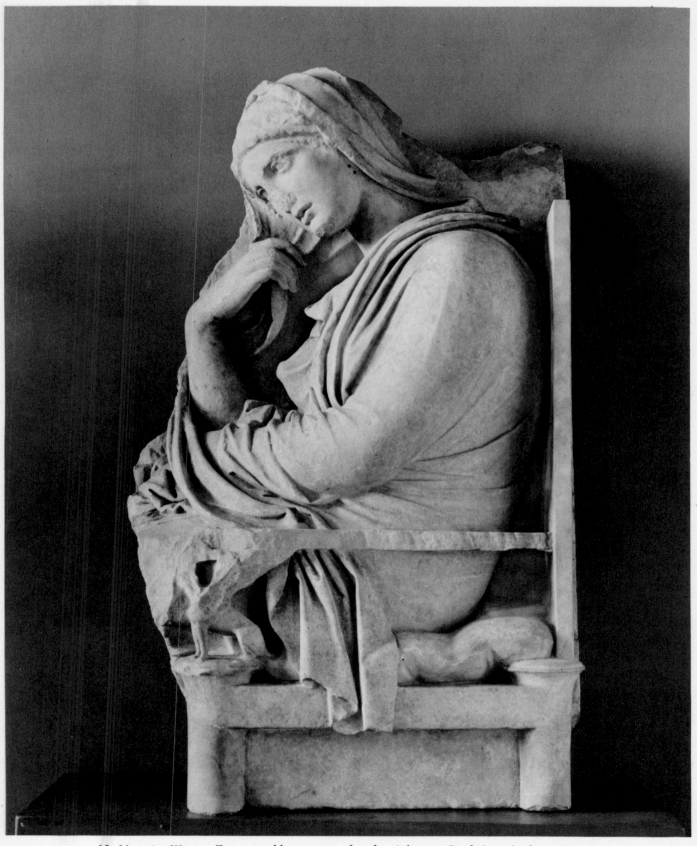

12. *Mourning Woman.* From a marble gravestone found at Acharnae. Greek (Attic), about 400 B.C.
48⅛″ high, as preserved

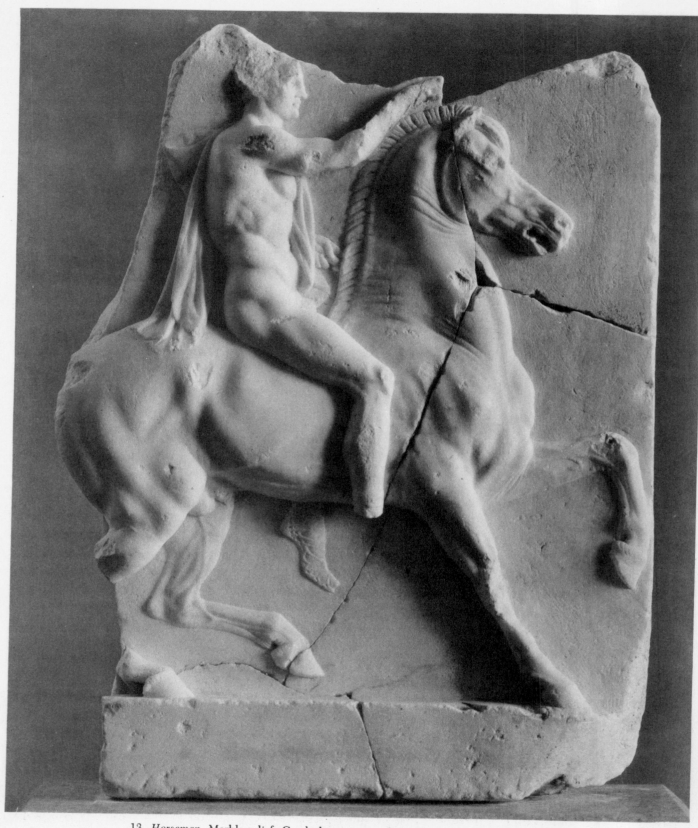

13. *Horseman*. Marble relief. Greek, last quarter of the fourth century B.C. 18″ high

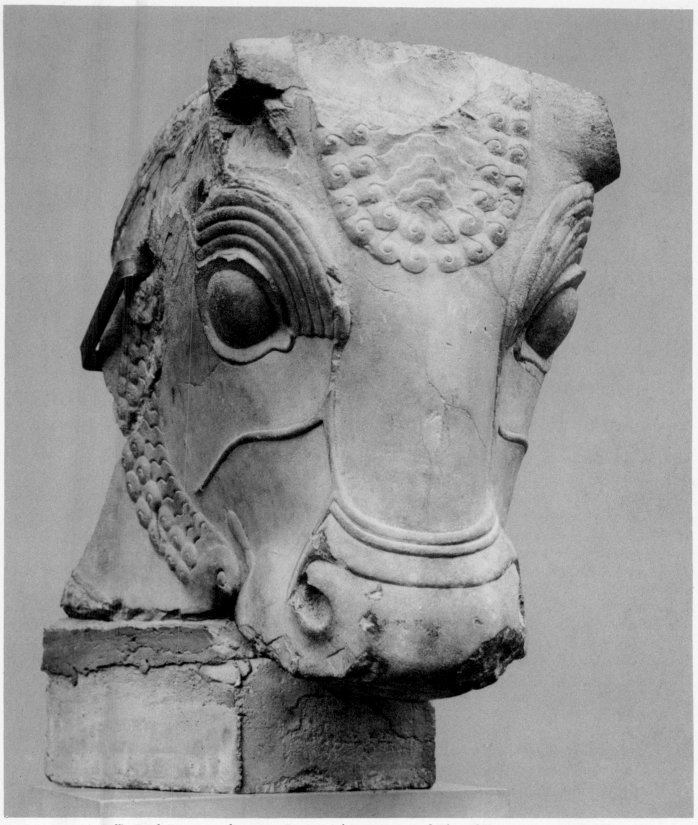

14. *Bull's Head*. Bituminous limestone. Persian, Achaemenian period, about fifth century B.C. 18½″ high

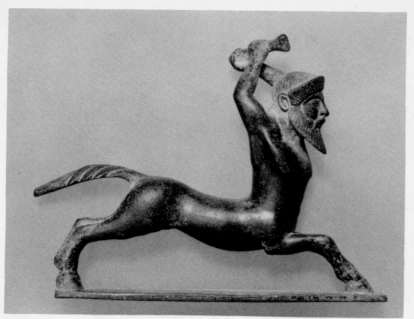

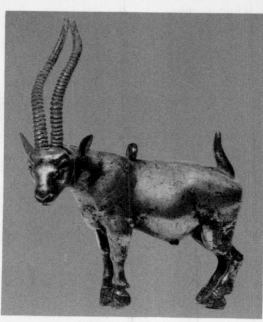

15. *Centaur Fighting*. Bronze statuette. Greek, late sixth century B.C.
4½″ high

16. *Antelope*. Silver. Persian, Achaemenian period,
about fifth century B.C. 4″ long

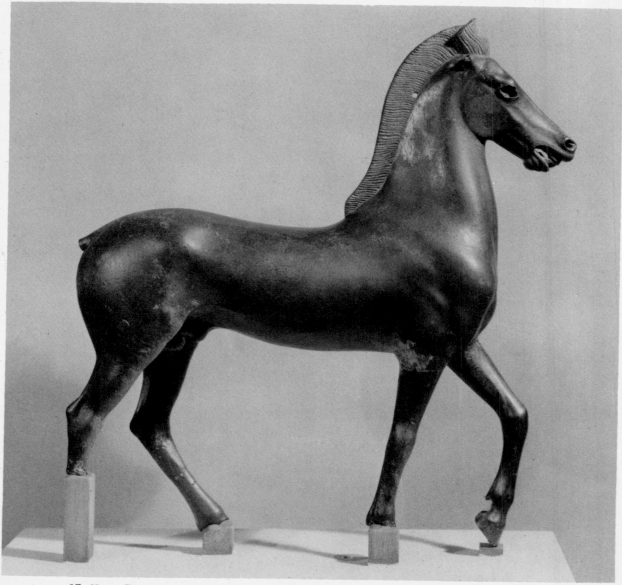

17. *Horse*. Bronze statuette, perhaps from a chariot group. Greek, about 480–470 B.C. 15¾″ high

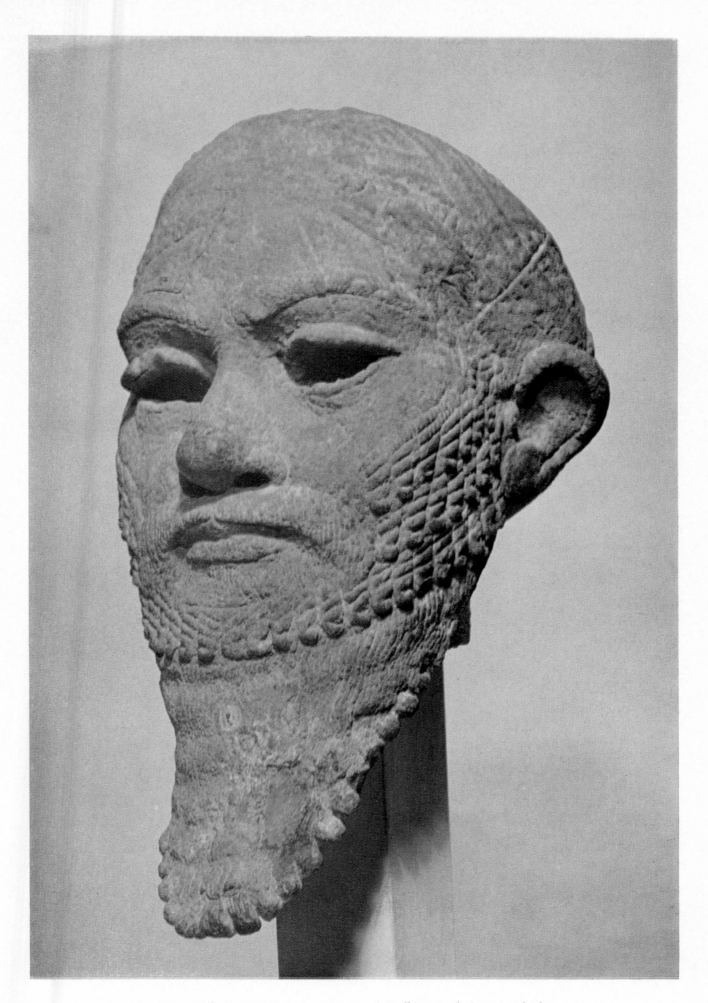

18. *Head of a Man* · Bronze · Iranian, II millennium B.C. · 13½″ high

19. *Girdle, Bracelet, and Armlets of Princess Sit Hat-Hōr Yunet* · Gold, carnelian, feldspar, turquoise, and paste · Egyptian, late XII Dynasty, about 1890-1840 B.C. · From el Lahūn

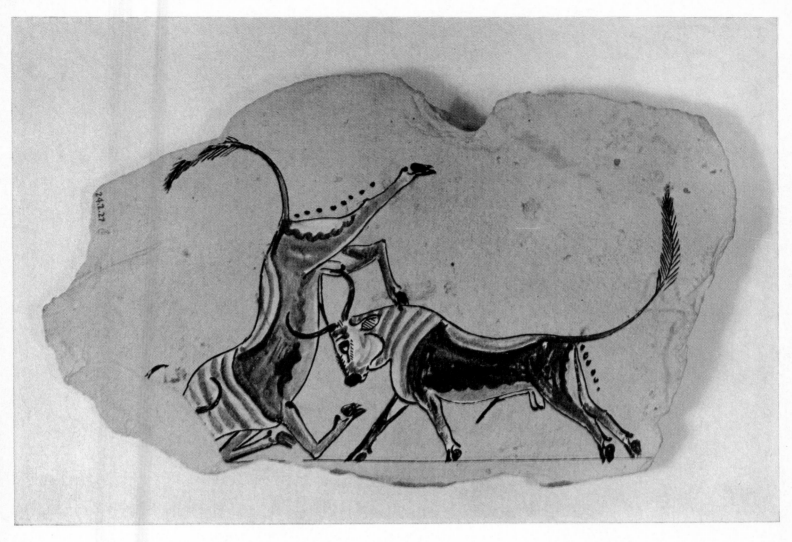

20. *Ostrakon with a Sketch of Two Bulls Fighting* · Limestone · Egyptian, New Kingdom, 1567-1085 B.C.
From Thebes · 7¼″ long

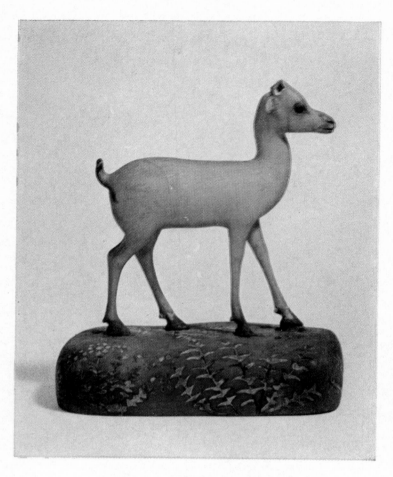

21. *Gazelle* · Ivory · Egyptian, late XVIII Dynasty,
1375-1350 B.C. · 4½″ high

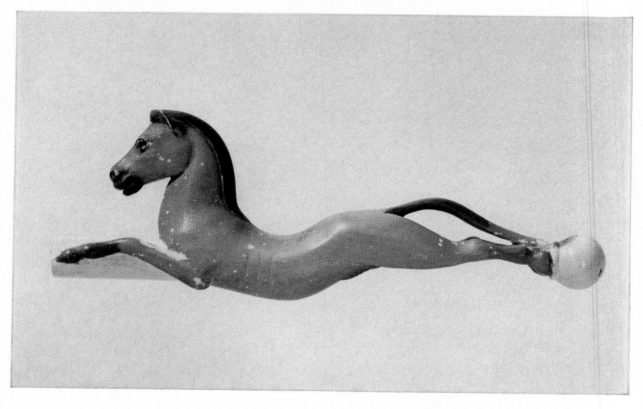

22. *Whip Handle* in the form of a prancing horse · Ivory · Egyptian,
late XVIII Dynasty, 1375-1350 B.C. · 5⅞″ long

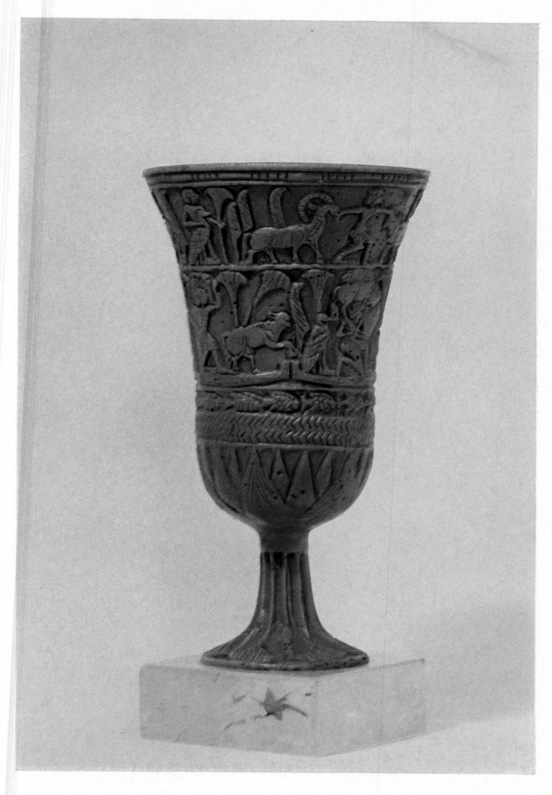

23. *Lotiform Cup* · Faience · Egyptian, XIX-XX Dynasty,
1320-1085 B.C. · 5¾″ high

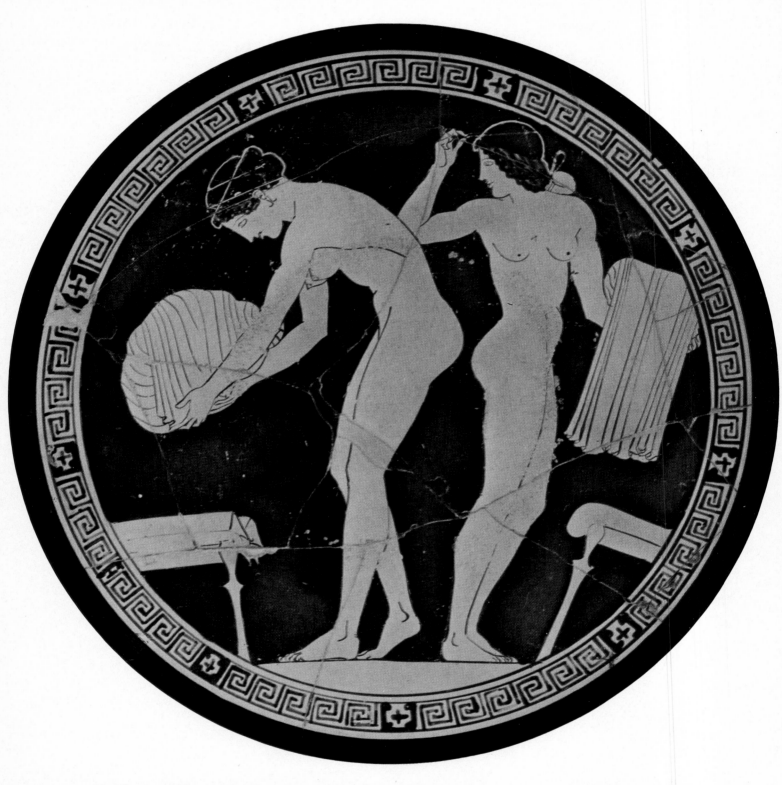

30. *Women Folding Their Clothes* · Tondo from the interior of a kylix, attributed to the painter Douris
Greek, about 470 B.C. · Attic red-figured style · Diameter of tondo 8″

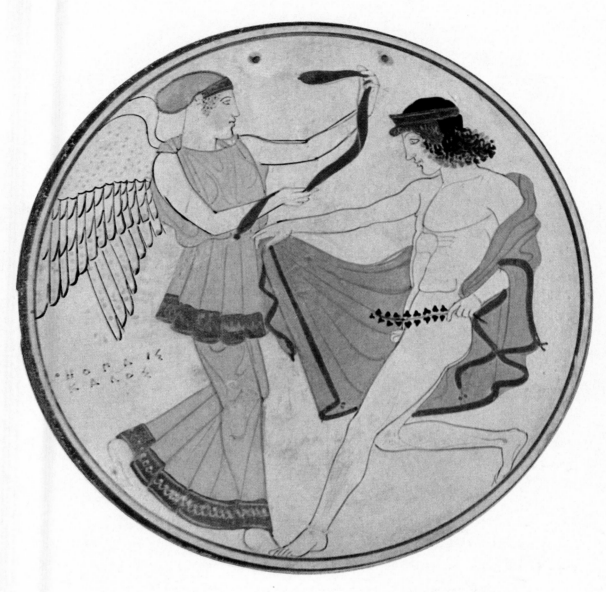

31. *Nike and a Victor* · Terracotta bobbin, attributed to the Penthesilea Painter
Greek, about 460-450 B.C. · Attic polychrome style · Diameter 5″

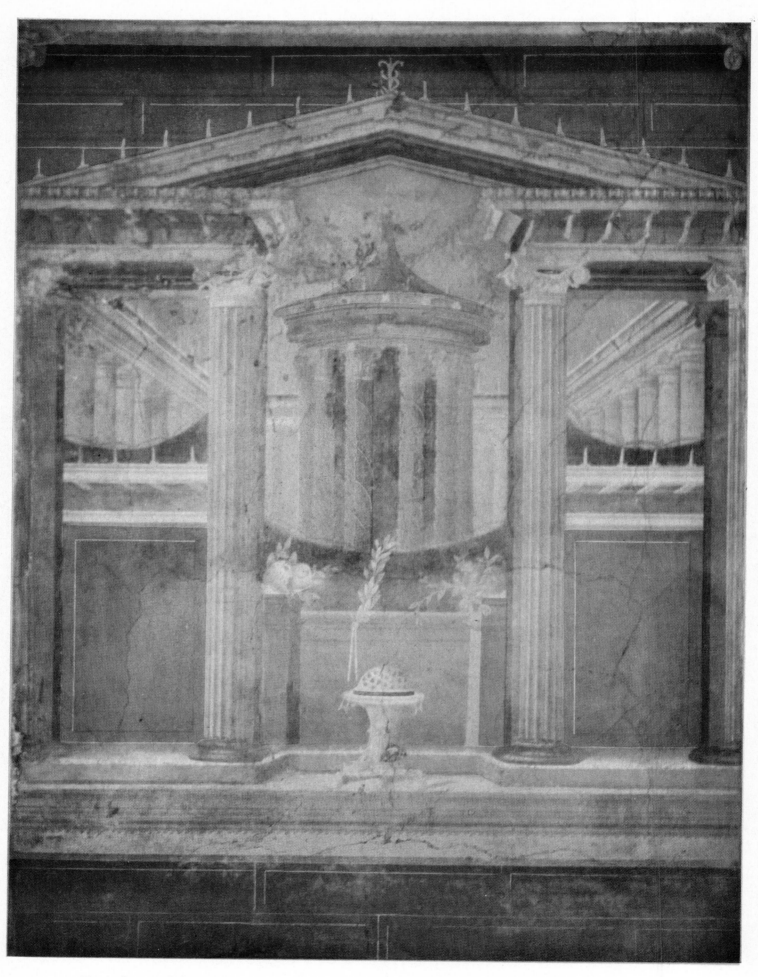

32. *Architectural Composition* · Detail from a wall painting from the cubiculum of a villa at Boscoreale
Roman, first century A.D. · Portion illustrated about 6′ high

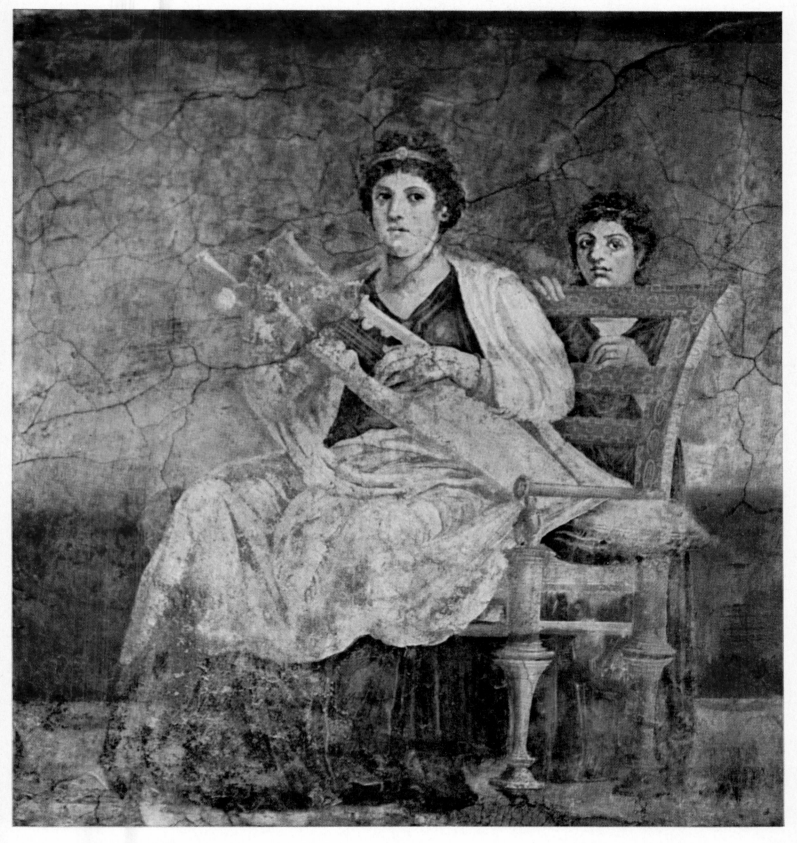

33. *Woman Playing the Kithara, with Her Servant* · Wall painting from the triclinium of a villa at Boscoreale
Roman, first century A.D. · Portion illustrated about 5′ high

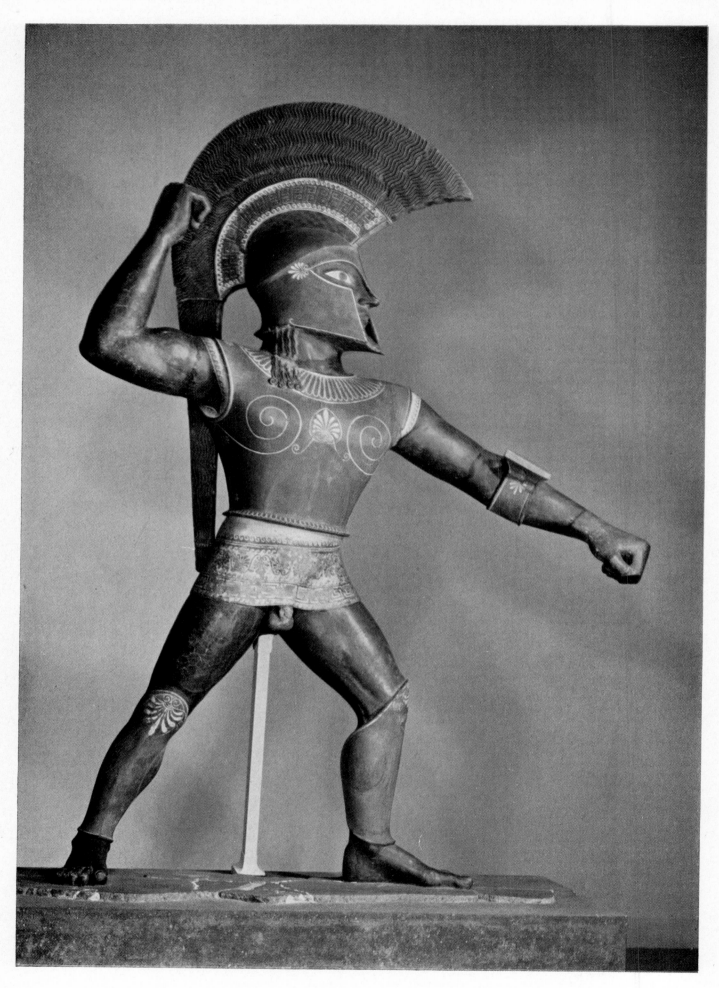

34. *Mars or a Warrior* · Terracotta statue · Etruscan, about 500 B.C. · 8′ high

MEDIEVAL ART

THE ROMAN EMPIRE declined and fell. In its eastern provinces, indeed, an emperor still reigned, with Constantinople as his seat, and called himself "Roman"; the old gods, nevertheless, were dead and, with them, the ideas that formed what we have described as "Ancient Art" were gone forever. New forms did not spring up in a day, but it was inevitable that they would be found to express the new ideas, most particularly the one great idea that, in Europe and parts of the Near East, eventually changed every aspect of life—Christianity. It was not merely a decline of technical skill nor the influx of barbarians in the West that altered the style of everything made by man; the craftsmen of the Byzantine Empire had all the ability of their forefathers, their lives were as secure and their patrons as rich as ever. But they built Hagia Sophia instead of the Parthenon or the Pantheon; and when color on a flat surface was wanted they made the mosaics of Ravenna (and the enamel roundels shown here, figures 38 and 39) instead of such frescoes as those from Boscoreale (figures 32 and 33). Our age, which has seen the art of painting move from the academicians to the abstractionists, can perhaps have a glimmering of an idea why the Christians turned away from an art so competent, so impressive, and so realistic; but the great change

from the ancient world to the Middle Ages took place far more slowly, far less self-consciously, and was far more deep-reaching than anything the last hundred years have experienced.

The earliest Christians, indeed, used the forms they saw around them. The Chalice of Antioch (figure 41), perhaps the earliest surviving Christian chalice, is still classical in style, and even the seventh-century silver dish from Cyprus (figure 35), remotely recalls a Mithraic relief. Byzantine art acquired coherence and unity long before the war-torn countries of the West had regained sufficient prosperity to make works of art in any quantity. When these countries began to take shape, their early attempts to create beautiful things were deeply influenced by the ancient past, the early Christian period, and contemporary Constantinople. But from the eighth century, the creative tide began to flow strongly again, and within a few hundred years Europe was to have its mighty cathedrals, its tens of thousands of churches, its palaces for princes and prelates, all suitably furnished and all to grow in numbers and riches and beauty.

For architecture was the great art of Europe in the Middle Ages. Each century, or stylistic period, is most clearly characterized by its buildings, from the Romanesque to the Flamboyant;

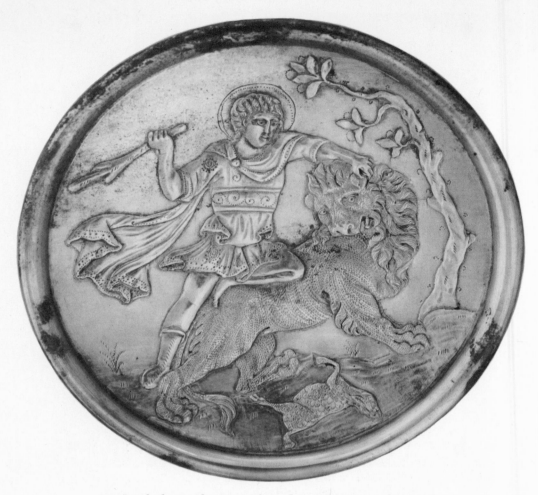

35. *David Slaying the Lion*. Silver plate. Byzantine, early seventh century. Found in Cyprus. Diameter 5½″

but every work of art, from the great cathedral down to the smallest trinket, shows the spirit of its age. If we stare long enough at the twelfth-century Madonna illustrated in figure 37, the pillars of such a Romanesque church as St. Sernin at Toulouse seem to rise around us; at the Christ Pantocrator in enamel (figure 39), and He grows to become the stupendous Ruler of the World in the apse of Monreale. A modern Gothic cathedral can overwhelm the spectator who enters it; the towering lines of the pillars soaring to the fretted roof, the ineffable sense of solemn grandeur and holiness cannot fail to create awe and admiration. But when the eye falls on the mouldings at the base of the columns, or the details of the carved reredos, or the designs in the rose window, it will not receive the same satisfaction that it would gain from similar but ancient objects in an old cathedral. The modern versions are palpable imitations; styles in art can never be repeated. A medieval cathedral might be centuries in building, but every item of all its carvings, tapestries,

paintings, glass, and goldsmiths' work would reflect the architectural style of the period when each was made. And, though it would be an exaggeration to say that all were made solely to the glory of God, yet the chief purpose of the cathedral was to declare that glory, and this is true, to a greater or less extent, of all the objects within it. *Ex divina pulchritudine esse omnium derivatur* ("All being is derived from divine beauty"), wrote Aquinas, and the beautiful and the divine seldom seem far apart during the Middle Ages.

A group of medieval objects can be said to represent the details of a church or a great man's house—those details, in fact, which the most precise copyist can never render satisfactorily for the modern cathedral. They are most at home in an architectural background, and it is this that the Metropolitan Museum has, to some extent, been able to supply in its branch museum, The Cloisters, which can be called unique in the true, unalloyed significance of the word. We cannot build Chartres cathedral today in America, but

46

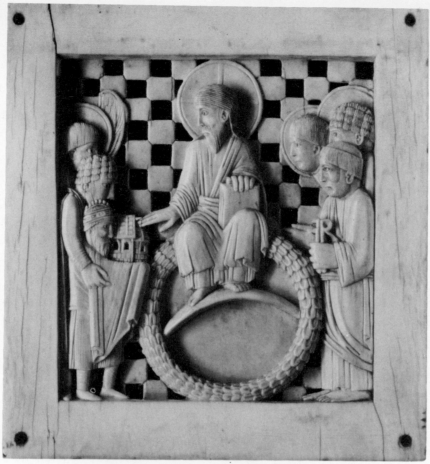

36. *Otto I Presenting a Church to Christ.* Ivory plaque. German or Italian,
second half of the tenth century. 5⅛" high

we can walk in the cloister of Saint-Michel-de-Cuxa or Saint-Guilhem, smell the herbs of a monastery garden, and look out over a view of river and cliffs from a site as splendid as any the monks ever chose in the Old World, and so often and affectionately christened "Beaulieu."

Though this incomparable setting cannot be illustrated in this book, it is not possible to think of the medieval collection of the Metropolitan Museum without remembering it. But the medieval galleries in the main building of the Museum (in which many of the objects illustrated are exhibited) have a longer history. The first important medieval pieces to enter the Museum were the Gothic items in the Hoentschel Collection acquired by J. Pierpont Morgan in 1907, and exhibited as a loan; they were part of the great gift made by his son, J. P. Morgan, in 1916. The Pierpont Morgan Wing, built to show these objects and the other Morgan gifts of decorative art, was opened in 1918. It was at first intended that this collection should remain in the wing for fifty years, but Mr. Morgan showed real understanding of the function of a museum by cancelling this requirement shortly before his death in 1943.

The Department of Decorative Art, established in 1907 with, first, Wilhelm R. Valentiner and, later, Joseph Breck as curators, originally included all the objects in the Museum that were not Egyptian, Greek or Roman, paintings, prints, or books. This unwieldy conglomeration was obviously an unsatisfactory unit, and, in the course of time, it has been divided into the present well-defined and logical departments. The Medieval Department was formally so designated in 1933, but its creation had been inevitable since 1925, when John D. Rockefeller, Jr., presented to the Museum funds for the purchase of the Barnard Collection of sculpture and architectural material, and the building in which it was housed. It would hardly be possible to write a history of any admirable activity in New York City during the last thirty years, from medicine to international co-operation, in which Mr. Rockefeller's name would

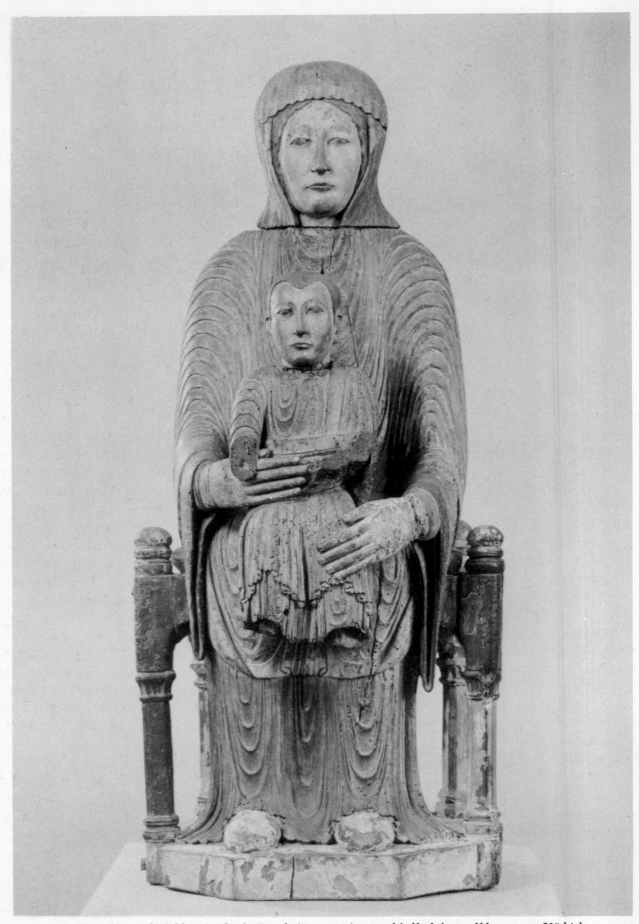

37. *The Virgin and Child.* Painted oak. French (Auvergne), second half of the twelfth century. 31″ high

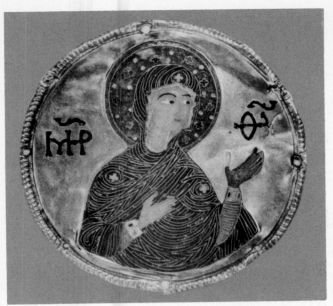

38. *The Virgin*. Cloisonné enamel on gold. Byzantine, eleventh century. From Djumati, Georgia. Diameter, 3¼"

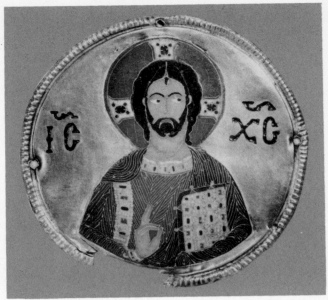

39. *Christ*. Cloisonné enamel on gold. Byzantine, eleventh century. From Djumati, Georgia. Diameter, 3¼"

not occur as an outstanding benefactor. For the benefit of the Metropolitan Museum, his interest in art and his interest in natural beauty could be happily combined. In 1930 he presented to the city the high land overlooking the Hudson which is now Fort Tryon Park; he had always intended that the Barnard Collection should eventually be exhibited in a worthy setting. A superb solution presented itself, the idea of using the northern hilltop of the park for a specially designed structure for medieval art. In 1938 The Cloisters was formally opened, a long-held vision magnificently translated into fact. An engraved slab stands at the entrance to the building as a testimony of gratitude to the man "whose generosity has made it possible to give reality to the past."

George Blumenthal was President of the Museum at the time of the opening of The Cloisters, and to him also the Medieval Department is deeply indebted. A generous donor during his liftetime, he bequeathed to the Museum all his works of art made before 1720; many of the finest of these were medieval, including enamels, ivories, and great tapestries. The Museum owns some seventy medieval hangings, a collection worthy of a prince of the House of Burgundy or Anjou, among them the beautiful Annunciation tapestry given by Mrs. Harold Irving Pratt, two given by Mr. and Mrs. Frederick B. Pratt, two from Frank J. Gould, and a group from George D. Pratt. Outstanding examples are Rockefeller gifts, the Hunt

of the Unicorn series (figure 56), and the greater part of the set of Nine Heroes (figure 55), made for the Duke of Berry in the fourteenth century; equally unforgettable are the Sacraments tapestry, given by J. Pierpont Morgan, and a great purchase, the tapestry of the Roses. Throughout its existence, in fact, the Medieval Department has been able to acquire by purchase works of art of the very highest quality. Thus, in 1947, the death of Joseph Brummer enabled the Museum to acquire great treasures from his estate (the most considerable single collection of medieval art ever dispersed in this country); they included many early objects, provincial Roman enamels and silver, Byzantine bronzes and silver, which complement the Cyprus silver plates from the Morgan Collection, early Christian and Byzantine sculptures. These pieces are like lightning flashes illuminating the difficult centuries between the conversion of Constantine and the rise of new kingdoms in the West.

But the most famous object of this kind is an even more recent accession, the Chalice of Antioch (figure 41). Out of the myths of controversy and irrelevant myth-making, the cup stands and speaks for itself, one of the first products of an accepted Christianity, no longer hiding in catacombs. Its restrained vine scrolls, with the realistic bunches of grapes, are in startling contrast with the great swirls of foliage on the twelfth-century limestone pilaster (figure 40), filled with

49

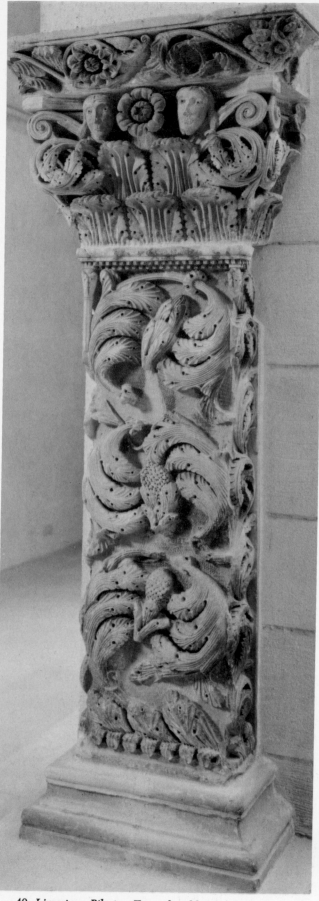

40. *Limestone Pilaster*. From the abbey of Saint-Guil-
hem-le-Désert. South French, before 1206. 5′ 3″ high

the vigor and tension of coiled young fern fronds. Such a decoration for a pillar and such a mingling of old and new in the capital, the human heads peering from above the acanthus, would have astonished Vitruvius. It is not easy to name the species of the leaves; as in the so-called "pomegranate" velvets of three hundred years later, we see a plant form filling every nook and cranny of the design with an almost more than natural urgency and force, but not exactly copied from any specific type. The medieval craftsman could observe and reproduce, as is shown by the flowers, trees, and shrubs which are rendered with such exactitude and affection in so many tapestries, to the great joy of botanists, but he was equally capable of taking a generalized form and giving it the power of a living thing.

The favorite theme of the medieval artist, the Virgin with the young Christ Child, appears in two very different forms in this book, one (figure 37) from the beginning, the other (figure 53) from the end of the medieval period. There are, indeed, more than sixty representations of this subject in the main building of the Museum alone, which would, in themselves, provide adequate illustrations for a history of the development of medieval styles. The Mother of Christ can be shown enthroned, motionless, hieratic, the very "seat of the Most High, the seat on which Our Lord sits, who governs the universe"; she can stand, gracious and welcoming, at the cathedral door; a courtly young lady, she can bend so that her draperies flow easily into the most elegant and graceful folds; she can sit humbly on a grassy bank, with such a warm, human bond between her and her Son that any mother can recognize the feeling the artist wished to express.

The standing male saint shown in color (figure 49) is probably St. James the Less, who was said to have borne a strong resemblance to Christ. Seldom has such a large and distinguished wood piece survived the ravages of time. Most of the fine large stone sculptures still to be seen in the cathedrals of Europe have lost their gilding and paint, but, on the statue of St. James, the blue mantle bordered with gold and the red tunic, the flesh tints and the gilded hair, were preserved beneath later repaints. This and many other sculptures in the Museum's collection have been painstakingly restored to what is more nearly their original condition; the weather-worn, scraped or

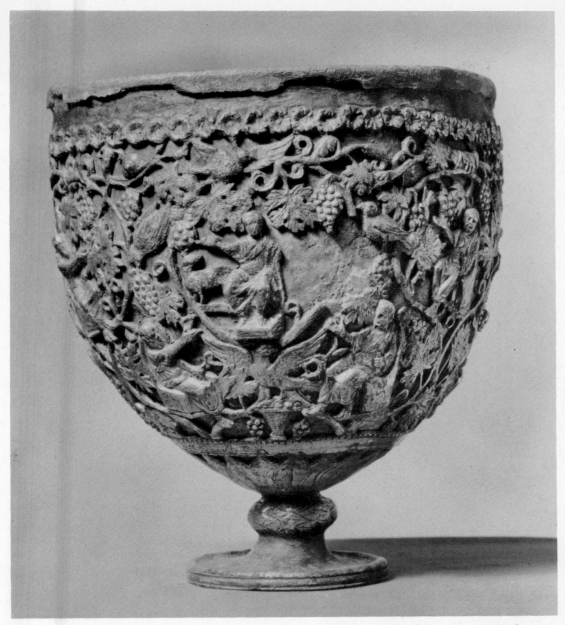

41. *Chalice of Antioch.* Silver, parcel-gilt. Early Christian, fourth or possibly fifth century. 7½" high.
The Cloisters Collection

refurbished state so usually thought to be characteristic of medieval sculpture hardly conveys the intention of the sculptor.

It is this splendor of color, in fact, which was characteristic of medieval art and which is hard to visualize when we stand under the great stone vault of a cathedral that is no longer even white. Paintings are covered with plaster, tapestries fade, and color falls from wood and stone. Stained glass and enamels remain in all their original brilliance—a brilliance, alas, that can only be partially transferred to the printed page, where the gold on the enamels cannot glisten in a changing light nor the sun blaze through the glories of reds and blues unparalleled. But even so we can catch something of the richness of the Tree of Jesse window (figure 57); here the stories of the ancestors of Christ and of His life are vividly portrayed, with emphasis on individual scenes harmoniously accented in an all-over decorative pattern. This art will not appear again in this book; sculpture and metal work, enamel and tapestry go on to other triumphs in other styles, but, though fine examples were made in the Renaissance period, when we hear the words "stained glass," we think first of the great windows of Chartres and their peers, such as the Tree of Jesse.

51

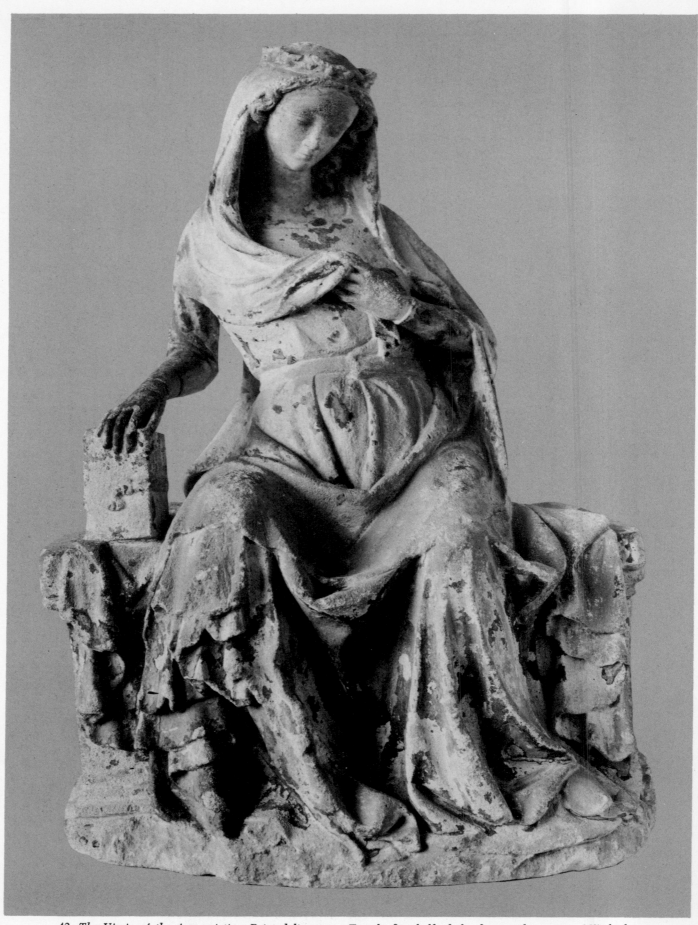

42. *The Virgin of the Annunciation.* Painted limestone. French, first half of the fourteenth century. 16¾" high

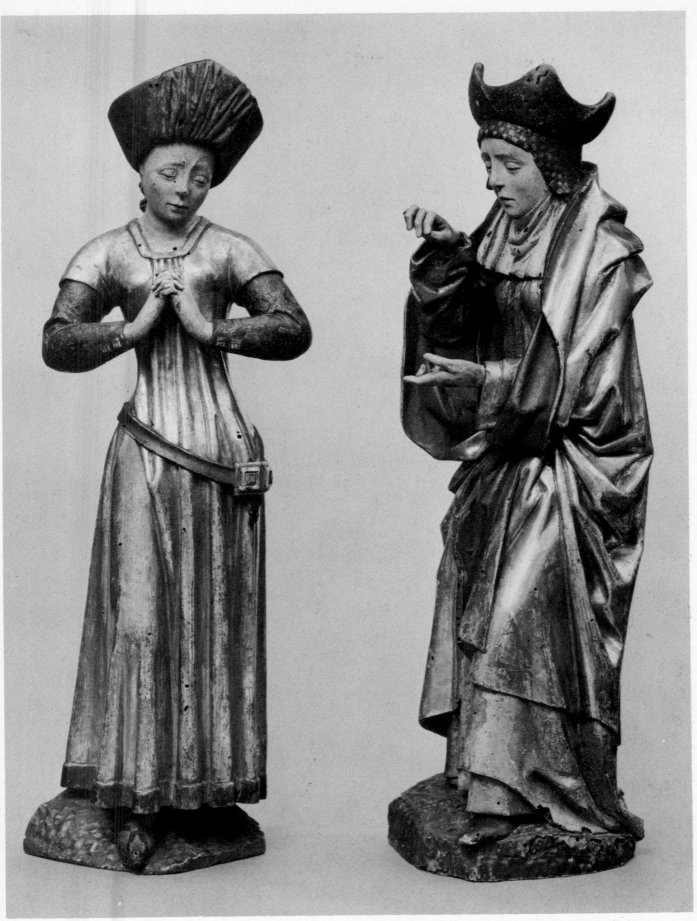

43. *Two Holy Women.* Painted walnut. Flemish, second half of the fifteenth century. Each figure 19¼″ high

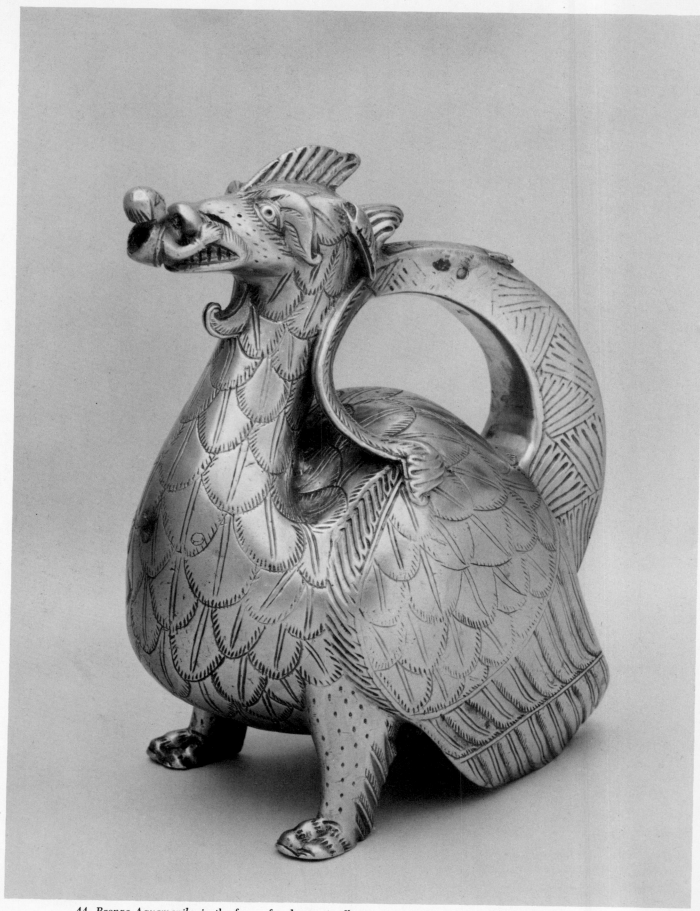

44. *Bronze Aquamanile*, in the form of a dragon swallowing a man. German, twelfth or thirteenth century.
8½″ high. The Cloisters Collection

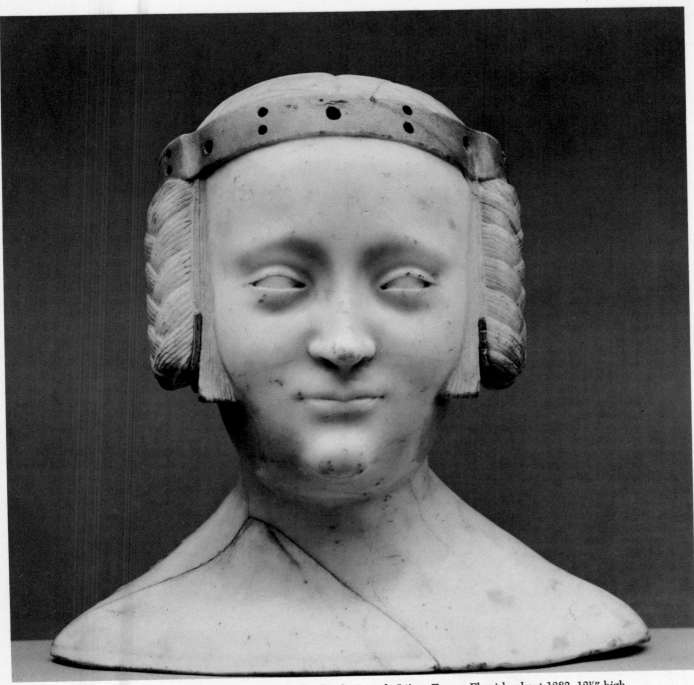

45. *Marie de France*. Head from a marble tomb effigy by Jean de Liège. Franco-Flemish, about 1382. 12¼″ high

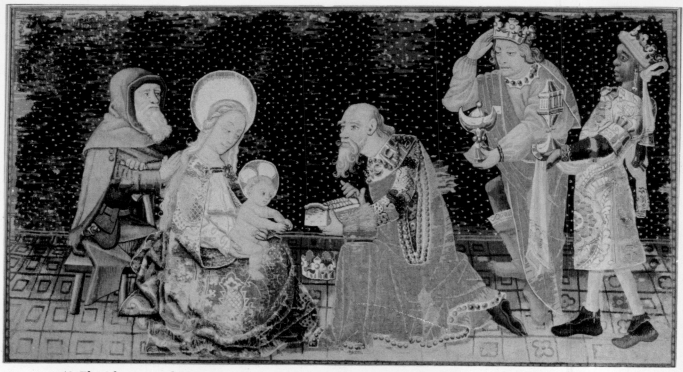

46. *The Adoration of the Magi.* Wool and silk tapestry. Franco-Flemish, fifteenth or sixteenth century. 6′ 5½″ wide

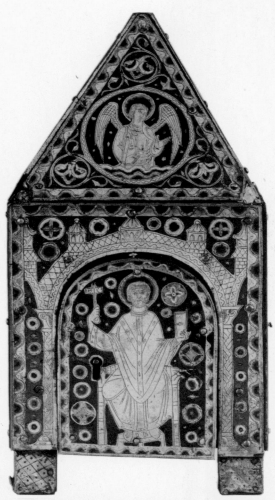

47. *Reliquary Box.* Champlevé enamel on copper-gilt.
French (Limoges), thirteenth century. 14¼″ high

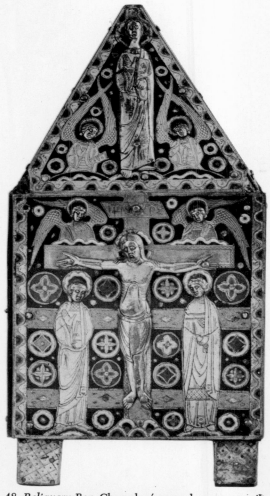

48. *Reliquary Box.* Champlevé enamel on copper-gilt.
French (Limoges), thirteenth century. 14¼″ high

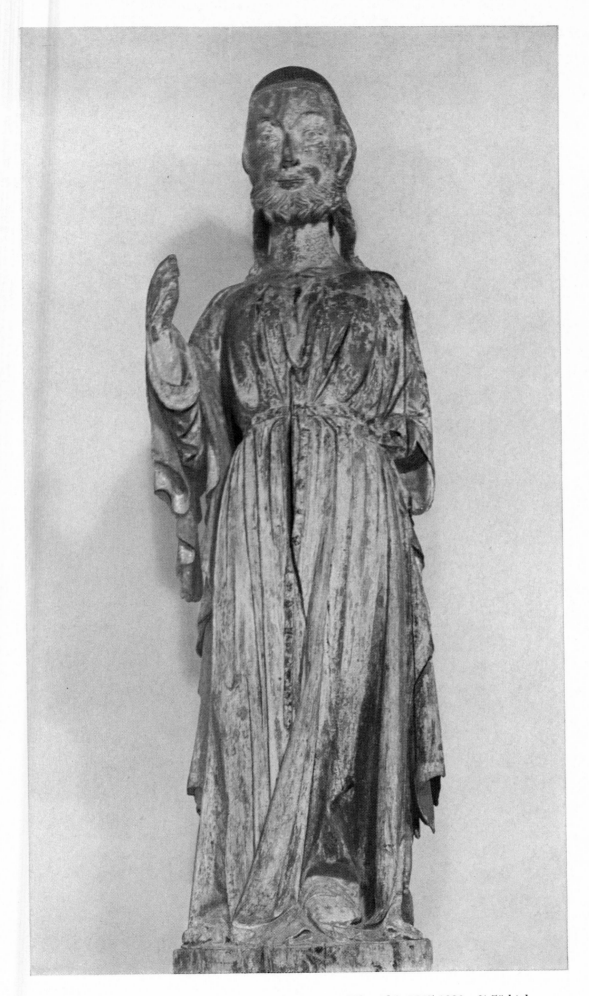

49. *Saint James the Less* · Painted wood · German [Rhenish], 1265-1280 · 6' 5" high

50 and 51. *Reliquary Box*, top and side view · Cloisonné enamel
on silver-gilt · Byzantine, eighth to ninth century · 4″ long

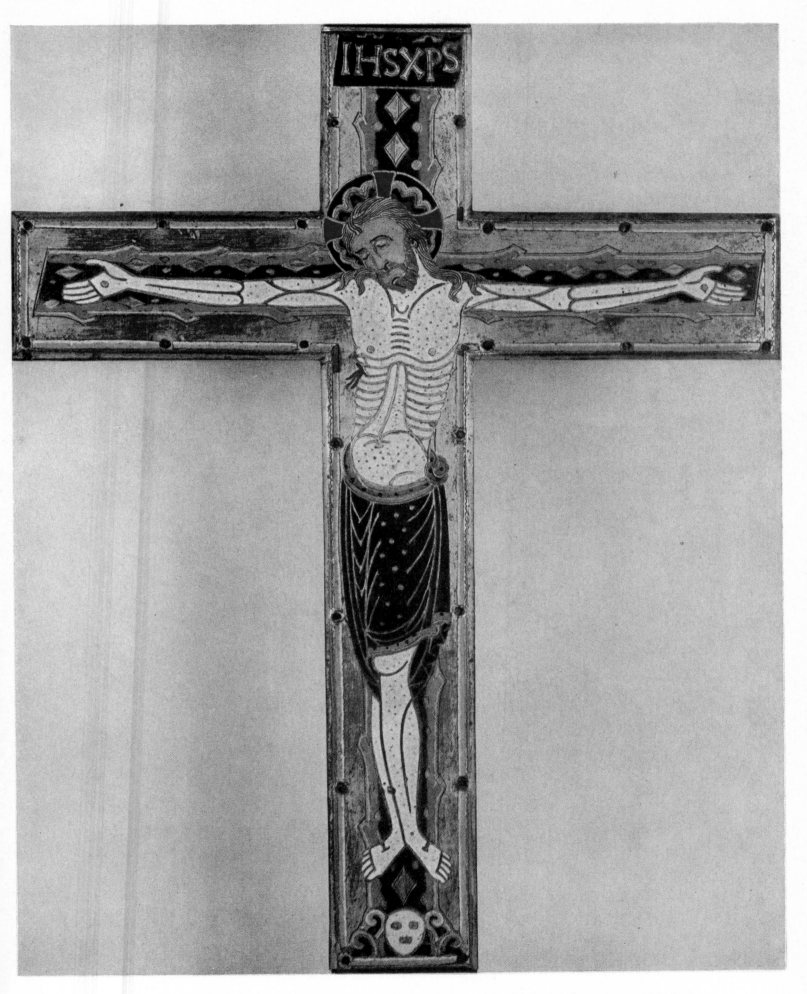

52. *Crucifix* · Champlevé enamel on copper-gilt · French [Limoges], early thirteenth century · 22½″ high

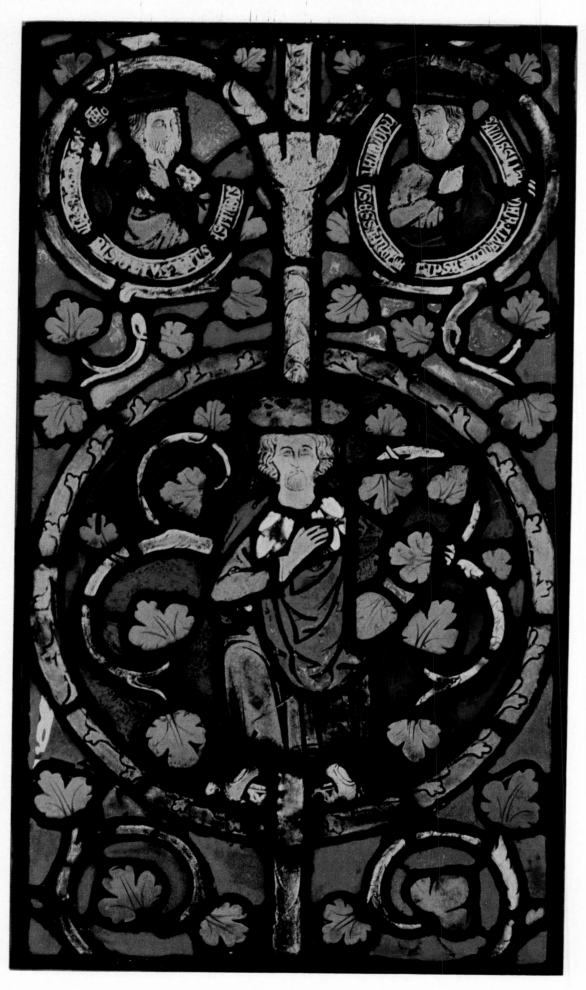

57. *Old Testament King* · Panel from a stained-glass window · German [Rhenish]
About 1300 · 26″ high

DRAWINGS AND PAINTINGS

NOT ONE OF THE NINE MUSES devotes herself to painting, yet the average man, if asked what he would expect to find in an art museum, would certainly answer, "Pictures." This extreme specialization in the meaning, or rather the connotation, of the word *art* is a fairly recent development. As late as 1826, William Cullen Bryant, lecturing on the fine arts—"those arts the principal aim of which is to please the imagination"—had to justify his inclusion of painting. Though painters, and writers on painting, have used the word *art* in the modern sense for painting, engraving, sculpture, and architecture since the seventeenth century, it was not given this meaning in dictionaries until 1880. Nowadays even sculpture does not come immediately to mind when we hear the word—*art* is paintings and an *artist* is a painter.

One of the great tasks of the museum, of course, is to combat this tendency; the illustrations of this book in every other section show "art" in the form of stone, steel, bronze, wood, wool, and a dozen substances that are not pigment on a flat surface. Yet to the average European or American reader this section cannot but be the heart of the matter; a painting by Raphael or Rembrandt, by El Greco or Cézanne, needs no introduction or explanation. There are fashions in

appreciation, but, generally speaking, scarcely any old masters have entirely fallen from grace in the last thirty years; violent fluctuations in standing have been confined to works painted since 1800. The rediscovery of forgotten artists that began in the nineteenth century (when a poet could sing "My painter who but Cimabue?" and Mr. Punch's fashionable young men asked whether Botticelli or Gorgonzola was the name of the cheese) still continues (witness the recent emergence of Georges de la Tour), but, most happily, there are very few corresponding losses. It is true that a Romney portrait of a pretty woman is no longer likely to bring a record price at auction, but this reflects as much a change in the economic and social situation as in taste. From Giotto to Ingres there are no painters or schools of painting that the *Zeitgeist* absolutely forbids us to admire; and even for the nineteenth century the range of permissible enthusiasms is very wide indeed and is growing. Individual preferences there must always be, but we can all hope nowadays to overcome our personal dislikes; we may suspect them to be confessions of ignorance.

The illustrations of this section give some idea of the scope of the Paintings Collection in the Metropolitan Museum (always bearing in mind that American art is not included), but they are

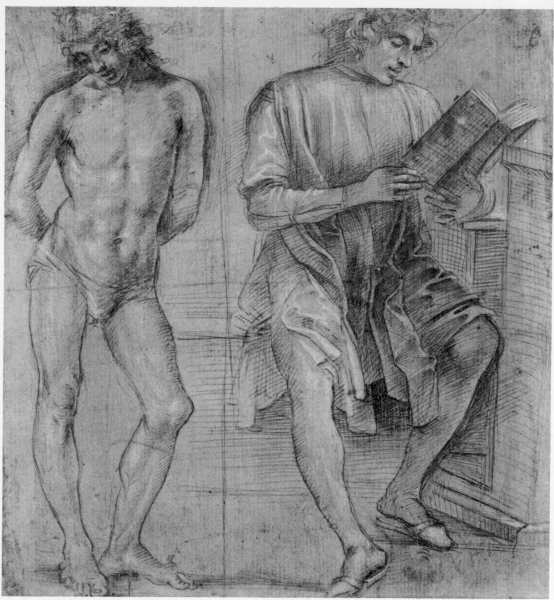

58. FILIPPINO LIPPI (about 1457–1504). *Two Male Figures: St. Sebastian and Young Man at a Desk.*
Silverpoint and white wash on paper, 9¹¹⁄₁₆ x 8½"

only a scattering of the brightest jewels from a boxful as glistening as ever Faust handed to Marguerite. One out of five Vermeers, two out of twenty-eight Rembrandts, two out of five El Grecos, are all that could find a place here; it is obvious that the selection was an almost impossibly difficult one. Among the illustrations are seven from the last great collection to enter the Museum, the Harkness Bequest of 1950; and one, the Guardi, from the group of 174 pictures purchased by the new-born Museum in 1871.

These 174 pictures were almost all Dutch and Flemish. They had been the property of two collectors, one in Brussels, the other in Paris, and were bought in Europe by William T. Blodgett, a member of the first executive committee, a future Benefactor, and himself a collector, with the intention of transferring them to the Museum at cost. The President, John Taylor Johnston, was delighted with the pictures, and thus the Museum had works of its own when its first temporary home was opened to the public in 1872. Fifty-five of these paintings were of sufficiently high quality to be shown in the fiftieth anniversary exhibition of 1920, and they included Hals's *Malle Babbe;* as the average purchase price had been under $150 a picture, the investment may be said to have been profitable.

Thus from the very beginning the Museum owned a splendid work by Hals, a prophetic in-

66

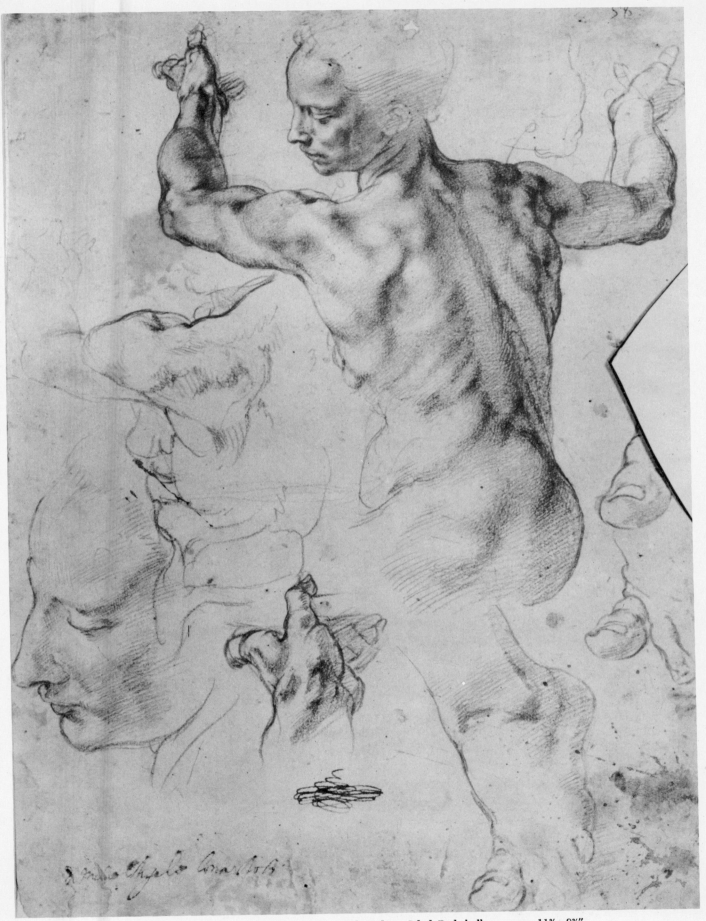

59. MICHELANGELO (1475–1564). *Studies for the Libyan Sibyl*. Red chalk on paper, 11⅜ x 8⅜″

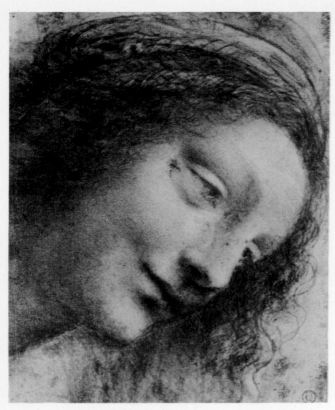

60. LEONARDO DA VINCI (1452–1519). *Head of the Virgin.*
Red and black chalk on grey paper, 8 x 6⅛″

Metropolitan Museum outstanding in this field.

French paintings made up the major part of the first large collection bequeathed to the Museum. It had belonged to Catharine Lorillard Wolfe, the one woman whose name appears among the one hundred and six original subscribers of 1870. She made her bequest in 1887; women were first elected to the Board of Trustees of the Museum in 1952, a somewhat belated tribute to the part they have played in its growth. Miss Wolfe's collection was "modern," and she had not patronized the *avant garde* of her day; comparatively few of her paintings would appeal to present-day taste, but she stated in her will that she wished to afford "enjoyment and recreation," and this, for thousands of people for many years, her collection certainly did. A further clause bequeathed a substantial sum for the upkeep of her pictures and for the purchase of other original modern oil paintings; these had to be "figure, landscape, and genre subjects." Thus her name appears under many of the paintings illus-

dication, for the schools of seventeenth-century Holland and Flanders have continued to be more and more grandly represented, as is indeed appropriate for the greatest art gallery of a metropolis once called "Nieuw Amsterdam." Three of these pictures (two reproduced)—the Metsu, van Dyck's *James Stuart,* and Vermeer's *Woman with a Water Jug*—were among the thirty-five paintings, mostly old masters, given by Henry G. Marquand, the second President, in 1889; an early gift, but one that is still remarkable for high quality. Five more, Hals's *Yonker Ramp and His Sweetheart,* Rembrandt's *Auctioneer,* Vermeer's *A Girl Asleep,* the Ruisdael, and the Hobbema were part of what was described by the Director in 1913 as "from every point of view the most splendid gift ever received by the Museum from an individual," the Benjamin Altman bequest. The Rubens, given by Harry Payne Bingham in 1937, is one of a group of fine works by this master, and the Steen came to the Museum from Helen Swift Neilson as recently as 1945. Other van Dycks, other Rembrandts, other paintings by Hals, as well as by Pieter de Hooch, Terborch, Cuyp, Brouwer, etc., help to make the

61. FOUQUET (1415/20–1481). *Portrait of an Ecclesiastic.*
Silverpoint on paper, 7¹¹⁄₁₆ x 5⁵⁄₁₆″

trated here, for the J. L. David, the Delacroix, the Ingres, and the Renoir are purchases from the Wolfe Fund. The Trustees have interpreted "modern" in the sense Miss Wolfe would have approved; her ghost would certainly haunt the galleries if her money were used for Picassos.

Two more pictures painted in France in the nineteenth century arrived in 1889, the gift of Erwin Davis. The artist had been dead only six years, and these paintings must have looked remarkably different from anything else then to be seen in the galleries of the Museum. They were the *Woman with a Parrot* and the *Boy with a Sword*, by Manet, the first of the great nineteenth-century French painters of revolutionary tendencies to be appreciated in America. His paintings, in fact, were collected here before he became truly popular in Europe. A great Renoir actually entered the Museum during the artist's lifetime, for *Mme. Charpentier and Her Children* was bought in 1907; equal courage must have been necessary for the purchase in 1913 of a Cézanne that had

been exhibited in the epoch-making Armory show of that year.

But that the Metropolitan Museum now holds an assured position, alongside the Louvre or any other art gallery, in the field of modern French art, is due principally to the bequest of Mrs. H. O. Havemeyer in 1929. By this date there had been a complete reversal of roles among French nineteenth-century painters; as in a medieval representation of the Wheel of Fortune, those that had been up were down and those that had been down were up. The works of some once-despised artists now fetched fantastic prices and their absence in the Museum was conspicuous. The Havemeyer Bequest changed all this; of the ten pictures shown here, five are works by Courbet, Daumier, Monet, Degas, and Cézanne. Four painters of this period missing from this list, Gauguin, Seurat, Rousseau le Douanier, and van Gogh, are represented by pictures from the Samuel A. Lewisohn bequest of 1951. The earlier French masters, whose relationship to their nine-

62. WATTEAU (1684–1721). *Mezzetin.* Red and black crayon on white paper, 5⅞ x 5⅛"

63. GOYA (1748–1828). *Portrait of the Artist.* India ink wash on paper, 6 x 3⅜"

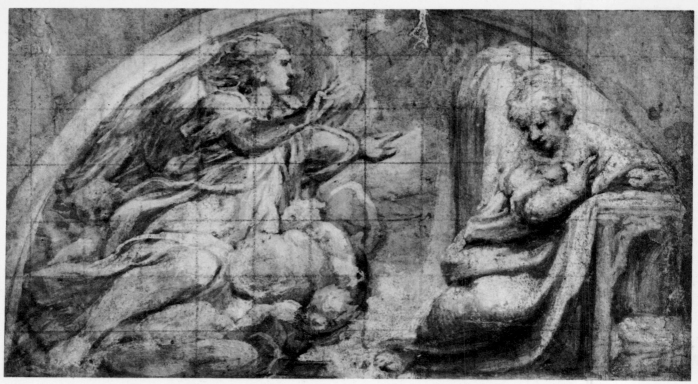

64. CORREGGIO (1489–1534). *The Annunciation*. Tempera on paper 3¾ x 6⅞"

teenth-century descendants can now be so clearly seen, form a group of excellent quality. Here illustrated are a sixteenth-century work, Chrétien's *Moses and Aaron before Pharaoh*, recently purchased, Boucher's *Toilet of Venus*, one of a group of twelve paintings and pieces of furniture, all of high quality, bequeathed by William K. Vanderbilt in 1920, the Chardin purchased from the Wentworth Fund, the Watteau formerly in the Hermitage, Poussin, and Fragonard. The Museum also owns other important early works, such as portraits by Clouet and Corneille de Lyon, and many more splendid pieces from the seventeenth and eighteenth centuries.

It will have been noticed that, along with the magnificent gifts and bequests that constitute the bulk of the paintings in the Museum, there have been a remarkable number of purchases, important individually, collectively, and as components of a well-balanced collection. The credit for these must be divided between the Trustees and the curators of the Department of Paintings, which was formed as early as 1886. William Henry Goodyear was curator until 1889, when he was succeeded by George H. Story, who held the position until 1906. This was the time when, as has been described, the Museum acquired a new President, a new Director, a new departmental

organization and, above all, a new purchase fund. Along with all this novelty, Roger Fry came from England to be curator of the Paintings Department. He stayed less than a year, during which time he was bitterly attacked in the press because he bought El Greco's *Adoration* and because he had some pictures cleaned. From his later years date the writings that made him famous, but he was already a master of practical esthetics. This appears in what he wrote of the picture gallery of the Metropolitan Museum; he said, "There is only one aspect of the art which is adequately represented and that is the sentimental and anecdotic side of nineteenth-century painting. For the rest we can only present isolated points in the great sequence of European creative thought. We have as yet no Byzantine paintings, no Giotto, no Giottesque, no Mantegna, no Botticelli, no Leonardo, no Raphael, no Michelangelo." This list might be criticized on the grounds that it contains only Byzantine and Italian masters, but the purchases in 1906, which include works by Etty, van Goyen, Maes, Blake, Goya, and Holbein, show that Fry was not as narrow-minded as he seemed.

The most interesting point about this list of those absent in 1906 is that they are almost all present in 1952, many of them illustrated in this

70

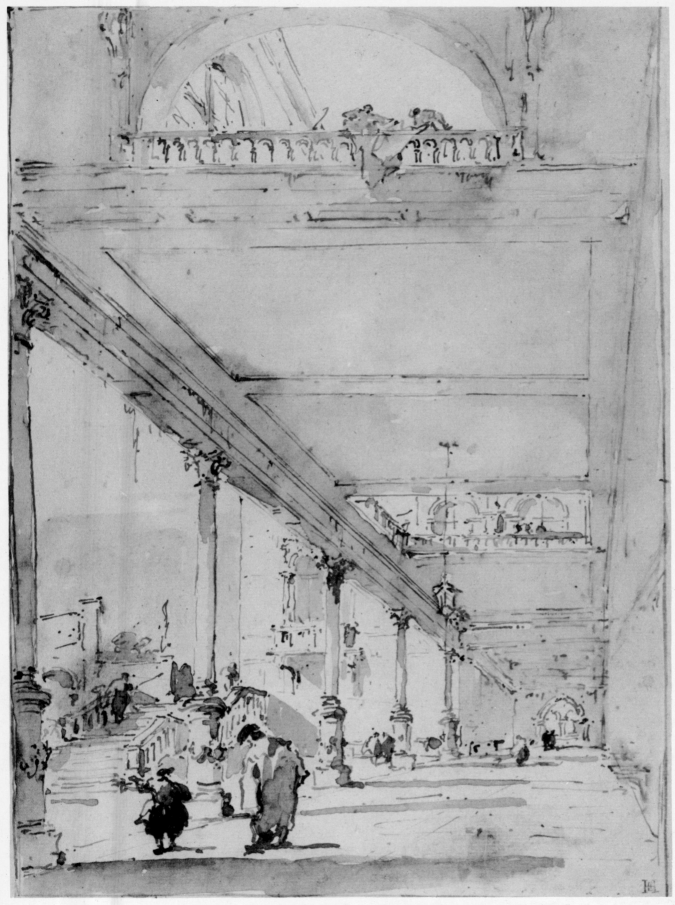

65. GUARDI (1712–1793). *Loggia of a Palace*. Pen and bistre wash on paper, 10¹³⁄₁₆ x 7⁹⁄₁₆″

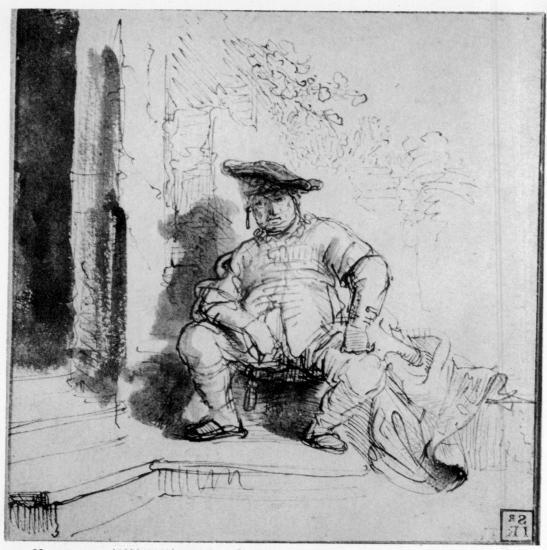

66. REMBRANDT (1606–1669). *Man Seated on a Step*. Pen and bistre, washed, on paper, 5¾ x 5⁷⁄₁₆"

book. There is the *Epiphany*, certainly painted in Giotto's workshop, purchased in 1911; Mantegna's *Adoration of the Shepherds*, an anonymous gift of 1932; Botticelli's *Last Communion of St. Jerome* from the Altman Collection; Raphael's *Madonna and Child Enthroned*, the great showpiece of the collection, given by J. P. Morgan in 1916; drawings by Leonardo and Michelangelo. A very early gift is represented by the Piero di Cosimo; this work and its companion piece were received in 1875, probably without much fanfare, from a member of the executive committee, Robert Gordon. The artist's name was known, but we may suspect that it was not then familiar to many of the people who saw it on the labels; he is very differently regarded today.

Great Italian paintings have been included in many of the large donations to the Museum; the name of Jules S. Bache stands under pictures from many schools, but the importance of his collection can be judged from the Ghirlandaio, the Fra Filippo Lippi, the Tura, and the Crivelli, which are here illustrated among the Italian masters. In the same way, the Francesco di Giorgio and the Sassetta from the Maitland S. Griggs bequest, the Giovanni Bellini bequeathed by Theodore M. Davis, and the Pollaiuolo from the Harkness Bequest are selections from the great array of the paintings of Italy. Roger Fry would certainly now agree that the "great sequence of European creative thought" is well shown in the Metropolitan Museum. That this is so is due in great measure to his successors as curators of the Paintings Department, the first being Bryson Burroughs, who held the post until his death in 1934. Though he was never free to obtain as many French nineteenth-century paintings as the Museum needed, his extraordinary understanding of all schools

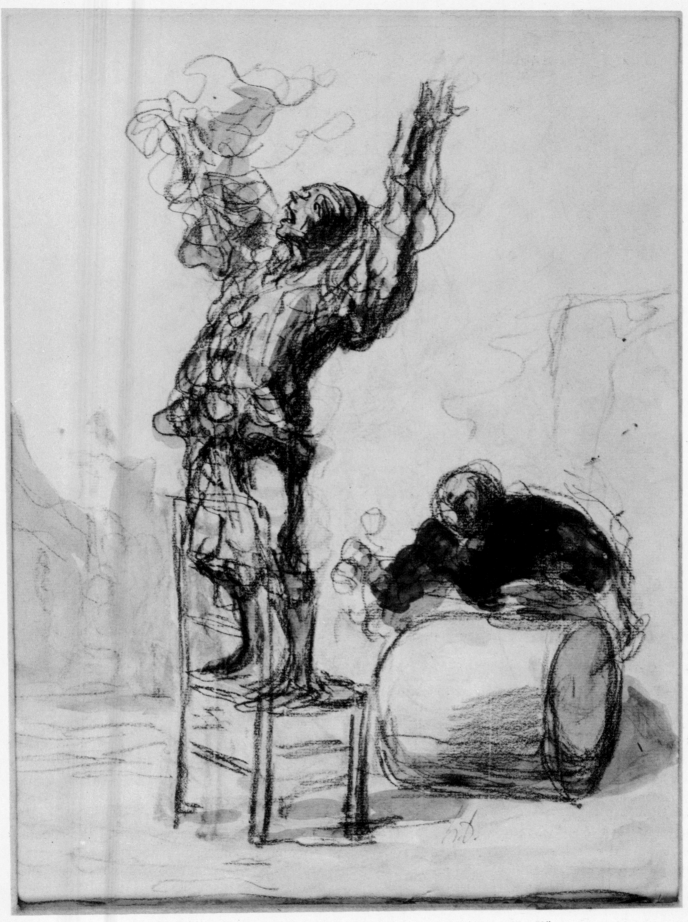

67. DAUMIER (1808–1879). *A Clown.* Charcoal and water color on paper, 14⅞ x 10″

68. INGRES (1780–1867). *Study for Portrait of Louis-François Bertin.* Chalk and pencil on paper, 13¾ x 13½"

and periods, and his feeling for quality, are shown in the purchases made during his curatorship. Many of these are Italian, such as the Carpaccio, the Giovanni di Paolo, and Veronese's *Mars and Venus* here illustrated. As much can be said for the next curator, Harry B. Wehle, whose Italian purchases are here represented by Tintoretto's *Finding of Moses,* the Carnevale, and Titian's *Venus and the Lute Player.* A more recent Italian purchase is Castagno's *St. Sebastian.*

At the end of Mr. Burroughs' career occurred a purchase as spectacular, though not as much cri-

ticized, as that of the Renoir a quarter of a century before. This was the acquisition of the wings of a triptych by Hubert van Eyck from the Hermitage in Leningrad. The present régime in Russia has blacker crimes to answer for, but their contempt for the people they profess to represent was never more clearly shown than when, in 1933, they sold treasures that should have been considered the property of all Russians, alive and to be born. In a wider sense, however, these treasures are the property of all mankind, and certainly a larger proportion of their owners can see them

74

69. DEGAS (1834–1917). *Emile Duranty*. Charcoal and white chalk on bluish grey paper, 12⅛ x 18⅜″

where they are now than could do so if they were still on the walls of the Hermitage. Hubert's brother, Jan van Eyck, is represented in the Museum by the *Annunciation* of the Friedsam Collection; in fact, the Flemish and Dutch works of the fifteenth and sixteenth centuries constitute as strong a group as those of the seventeenth. Scarcely a great name is missing and the illustrations in this book—van der Goes, van der Weyden, Dieric Bouts, Petrus Christus, Memling, Gerard David, Patinir, Bosch—in most cases represent a display in the Museum of more than one work by each painter. Bruegel's *Harvesters,* purchased in 1919 thanks to Mr. Burroughs' insistence, was, like the Renoir, another interesting instance of anticipation of public appreciation; it was also one of the greatest bargains ever obtained by the Museum.

German art, on the other hand, is much less thoroughly shown, as, indeed, it is in all art museums outside Germany. But here are the most celebrated masters, Holbein and Dürer, and the Museum also owns a fine group of fifteenth-century works. The Spanish collection, also, is not

numerically large, but its quality ranks it very high. *Cardinal Guevara* and the *View of Toledo,* both from the Havemeyer Bequest, are counted among El Greco's greatest masterpieces, and the Goya *Majas on the Balcony* is, like several other Metropolitan Goyas, a famous work. There are a number of paintings by Velasquez, as well as by Zurbaran, Ribera, and Murillo.

British art has always been popular in the United States, so it is natural that it should be excellently represented in the Metropolitan Museum. As well as the great portraitists and landscape painters—Reynolds, Gainsborough, Lawrence, Constable, Turner—a less well-known kind of English picture is shown in the recently purchased group portrait, *Henry Frederick, Prince of Wales, and Sir John Harington,* painted in 1603.

It has not been possible to give here more than a sketch of the contents of the Paintings Collection of the Metropolitan Museum; the illustrations that follow speak more clearly than any words, but they speak only for themselves. They are presented as a handful of jewels from one of the world's greatest treasure houses of painting.

75

70. WORKSHOP OF GIOTTO [*first quarter, fourteenth century*] *The Epiphany* · Florentine
Tempera on wood, gold ground, 17¾ x 17¼″

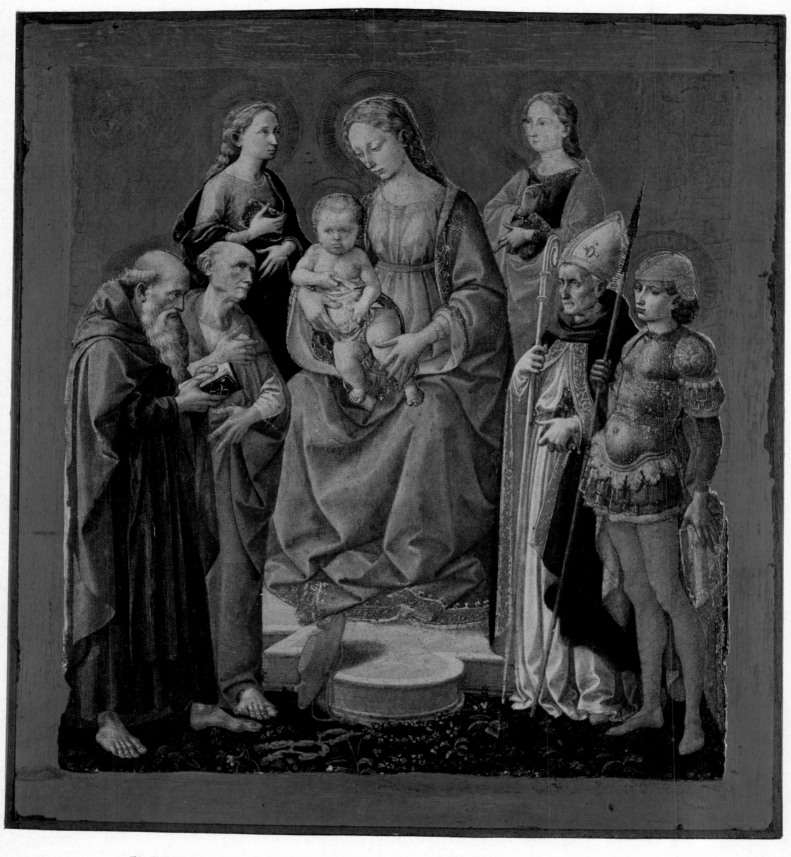

71. PESELLINO [*about 1422-1457*] *The Madonna and Child with Six Saints* · Florentine
Tempera on wood, gold ground, 10¼ x 9⅜″

72. GIOVANNI DI PAOLO [*1402/3 — about 1482*] *Paradise* · Sienese · Tempera on canvas, transferred from wood, 18½ x 16″

73. FRA ANGELICO [1387-1455] *The Crucifixion* • Florentine • Tempera on wood, 13⅜ x 19¾"

74. SASSETTA [1392-1450] *The Journey of the Magi* · Sienese · Tempera on wood, 8½ x 11⅝"

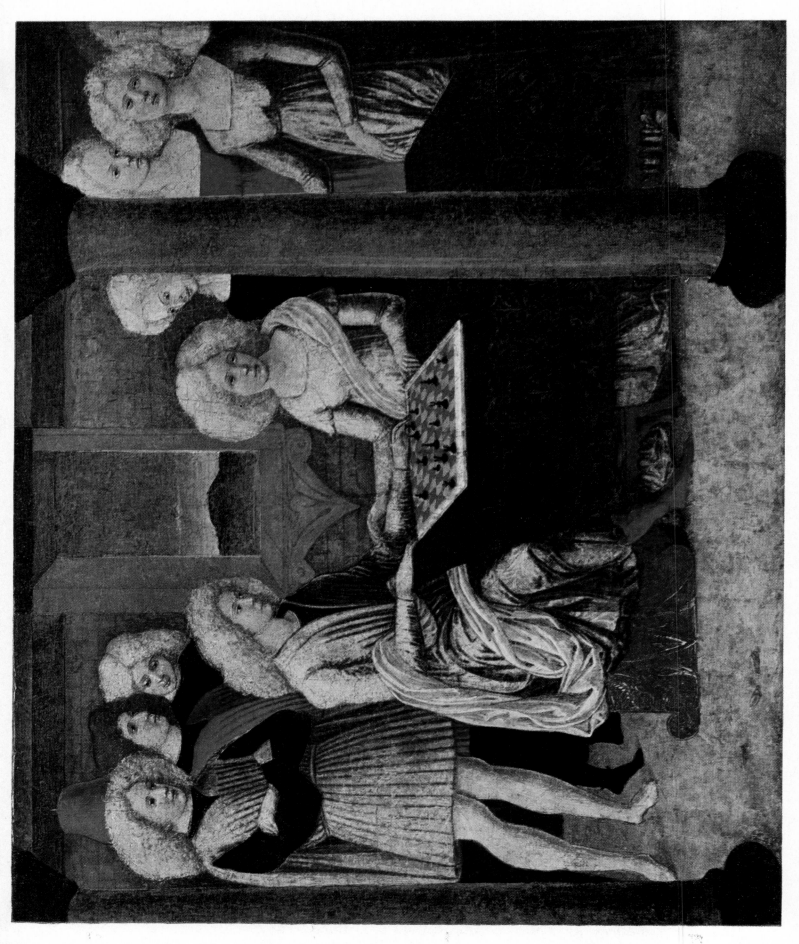

81. FRANCESCO DI GIORGIO [1439-1502] *The Chess Players* · Sienese · Tempera on wood. 19⅜ x 16″

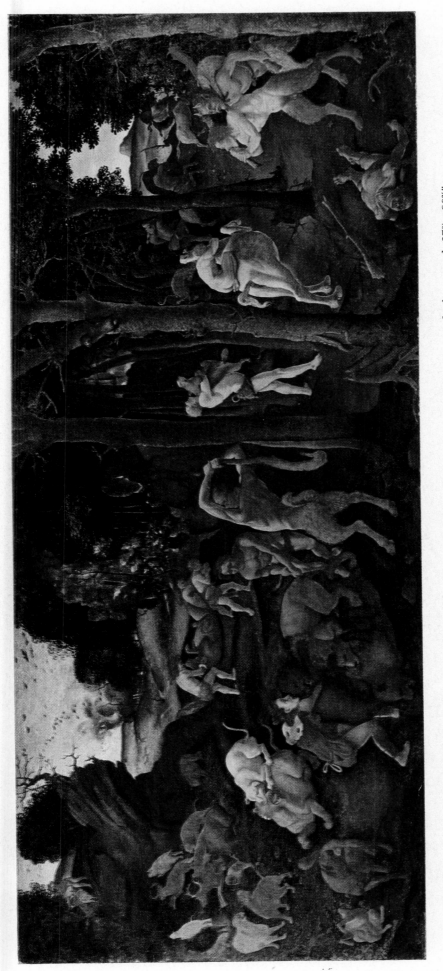

82. PIERO DI COSIMO [1462-1521?] A *Hunting Scene* · Florentine · Tempera and oil on wood, 27¾ x 66¾"

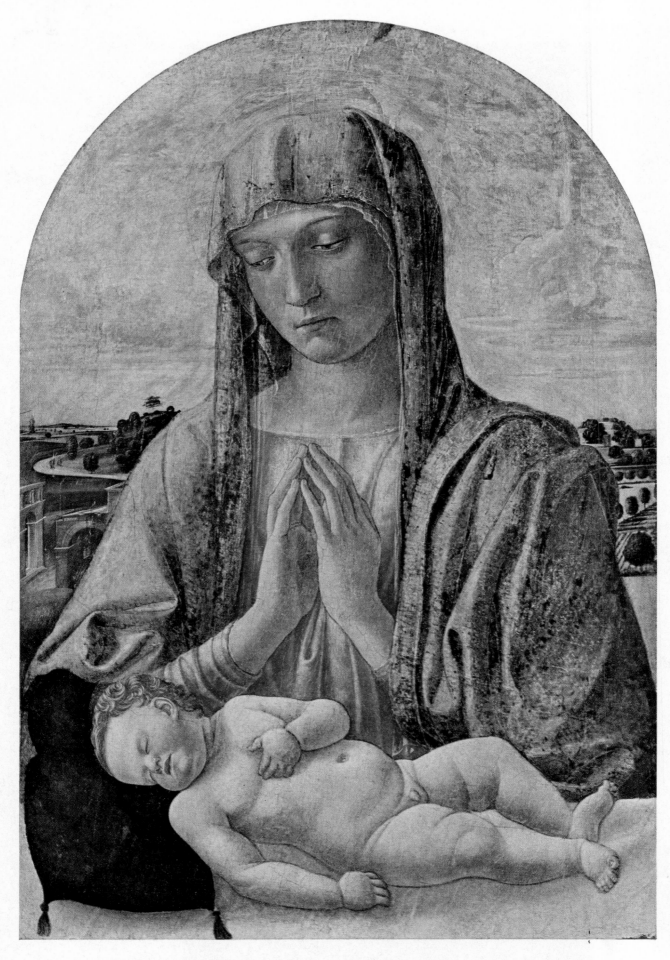

83. GIOVANNI BELLINI [*about 1430-1516*] *Madonna Adoring The Sleeping Child* · Venetian
Tempera on wood, 28½ x 18¼″

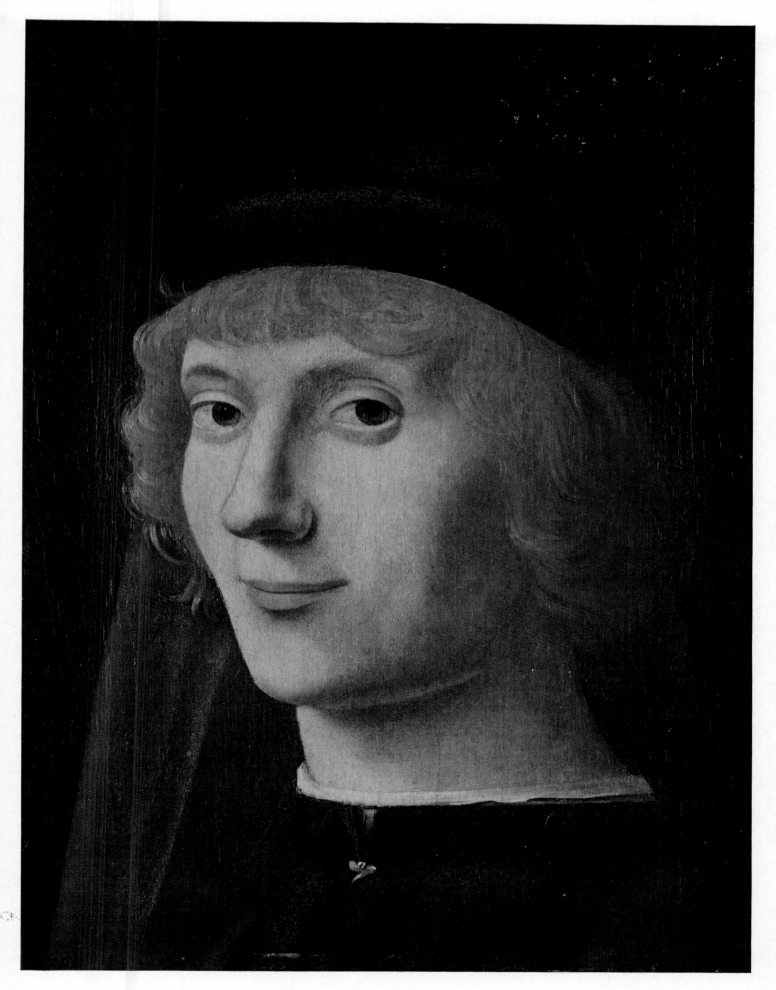

84. ANTONELLO DA MESSINA [*about 1430-1479*] *Portrait of a Young Man* · Venetian
Oil on wood, 10⅜ x 8⅛"

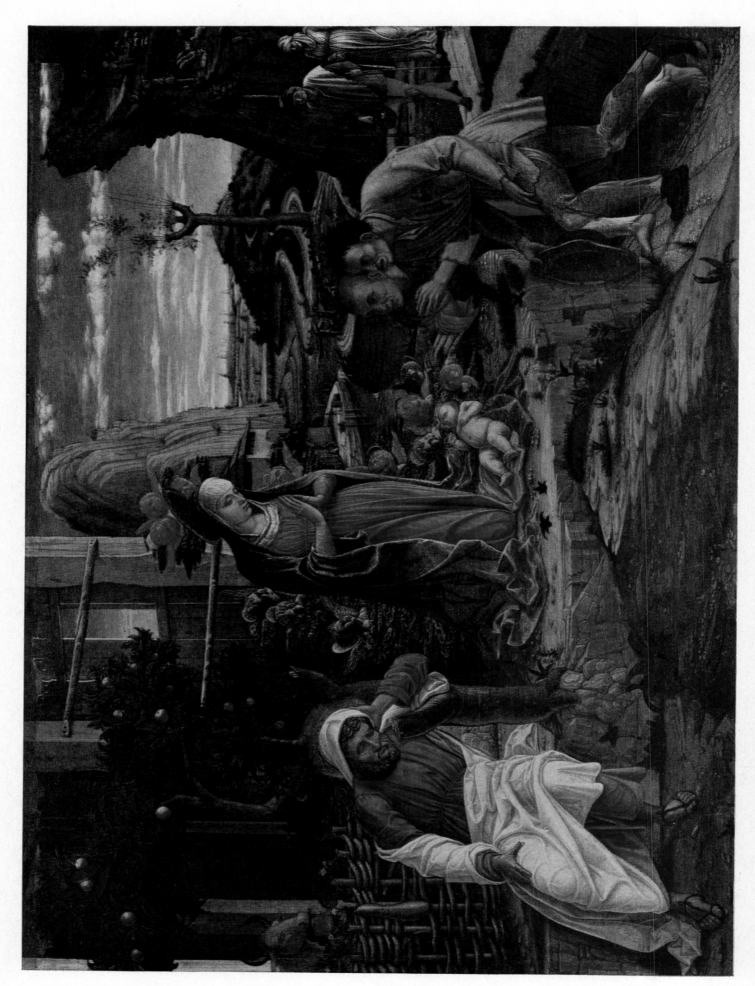

85. MANTEGNA [1431-1506] *The Adoration of the Shepherds* · Paduan · Tempera on canvas, transferred from wood, 15¾ x 21⅞"

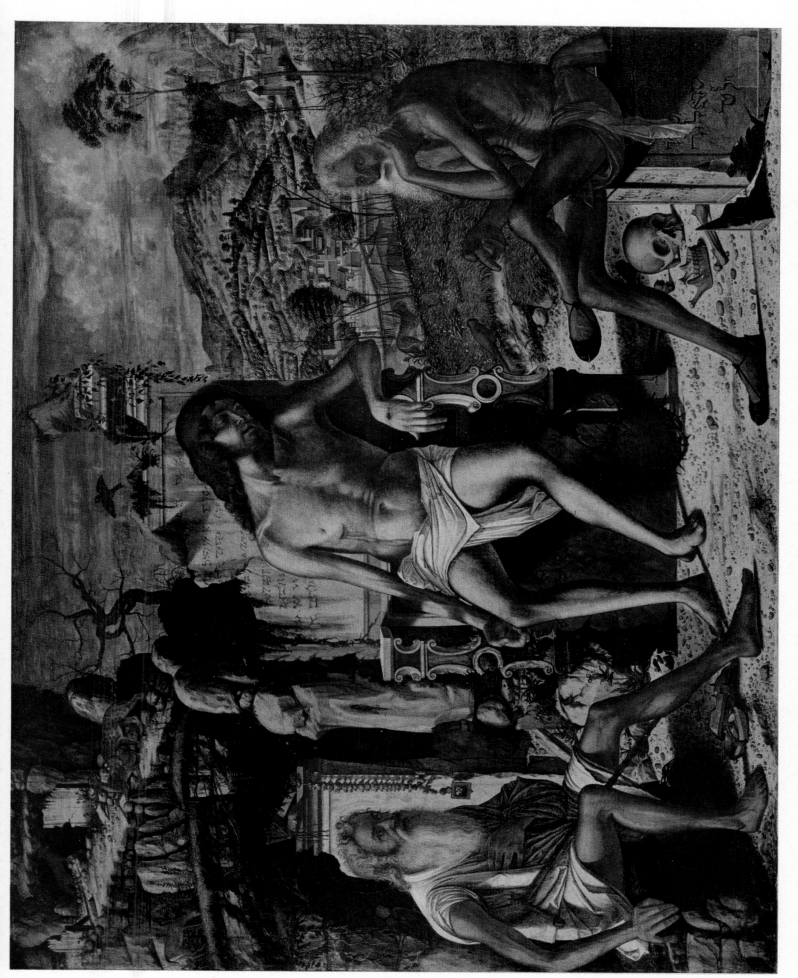

86. CARPACCIO [about 1455-1523/6] *The Meditation on The Passion* · Venetian · Tempera on wood, 27¾ x 34⅞"

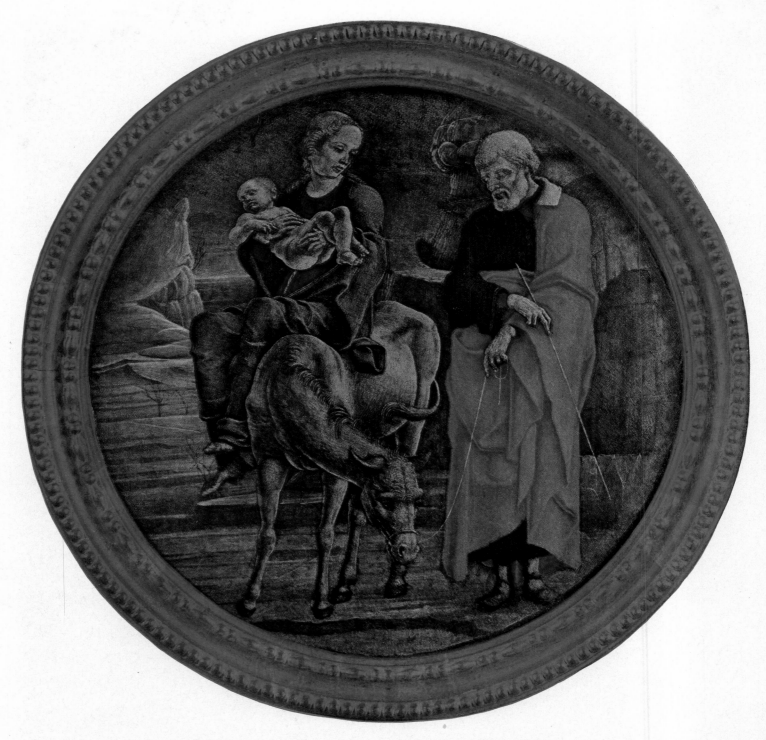

87. TURA [*active by 1451 — died 1495*] *The Flight into Egypt* · Ferrarese
Tempera on wood, diameter 15″

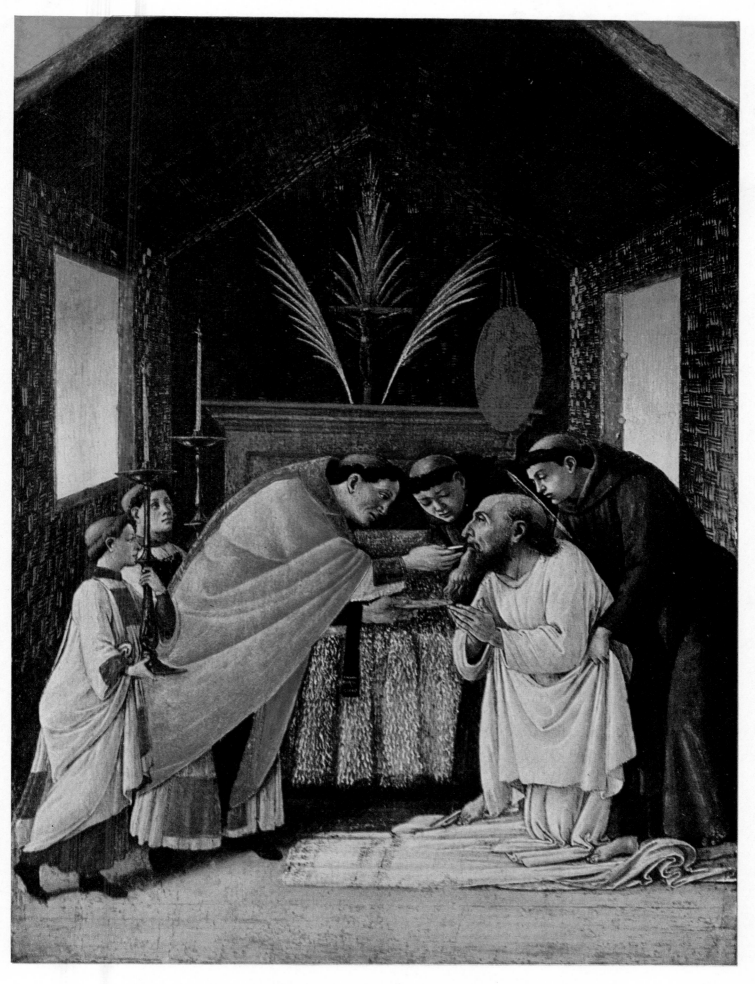

88. BOTTICELLI [*1444/5-1510*] *The Last Communion of Saint Jerome* · Florentine
Tempera on wood, 13½ x 10″

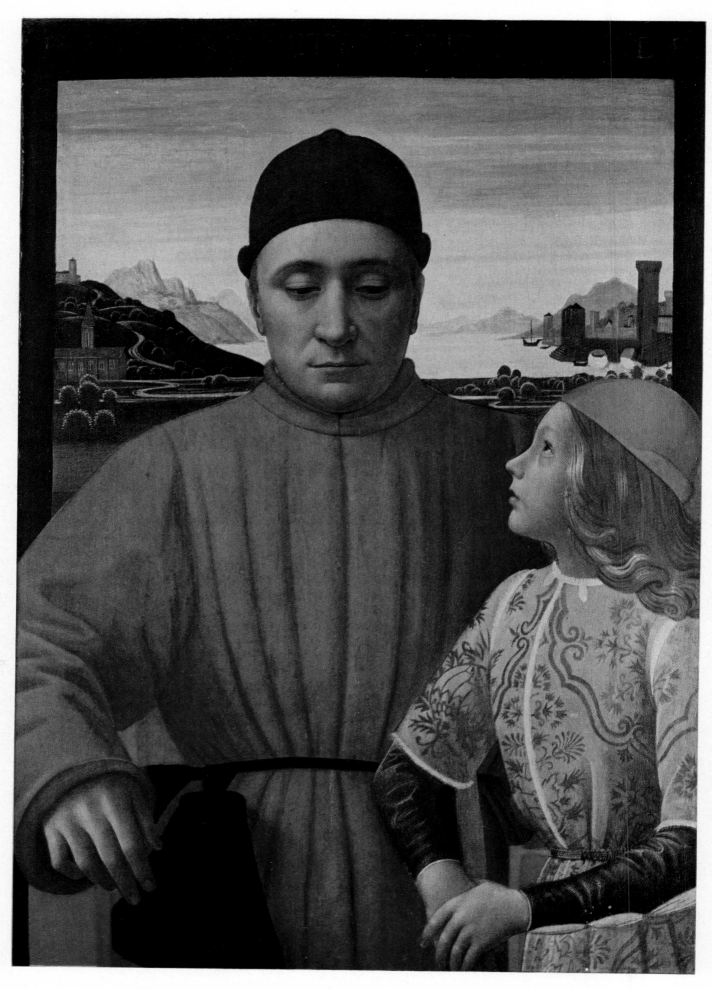

89. GHIRLANDAIO [1449-1494] *Francesco Sassetti and His Son Teodoro* · Florentine
Tempera on wood, 29½ x 20½″

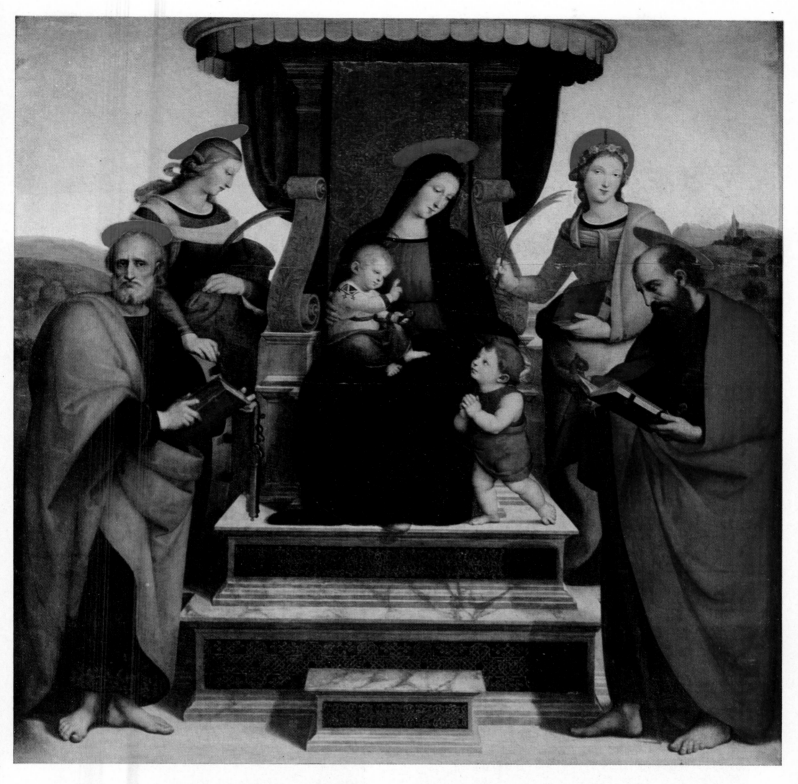

90. RAPHAEL [1483-1520] *The Madonna and Child Enthroned with Saints* · Umbrian
Main panel, tempera on wood, 66⅝ x 66¾"

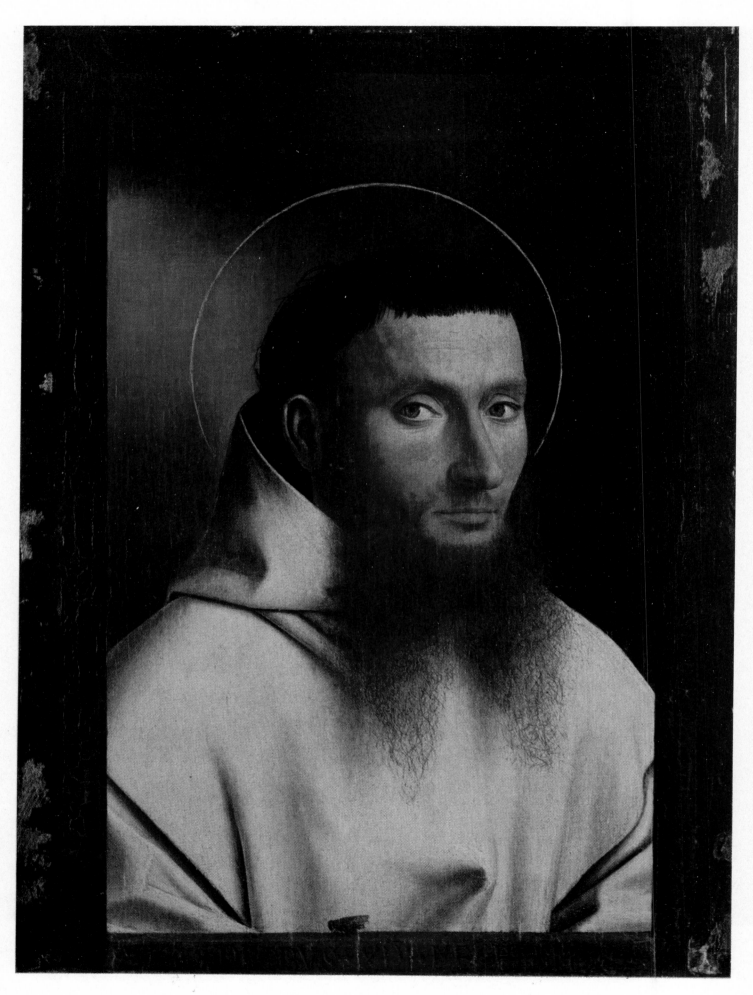

93. CHRISTUS [*active 1444 – died 1472/3*] *Portrait of a Carthusian* · Flemish
Tempera and oil on wood, 11½ x 8″

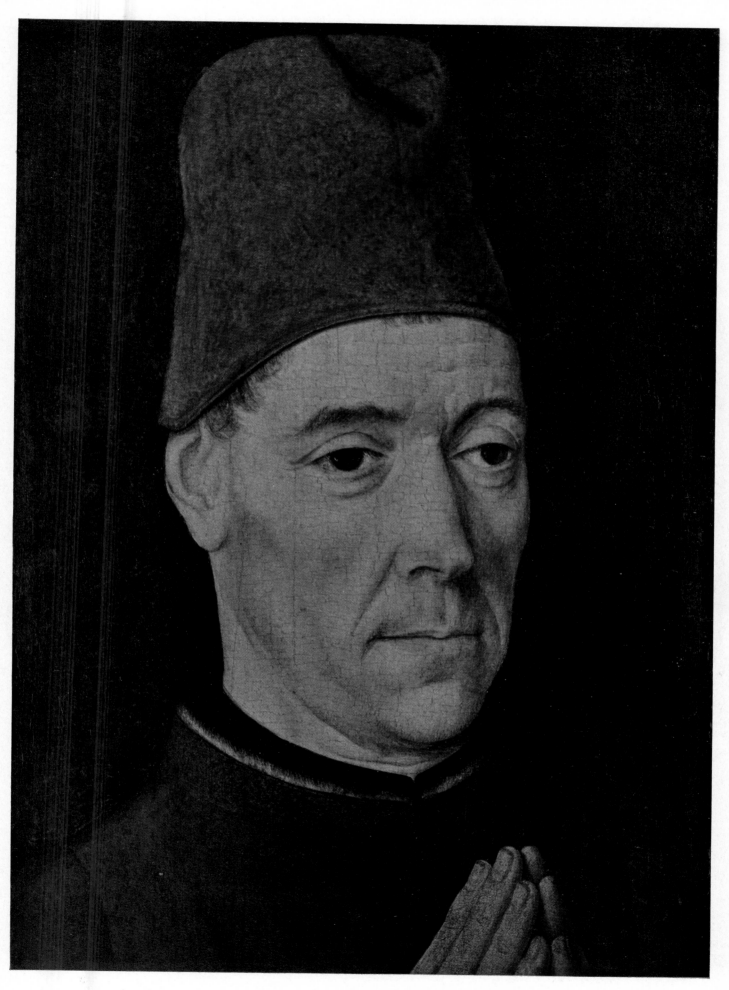

94. BOUTS [*active by 1457 — died 1475*] *Portrait of a Man* · Flemish
Tempera and oil on wood, 12 x 8½"

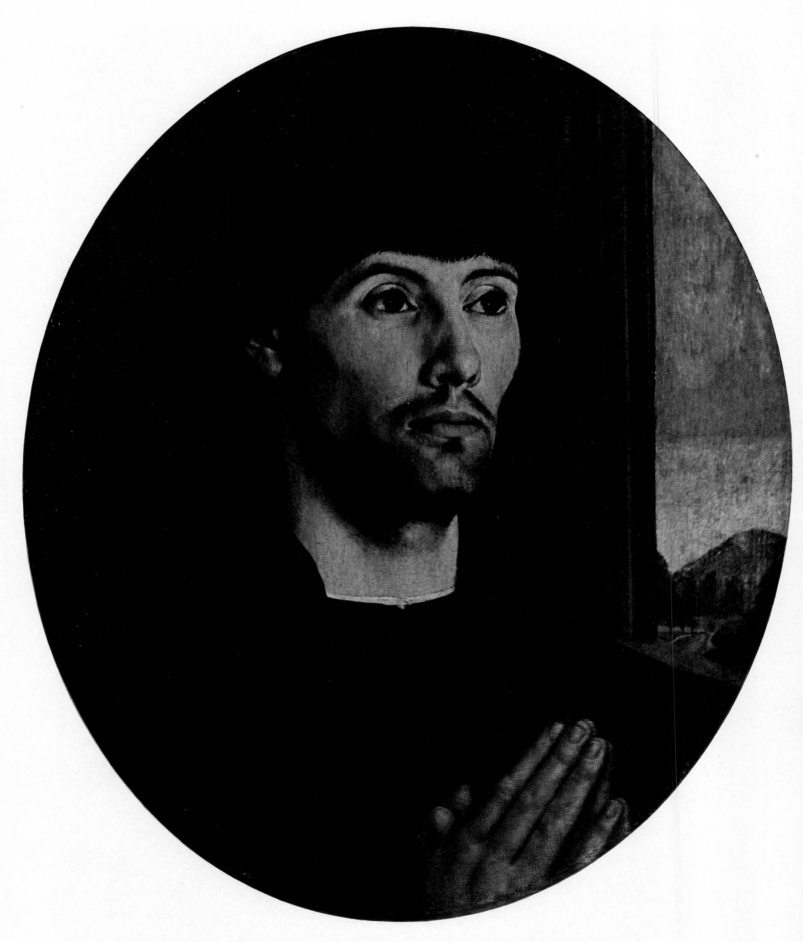

95. VAN DER GOES [*active 1467 — died 1482*] *Portrait of a Man* · Flemish
Tempera and oil on wood, 12½ x 10½″ (oval)

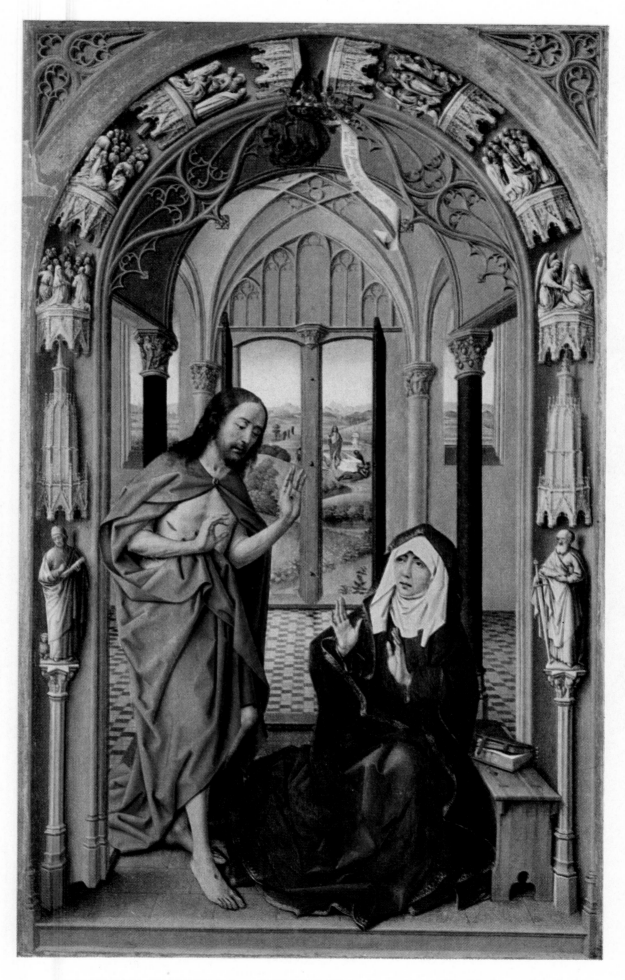

96. VAN DER WEYDEN [*about 1400-1464*] *Christ Appearing to His Mother* · Flemish
Tempera and oil on wood, 23 x 15″

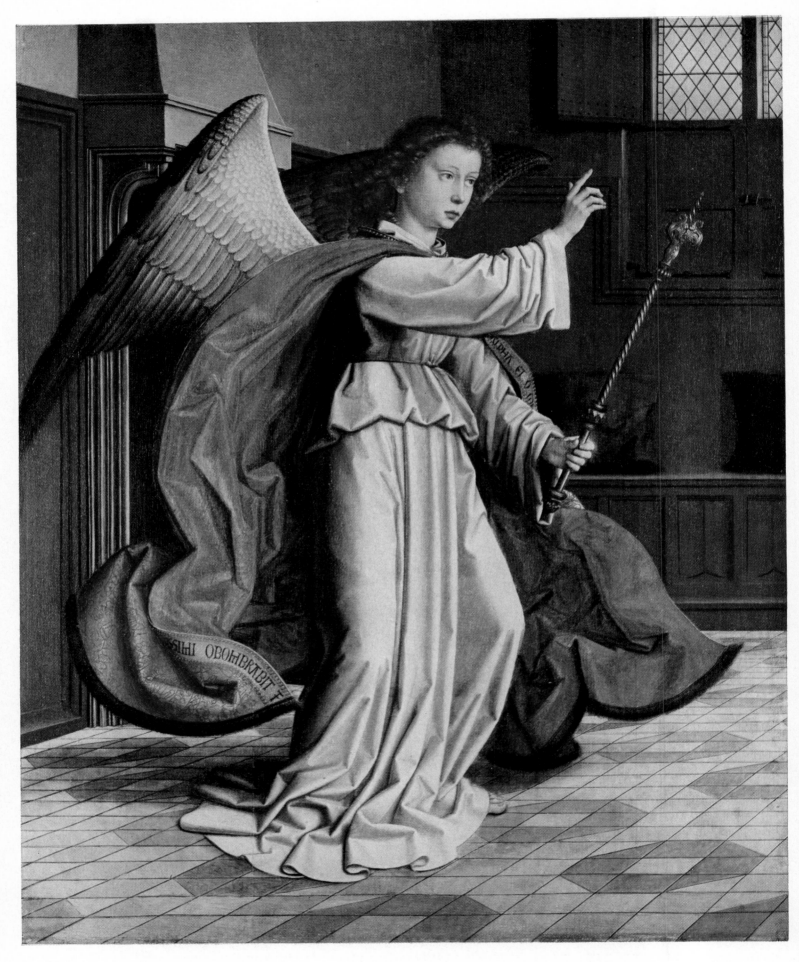

97. GERARD DAVID [*active before 1484 — died 1523*] *The Archangel Gabriel* · Flemish
Tempera and oil on wood, 30 x 24″

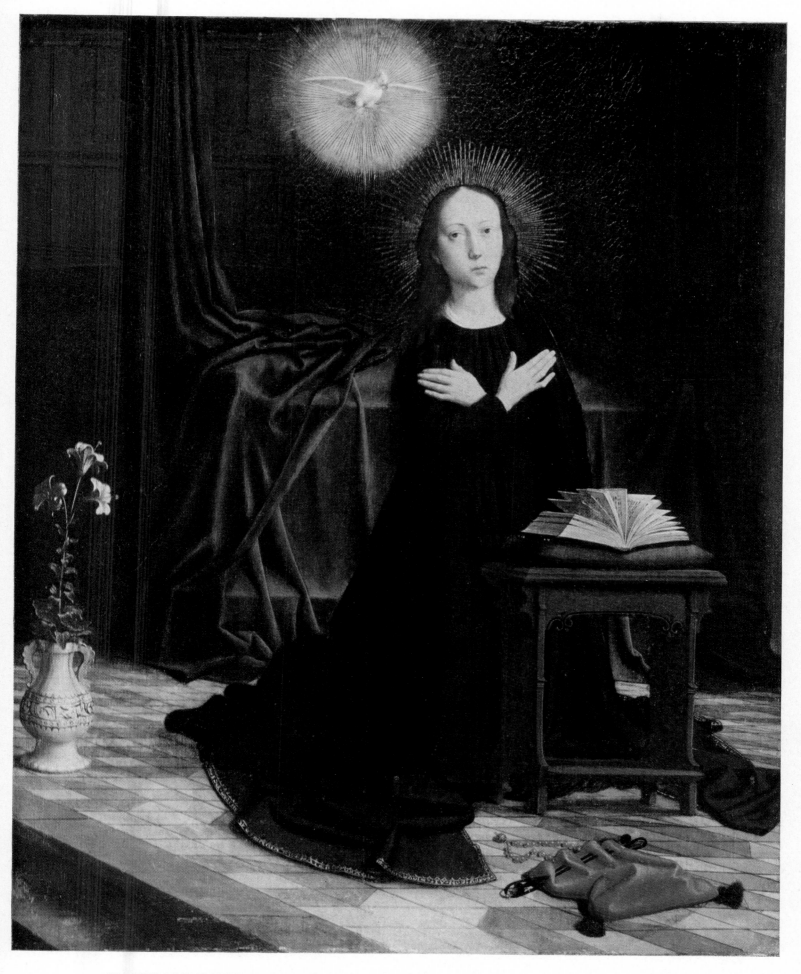

98. GERARD DAVID [*active before 1484 — died 1523*] *The Virgin of the Annunciation* · Flemish
Tempera and oil on wood, 30 x 24″

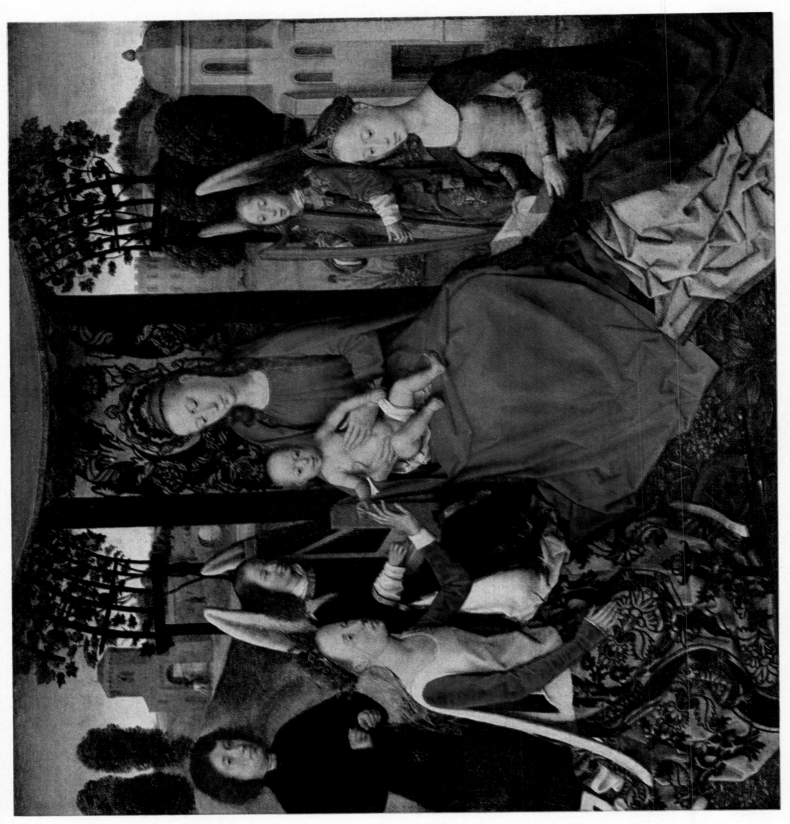

99. MEMLING, *active about 1465 – died 1494\ The Betrothal of Saint Catherine · Flemish · Tempera and oil on wood, 27 x 28⅞"

100. PATINIR [active before 1515 – died 1524] The Penitence of Saint Jerome · Flemish · Tempera and oil on wood, center panel, 47⅞ x 32″; wings, 48 x 14½″

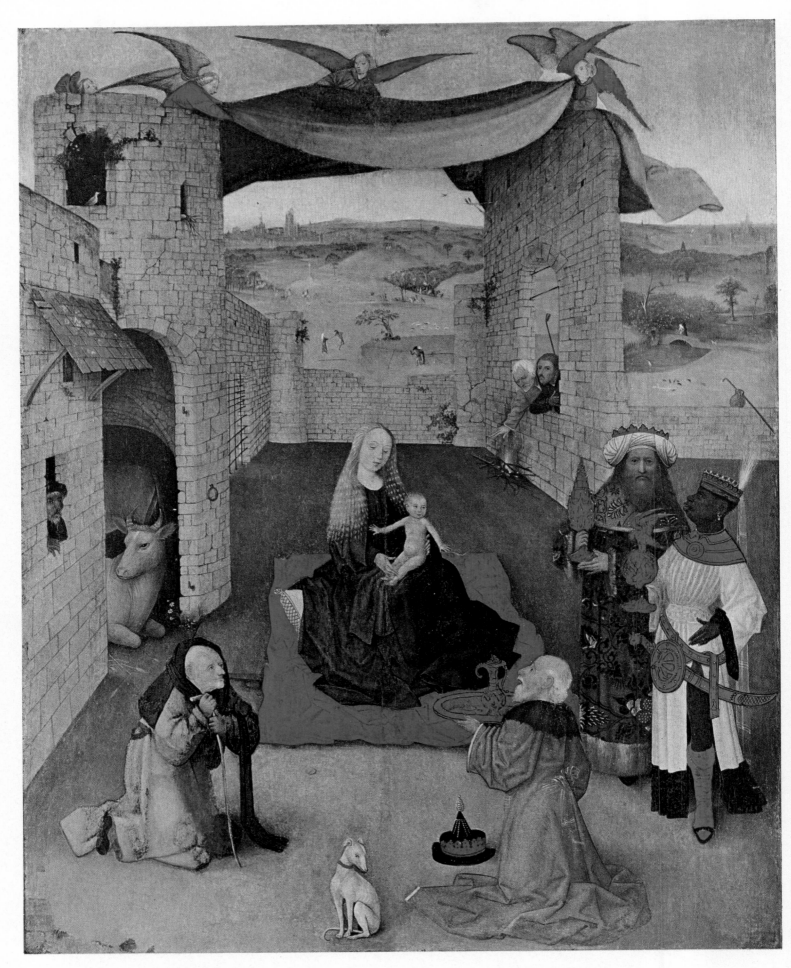

101. BOSCH [*active by 1488 — died 1516*] *The Adoration of the Magi* · Flemish
Tempera and oil on wood, 28 x 22¼"

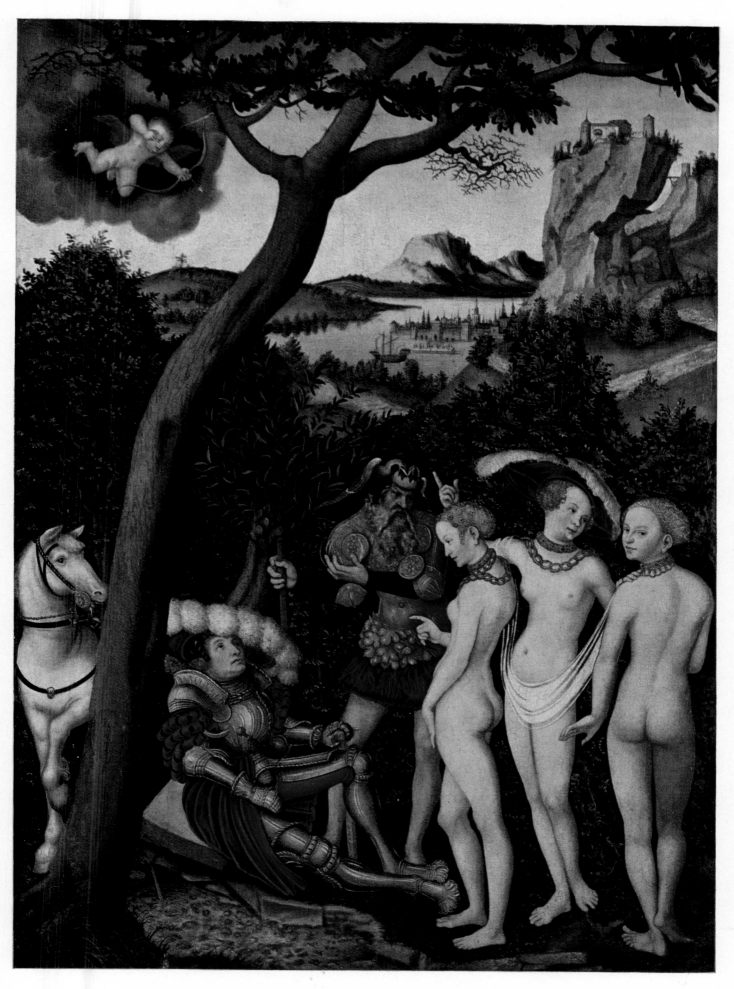

102. LUCAS CRANACH THE ELDER [1472-1553] *The Judgment of Paris* · German
Oil on wood, 40⅛ x 28″

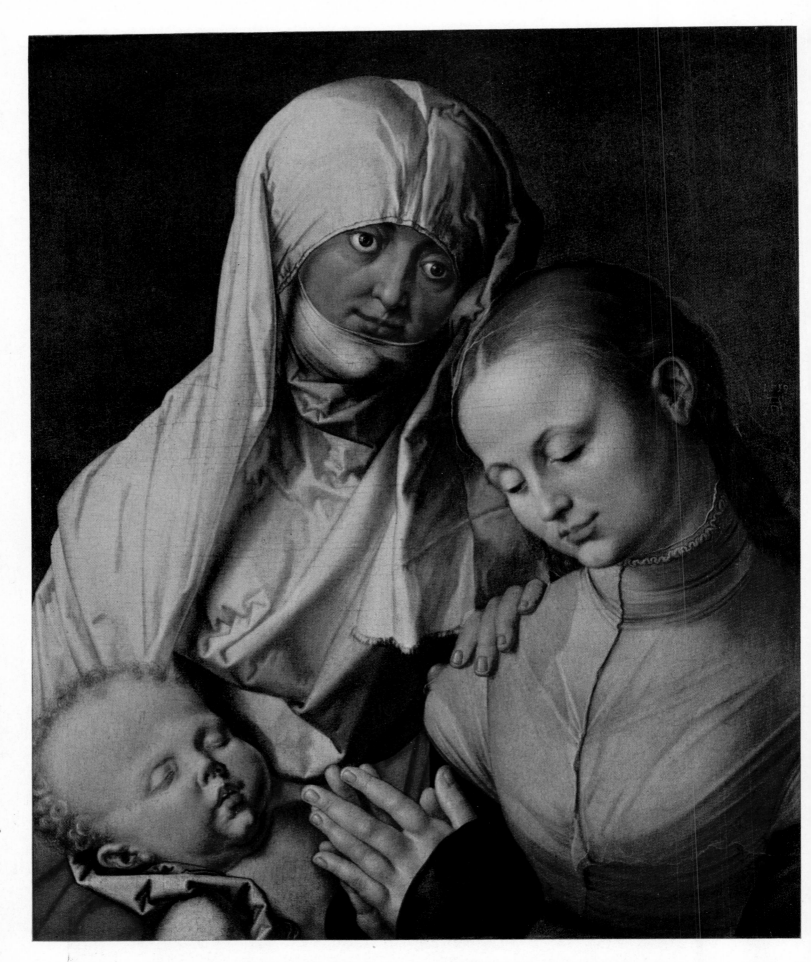

103. DÜRER [1471-1528] *The Virgin and Child with Saint Anne* · German
Tempera and oil on canvas, 23⅝ x 19⅝"

104. UNKNOWN PAINTER [*active in 1603*] *Henry Frederick, Prince of Wales, and Sir John Harington*
British · Oil on canvas, 79½ x 58″

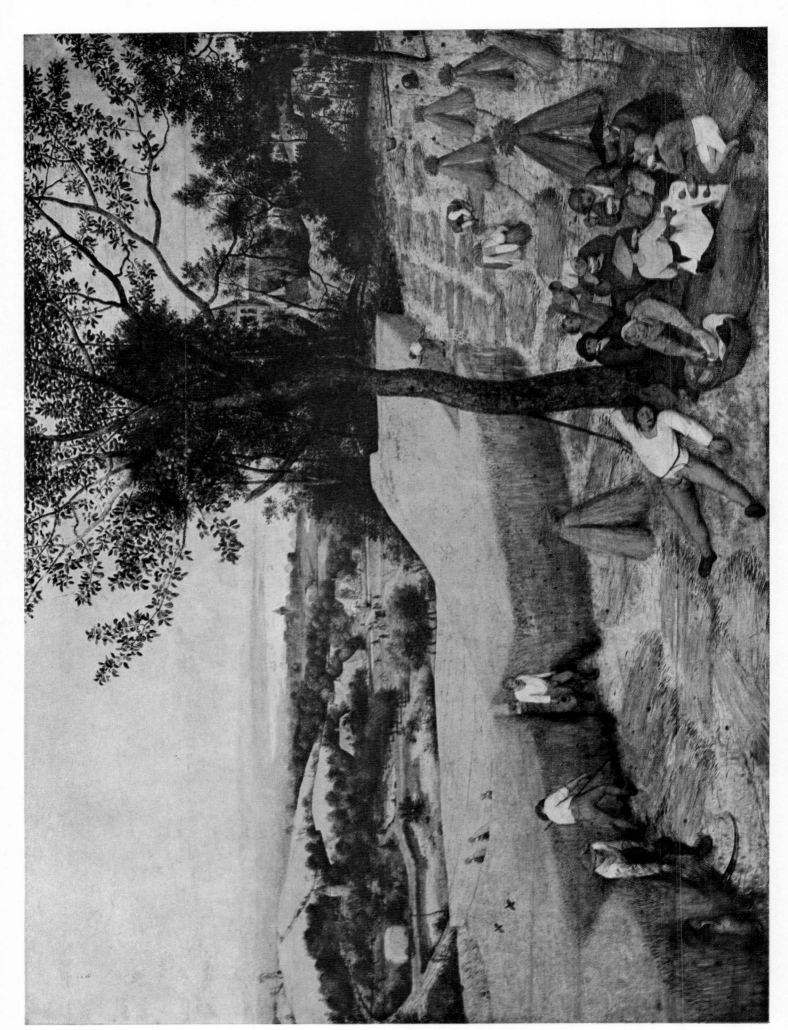

105. BRUEGEL [active 1551 — died 1569] *The Harvesters* · Flemish · Oil on wood, 46½ x 63¼"

106. CHRÉTIEN [*about 1510-1579*] *Moses and Aaron before Pharaoh* · French
Tempera and oil on wood, 69½ x 75⅜″

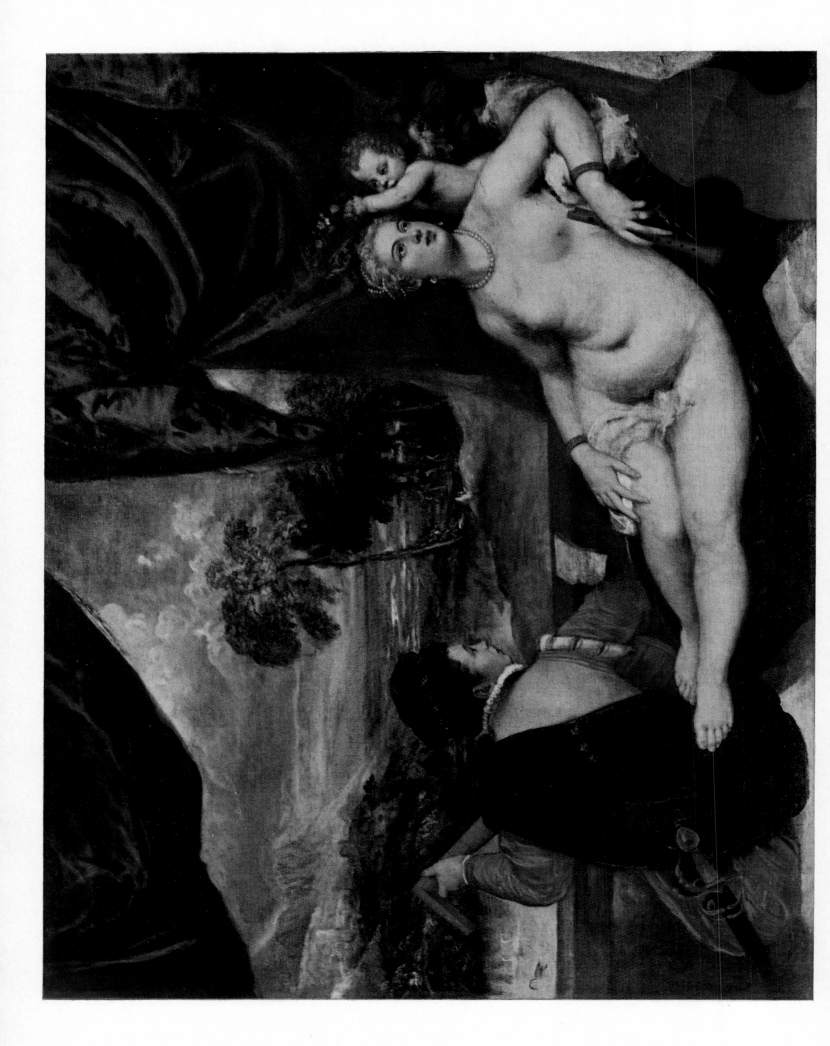

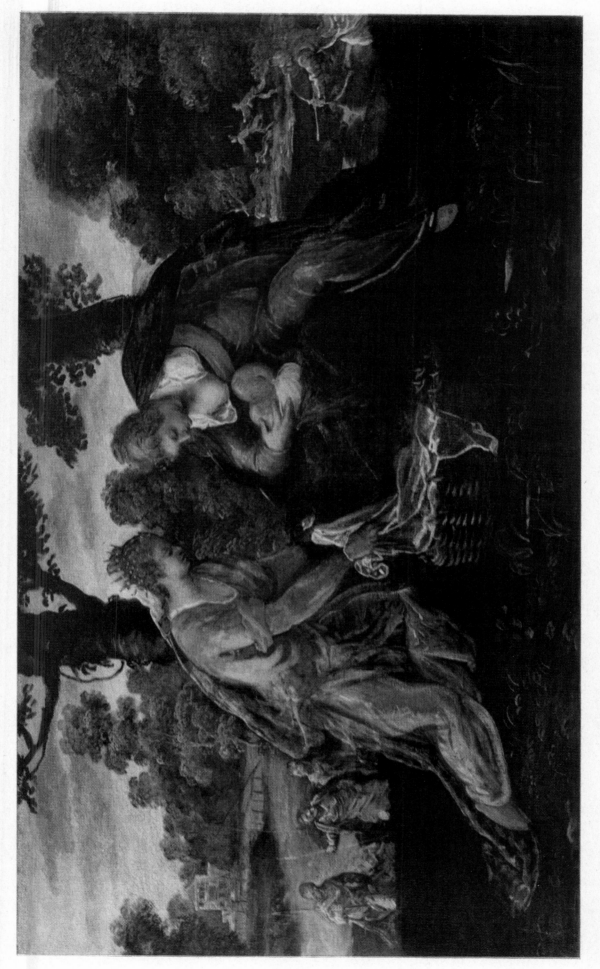

110. TINTORETTO [1518-1594] *The Finding of Moses* · Venetian · Oil on canvas, 30½ x 52¾"

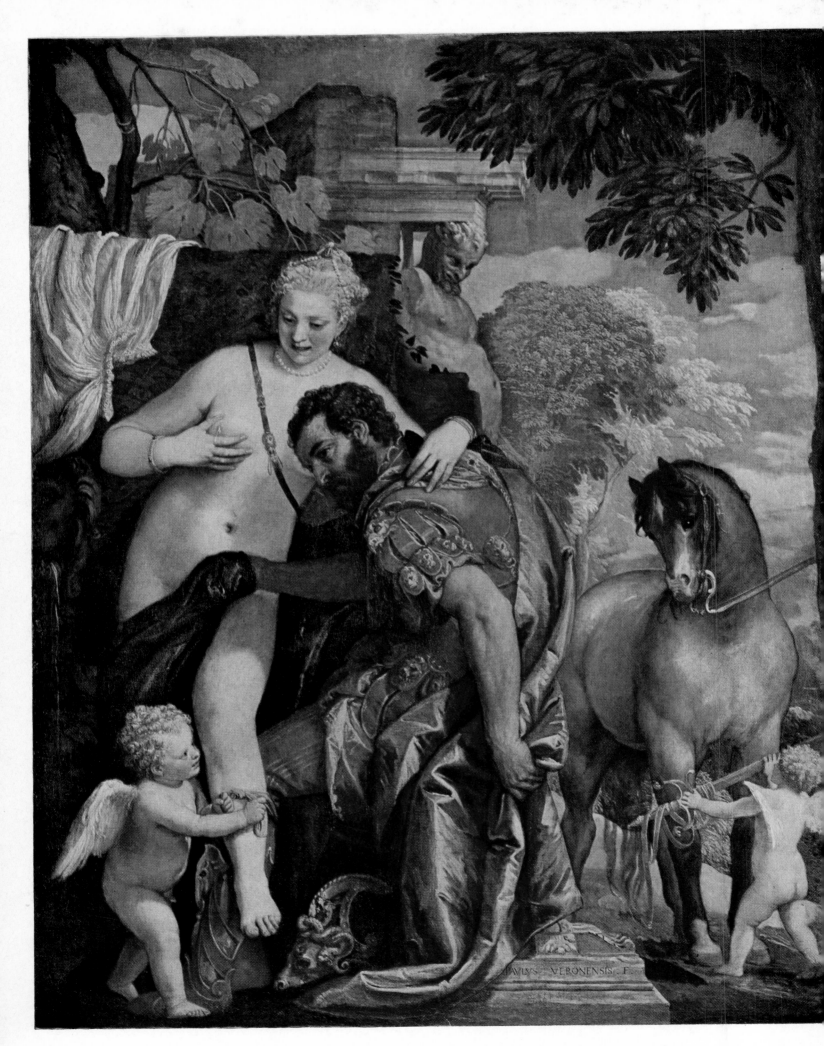

111. VERONESE [1528?-1588] *Mars and Venus United by Love* · Venetian
Oil on canvas, 81 x 63⅜″

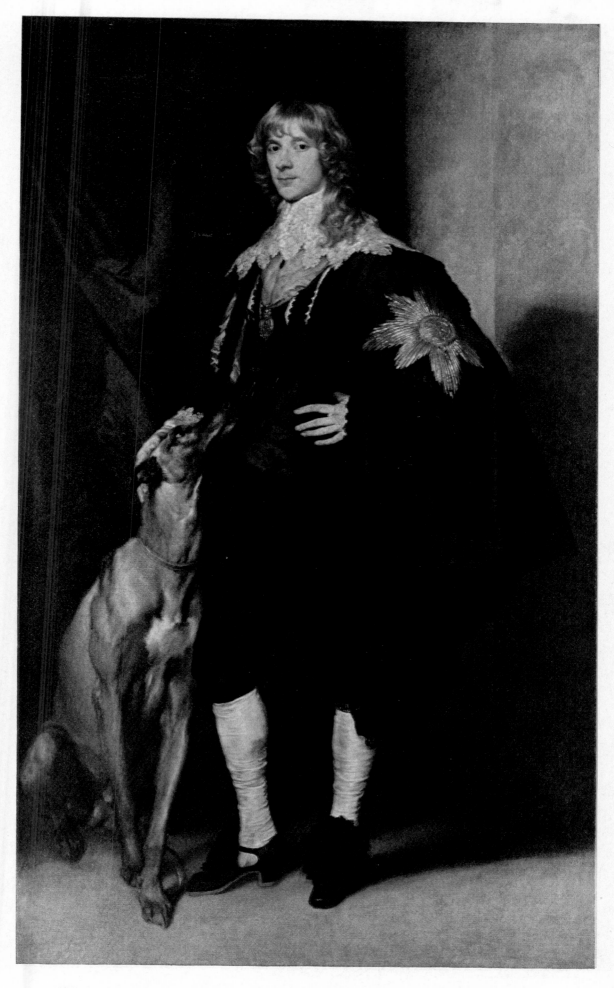

112. VAN DYCK [1599-1641] *James Stuart, Duke of Richmond and Lennox* · Flemish
Oil on canvas, 85 x 50¼″

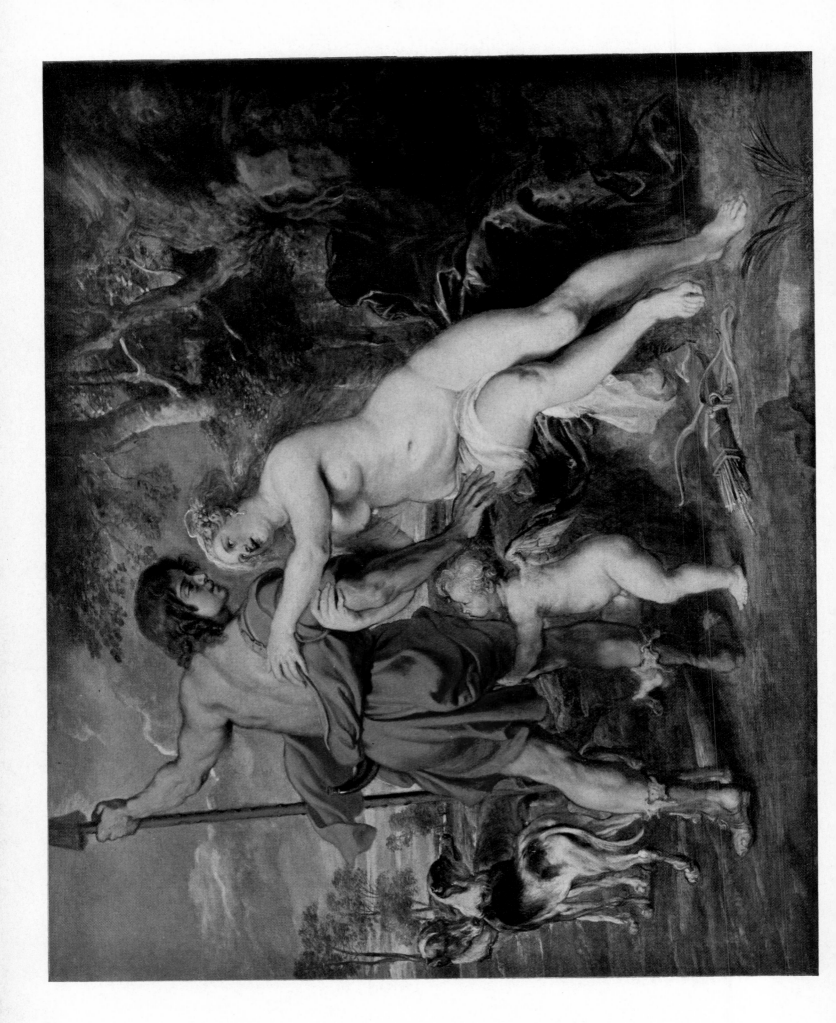

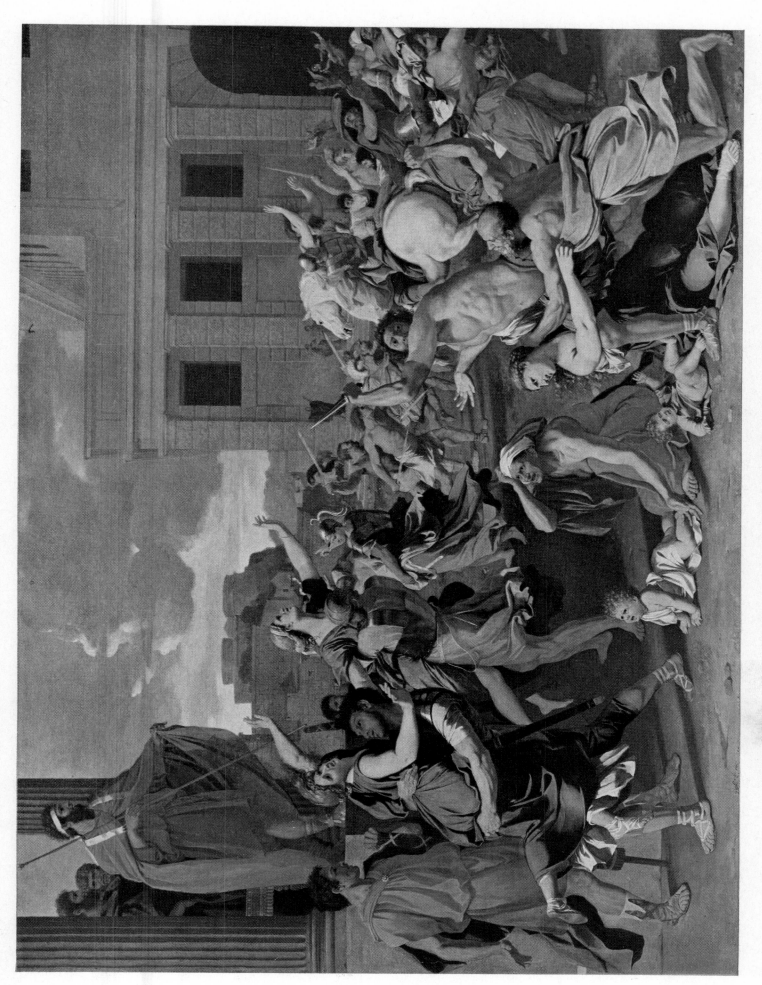

114. POUSSIN [1593/4-1665] *The Rape of the Sabine Women* · French · Oil on canvas, 60⅞ x 82⅝"

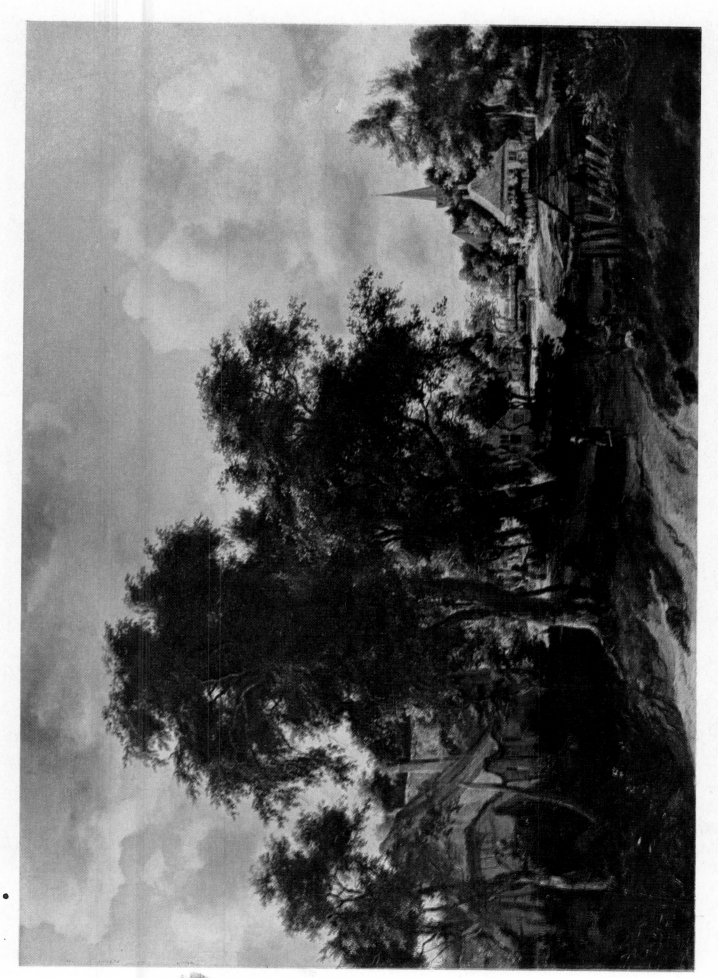

116. HOBBEMA [1638-1709] *Entrance to a Village* · Dutch · Oil on wood, 29½ x 43⅜"

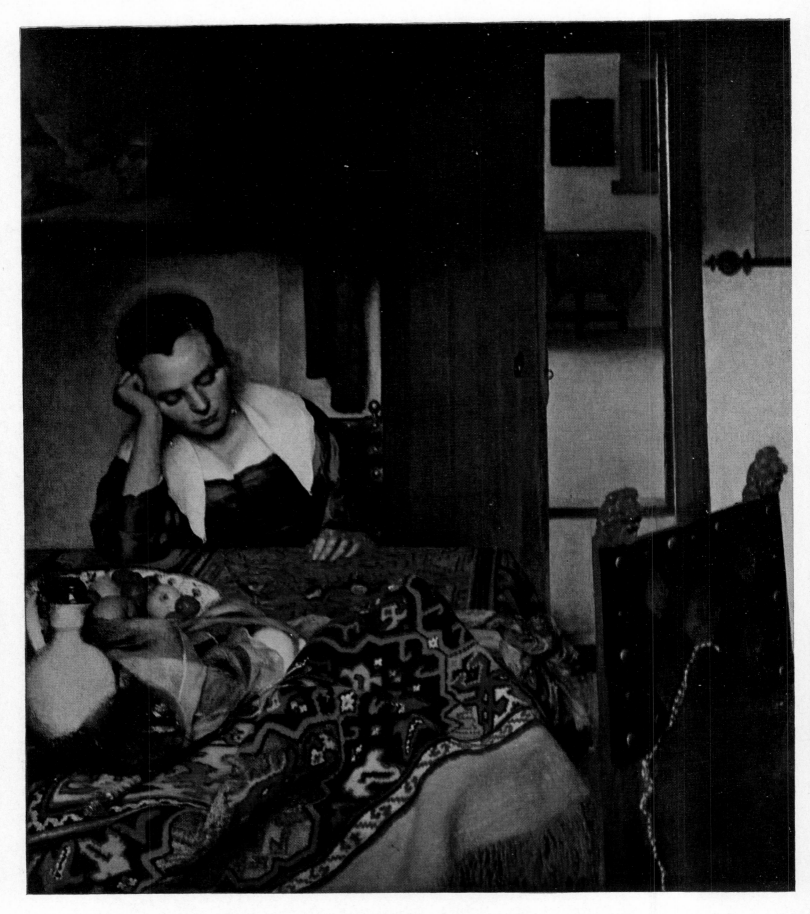

117. VERMEER [*1632-1675*] *A Girl Asleep* · Dutch · Oil on canvas, 34½ x 30⅛"

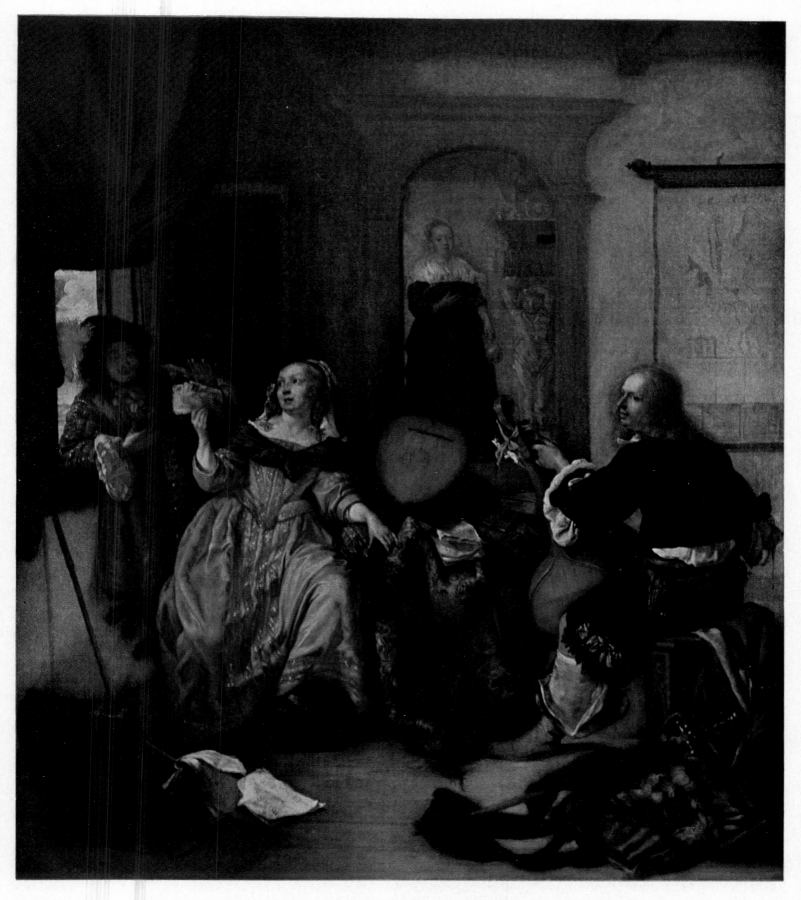

118. METSU [*1629-1667*] *The Music Lesson* · Dutch · Oil on canvas, 24½ x 21⅜″

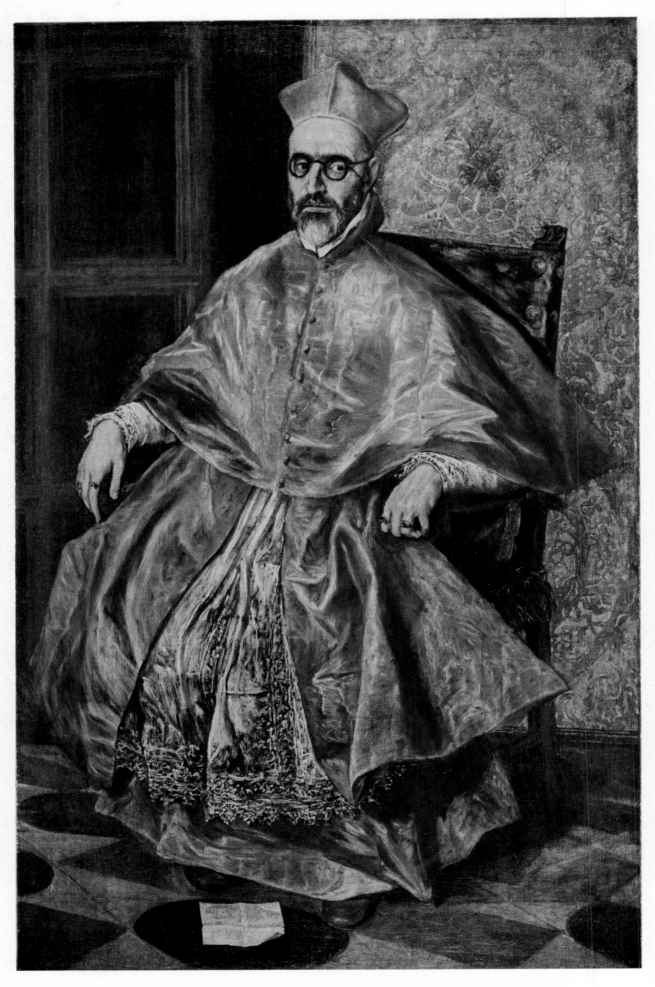

123. EL GRECO [1541-1614] *Cardinal Don Fernando Niño de Guevara* · Spanish
Oil on canvas, 67¼ x 42½″

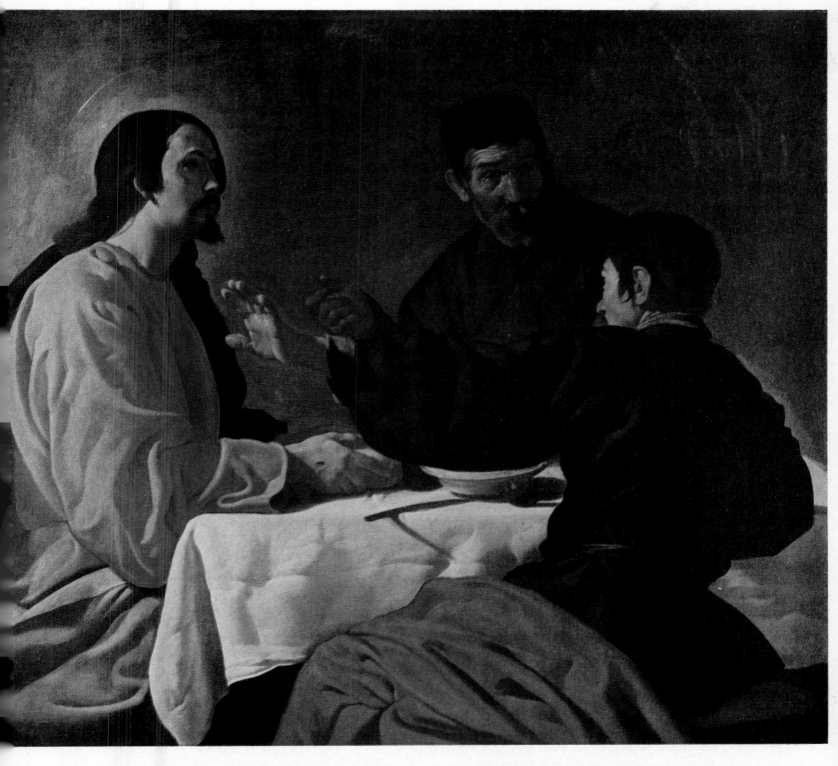

124. VELASQUEZ [1599-1660] *Christ and the Pilgrims of Emmaus* · Spanish
Oil on canvas, 48½ x 52¼″

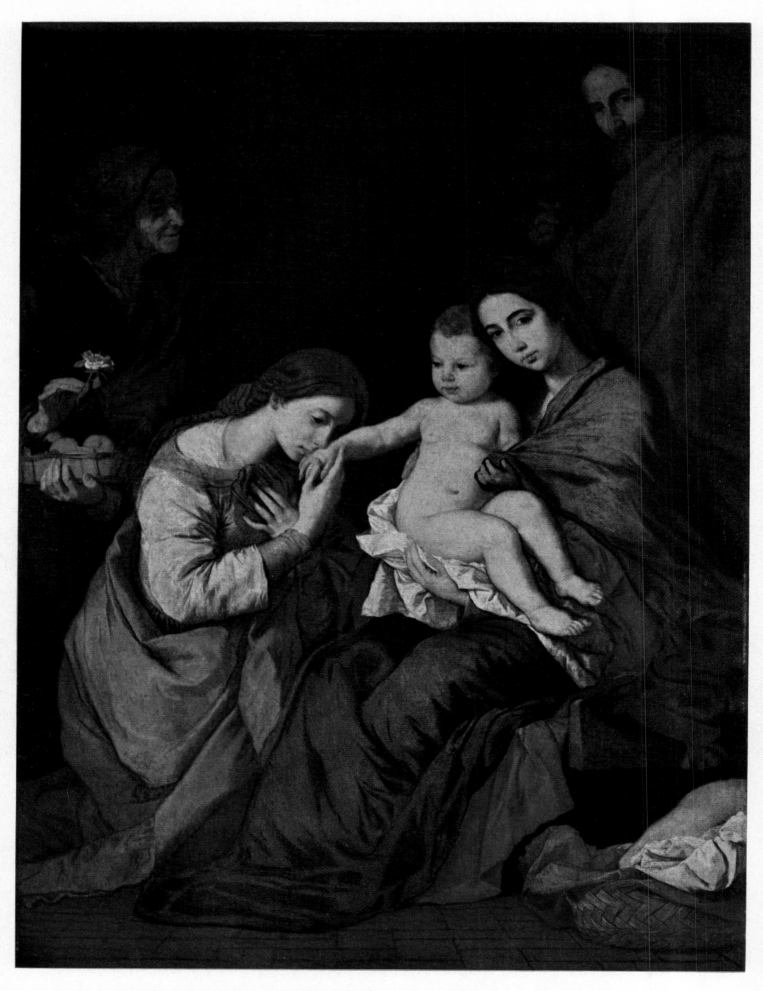

125. RIBERA [1591-1652] *The Holy Family with Saint Catherine* • Spanish
Oil on canvas, 82½ x 60¾"

126. GOYA [1746-1828] *Majas on a Balcony* · Spanish
Oil on canvas, 76¾ x 49½″

127. WATTEAU [*1684-1721*] *Mezzetin* · French
Oil on canvas, 21¾ x 17″

128. BOUCHER [*1703-1770*] *The Toilet of Venus* · French
Oil on canvas, 42⅜ x 33½″

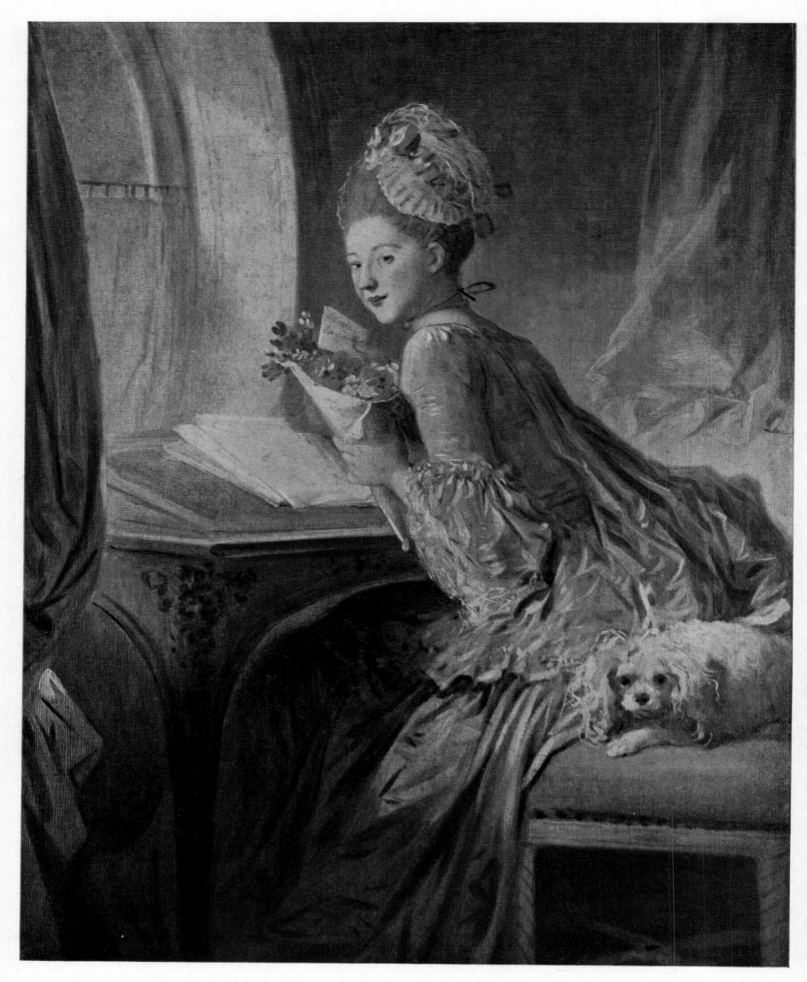

129. FRAGONARD [*1732-1806*] *The Love Letter* · French
Oil on canvas, 32¾ x 26⅜"

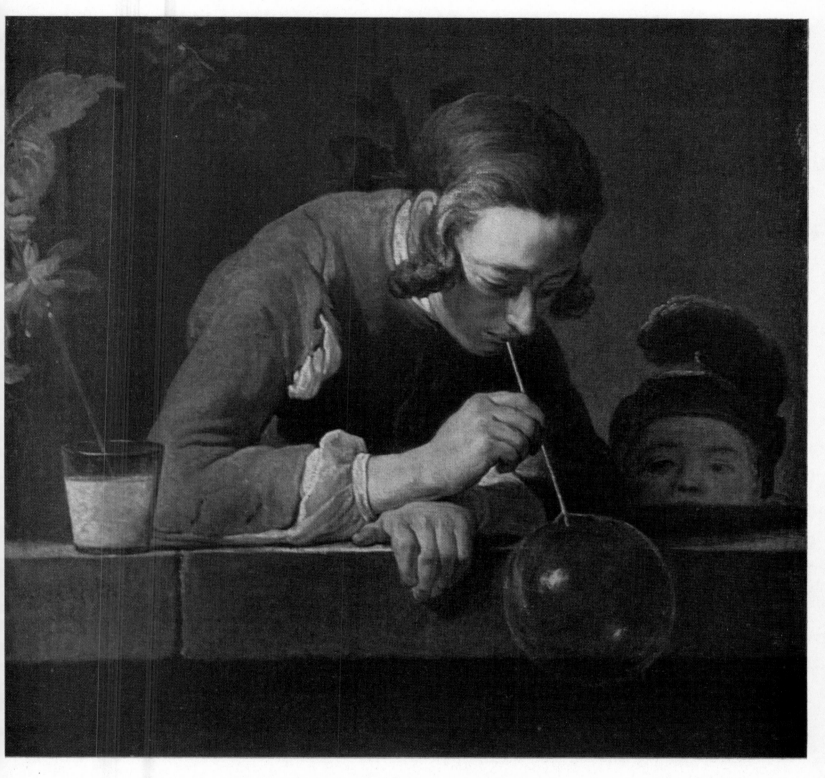

130. CHARDIN [*1699-1779*] *Blowing Bubbles* · French
Oil on canvas, 24 x 24⅞″

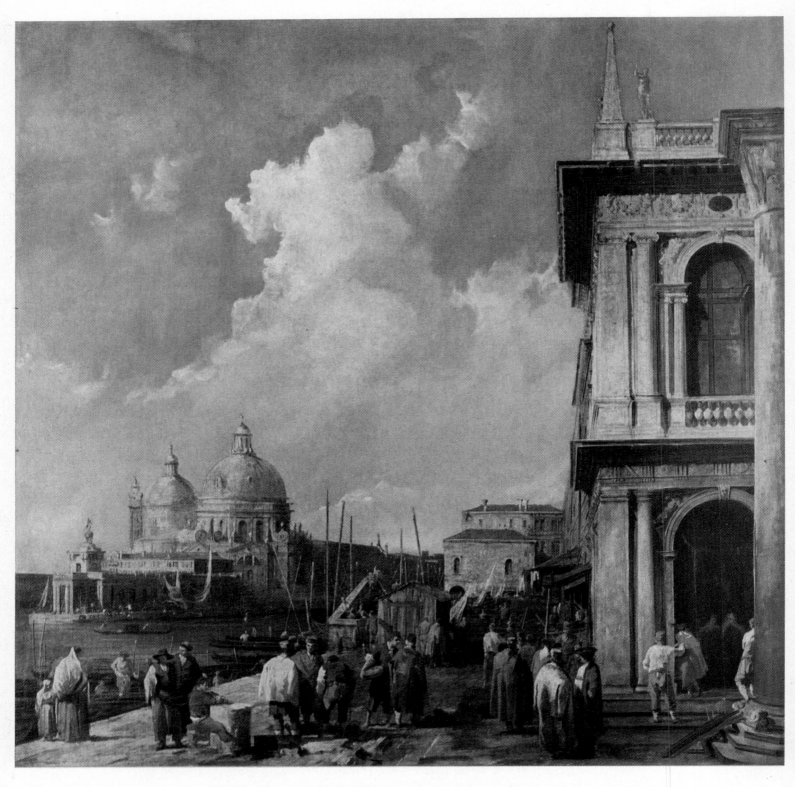

131. CANALETTO [1697-1768] *Scene in Venice: The Piazzetta* · Venetian
Oil on canvas, 51½ x 51¼"

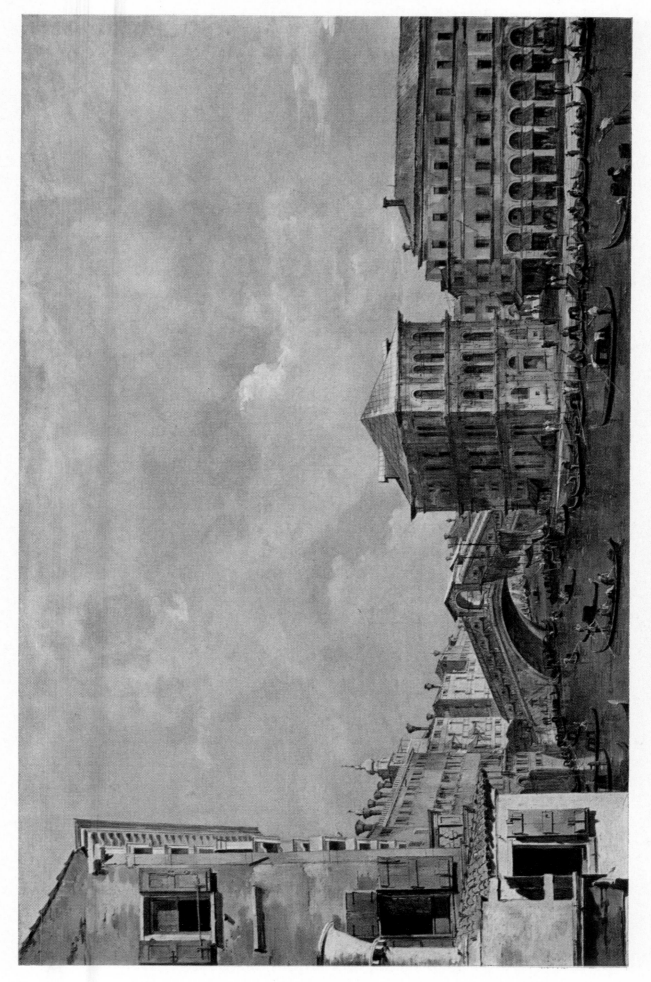

132. GUARDI [1712-1793] *The Rialto* · Venetian · Oil on canvas, 21 x 33¾"

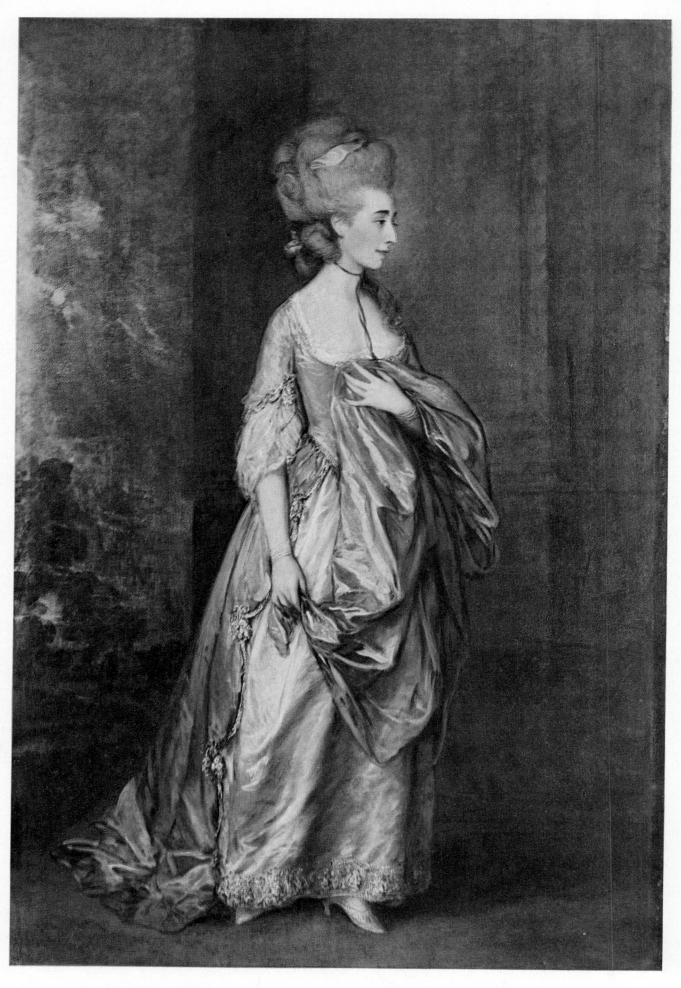

133. GAINSBOROUGH *[1727-1788] Mrs. Grace Dalrymple Elliott* · British
Oil on canvas, 92¼ x 60½″

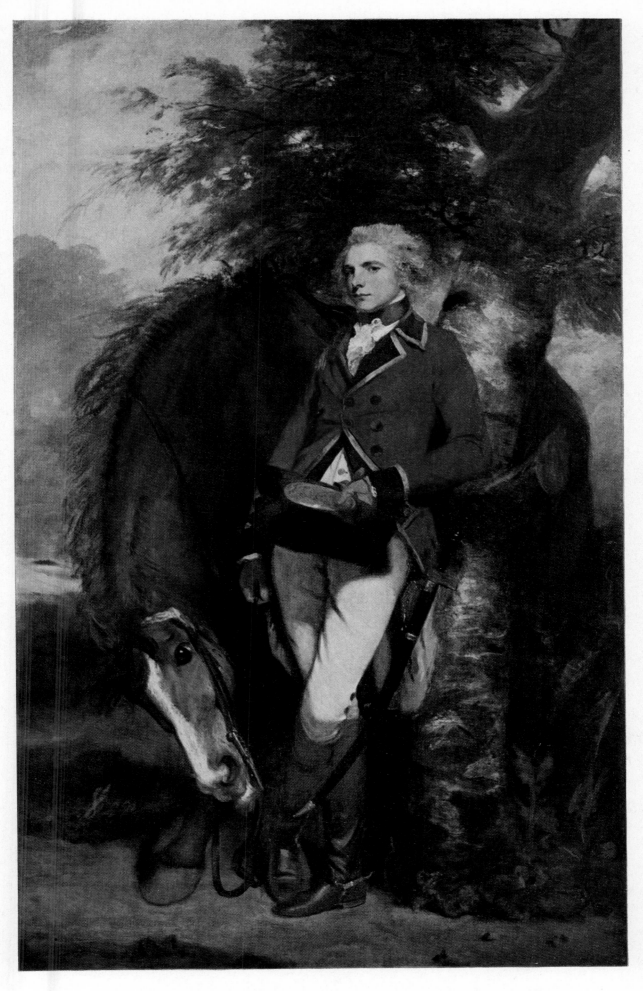

134. REYNOLDS [1723-1792] *Colonel George K. H. Coussmaker* · British
Oil on canvas, 93¾ x 57¼"

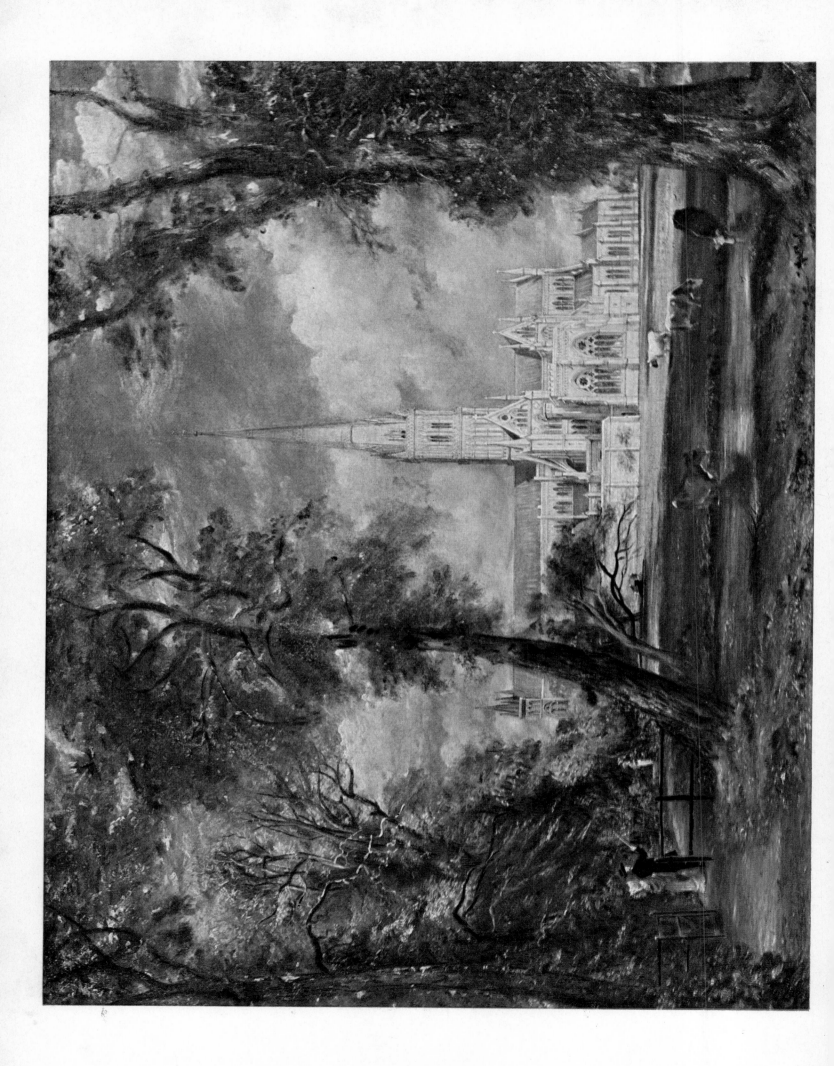

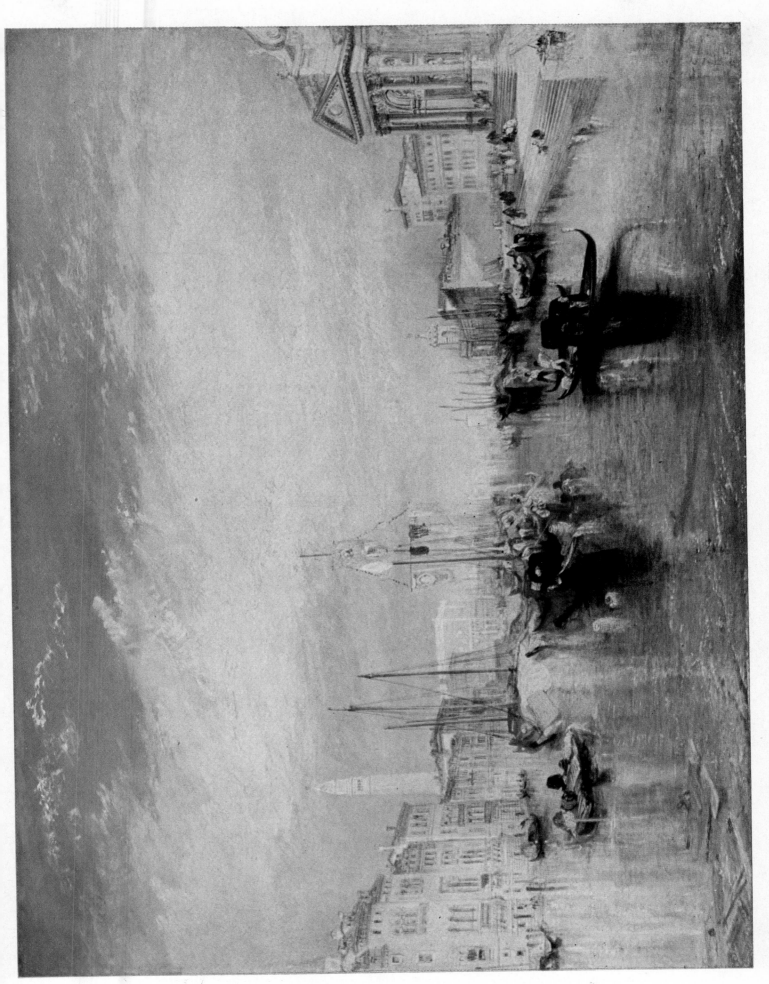

136. TURNER [1775-1851] *Grand Canal, Venice* · British · Oil on canvas, 36 x 48⅝"

137. LAWRENCE [1769-1830] *Elizabeth Farren, Later Countess of Derby* · British
Oil on canvas, 94 x 57½"

138. CONSTANCE MARIE CHARPENTIER [?] [1767-1849] *Mlle. Charlotte du Val d'Ognes* · French
Oil on canvas, 63½ x 50⅝″

139. JACQUES LOUIS DAVID [1748-1825] *The Death of Socrates* · French · Oil on canvas, 51 x 77¼"

140. INGRES [*1780-1867*] *Madame Leblanc* · French
Oil on canvas, 47 x 36½″

141. COURBET [1819-1877] *Woman with a Parrot* · French · Oil on canvas, 51 x 77"

142. DAUMIER [1808-1879] *The Third Class Carriage* · French · Oil on canvas, 25¾ x 35½"

143. DELACROIX [1796-1863] *The Abduction of Rebecca* · French
Oil on canvas, 39½ x 32¼"

144. COROT [*1796-1875*] *Woman Reading* · French
Oil on canvas, 21⅜ x 14¾″

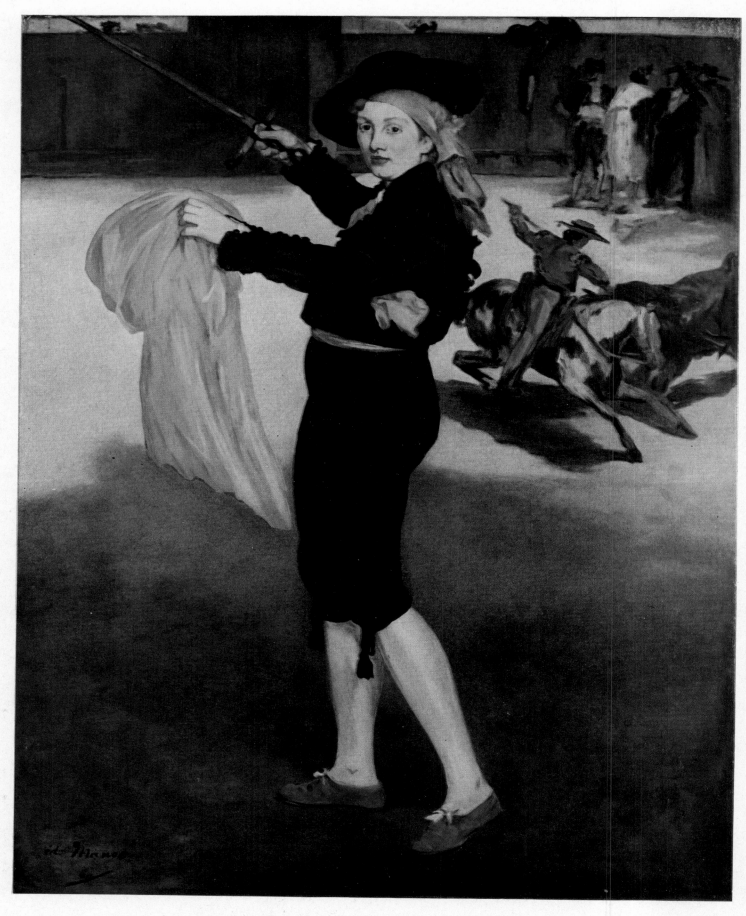

145. MANET [1832-1883] *Mlle. Victorine in the Costume of an Espada* · French
Oil on canvas, 65 x 50¼″

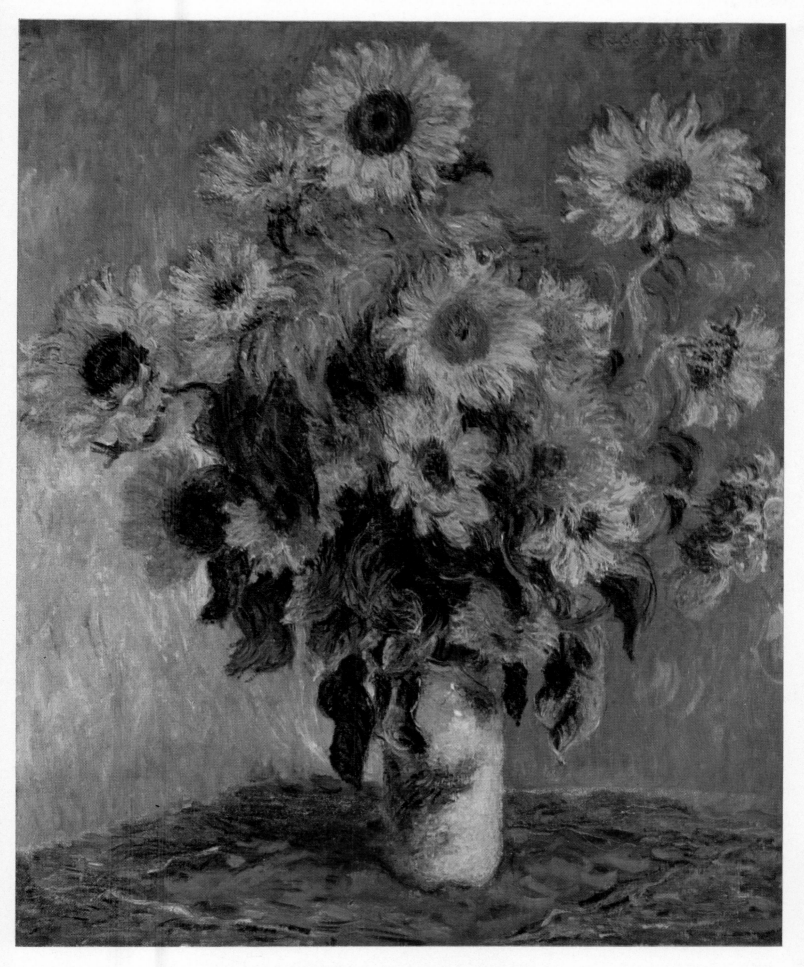

146. MONET [*1840-1926*] *Sunflowers* · French
Oil on canvas, 39¾ x 32″

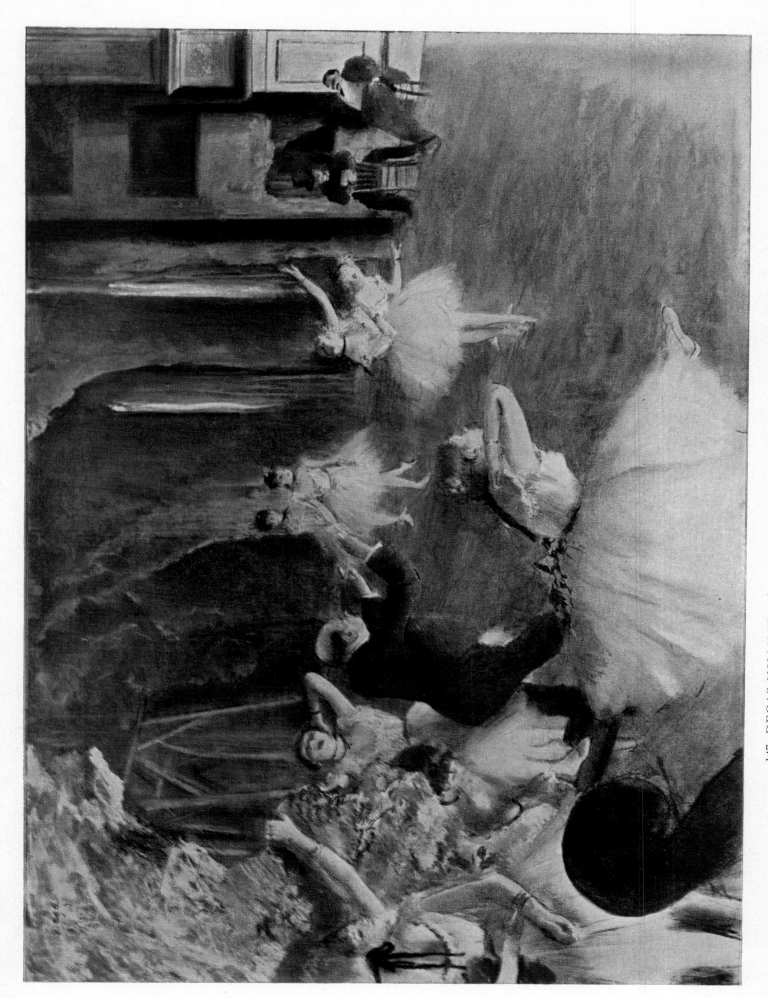

147. DEGAS [1834-1917] *Rehearsal on the Stage* · French · Pastel on cardboard, 21 x 28½"

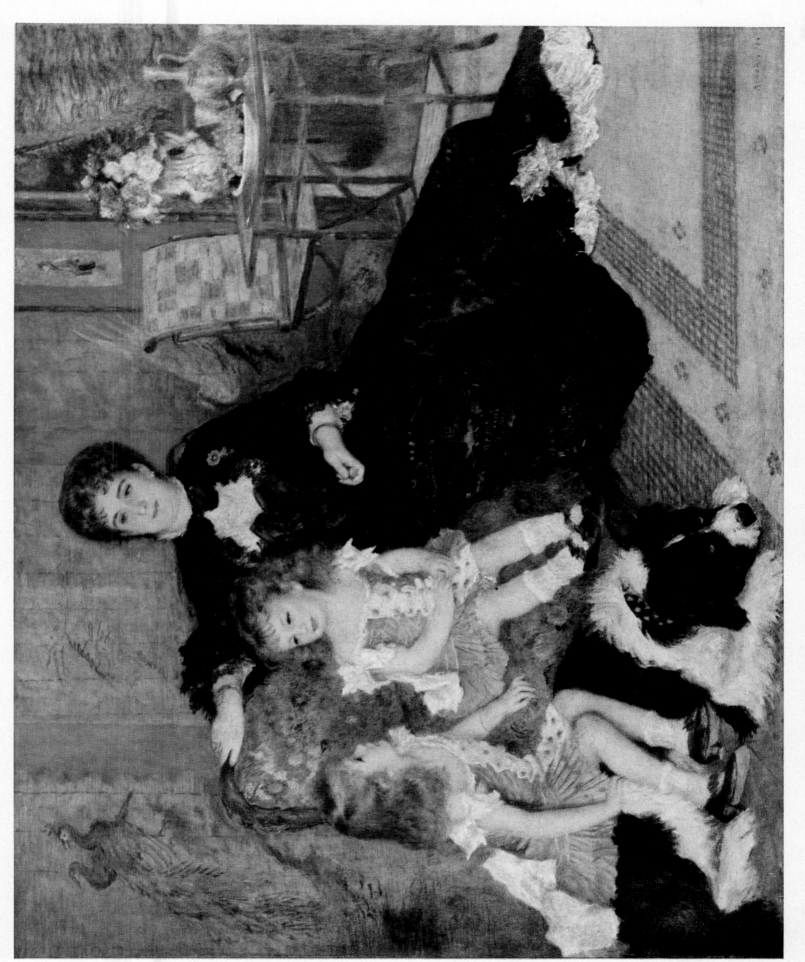

148. RENOIR [1841-1919] *Mme. Charpentier and Her Children* · French · Oil on canvas, 60½ x 74⅞"

150. SEURAT [1859-1891] *An Afternoon at La Grande Jatte* · French · Oil on canvas, 27¾ x 41"

151. VAN GOGH [1853-1890] *L'Arlésienne* · French
Oil on canvas, 36 x 29″

152. GAUGUIN [*1848-1903*] *Ia Orana Maria* · French
Oil on canvas, 44¾ x 34½″

153. HENRI ROUSSEAU [1844-1910] *The Repast of the Lion* · French · Oil on canvas, 44¾ x 63"

PRINTS

On A MAP OF THE WORLD, Europe is a queerly shaped and rather small peninsula; in the history of art, the period since the early fifteenth century is a very short space of time. Yet from this peninsula and these few centuries come the works of art that are probably as great in number and as wide in range of subject matter as those of any other department of the Museum, the prints. The technique, in its first form, the wood block, is, of course, much older, and was invented, like so many of the achievements of man, in the East, but, even in Europe, the basic idea, making a picture in two steps instead of one, can be found before the fifteenth century. The cave man who put his hand on the rock and painted round his outspread fingers was not far from it. To put color onto a piece of wood and dab it onto something else was certainly done intermittently from the time of the Copts, but it is not hard to see why this simple action did not develop into an "art," in the modern sense of the word, until so late in the history of the world.

The chief obstacle, of course, was the lack of a suitable "something else" on which to print; when paper came to Europe, printing, both of letterpress and of pictures, was bound either to follow or to be invented independently. In the same way, lace could not be more than a little decorative twisting of threads until pins were abundant and cheap, and the airplane was impossible before the perfection of the internal combustion engine. But one must also consider the state of society and the demand for art. A Carolingian serf would not have had even the few coins that the burghers of Nürnberg some centuries later happily spent for ink lines on paper, and the great lords of the ninth century would have despised such "cheap trifles." It is no accident that prints and the Renaissance were born at the same time.

Once brought to life, printing, as we all know, has behaved like the broom of the sorcerer's apprentice, and there is no sign of the return of the master magician. But while the man who prints letters has never needed anything very different from Gutenberg's basic idea until quite recently, the picture printer has invented process after process, using wood, copper, steel, and stone, metal and acid, intaglio and relief, until the technical jargon of the people who make or collect prints is as thick and rich and incomprehensible as the conversations of a garden club.

There is a more important aspect, however, than a multiplication of processes, from woodcut to engraving to mezzotint to lithography, in which a great print collection is many-sided. This is in its range from the merely useful, through

161

154. ANONYMOUS ARTIST. *Christ Sitting by His Cross.*
Woodcut. Ulm, about 1485. 4″ high

155. ANONYMOUS ARTIST. *The Lovers*. Woodcut from *Storia di due amanti*, Florence, about 1490–1500. 4¼″ high

the ornamental, to the purely beautiful. Prints, like pottery or glass, are very much the product of "art" in its original sense of a skill; our word "artificial," which used to mean simply "made by man, not Nature," and was once a compliment (as James II showed when he called St. Paul's cathedral "amusing, awful and artificial"), has acquired a pejorative sense. The usefulness of prints was most clearly shown in the first centuries of their existence; suddenly the botanist, the surgeon, the architect, any man of science who observed and wished to describe, or any designer who wished to instruct, had a tool handed to him which, in many cases, changed his whole approach to his business. (The invention of photography has done the same thing for the study of the history of art). For the first time, a student could have a visual definition of a species or an organ or a decorative motif that was not a copy of a copy of a copy, but an accurate reproduction of what the original draughtsman had wanted to tell him. This useful aspect of the art is still very much in evidence in the Print Room of the Metropolitan Museum; just as a Shakespeare library will have, as well as all the Folios and Quartos it can lay its hands on, as much more contemporary material as possible—broadsheets, letters, account books, or

inventories as well as historical and literary works—so the Print Room provides sources for workers in a dozen activities. The great city outside is in ceaseless production and the makers of many of the things it turns out—paintings and sculpture, stage sets, fashions, books, and magazines—come to the Print Room for help. Only the Costume Institute and the Library can be of as much service to the workaday world.

But the Metropolitan Museum is a museum of art and, amid all this hum and bustle of useful service, the chief function of the Print Room is still to house works of art. Like cheerfulness for Dr. Johnson's would-be philosopher, art will keep breaking in. The *Biblia Pauperum* which was to teach the truths of religion to the illiterate, or, possibly, to assist poor preachers with their sermons, the illustrations to Vesalius which were to instruct the medical student, the flower prints which were to serve as designs for embroiderers, are now treasured as works of art only. And these techniques of printing, which can have such practical applications, which can require the use of such solid materials and tools, can give birth to such unquestioned masterpieces of all ages and arts as Mantegna's *Battle of Sea Gods* or Rembrandt's *Three Crosses* (figures 156 and 163),

156. MANTEGNA (1431–1506). *The Battle of the Sea Gods*. Engraving, 11″ high

157. DOMENICO DALLE GRECHE (Venice, 1549). Detail from a woodcut after Titian.
Pharaoh's Army Drowned in the Red Sea. Detail 16″ high

163

158. MASTER I. A. OF ZWOLLE, HOLLAND (active 1485). *Saint George and the Dragon*. Engraving, 8⅛" high

and can result in an end product, a few lines breathed across the flimsy paper, as ethereal as a silver-point drawing.

The museum man trained in a print room is apt to boast of the universality of his knowledge. Nothing, he points out, is alien to him, and his domain is the very heart of the museum, in that all the decorative arts, as well as painting and sculpture, have arteries linking them to his prints. His knowledge and his collection are used for many a temporary exhibition, illustrating a place, a period, an event, or a personage; he must transcend departmental boundaries and know the history of art from the late Gothic to Picasso, the techniques of art from lace-pattern books to the laws of perspective. The Metropolitan Museum was fortunate that its first curator of prints, head of the department for thirty years, was indeed a man of this encyclopedic character, with all the instincts of an artist, disciplined by the practice of law; his intellectual curiosity and erudite imagi-

nation made the collection what it is today.

William M. Ivins, Jr., began to put his policies into effect when he took charge of the newly formed department in 1917. But prints, of course, had been among the earliest objects considered worthy to enter the Museum; even before it existed, the organizing committee stated that "it should include not only collections of paintings and sculpture, but should also contain drawings, engravings, medals, photographs, architectural models, historical portraits, and specimens illustrating the application of art to manufactures." The inclusion of photographs is particularly interesting, as the Metropolitan Museum does own enough examples of this youngest and brashest of the arts to show the development of photography since its very beginnings. To the founders of the Museum it was probably merely an educational

159. RENÉ BOYVIN (1525–1598). *Masquerade Costume*. French. Engraving, 12¾" high

tool, like architectural models, but it has had the same successful career as its forerunners in reproduction (some of them, such as lithography, rising from equally humble origins); there are now Old Masters among the photographers, and styles, periods, influences, and iconological problems in the best art-historical manner.

Before the Museum even had its own building, there had been a loan exhibition of engravings, etchings, and mezzotints, but no great effort was made to acquire prints as permanent possessions. The Huntington Collection of Americana, devoted principally to Washington, Lafayette, and Franklin, given to the Museum in 1885, contained many prints, but these were considered primarily as illustrations or historical documents. The few works by "artist-engravers" owned by the Museum were sometimes considered part of the Li-

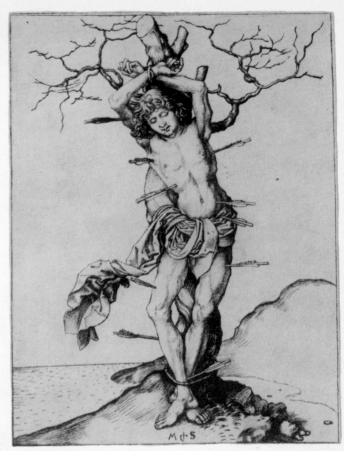

161. SCHONGAUER (1440/5–1488/91). *Saint Sebastian*. German. Engraving, 6¼" high

160. GIORGIO GHISI (1520–1582). *Ceiling Decoration*. Italian. Engraving after Primaticcio, 11¾" high

brary, at other times part of the Department of Paintings; in neither place were they truly at home. (It is indeed indicative of the nature of prints that they have affinities with books on the one hand and paintings on the other; only since the invention of photography has their place in the art museum become perfectly clear.) But this confusion and neglect was changed by the will of Harris Brisbane Dick in 1916; he made the Museum his residuary legatee, the income from this estate to be used "in the purchase of desirable and proper objects of the Fine Arts." Now, Mr. Dick and his father had been print collectors and the first use to which his money was put was to buy in most of his own collection; later purchases often benefited other departments, but, in general, the Dick Fund has provided what Mr. Dick enjoyed, including some of the pieces in this book.

With such a solid foundation and with Mr. Ivins as curator, the department could not but grow, with a series of gifts, bequests, and purchases. Some of the most important accessions are the Dürer prints of the Junius S. Morgan Collection, given and bought (out of the Mr. and

165

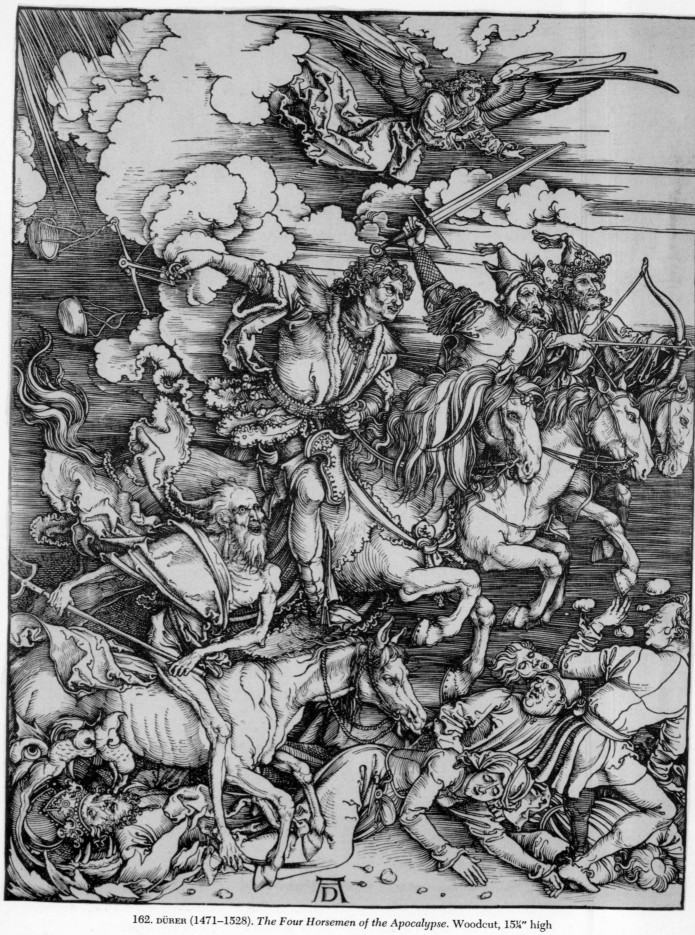

162. DÜRER (1471–1528). *The Four Horsemen of the Apocalypse.* Woodcut, 15¼″ high

166

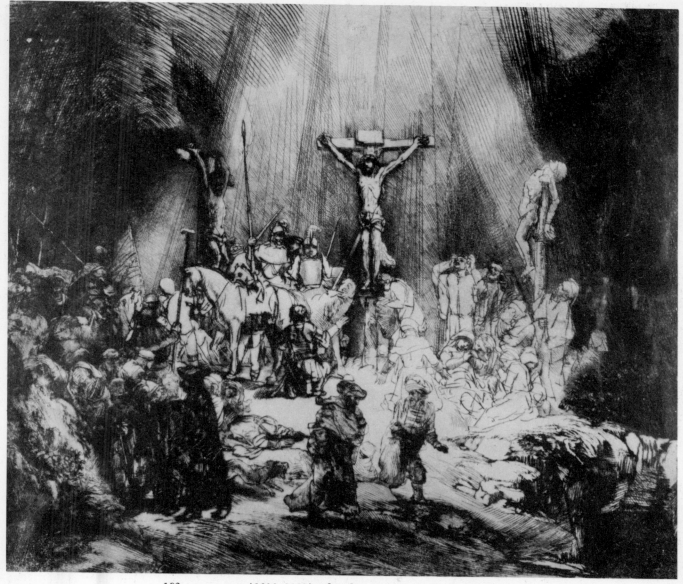

163. REMBRANDT (1606–1669). *The Three Crosses.* Etching, 15¾₆" high

Mrs. Isaac D. Fletcher Fund) in 1919; the bequest of Mrs. H. O. Havemeyer, with additional gifts from her children, in 1929, consisting of rare French Impressionist prints and very beautiful Rembrandt etchings; James C. McGuire's noteworthy collection of early singlesheet woodcuts and metalcuts, bequeathed in 1931; the gift of Felix M. Warburg and of his family in 1941, magnificent in early examples and in Rembrandts. Recently purchases of prints have been made mostly from the fund bequeathed by Elisha Whittelsey in 1941. These acquisitions have built up a collection which, of course, is surpassed in various specialties by libraries and museums in other parts of the world, but which has more variety than any other. Here, too, are many of the

Museum's drawings—all that are connected with the decorative arts or were made as preliminary studies for prints. This Print Room is the only one in which can be studied the history of the printed picture in all its applications everywhere—as a single sheet print, as book illustrations, and as ornament. The categories are usually separated. But more important to the visitor and to the reader of this book is the fact that here are the visionary masterpieces of Rembrandt's maturity in impressions of a sumptuousness that never occurs in the market any more; here are all Dürer's copper plates and over half his woodcuts; here are the Gothic North, Renaissance Italy, eighteenth- and nineteenth-century France, all summed up in a few lines, on a few square inches of paper.

167

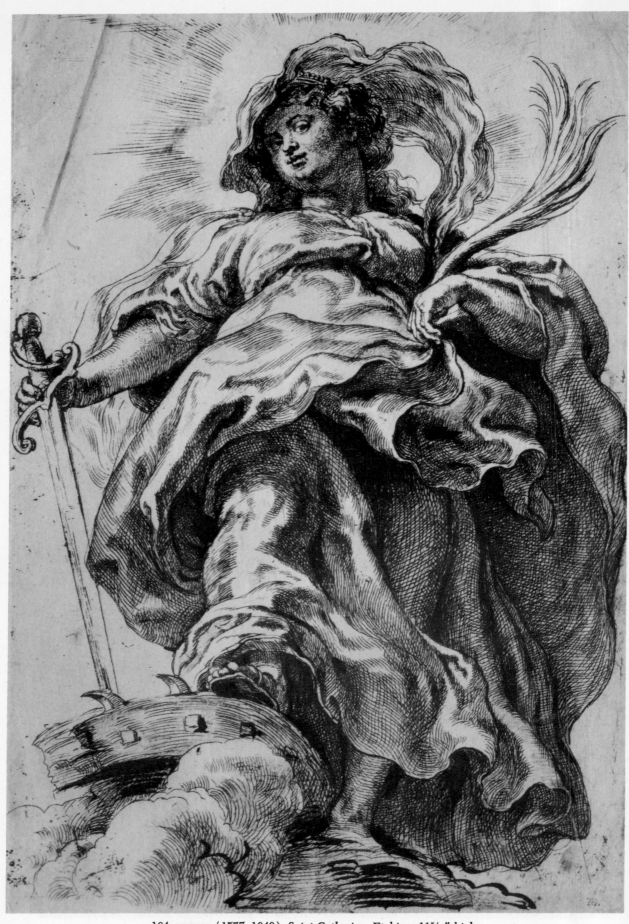

164. RUBENS (1577–1640). *Saint Catherine*. Etching, 11⅗₁₆″ high

165. DELACROIX (1798–1863). *Wild Horse Attacked by a Tiger*. Lithograph, 8⁵⁄₁₆″ high

166. GOYA (1746–1828). *Ni por esas* ("Not even for these women"). Etching, 6⁵⁄₁₆″ high

167. MOREAU LE JEUNE (1741–1814). *Les Adieux*, 1777. Engraving by de Launay. 10″ high

168. DAUMIER (1808–1879). *Peace*. 1871. Lithograph, 9¼″ high

169. Pen drawing for Chippendale's *Gentleman's and Cabinet-maker's Director*, London, 1754. 11″ high

DECORATIVE ARTS

OBJECTS OF DECORATIVE ART can be defined as things to which something more has been done than the bare minimum necessary to make them fit for their proper function. If the word "functional" is interpreted extremely broadly, all the things illustrated in this section may be said to possess this quality. The function of the Maillol torso (figure 177) is, like that of any great sculpture or painting, to arouse esthetic emotion, to move the onlooker; the function of the Cellini cup (figure 172)—at the time it was made—to demonstrate the wealth and taste of its owner; the function of the Civitali Angel (figure 182), to assist devotion, or (to put the most generous interpretation upon the action) to express the love of God felt by the man who commissioned it. But if we define "functional" narrowly, as a near equivalent of "useful," the quality, clearly apparent in the suit of armor, the furniture, the maiolica dish, the andiron, becomes fainter in the tapestry and almost invisible in the Cellini cup (there is a cavity that *could* hold nuts); the figures in the Meissen group (figure 179) would laugh at the idea that they had any other use than to give pleasure, and for the Maillol torso such an adjective is meaningless.

What then is this section? It displays the works of art of Europe, other than paintings, from the Renaissance to the present day. The Renaissance was once thought to have occurred, like a chick breaking out of an egg, in 1453; now, sometimes, as a period in the history of art—crowded at the one end by Late Gothic and pressed down on the other by Mannerism—it seems to have dwindled to the works of Raphael. Scholars have been known to discuss it, brilliantly, for three days, without ever agreeing on what they were talking about. But something happened in Europe that made the works of art shown here differ from those in the section on Medieval Art, and it began in Florence in the fifteenth century, whether we date its birth from the competition for the Baptistery doors or Masaccio's frescoes in the Brancacci Chapel, or any other specific event. In its first and purest form it is seen in the Verrocchio relief illustrated in figure 183; the classical columns, the swags of fruit between winged heads, the realism of the nude Child and the simple lines of the drapery, are easily-grasped tokens of the change of style, which, however, goes much deeper than the mere adoption of a different decorative vocabulary. It can be appreciated if this Madonna is compared with either of the Medieval ones shown.

Starting in Florence, this new way of making works of art spread throughout Europe, arriving

at varying dates and taking on varied forms in different countries. From it have grown all the succeeding styles, which, one after another, have made the world we live in. For the culture illustrated in this section is our own, and, for that reason, the hardest for us to consider without preferences and prejudices. It is possible that the art historians of the future will pinpoint, say, the second or third decade of the twentieth century as another great divide, similar to that between the Medieval and the Renaissance periods, and

170. *Andiron Surmounted by a Figure of Mercury.* Italian (Venetian), late sixteenth century. Bronze, 36⅛" high

argue whether the Bauhaus or Taliesin should stand for the neo-Florence of the movement, but the worm's-eye view of the 1950's cannot tell whether we have crossed a true watershed or run into a mole-hill. All around us, all day long, are objects whose basic form or decorative detail was conceived in Europe in the centuries we are considering: a hundred stories in the air, the sky-scraper bursts into Renaissance garlands, classical pilasters grow on the exterior walls of banks, our furniture, wall-paper, china, and silver, as likely as not, are derived from eighteenth-century prototypes. Even the furnishings of churches, unless they are self-consciously pure Gothic, Romanesque, or Byzantine, or in a deliberately exotic style, reflect the tradition whose starting point is the religious sculpture shown here.

The Renaissance is proclaimed by its very name as a style that did not attempt originality; it was a re-birth, or intended to be such, of classical antiquity. This custom of borrowing from other times or countries has been characteristic of the European arts ever since, culminating in the various revivals of the nineteenth century. Other cultures are "influenced": the European artist and craftsman have time and again set out to imitate. But a curious fate awaits imitators. G. K. Chesterton has written of the simple but satisfying trick that people play on prophets; they listen to them respectfully, bury them decently, and then go and do something entirely different from the actions so confidently predicted. In the same way, a Paduan sixteenth-century bronze-caster imitating the antique, a French eighteenth-century tapestry designer depicting life in China, an English nineteenth-century architect copying the Sainte Chapelle, all succeeded in producing works of art, which, now that the makers are dead, could never be taken for anything but products of the time and place that actually produced them. This ability to borrow, to absorb, to use to good purpose the inventions of more and more distant lands and periods, is what has given the arts of Europe their kaleidoscopic variety and brilliance.

This was very well known to the founders of the Metropolitan Museum, who, from the very beginning, had a dual purpose. The Museum was to open "a fountain of pure and improving pleasure," to be, as a clergyman said at the initial meeting, "a museum of Virtue, a museum of Purity, and a museum of Goodness and Truth," but it was

171. KUNZ LOCHNER. *Armor for Man and Horse*. German (Nuremberg), dated 1548. Steel. Knight's armor 5′ 5″ high

172. BENVENUTO CELLINI. *Cup of Gold, Enamel, and Pearls* (the "Rospigliosi Cup").
Italian (Florentine), sixteenth century. 7¾" high

also to be, as an architect said at the same meeting, "a museum similar to the Kensington Museum in London," that is, a collection of objects of all materials, of all countries and periods, suitable for copying.

Human beings are very apt to do something in the hope that something else, quite different but highly desirable, will result. Female suffrage was to purify public life, prohibition to diminish crime, the League of Nations to abolish war. The art museum in the nineteenth century was also saddled with a task of which our disillusioned age no longer believes it capable. It was to "irradiate all with its refining, inspiring influences"; to combat vice by "attractive entertainments of an innocent and improving character." But the more modest goal of being useful to artists, designers, and craftsmen was equally important to the Founders, who congratulated themselves as early as 1876 on the "number of artisans who visit the Museum" and believed that, even at this date, "styles of household and home decoration are materially changing," as a result, at least in part, of

the influence of the Museum. This last piece of rosy optimism may seem a little premature, but there is no doubt whatever that, by now, nearly three generations of "artisans" in many crafts have profited from the decorative arts collection of the Metropolitan Museum.

From the first these were very varied. The guide book of 1875 lists, as loans, Peruvian pottery, Sèvres and Dresden porcelain, carvings, enamels, antique watches, coins, arms, armor, and many Oriental objects. Peruvian pottery lies outside the scope of this book, but the other display cases (as we may imagine them) have each grown into a great collection. Much progress was made in the first thirty-five years toward the announced goal of a museum similar to the Victoria and Albert Museum in London. Mrs. John Crosby Brown presented her collection of musical instruments in 1889; this still constitutes the main part of the nearly four thousand objects in the Department of Music. Here is the pianoforte—now once again in playing condition—built in 1721 in Florence by Bartolommeo Cristofori, who

176

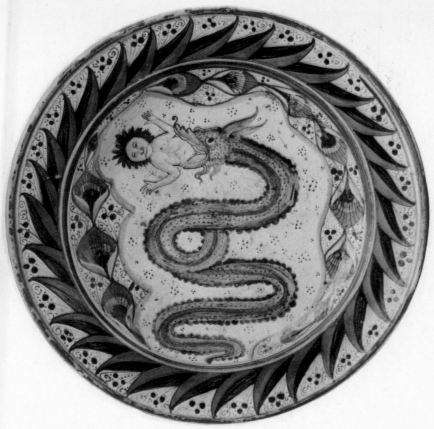

173. *Maiolica Dish Bearing the Emblem of the Visconti-Sforza Family.*
Italian (Florentine), about 1480. Diameter 15"

invented the instrument, and a long line of the lovely things with names as mellifluous as their notes—virginals, harpsichords, clavichords, viols, lutes, and archlutes. The non-European section is perhaps the largest and the most systematic in the world. Another entire department of the Museum, which also is not restricted to Europe, and which covers a period from Merovingian times to the nineteenth century, the Arms and Armor Department, traces its origin back to these early years, when Rutherford Stuyvesant, a Founder, Trustee, and Vice-President, was making his own collection, one of the first in America; he was instrumental in securing the collection of the Duke of Dino in 1904 for the Museum. Two years later Bashford Dean was appointed honorary curator, though the Department was not officially recognized as such until 1912. It is now one of the world's most complete and magnificent armories. Here are signed works by many of the best-known artist-armorers, and many suits or single pieces made for famous men, such as François I, Cosimo II de' Medici, and George Clifford, Earl of Cumberland and Queen's

Champion to Elizabeth I.

After the turn of the century, in fact, objects that were not paintings, or Egyptian, Greek, or Roman, began to enter the Museum in such quantity that an organizational problem arose. In 1886, when the collections were first sorted out into three departments—Paintings, Sculptures, and Casts—these decorative pieces were placed (under the name of bric-a-brac) in the Sculpture Department. A department of metalwork was established in 1906 and, with Arms and Armor virtually a separate entity from the same date, it began to look as if the organization as well as the scope of the Victoria and Albert Museum was to be copied in New York. But the Metalwork Department lasted only until 1912 and the Department of Decorative Arts, founded in 1907, absorbed it easily into its enormous kingdom, which then included all non-classical European objects other than arms and armor and paintings, and all Oriental and all American objects other than arms and armor; it is, in fact, far simpler to describe what it was not than to characterize it positively.

It was the acquisition by J. Pierpont Morgan

177

174. *Harpsichord of Gilded Wood.* Italian (Rome), seventeenth century. 8′ 9″ long

of the Hoentschel Collection and his gift of the eighteenth-century part of it that caused the formation of this department and the building of a wing for the decorative arts. Wilhelm R. Valentiner was appointed curator; as was proper in a pupil of Bode, his interests and knowledge covered all fields of art, a necessary qualification for this position. Before his resignation in 1914, the bequest of Benjamin Altman had brought to the Museum a great collection of paintings, porcelains, tapestries, rugs, enamels, rock crystals, marbles, bronzes, and furniture.

Joseph Breck succeeded Dr. Valentiner as curator of the department which was to lose its Far Eastern objects in 1915 and its Near Eastern in 1932, but which still remained gigantic. Shortly after his death a further division was made; three departments were created, Medieval Art, Renaissance and Modern Art, and the American Wing, each of which has grown to a size which would have astonished the founders of the Museum. The harpsichord, borne by sturdy Tritons, like Venus rising from the waves, is from the Music Department; the suit of armor for horse and man from the Department of Arms and Armor, but the bulk of the objects illustrated in this section are from

the Department of Renaissance and Modern Art.

The riches and variety of this department can only be hinted at here. There have been many great gifts; the bequest of George Blumenthal in 1941 included much Renaissance art, marbles, bronzes, tapestries, and especially maiolica; the children of Mrs. Harry Paine Whitney gave the Bastie d'Urfé chapel and two unique French Renaissance tapestries with the story of Diana, woven for Diane de Poitiers' Château d'Anet; the Bache Collection included Limoges enamels, French furniture, tapestries, and sculpture (including Pigalle's bust of Mme. de Pompadour, the della Robbia David, and the Peter Vischer self-portrait). Outstanding objects have been purchased, such as the early maiolica from the Mortimer Schiff Collection, the incredible little intarsia *studiolo* (the diminutive here certainly sounds like one of affection) made for Federigo da Montefeltro's ducal palace at Gubbio, and the luxurious Baroque bedroom from the Palazzo Sagredo in Venice. There are specialized collections, such as the gold snuffboxes, étuis, and carnets de bal; rare watches and clocks; Renaissance jewelry. French interiors in the collection come from such well-known Parisian houses

175. JEAN-HENRI RIESENER. *Desk* (secrétaire). Ebony, with panels of black and gold lacquer, and gilt-bronze mounts. Made for the royal Château of Saint-Cloud. French, period of Louis XVI (1774–1793). 4′ 9″ high

176. JEAN ANTOINE HOUDON. *The Bather*. Marble statue probably made for the Duc de Chartres' gardens at the Château de Monceaux in Paris. French, period of Louis XVI (1774–1793), dated 1782. 47″ high

177. ARISTIDE MAILLOL. *Female Torso*. French, 1929. Bronze, 47″ high

178. ANTOINE SIGALON. *Pilgrim Bottle.* Lead-glazed earthenware, bearing
the arms of John Casimir of Bavaria. French (Nîmes), 1581. 15″ high

as the *hôtels* de Pomponne, de Tessé, and de Cril-
lon; the English examples are from Kirtlington
Park and Lansdowne House. In furniture, there
are the Strozzi *sgabello,* the French Renaissance
cabinet illustrated, the black-lacquer and gilt-
bronze secretary and matching commode made
for Marie-Antoinette by Riesener for use in the
Château of Saint-Cloud, the English eighteenth-
century marquetry cabinet with the arms of the
Bowes (later Bowes-Lyon) family. Renaissance
bronzes are conspicuous among the metalwork,
which also includes cups, chalices, and shrines.
The Cellini cup in the Altman Collection is the
most spectacular example. In silver, French eight-

eenth-century pieces are noteworthy, such as the
tureen and *plateau,* part of an enormous service
made by Roettiers for Catherine the Great, and
the coffee pot made by Germain for the court of
Portugal; the Catherine D. Wentworth bequest
added another magnificent group of this French
silver. There are also English examples, such as
the silver-gilt mounts of about 1585 added to five
pieces of Wan Li porcelain for Lord Burghley.
Important groups of ceramics are the porcelains
and faience given by R. Thornton Wilson and
maiolica from V. Everit Macy. As well as the tex-
tiles mentioned, there are two Brussels tapestries
with scenes from the story of Therse, Mercury,

179. *Artist and Scholar Being Presented to the Chinese Emperor.* German, about 1765. Porcelain group, 15⅞″ high

180. JEAN BAPTISTE LEMOYNE. *Louis XV of France.* Marble bust, once in the
possession of Madame de Pompadour. French, dated 1757. 34¼″ high

and Aglauros, the Crucifixion illustrated, ten of a
set of the Months of the Year, woven at the Gob-
elins manufactory for the Comte de Toulouse, a
son of Louis XIV, the gift of John D. Rockefeller,
Jr., and four large embroideries representing
Spring, Summer, Fire, and Air, made about 1683
by young protegées of Mme. de Montespan. All
other varieties of textiles are fully represented
and the lace collection is one of the finest in ex-
istence. Venus and Mars would be equally de-
lighted with the Metropolitan Museum; Mars
could arm himself to his heart's desire and Venus

could not fail to be pleased with lace, invented
since her day.

One of Mr. Taylor's "five museums under one
roof" is what is represented in this and the medi-
eval section of this book. He has described its
contents as "architecture (including period in-
teriors), furniture, sculpture, tapestries, arms and
armor, textiles, costume, glass, ceramics, metal-
work, etc." It is the Museum of European Deco-
rative Art, a museum where, after our fascinating
voyages to Egypt, to classical Greece, to China, to
Persia, we can all come in and feel at home.

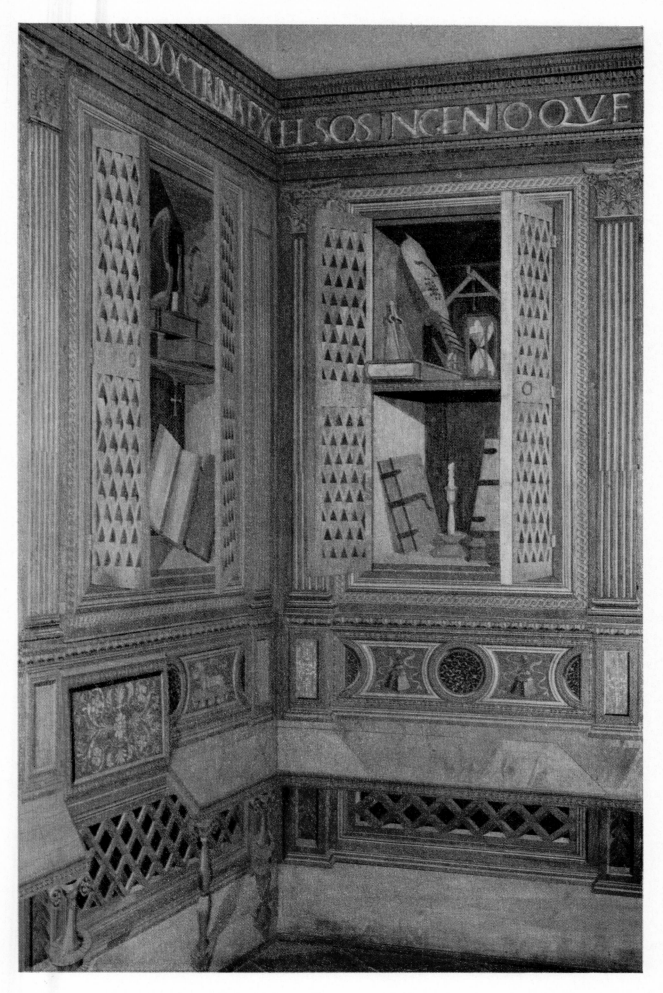

181. *Intarsia Paneling* in the private study of Federigo da Montefeltro, from the ducal palace at Gubbio · Italian, about 1479-1482 · Paneling 9′ 7″ high

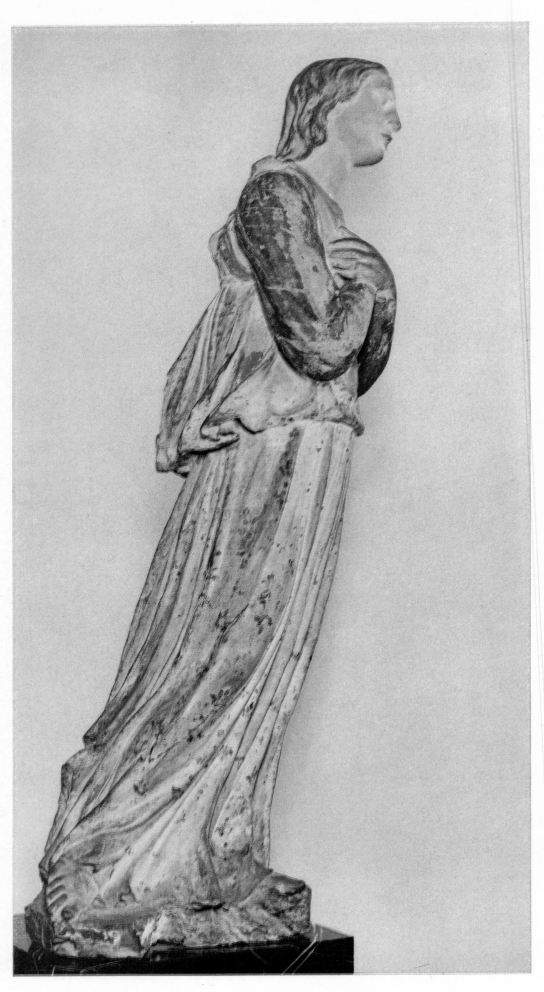

182. *The Angel of the Annunciation* · Matteo Civitali [1436-1501] · Italian [Lucca]
From a terracotta group · Fifteenth century · 51½″ high

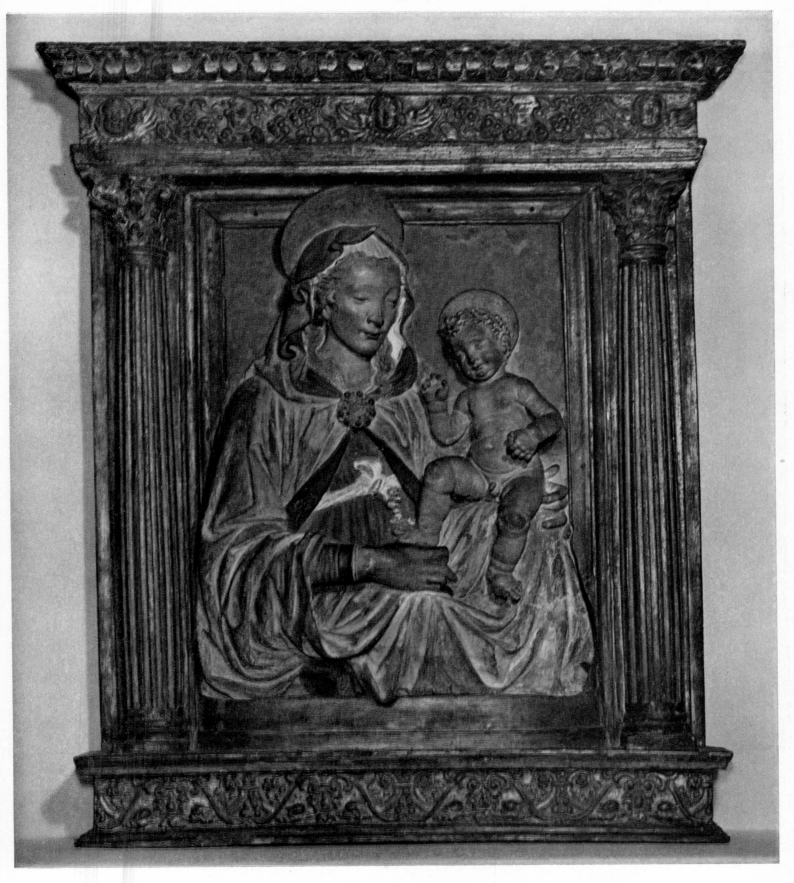

183. *The Virgin and Child* · Terracotta relief, painted and gilded, by Andrea del Verrocchio [1436-1488]
Italian [Florentine], fifteenth century · 30½″ high

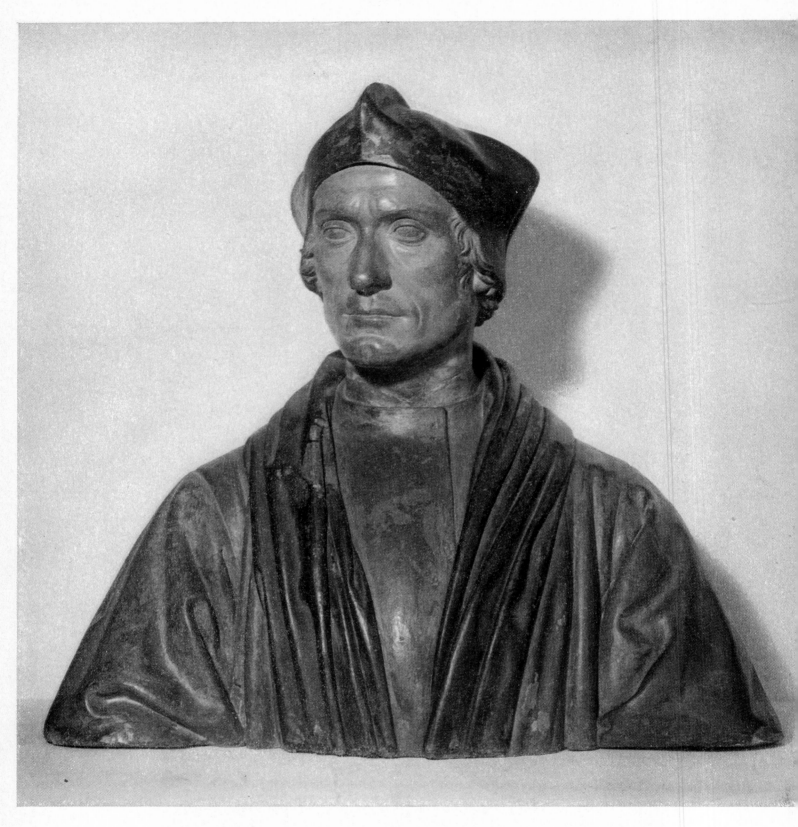

188. *An English Ecclesiastic*, said to be John Fisher, Bishop of Rochester · Painted terracotta bust
Probaby by Pietro Torrigiano [1472-1528] · Italian [Florentine], early sixteenth century · 24¼″ high

ORIENTAL ART

BEFORE THE DISCOVERY of the Americas, the West, to Europeans, was the Vale of Avalon and the Isles of the Blessed; the East was the land of true wonders, the source of everything that was rich and strange. To the West went departed spirits, never to return; from the East came silk and spices, precious stones, and the horns of rhinoceros and unicorn. In Ormus and Ind, Cathay, Cipango, and Trebizond, little lambs grew on bushes (the English still speak of "cotton wool") and diamonds clung to the lumps of meat that men threw down for the rocs to carry out of the inaccessible valley. But part of this world lay actually to the south; Granada was for many centuries as different from Paris as Samarkand, and even the traveler of today, whose boat puts in at Algiers, feels he has had a glimpse of "the East," an impression he would certainly not obtain in Vienna. We are considering in this section a truly vast expanse of territory, stretching from the Atlantic coast all along the southern shore of the Mediterranean, across Egypt, Turkey, Syria, Arabia, Persia, Afghanistan, India, Tibet, and China, to Japan and the other western islands of the Pacific. In the western reaches of this territory we are dealing with new civilizations that occupy the same ground as the ancient ones whose works we have seen; in Egypt come

the Christian Copts and then their Muslim conquerors, who succeed the Sasanians in Persia during the same period; the Byzantine Empire holds out longer, but is eventually overcome by Muslim Ottoman Turks, who then produce their miniatures, pottery, glass, and carpets in regions that once were Greek. Even part of India was on the fringe of the Greco-Roman world. Its ancient indigenous civilizations lay far in the past when the earliest Indian work of art here illustrated was made, but if we look at the oldest Chinese piece we find that our time scale has once again been extended enormously. The dynasty of Shang seems as remote as the earliest Pharaohs, and through the succeeding millennia, punctuated by the solemn and resonant monosyllables—Han, T'ang, Sung, Ming, Ch'ing—the Chinese went on casting bronze in forms that continued to recall their earliest ancestors.

For we are here concerned with civilizations that are still alive. No one now adores Ra as he rises in the East or burns incense before a statue of Zeus, but many men turn towards Mecca as they pray, or murmur with intense meaning that the jewel is in the lotus, and, as E. M. Forster has told us, "Esmiss Essmoor" can join today the living Pantheon of the Hindu gods. Though they may wear our clothes and imitate our ways, the

193

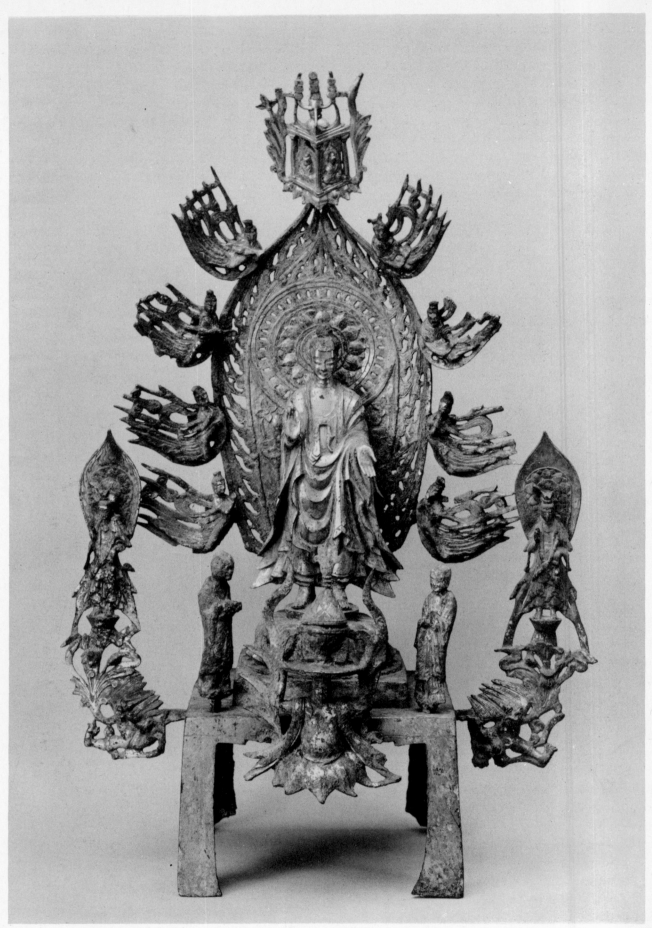

189. *Buddhist Altarpiece.* Gilt-bronze. Chinese, sixth century. 23¼″ high

men of the East are products of the cultures that made the works of art illustrated in this section, as surely as we are children of Christ and Aristotle, of Chartres and the Parthenon.

Is there any element common to the arts of all these peoples we call "Orientals"? Perhaps the only one is that they have never adopted the extraordinary idea, conceived by the ancient Greeks and revived in Renaissance Europe, that the noblest aim of art was to reproduce the outside world in all its length, breadth, and thickness, so that fingers would twitch to remove the painted fly from the painted fruit, and cherubs fill the dome as solidly as if a flock of birds had been released there. Oil paint on canvas, which was the most effective means of performing this trick before the camera was invented, has never been an indigenous medium of the East. Though painting (in water-color on silk) is the great art of China (where, indeed, a patient and exact observation of the details of Nature, as loving and painstaking as Ruskin's, is the duty of the artist), it is the arts other than painting and sculpture that give us the clearest impression of the Oriental civilizations. Even in China, the gulf between the painting on the wall and the porcelain in its niche is not as profound as that which separates the oil in its gold frame from the bibelot on the mantelpiece.

It is just as well that this should be so, as for a very long time it was pieces of decorative art only that reached Europe, or America, from the East. At first they were brought simply to be used, though, after the weary miles of the Silk Road across Asia or the long sea voyage, this usage was confined to the very rich. The moralists of ancient Rome attacked the ladies who wore robes of Chinese silk, both because these were transparent and because good Roman gold was exported to pay for them. Rather more easily-come-by objects from the Near East were nevertheless considered things of fairy-tale beauty and worth; Eastern silks were used from the seventh century onward to wrap the bodies of saints and kings, a custom to which we owe much of our knowledge of these fabrics. The Crusaders brought nothing but death and destruction to the East, but they took back glass, crystal, metalwork, ivories, whether "liberated" or honestly acquired; each object was likely to become an heirloom. Persian and Chinese vases were given mounts of precious metals (the splendid Elizabethan ex-

amples in the Metropolitan Museum have been mentioned), as if they were just as valuable as ostrich eggs or cups of agate.

In the seventeenth century collecting, in the modern sense of the word, begins to be fashionable. We learn this from the satirists, who ridicule the tall corner-piece, all its shelves crowded with little Oriental deities, or, like Hogarth, show us the Eastern trifles strewn around with the other

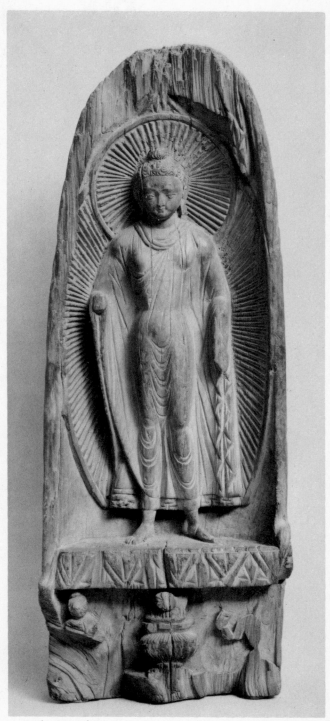

190. *Buddhist Traveler's Shrine.* Wood. Chinese Turkestan, T'ang Dynasty, 618–906 A.D. 14¼" high

195

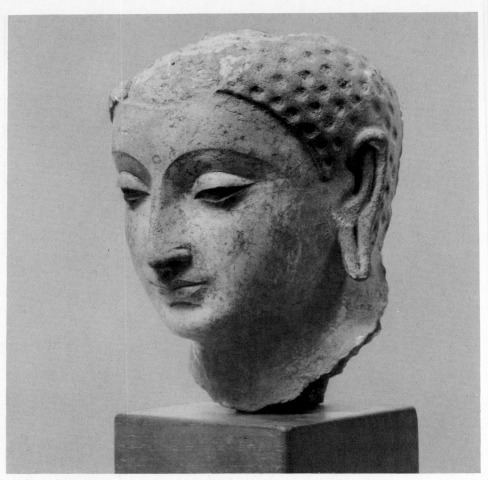

191. *Head of a Buddha.* Stucco. Chinese Turkestan, T'ang Dynasty,
618–906 A.D. 7¼″ high

expensive rubbish of a fashionable lady's boudoir. The admiration and awe, in fact, with which an earlier Western world had regarded the products of the East, had changed, by the eighteenth century, into a kind of affectionate condescension. The textile designer, who, in the fourteenth century, had altered his style fundamentally when he saw what the Chinese were doing, in the eighteenth century was inspired only to make "chinoiseries," elegantly humorous depictions of the little yellow men, who, though undoubtedly clever as monkeys, were generically absurd. The influence of the East upon the decorative arts of Europe, which had existed throughout history, and is so marked in Renaissance textiles, book-covers, metalwork and lusterware (a Near Eastern technique), continued during the eighteenth century; we find it in painted and printed cottons and Sir William Chambers' pagoda in Kew Gardens, but Europeans found it hard to take Orientals quite seriously. That this attitude persisted until late in the nineteenth century, as far as Japan is

concerned, is apparent in *The Mikado*. But Japan had been self-isolated from the world to a far greater extent than the rest of Asia. The Chinese emperor Ch'ien Lung could tell George III that his realm produced everything necessary to mankind and that trade was therefore totally impossible, but his successors could not stop the missionaries and merchants; the Japanese were able to limit their traffic with the West to two Dutch ships a year, making their captains trample upon a Crucifix (which they, as good Calvinists, doubtless accomplished without pain) before they could do business. When Japanese art finally reached Europe, it was immensely admired and affected all the arts and crafts, from patchwork to the paintings of Whistler.

The art of Islam contended with as great difficulties as that of the Far East before it could be understood and appreciated by the general public in the West. The objects brought to Europe by the Crusaders, or carried over the Alps and the Pyrenees from Spain and Southern Italy, were al-

196

ways things of the greatest richness and value, and the princely collections of the sixteenth and seventeenth centuries, such as those of the Doges of Venice and the Hapsburgs of Vienna, full as they were of beautiful Oriental rugs, textiles, crystals, glass, and metalwork, were private instances of "conspicuous display." In the eighteenth century a widening interest in the Near East produced "turqueries" of the same bizarre nature as the "chinoiseries" of the period, but it is only within the last century that Islamic art has been presented to the Western world in its true light through scholarly publications and magnificent exhibitions, beginning with the one in Munich in 1910.

The fact that the East has produced comparatively little, apart from Muslim architecture, that nineteenth-century Europe would have placed automatically and without question in the class "Fine Arts," has had two interesting consequences. It has tended, on account of the incredible technical perfection of so many Eastern artifacts, to encourage the classification by material of objects in museums, and yet it has assisted greatly in the process by which the line between "Fine" and "Decorative," or "Applied," arts has become hazy and finally of no importance. When collectors were paying far more than their weight in gold for "Hawthorn" vases and Persian rugs, it became clear to the meanest intelligence that these vases and rugs were worthy of the same respect accorded the collector's Rembrandts. When these treasures began to enter the museums in large numbers, the policy that segregated them by material, as primarily of use to "artisans," could not but be questioned. The potter, or the worker in leather, would undoubtedly prefer to see the finest samples of his craft, from all countries and periods, conveniently close together; the man-in-the-museum, who has come to understand that a vase or a bookbinding can be the source of the greatest esthetic pleasure, wants to see them where they show to best advantage, and so arranged that he can learn something of the culture that produced these marvels.

This change was effected in the Metropolitan Museum in 1915 for the art of the Far East. It was already quite substantially represented. As early as 1875, the Catalogue lists loan collections of "porcelain, ivory carvings, enamels, bronzes, lacquers, paintings, papers, etc.; chiefly Japanese

and Chinese"; and in 1880 a newspaper said, "You can take any standard work on Cyprus, Greece, Italy, or Japan and pick out your own illustrations for it in the Metropolitan Museum." "Japan," in this weird list of countries, certainly meant contemporary Japan. Its products were quite sufficiently different and enthralling so that it took some time for European and American eyes to be raised to the heights of Chinese art and the earlier centuries. Fine examples of Far Eastern art had come to Europe, along with the mass of trade-goods, as early as the eighteenth century, but it was some time before Occidentals could tell them apart. The Japanese and Chinese, also, have been very reluctant to part with their greatest paintings and sculptures; Japan, like many European countries, has a law forbidding the export of national treasures.

It is these paintings and sculptures, neverthe-

192. *Pottery Vase.* Tz'u Chou ware. Chinese, Sung Dynasty, 960–1280 A.D. 12½" high

197

193. *King Peroz I Hunting Ibexes.* Silver dish, with niello inlay. Persian, Sasanian period, fifth century. Diameter 8⅝″

less, that the Far Eastern Department has been determined to secure; the illustrations of this book show with what success. The greatest strength of the Department is in Chinese art, notably paintings, a number certainly from the Sung dynasty and one from the T'ang, and sculpture, from Han to Ch'ing. There is also the spectacular collection of jades and hardstones, chiefly from the Ming and Ch'ing periods, the gift of Heber R. Bishop; two gilt bronze altarpieces (of three known, early and complete) from the collection of the late Mrs. John D. Rockefeller, Jr.; ceramics from Han

to Ch'ing and an outstanding group of textiles. The Altman Collection of porcelains is still one of the most handsome single collections in the world, strongest in beautiful monochromes and magnificent figured and flowered K'ang Hsi imperial wares. The Japanese collections are rich in ceramics and lacquers, good in prints (especially the "Primitives") and in textiles: there are a few fine examples of early sculpture and a very few fine paintings and screens.

The Near Eastern objects in the Museum were not gathered into their own department until

194. *Detail from a Wall Hanging.* Wool tapestry on linen. Coptic, about 400 A.D. Detail 10″ high

1932, when there were already a great many of them. The department had benefited from a number of gifts and bequests of "decorative art," including magnificent enameled glass mosque lamps from Syria and inlaid metal work in the Edward C. Moore gift in 1891, which made the real foundation of the Islamic collection. The enameled glass collection in the Metropolitan Museum is second only to that in the Arab Museum in Cairo. In 1913 Alexander Smith Cochran presented many fine Persian and Indian manuscripts, richly illustrated and illuminated, and single miniature paintings. The rug collection is one of the finest in the world, with oustanding pieces from the Benjamin Altman bequest of 1914, the J. P. Morgan gift of 1917, the James F. Ballard gift of 1922, and many other donors; the Samuel H. Kress Foundation presented the "Anhalt Carpet" in 1946, a medallion carpet remarkable for its beauty and perfect condition. The ceramics collection illustrates forms, techniques, and ornaments from the early centuries of the Christian era to the present day; the textile collection is important both for quality and quantity of

195. *Egrets in a Landscape*. Detail from a *Marsh Scene with Birds*. Handscroll painting in ink on paper. Attributed to Shên Chou (1427–1509). Chinese, Ming Dynasty, 1368–1644 A.D. 11½″ high

material. Like the Egyptian collection, the Islamic collection has been added to by excavations, in this case from 1931 to 1940; Ctesiphon, near Baghdad, yielded important objects of the Sasanian era, and Nishapur provided early Islamic wall-paintings, stucco panels, and ceramics.

The reader who turns these pages looking at the pictures will find he has seven-league boots and is traveling in a time-machine of extraordinary efficiency; he can also test his capacity for enjoying the most diverse works of art, a faculty generously vouchsafed to our modern age, perhaps to recompense us for losing the power of creating them. Figure 195 is a detail from a painting attributed to Shên Chou, one of the most famous painters of the Ming dynasty, and certainly of his period. From it we can begin to understand the emphasis the Chinese lay on the relationship between painting and calligraphy; it is not hard to imagine the beautiful Chinese letters brushed in with just the same strokes that here give us the very life of the reeds. Figure 196 is an object as different as could be imagined; the large fourteenth-century Syrian enameled glass bottle,

formerly in the magnificent and extensive collections of the Imperial House of Hapsburg, decorated in brilliant colors and gilding.

The Buddhist sculptures take us from Chinese Turkestan, where Greco-Roman reminiscences still persist, to the perfect relaxation and unutterable calm of the T'ang bodhisattva, Kuan Yin, in the position of "royal ease" (figure 200). Buddhism, which swept over China in the Wei dynasty, inspiring literally thousands of temples, reached its fullest expression in the T'ang dynasty; its sculpture took on an air of agreeable accomplishment in the Sung dynasty, and from then on became conventional and pedantic.

The greatest glory of Persian art is its color, shown here in paint and fabric and glaze. The earlier miniature (figure 206), *Jonah Released from the Whale* (actually a Chinese carp), is from the period when Far Eastern influence was at its strongest, but it is still an odd contrast to the detail of the Japanese painting facing it, one of the very few great examples outside Japan. The gentle whale would be no match for the ferocious Thunder God, in whose guise Michizane Sugawara

200

196. *Enameled and Gilded Glass Bottle*. Syrian, Mamluk period, about 1320 A.D. 17⅛" high

197. *Bronze Ewer*. Decorated in relief and inlaid with silver. Persian (Khurasan), Saljuk period, early thirteenth century. 15½″ high

the poet, Buddhist scholar, and statesman, deified as Tenjin, is bringing destruction to those who had intrigued against him in life. The Persians have no liking for horrors, and the supernatural in general is less common in their art than a depiction of the pleasant things all about them, flowers and blossoming trees and lovely people as beautifully dressed as they.

But this gentleness was not always an overriding characteristic of the Persians, as can be seen from the bronze incense burner illustrated below. Though the great beast is covered with elegant interlacings, the impression he gives is not one of subtlety but of force. He stands as if nothing could shake him. He is the idea, *cat*, reduced to its essentials, not purr and fur, but power, spirit, and *élan*. When the fragrant blue smoke poured from his glistening body, how greatly he must have contributed to the princely pleasure of his owner, a true symbol of the glory of the Emir, whose title was "Sword of the world and of religion"!

198. *Incense Burner in the Shape of a Feline*. Bronze, with openwork decoration. Made by Ja'far. Dated 577 A.H. (1181–1182 A.D.). Persian (Khurasan), Saljuk period. 33½" high

199. *Carved Panel from a Wooden Door*. Egypto-Arabic, Fatimid period, eleventh century. 13¾″ high

200. *Kuan Yin* · Polychromed wood · Chinese, late T'ang Dynasty,
618-906 A.D. · 43″ high

201. *Bronze Ceremonial Vessel [kuang]* · Chinese, Shang Dynasty,
1558-1050 B.C. · 12″ high

202. *Covered Jar* · Famille noire porcelain · Chinese, early K'ang Hsi period,
1662-1722 A.D. · 25″ high

203. *The Tribute Horse* · Painting on silk · Chinese, Sung Dynasty, 960-1280 A.D. · 32⅝" high

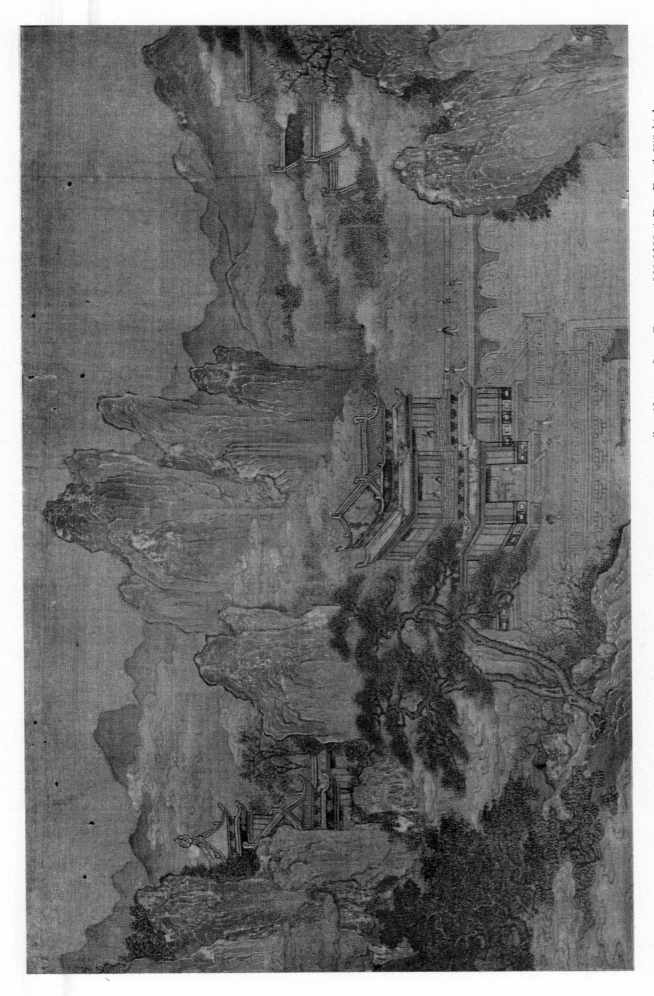

204. *Spring Morning at the Palaces of Han* · Detail from a handscroll painting on silk · Chinese, Sung Dynasty, 960-1280 A.D. · Detail 6⅜″ high

205. *Thunder God* · Handscroll painting, paper · Japanese, Kamakura period, 1186-1334 A.D. · 11¾″ high

206. *Jonah and the Whale* · Persian, Mongol period, Tabriz school, end of the fourteenth century · Tempera on paper, 12⅞" high

207. *The Birth of Zal* · Persian, Safavid period, late sixteenth century · Tempera on paper, 18½″ high

208. *Krishna Holding Mount Govardhan* · Indian, Mughal, 1556-1605 · Tempera on paper, 11½″ high

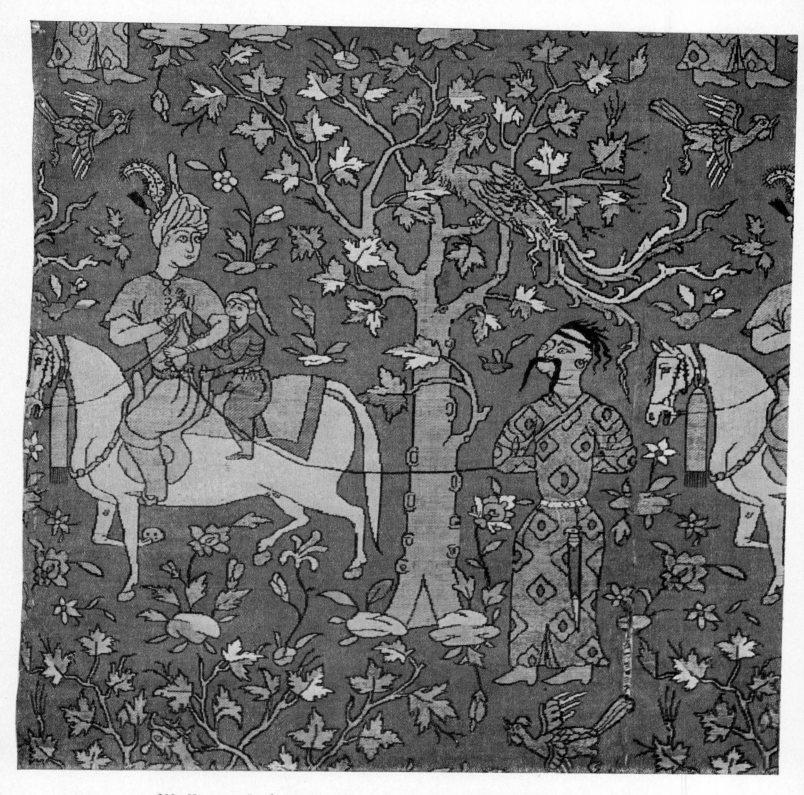

209. *Horseman Leading a Mongolian Captive* · Detail from a silk brocade · Persian,
Safavid period, second half of the sixteenth century · Detail 16½″ wide

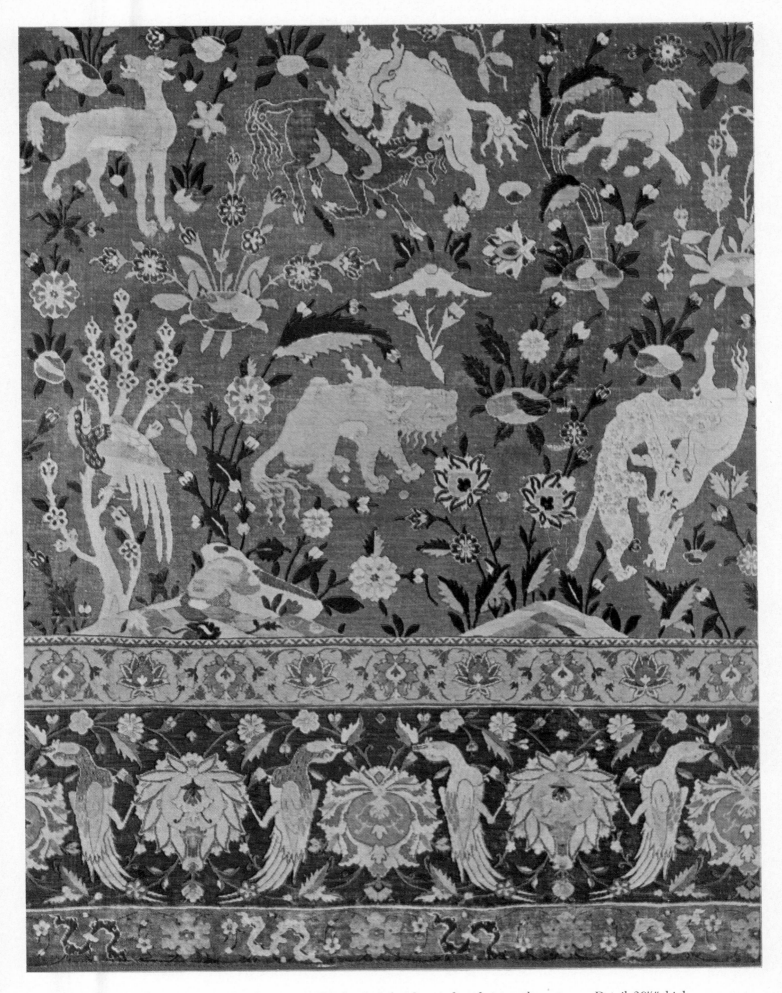

210. *Silk Animal Rug, detail* · Persian [Kashan], Safavid period mid-sixteenth century · Detail 36½″ high

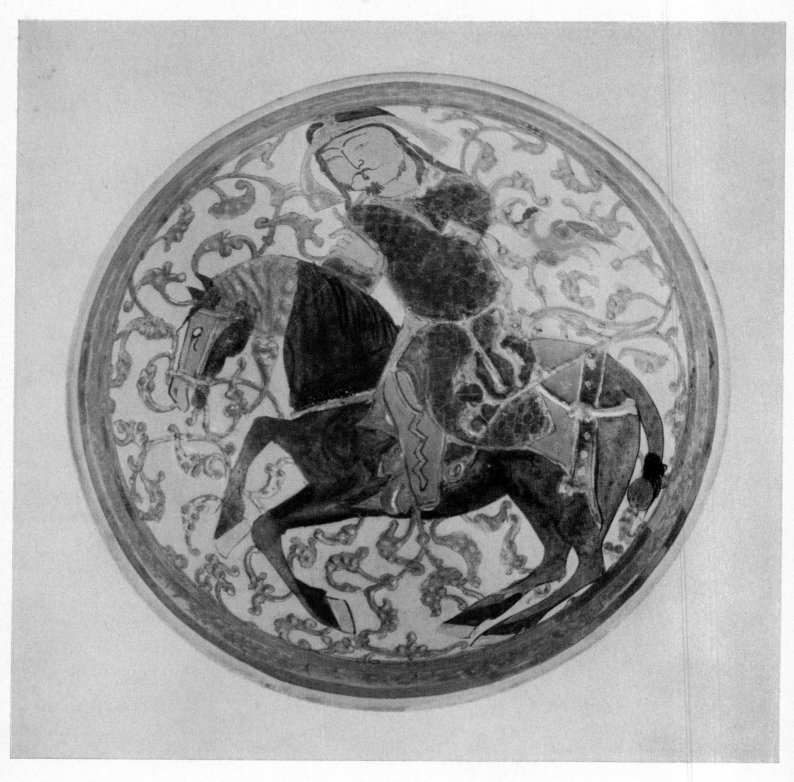

211. *Bowl with a Painting of a Saljuk Prince* · Pottery with overglaze painting
partly in relief · Persian [Kashan], thirteenth century · Diameter 8⁹⁄₁₆″

NOTES ON THE PAINTINGS
AND OBJECTS OF ART

The notes on the works of art illustrated have been prepared in the several curatorial departments. Those on the paintings were written principally by Clarissa Platt of the Catalogue Department. Each note includes the accession number (the first two digits indicating the year of acquisition) and the name of the donor or the purchase fund of the object described.

Frontispiece. El Greco (Domenicos Theotocopoulos). Spanish, 1541–1614. *View of Toledo.* Oil on canvas, 47¾ x 42¾″. Signed in Greek: "Domenicos Theotocopoulos made it"

El Greco painted the city of Toledo as it might be seen from across the Tagus river with its Moorish bridge, the Alcántara. To the left stands the San Servando castle, and against the dark skyline rise the Alcazar and the Cathedral. This canvas is the only surviving true landscape by El Greco. Although he describes a particular place, the artist's main concern is not with careful, realistic reporting. Actually, Toledo is a city of dead grey stone built on bare granite hills, dry and sun-drenched with but a few olive trees to relieve the monotony. El Greco has re-created a city full of foreboding, set against a sky with explosive clouds and blinding light. As in his portraits and religious scenes he has distorted reality to conform to the dramatic intensity of his own vision (see figure 123). [29.100.6 The H. O. Havemeyer Collection, Bequest of Mrs. H. O. Havemeyer]

2 *Jar.* Painted pottery. Egyptian, Predynastic Period, about 3400 B.C. 12″ high

Jars of various sizes and shapes, filled with provisions for the next world, were buried with the prehistoric Egyptians. Those with decorations represent the earliest attempts at painting and, although the designs are magical in intention, they satisfy our modern eye because of the Egyptian craftsman's natural feeling for design. This jar of buff pottery is decorated in red with wavy lines representing water, triangular desert hills, and the antelope and ostrich of the desert—presumably to insure good hunting in the hereafter. [20.2.10 Rogers Fund]

3 *Bull's Head.* Copper, with lapis lazuli eyes. Sumerian, III millennium B.C. 5¼″ high

Bulls and the heads of bulls have always figured very prominently in the art of the Near East. By Sumerian times they were being used in all sorts of ways. They appear as friezes of metal in low relief sometimes with the heads, in the round, made separately. Even musical instruments were adorned by bulls' heads, sometimes of gold, and it is possible that this head was once used for this purpose. The fact that the beard is held in position by a string above the animal's muzzle indicates that it is a false one. [47.100.81 Rogers Fund]

4 *Judgment Scene.* In the papyrus of Princess Entiu-ny. Egyptian, XXI Dynasty, 1085–950 B.C. From Thebes. 14¼″ high

This vignette showing the judgment of Osiris is from the copy of the *Book of the Dead*—the collection of spells to enable the soul to pass the last judgment, enjoy the benefits of the next world, and enter and leave the tomb at will—belonging to Princess Entiu-ny. Osiris sits enthroned at the right watching the heart of the princess being weighed against the symbol for Truth by Anubis. Entiu-ny herself, accompanied by the goddess Isis, stands at the left. Anubis announces, "Her heart is righteous." [30.3.31 Excavations of The Metropolitan Museum of Art, Rogers Fund]

5 *King Se'n-Wosret I.* Wood. Egyptian, XII Dynasty, 1991–1778 B.C. From el Lisht. Statuette 23″ high

This likeness of the second king of the XII Dynasty, wearing the Red Crown of Lower Egypt and carrying a scepter, was found in the tomb of a noble near the king's own pyramid. It is of fine cedar wood, the crown and skirt covered with stucco and painted. The nude parts were once also painted a reddish flesh color. The figure is one of a pair, a second (in Cairo) representing Se'n-Wosret with the White Crown of Upper Egypt. [14.3.17 Excavations of The Metropolitan Museum of Art, Contribution of Edward S. Harkness]

6 *Male Votive Figure.* White gypsum. Sumerian, about 2600 B.C. From Shrine II of the Square Temple at Tell Asmar in Mesopotamia. 11¾″ high

The eyes were inlaid with black stone and set with bitumen. The eyebrows were probably made of lapis lazuli. Originally the hair and the beard were colored black, of which some traces still remain. Small figures such as this were placed within the shrine of a god or goddess and were sometimes inscribed with the name of the person whom they were meant to represent. The statuette was one of many discovered in the excavations undertaken by the Oriental Institute of Chicago University. [40.156 Fletcher Fund]

7 *The God Amun.* Diorite. Egyptian, late XVIII Dynasty, about 1350 B.C. 16″ high

This head is from an over life-sized statue of the great god of the New Kingdom. It was made during the reign of Tut-ankh-Amun, and so—although idealized and impersonal—is a likeness of that king. The two feathers which characterize Amun once arose from the crown, and the beard associated with divinity was attached to the chin. The hard, grey stone from which the statue is carved was extensively used for sculpture during the New Kingdom. [07.228.34 Rogers Fund]

8 *Head of an Athlete.* Marble. Detail from a Roman copy of a Greek statue by Polykleitos, about 430 B.C. Head about 10″ high

The athlete is in the act of binding a fillet on his head in token of victory in the games, holding an end of the long fillet in each hand. Pliny describes him, from this action, with the Greek word *diadoumenos*, by which the statue is usually called. It is a sensitive copy, one of several marble replicas made in Roman times, of a famous bronze statue by the Greek sculptor Polykleitos. [25.78.56 Fletcher Fund]

9 *Lady.* Portrait bust in marble. Roman, early third century A.D. Life size

In the times to which this bust belongs a new sensitiveness becomes apparent in Roman portraiture. The brutal energy of a Caracalla, or the quiet grace of an unknown lady such as this, are alike discerned and made vivid by the portrait sculptors of the day. The bust is said to have been found in the Greek islands. [30.11.11 Fletcher Fund]

10 *Head of a Youth.* From a marble statue. Greek (Attic), about 600 B.C. Detail, 12″ high

This is from one of the earliest and best preserved of the archaic Attic male statues standing in frontal pose. The type is called *kouros,* the Greek word for a youth. Such statues represented a god, Apollo for example, or a victor in the games, and served also as grave monuments. The sculptor drew upon the artistic conventions of Egypt and the East, and created a Greek type which was continuously modified by succeeding generations. [32.11.1 Fletcher Fund]

11 *The Chief Royal Scribe, Yuny, Offering an Enshrined Statue.* Limestone. Egyptian, XIX Dynasty, about 1300 B.C. From Asyut. 51" high

Yuny was the son of a judge and chief physician, and his wife's father was a superintendent of the Necropolis. He himself was the administrator for the king of the local priesthood in Asyut, where the statue was found. Yuny is shown kneeling as he offers a shrine which contains a figure of the god to Osiris. His elaborate costume is typical of that worn by the nobles of the time. [33.2.1 Rogers Fund]

12 *Mourning Woman.* From a marble gravestone found at Acharnae. Greek (Attic), about 400 B.C. 48⅛" high, as preserved

The woman is seated in an attitude of mourning, and the composition originally included one or more members of her family, united in a farewell scene. That they were persons of consequence is suggested by the scale and grandeur of the sculpture. The fragment was found before 1827, and went to England on the same wave of antiquarian activity that brought the Parthenon sculptures there. It was until recently at Lowther Castle. [48.11.4 Dick Fund]

13 *Horseman.* Marble relief. Greek, last quarter of the fourth century B.C. 18" high

The rider was perhaps paired with another, now lost, and if so the twin horsemen were the *Dioskouroi*. The youth rides in finished and effortless style, in rapport with his mount. The workmanship of the relief suggests that it may be a Greek original of the fourth century B.C., rather than one of the Roman versions of this subject. It is said to have been found on the island of Rhodes. [07.286.111 Rogers Fund]

14 *Bull's Head.* Bituminous limestone. Persian, Achaemenian period, about fifth century B.C. From near Persepolis. 18½" high

This bull's head once formed part of the capital or impost block of a column. The capital, when complete, consisted of the head and forequarters of two bulls, the beam of a wooden roof being supported between them. It was found in Istakhr, a Sasanian and early Islamic town near the Achaemenian site of Persepolis, a city that was sacked by Alexander the Great. The capital was re-used in Mohammedan times. In these heads all the details—the hair, the eyebrows, and the veins—are reproduced as a pattern without much regard to the appearance of a live bull. [47.100.85 Rogers Fund]

15 *Centaur Fighting.* Bronze statuette. Greek, late sixth century B.C. 4½" high

This figure is a decoration from a large cauldron, for the plinth is curved to fit a circular rim. It was perhaps one of a series of centaurs in combat with their enemies, the Lapiths,

and the weapon, partly preserved, was probably a bough. To the implausible union of man and horse in one figure, and that in violent action, the archaic artist has lent both humor and grandeur. [17.190.2070 Gift of J. Pierpont Morgan]

16 *Antelope.* Silver. Persian, Achaemenian period, about fifth century B.C. 4" long

The animal has been made so that it balances exactly when suspended by the loop in its back. What its function was is not known. This gazelle has been modeled with great sensitivity and in a very naturalistic way. The spirit is thus entirely different from most of the Luristan bronzes and from much of the sculpture at Persepolis whence it may originally have come. Comparison with the stone bull's head (figure 14) shows how great the difference can be at one particular period. [47.100.89 Rogers Fund]

17 *Horse.* Bronze statuette, perhaps from a chariot group. Greek, about 480–470 B.C. 15¾" high

The bronze horse is one of the finest surviving products of the period when Myron and his contemporaries had interested themselves in animal sculpture. The structure and gait of the horse are shrewdly observed by the sculptor, and are expressed within a decorative scheme which is nevertheless not static but moving. The statuette is cast solid, and is perhaps from a chariot group set up in commemoration of a victory in the races. [23.69 Fletcher Fund]

18 *Head of a Man.* Bronze. Iranian, II millennium B.C. From Azerbaijan, northwest Persia. 13½" high

This head was reputedly found at Tikhon Teppeh to the south of Lake Rezaieh (Urmia) in northwest Persia. This is in the land of the biblical Minni, who were sometimes the allies and sometimes the foes of the Assyrians. The head is cast solid and, unlike a fine bronze head of the Akkadian period (2330–2180 B.C.) discovered at Nineveh in 1931, is nearer copper than bronze, for the metal is practically unalloyed. It is now deeply corroded with layers of malachite. Beneath the head is a square projection by means of which it was securely fastened to the body. The body also may have been of metal. A superb but headless figure of an Elamite queen made about 1500 B.C. and discovered at Susa is concrete evidence that large metal statues could be fashioned at that time. She is now in the Louvre and weighs about one and three-quarter tons. The eyesockets of the man's head were once filled, probably with white and black, or with white and blue stone. The hair of the head is completely contained by a very tightly wound narrow band and so is unlike the turbans shown in Assyrian sculptures. The date of the manufacture of this magnificent head is still somewhat uncertain, some archaeologists believing it to be as early as the invasion of Mesopotamia by the Guti from Iran (about 2500 B.C.). Others have placed it much later in the Achaemenid era (sixth-

fourth century B.C.). It is doubtful that it actually was made before the middle of the second millennium B.C. The style is archaistic rather than archaic and, despite its conventions, the modeling is extremely sensitive. [47.100.80 Rogers Fund]

19 *Girdle, Bracelet, and Armlets of the Princess* Sit Hat-Hor Yunet. Gold, carnelian, green feldspar, turquoise, and paste. Egyptian, late XII Dynasty, about 1890–1840 B.C. From el Lahun. Girdle, bracelet, and armlets 33", 5", and 5¾" in circumference, respectively

Never have excellence of workmanship and purity of design been more highly regarded than by the pharaohs of the XII Dynasty, and the jewelry of Sit Hat-Hor Yunet, a daughter of Se'n-Wosret II, is as fine as any surviving from antiquity. This jewelry, together with the toilet articles of the princess, her ivory-and-ebony jewel and toilet caskets, and some of her funeral equipment, was discovered in her tomb by Sir Flinders Petrie, having been overlooked by ancient plunderers, and is now divided between the Metropolitan and the Cairo Museums.

Among the share falling to the Metropolitan Museum are these pieces of jewelry. The girdle is of gold cowrie shells separated by acacia pods of semi-precious stones. The shells are hollow and contain silver pellets which tinkled as the wearer moved. The clasp is formed by one of the shells, which is divided laterally, a tongue in the upper half sliding into a corresponding groove in the lower. The bracelet—one of a pair—is inlaid with the cartouche of the princess' nephew, Amun-em-het III, in whose reign she died. The lions on the armlets represent Shu, the god of the atmosphere, and his wife Tefenet, goddess of the dew. [Girdle, 16.1.5; bracelet, 16.1.8; armlets, 16.1.12, 15 Rogers Fund and Contribution of Henry Walters]

20 *Ostrakon with a Sketch of Two Bulls Fighting.* Limestone. Egyptian, New Kingdom, 1567–1085 B.C. From Thebes. 7¼" long

Because of the lack of other cheap writing materials, flakes of limestone, which could be picked up around any building, were used by Egyptian artists for quick sketches much as we use scratch paper. Students and the less skillful draftsmen practiced on such "ostraka"; and often an outstanding artist, tired of the conventional subjects which he was required to produce professionally, would pick up a handy flake and dash off some chance idea or jest.

This ostrakon originally bore the outline of a very similar sketch, in which one of the bulls was restrained by a herdsman—a student's effort or perhaps the master's own first attempt. At any rate, we can almost hear him say, "This is how it ought to be done," as he adjusted and filled in the drawing with firm, sure strokes of the brush. The thrust of the hind legs, the flying tails, and the rolling eye of the victor are lifelike touches not found in more conventional painting, while the manner in which the folds and markings of the hides have been schematized possibly reflects

Egypt's ever-increasing contact with the rest of the Mediterranean world. [24.2.27 Rogers Fund]

21 *Gazelle.* Ivory. Egyptian, late XVIII Dynasty, 1375–1350 B.C. 4½" high

The gazelle was admired for its gentle grace, and was often kept as a household pet. Most frequently, however, it was portrayed in scenes of hunting in the desert, or included among the livestock on large estates.

This little gazelle is of tinted ivory with eyes of garnet. Its missing horns were inset in some other material. It stands on a hillock in which desert plants are inlaid in colored paste. Here we seem to have an example, extremely rare in ancient Egypt, of an *objet d'art*—a product of a royal atelier made simply to delight the eye and serving no other purpose. [26.7.1292 Carnarvon Collection, Gift of Edward S. Harkness]

22 *Whip Handle in the Form of a Prancing Horse.* Ivory. Egyptian, late XVIII Dynasty, 1375–1350 B.C. 5⅞" long

The ivory horse, unlike the gazelle, was made for a practical purpose. Sculpture for its own sake was rare, but artists delighted to decorate articles of everyday use. Handles, in particular, were often elaborately designed, perhaps with human or animal figures or with floral devices. A number are known in the form of a horse, a practical shape, as the arched neck and curving back allowed a secure grip. They may once have been attached to whips, or perhaps to fly-whisks made of horsehair. The horse was introduced into Egypt from the Near East just before the beginning of the XVIII Dynasty and was apparently venerated.

This horse is extended in the position known as the "flying gallop," the origin of which has been much discussed. Although it is often stated that the attitude was a convention originating in Crete and that its presence in Egypt is due to Minoan influence, it seems more likely that the Egyptian examples, not uncommon during the XVIII Dynasty, developed naturally from a native manner of representing running animals which goes back to the Old Kingdom. [26.7.1293 Carnarvon Collection, Gift of Edward S. Harkness]

23 *Lotiform Cup.* Faience. Egyptian, XIX–XX Dynasty, 1320–1085 B.C. 5¾" high

The shape of this goblet was inspired by the long, slender blossom of the blue water lily (the lotus *nymphaea caerulea*). The entire goblet is covered with decoration in low relief. The base and stem represent an inverted bunch of lotus flowers, and the lower part of the cup a single open blossom of the white lotus. Above are scenes, divided into three bands, which recall the busy life of the marshes where the flowers grew. First is shown the water, full of fishes, then the surface, with papyrus skiffs moving among the reeds; the skiffs are full of wild animals and birds which have been caught along the edge of the swamp in which they lived. More or less solid ground is represented in the uppermost band, in which the birds and animals are shown with their captors, waiting to be collected by the boatmen.

A number of fragments of these elegant, fragile goblets are known, but it is rare to find a complete example or one in which the original color was so beautiful and is so perfectly preserved. [26.7.971 Carnarvon Collection, Gift of Edward S. Harkness]

24 *Fishing and Fowling Skiff.* Tomb model, painted wood. Egyptian, XI Dynasty, about 2000 B.C. From Thebes. 45" long

This is a funerary model from the tomb of Meket-Re, Chancellor and Steward of the Royal Palace at the beginning of the Middle Kingdom. His models, of a kind popular when the tomb was made, are more elaborate and numerous than any others known. They illustrate the everyday life of a rich man surrounded by servants, and were expected to insure that the wants of his soul should be ministered to eternally.

About half the models represent boats of various sorts, as Meket-Re's position necessitated frequent journeys up and down the Nile, the highway of Egypt. Sport on these journeys was not overlooked. The narrow, light-draft skiff shown here was used for hunting birds and spearing fish in the backwaters of the river. The cabin, of heavy fabric lashed to a light framework, offers a shelter from the blazing sun. Two shields of hide are hung from it in case of a surprise attack. The poles and stakes lashed to the sides are for bird nets, and a boy and girl are bringing live ducks which they have caught to the master and his son, who sit on deck. In the bow are harpooners, and an enormous fish struck by one is being landed over the gunwale. The captain stands amidships over the six paddlers. The skiff is steered by the large oar in the stern. [20.3.6 Excavations of The Metropolitan Museum of Art, Rogers Fund supplemented by a contribution from Edward S. Harkness]

25 *Horse and Rider.* Painted wood. Egyptian, XVIII Dynasty, about 1550 B.C. 12" high

We usually connect Egyptian sculpture with the formal figures which were intended to represent the wealthy in the next world. But sculptors enjoyed experimenting with an unconventional pose, as was permissible only when the subject was some unimportant person who could have no hope of impressing the gods with the dignity he had possessed on earth. Egyptian artists were also happy in depicting animals, when they were less bound by convention than when representing a human being. This rider and his mount were carved when horses were still a novelty in Egypt, and this is one of the earliest attempts at portrayal. Soon it became customary to show kings and sometimes high officials in their chariots, but horseback riding was never fashionable nor was a successful cavalry developed owing to the absence of horseshoes and stirrups. The rider is therefore probably a groom.

The sculptor has caught the spirit of the animal but has exaggerated the length of the body in proportion to the neck, as Egyptian horses were of the Arab breed. The white lines are a schematized rendering of piebald markings.

Egypt eventually became famous for its horses, which formed a valuable export trade. King Solomon "had horses brought out of Egypt . . . for an hundred and fifty shekels of silver, and so for all the kings of the Hittites and for the kings of Syria." [15.2.3 Rogers Fund]

26 *Portrait Panel.* Encaustic on wood. Egypto-Roman, second century A.D. From el Fayyum. 15" high

As Egypt became more and more a part of the Mediterranean world foreign fashions were grafted onto the ancient native customs. The ritual of funeral ceremonies lingered on even in Roman times, and the body was still laid away, embalmed and bandaged; but instead of the face being covered by an impersonal mask there was some attempt to bury a real likeness of the deceased with him. Sometimes this was modeled in plaster. Sometimes it was painted on a wooden board let into the bandages over the face. These portrait panels were executed in encaustic, the colors being applied in a heated wax medium. Most of the panels have been found in the oasis of the Fayyum, which was largely settled by Greeks. The work of Greek artists, the style is Hellenistic rather than Egyptian. Adoption of such panels in Egypt for funeral purposes has resulted in the survival of these remarkable examples of classical painting.

The subject of this portrait, although buried according to the Egyptian tradition, cannot have been of pure Egyptian blood, to judge by his curly hair. Moreover, neither the beard nor the moustache was worn by Egyptians, and the garment seems to be Greek. [09.181.1 Rogers Fund]

27 *Tragic Mask.* Faience. Egypto-Roman, first century A.D. From Medinet el Fayyum. 7½" high

This mask, like the portrait panel, was found in the Fayyum and is the product of the Hellenistic culture of that province. Although Egyptian actors who represented animal-headed divinities in religious dramas had always worn suitable masks, the existence of a popular theater in Egypt is disputed, and the idea of the comic and the tragic mask was purely Greek. This mask is made of a characteristic material of ancient Egypt, faience, but the brilliant, translucent glaze with which it is covered could not have been produced before the kilns of the Roman period with their high temperatures. The mask may have been a votive offering or perhaps a wall decoration, as it is pierced for suspension. [26.7.1020 Carnarvon Collection, Gift of Edward S. Harkness]

28 *Colossal Vase of Terracotta,* showing the lying-in-state of the dead and the funeral procession. Greek, eighth century B.C. Attic Geometric style. 42⅝" high

Colossal vases of this kind were set up as grave monuments, and are sometimes called Dipylon vases, after a cemetery of that name outside the gates of Athens. The entire girth

219

of the vase is covered with decoration. The dead man is seen lying in state, surrounded by mourners tearing their hair, and by the warriors and chariots that took part in the funeral rites. The scenes, though simplified into geometric patterns, have a lifelike quality and narrative power which foreshadow the great vase-painting of the Attic black-figured style. The vase is left open at the bottom, so that libations poured into it for the dead could flow into the ground. It was thrown on the potter's wheel in sections, put together, and fired in one piece, a process that would tax the skill and equipment of a modern potter. [17.130.14 Rogers Fund]

29 Terracotta Amphora, signed by Taleides as potter, showing Theseus attacking the Minotaur. Greek, about 550–525 B.C. Attic black-figured style. 11⅝″ high

The potter Taleides signed this amphora, which was presumably decorated by another artist who did not add his signature. In contrast to the preceding vase, the scenes are here confined to two panels, one on each side. These are left in the reddish color of the clay, on which the figures are painted in black with incised lines and areas of opaque white. Potter and painter alike have observed a stringent economy of line. Theseus, the Attic hero, is in combat with the Minotaur, the monstrous offspring of the queen of Crete, confined by King Minos in the Labyrinth. Minos forced the Athenians to send him periodically a tribute of youths and maidens to be sacrificed to the monster. Theseus joined the victims, killed the monster, and found his way out of the Labyrinth with a clue provided by the king's daughter. Two youths and two maidens, out of the seven pairs of intended victims, are represented by the artist, although the whole company may be thought of as present and witnessing the struggle. This is a famous vase, found a century and a half ago at Agrigento in Sicily, the first Greek vase with a potter's signature to become known in modern times. [47.11.5 Pulitzer Bequest Fund]

30 Women Folding Their Clothes. Tondo from the interior of a kylix, or wine cup, attributed to the painter Douris. Greek, about 470 B.C. Attic red-figured style. Diameter of tondo 8″

This is the tondo from the interior of a shallow, stemmed cup, or kylix, of the Attic red-figured style. The technique reverses that of the preceding vase, the ground being covered with black and the figures reserved in the reddish color of the clay, allowing the artist to use his brush for the lines within the figures, rather than having to incise them. The cup is attributed to Douris, one of the great vase painters of the fifth century B.C., who was active for a long time and whose work is known from a large number of signed pieces. It is one of his masterpieces. The figures of the two women folding their clothes, one of them standing upright and the other inclined from the waist, are skillfully placed to fill the circle. They are graceful and drawn in careful detail, yet they have a monumental quality. [23.160.54 Rogers Fund]

31 Nike and a Victor. Terracotta bobbin, attributed to the Penthesilea Painter. Greek, about 460–450 B.C. Attic polychrome style. Diameter 5″

In another circular picture with two figures the artist has used a triangular composition. Nike (Victory) is offering a woolen fillet to a winner in the games, who holds a twig as another sign of his victory. The artist is known as the Penthesilea Painter, and this is one of a large number of vases attributed to him. The disk is one of two fastened back to back by a short cylinder, forming a utensil like a bobbin or reel. The technique of covering the reddish Attic clay with a white engobe, and painting on that, flourished alongside the black-figured and red-figured styles. It has enabled the artist to show the texture and richness of the drapery and its contrast with the skin. A small masterpiece like this affords some idea of the contemporary major art of painting, which is almost entirely lost. [28.167 Fletcher Fund]

32 Architectural Composition. Detail from a wall painting from the cubiculum of a villa at Boscoreale. Roman, first century A.D. Portion illustrated about 6′ high

This is part of the wall of a cubiculum, or bedroom, of a villa at Boscoreale, on the south slope of Vesuvius, between Naples and the summit of the volcano. The villa was the dwelling of a rich family, with its retainers, and included the farmhouse within its walls. It was a fairly old house at the time of the disaster in 79 A.D., when Pompeii and the region around it were overwhelmed by the eruption. Although the upper part of the structure was destroyed, the ground floor silted up with ash and pumice, which preserved some of the painted walls almost intact. The villa was excavated in 1900; some of the walls remained in Naples, the rest came to New York in 1903. This cubiculum, about 10′ 9½″ by 19′ in size, is painted with architectural views seen in depth. The panels of one side of the room are repeated on the opposite side in mirror reverse. [03.14.13 Rogers Fund]

33 Woman Playing the Kithara, with Her Servant. Wall painting from the triclinium of a villa at Boscoreale. Roman, first century A.D. Portion illustrated about 5′ high

The walls of the banquet room, the largest of the several dining rooms of the villa at Boscoreale, were painted with figures in what is called the megalographic, in contrast to the miniature, Pompeian style. A woman is here seen playing the kithara, seated on a richly decorated armchair, while a young attendant stands at gaze, listening to the music. The faces are individualized and the two personalities presented with a richness and vigor that seem to foreshadow the Renaissance. Greek painting, a major art like Greek sculpture, has been almost entirely lost, but through late Hellenistic works such as this, accidentally preserved through the eruption of the volcano, some of the splendor of the lost paintings can be guessed. [03.14.5 Rogers Fund]

34 Mars or a Warrior. Terracotta statue. Etruscan, about 500 B.C. 8′ high

A warrior or war god is seen striding forward to attack an enemy. He is bearded, longhaired, and dressed in full armor, with crested helmet, cuirass over a tunic, and greaves. The center strap of the missing shield is preserved on the left arm; the right hand held a weapon. Though the costume and style of this statue recall the warriors on Greek black-figured vases, there is an underlying ferocity in the conception that belongs rather to Etruscan art. No molds were used in making this colossal statue, which was built up freehand with rolls of clay, without an armature, and fired in one piece, the vent being a small opening at the top of the helmet. Such a task would hardly be attempted in a modern pottery. The colors, which also recall black-figure vase-painting, were applied before firing and are therefore well preserved. [21.195 Kennedy Fund]

35 David Slaying the Lion. Silver plate. Byzantine, early seventh century. Found in Cyprus. Diameter 5½″

This plate belongs to a set in the Metropolitan Museum representing the story of David and Goliath. It formed part of a treasure uncovered in 1902 at Karavàs, Cyprus. Silver marks of the Emperor Heraclius (613–630 A.D.) indicate Constantinople as a likely place of origin.

The scene depicted illustrates David's rescue of a lamb from the attack of a lion. "And David said unto Saul, Thy servant kept his father's sheep, and there came a lion . . . and took a lamb out of the flock: And I went out after him, and smote him, and delivered it out of his mouth" (I Samuel XVII: 34, 35). [17.190.394 Gift of J. Pierpont Morgan]

36 Otto I Presenting a Church to Christ. Ivory plaque. German or Italian, second half of the tenth century. 5⅛″ high

The plaque is probably one of a series which decorated the antependium of an altar in Magdeburg Cathedral. The church in the hands of the German emperor here portrayed, probably Otto I (962–973), presumably represents the cathedral. The plaque came from Seittenstetten, Austria; other plaques in the series are now in European museums. [41.100.157 Gift of George Blumenthal]

37 The Virgin and Child. Painted oak. French (Auvergne), second half of the twelfth century. 31″ high

This sculpture of the Virgin and Child represents a type of cult statue that was made in the Auvergne in the Romanesque period. Its prototypes were statues at medieval pilgrimage centers of the region, notably the statue of Notre-Dame du Puy (destroyed during the Revolution but recorded in woodcuts and engravings) and the tenth-century image in the Cathedral of Clermont. Such figures, showing the Virgin enthroned and holding the Child, are often referred to as "Majesties." [16.32.194 Gift of J. Pierpont Morgan]

38, 39 *The Virgin and Christ.* Cloisonné enamel on gold. Byzantine, eleventh century. From Djumati, Georgia. Diameter, 3¼″

These two roundels are part of a set which once decorated a silver-gilt icon of the Archangel Gabriel (now destroyed) in the monastery of Djumati, Georgia, in the Caucasus. The set, now in the Metropolitan Museum, was probably exported to Georgia from Constantinople, where it appears to have been made. [17.190.678, 675 Gift of J. Pierpont Morgan]

40 *Limestone Pilaster.* From the abbey of Saint-Guilhem-le-Désert. South French, before 1206. 5′ 3″ high, with modern base

This pilaster is one of a series of late Romanesque columns and capitals from the upper cloister of the abbey of Saint-Guilhem-le-Désert, near Montpellier in southern France. These magnificent architectural elements have been set up at The Cloisters in a reconstruction based on the cloisters of Saint-Trophime at Arles and of Montmajour. The date is suggested by an entry of 1206 in the cartulary of the monastery referring to the "new cloister." [25.120.97, 119, 120 The Cloisters Collection. Purchase]

41 *The Chalice of Antioch.* Silver, parcel-gilt. Early Christian, fourth or possibly fifth century. 7½″ high

The Antioch chalice, the earliest existing Christian chalice, was discovered along with other liturgical objects in 1910 by workmen digging a well in a village near Antioch, one of the most important early centers of Christendom in the East. This celebrated vessel was made for use in the sacrament of the Lord's Supper. Its simple undecorated cup of silver is set in an openwork cup, also of silver, enriched with gilding. In the openwork decoration the figure of Christ, young and beardless, appears twice on opposite sides of the cup. With him are ten of the Apostles. [50.4 The Cloisters Collection]

42 *The Virgin of the Annunciation.* Painted limestone. French, first half of the fourteenth century. 16¾″ high

This limestone statue must have been part of a group in which the Archangel Gabriel announces to the Virgin the coming birth of Christ. *The Golden Legend* says that "our blessed Lady was much abashed—and afeared of the salutation of the angel." It is this moment of maidenly hesitation which the sculptor has shown, recalling the painting by Simone Martini (1339) in the Uffizi Gallery, Florence. [17.190.739 Gift of J. Pierpont Morgan]

43 *Two Holy Women.* Painted walnut. Flemish, second half of the fifteenth century. Each figure 19¼″ high

These two painted walnut statuettes come from a group representing the Entombment of Christ. The left-hand figure, clasping her hands in grief, may represent Mary Magdalene; the right-hand figure, originally holding an ointment jar, one of the other holy women. Since the backs of the figures were not meant to be seen, they are unpainted. Probably the group was originally placed in a niche, perhaps a niche in a retable behind an altar. The headdress of the figure on the right has been restored. [41.100.128,129 Gifts of George Blumenthal]

44 *Bronze Aquamanile,* in the form of a dragon swallowing a man. German, twelfth or thirteenth century. 8½″ high

Ewers fantastically wrought in the form of animals, buildings, or men and called aquamaniles were often used in the Middle Ages for the ceremonial washing of hands by the priest during the ritual of the Mass. They were probably also used by the laity at feasts. A twelfth-century manuscript illumination in the library at Besançon shows Pilate washing his hands while a servant pours water from an aquamanile in the form of a dragon similar to this one. [47.101.51 The Cloisters Collection. Purchase]

45 *Marie de France.* Head from a marble tomb effigy by Jean de Liège. Franco-Flemish, about 1382. 12¼″ high

Marie de France was the daughter of Charles IV and Jeanne d'Evreux. She died in 1341 and was buried in the royal abbey of Saint-Denis. Many years after her death—about 1382—her sister Blanche de France ordered effigies for the double tomb which they shared. The marble head is all that remains of Marie's effigy, which was broken up during the French Revolution. [41.100.132 Gift of George Blumenthal]

46 *The Adoration of the Magi.* Wool and silk tapestry. Franco-Flemish, fifteenth or sixteenth century. 6′ 5½″ wide

The three Magi represent the nations of the world come to do homage to the Christ Child. Mary is dressed in rich robes to fit the occasion, but Joseph keeps his rustic garb, perhaps as a token of the humility and poverty of Christ's earthly home. [15.121.1 Bequest of Lillian Stokes Gillespie]

47, 48 *Square Reliquary Box.* Champlevé enamel on copper-gilt. French (Limoges), thirteenth century. 14¼″ high

The front of the box is distinguished from the three other sides by having the two figures of Christ and the heads of the other figures cast in relief. The richly ornamented disks are part of the enamel background but recall settings for precious jewels. On the door in the back of the box is an engraved figure of Saint Peter. [41.100.184 Gift of George Blumenthal]

49 *Saint James the Less.* Painted wood. German (Rhenish), 1265–1280. 6′ 5″ high

This monumental wood statue combines the nervous refinement of French Gothic with the robust vigor of German work. The rather large head bent slightly forward would indicate that the statue was meant to be seen considerably above eye level. The figure may well have stood against a pier of a church, perhaps as one in a series of the twelve Apostles. [28.32 Fletcher Fund]

50, 51 *Reliquary Box,* top and side view. Cloisonné enamel on silver-gilt. Byzantine, eighth to ninth century. 4″ long

The enamels on this box are among the rarest and the earliest in the Museum. According to tradition the box belonged to Pope Innocent IV (1243–1254), a member of whose family brought it back to Italy from the Crusades. It was made to hold a piece of the True Cross which was later given to the church at Lavagna. [17.190.715 Gift of J. Pierpont Morgan]

52 *Crucifix.* Champlevé enamel on copper-gilt. French (Limoges), early thirteenth century. 22½″ high

The practice, here followed, of showing figures in enamel against a gilded metal background was reversed in the ateliers of Limoges about the middle of the thirteenth century, when the figures were left in metal and the background was enameled. The contrasts between the different colors of the enamel and the gilding must have been brilliant even in the dim candlelight of a medieval church. [17.190.409 Gift of J. Pierpont Morgan]

53 *The Virgin and Child.* Painted limestone. French (Burgundian), about 1450–1475. From Poligny (Jura). 53¾″ high

This monumental limestone figure from Poligny is closely associated in style with other sculptures at Poligny and Baume-les-Messieurs. Its heavy, dramatic drapery follows a style established by Claus Sluter when he worked for the dukes of Burgundy at Dijon and reflects the pomp and splendor of the Burgundian court. [33.23 Rogers Fund]

54 *Saint Barbara.* Painted and gilded linden wood. German (Swabian), second half of the fifteenth century. 14″ high

This reliquary bust, with one of Saint Catherine, its companion piece, came from the church of Saints Peter and Paul at Weissenburg, Alsace, and is attributed to the school of Nicolaus Gerhaert von Leyden. A related bust assigned to this master is in the Art Institute of Chicago. The combination of feminine delicacy and strong modeling seen in these works is characteristic of late Gothic German sculpture. [17.190.1735 Gift of J. Pierpont Morgan]

55 *King Arthur.* Detail from a set of wool tapestries, *The Nine Heroes.* Workshop of Nicholas Bataille, Paris, fourteenth century. Detail 7′ 7½″ high

King Arthur is one of the Nine Heroes celebrated in medieval literature and art. This representation is one of five figures of Heroes remaining from a set of *Nine Heroes* tapestries woven for Jean, Duke of Berry, about 1385. The four other Heroes from the set have been identified as Joshua and David, Alexander the Great (or Hector), and Julius Caesar. Arthur is identified by his three golden crowns. The Duke of Berry's coat of arms appears on several banners in one of the hangings. This set of rare tapestries at The Cloisters is related in style to the Apocalypse tapestries in Angers, the only other set of French fourteenth-century tapestries in existence. [32.130.3 Munsey Fund. At The Cloisters]

56 *The Unicorn Tries to Escape.* Detail from one of a set of tapestries, *The Hunt of the Unicorn.* Wool and silk with metal threads. French or Flemish, about 1500. Detail 7′ 10″ high

The Hunt of the Unicorn, a set of six tapestries and fragments of a seventh, tells the symbolic story of the fabulous unicorn, a fierce, proud animal which, it was believed, could be caught only by a virgin. Five of these tapestries (one of which is chosen for illustration) were in all probability made for Anne of Brittany in celebration of her marriage to King Louis XII of France. Two others may have been added to the original set when Francis I married Anne's daughter in 1514. All seven were in the possession of the Rochefoucauld family for generations. The set is considered to be one of the finest ensembles of late medieval tapestries in existence. [37.80.3 The Cloisters Collection. Gift of John D. Rockefeller, Jr.]

57 *Old Testament King.* Panel from a stained glass window. German (Rhenish). About 1300. 26″ high

This panel represents one of the ancestors of Christ. It is part of a window illustrating the "Tree of Jesse." From the side of Jesse grows a stem in whose branches sit his descendants. This method of showing the genealogy of Christ is founded on the text in Isaiah XI:1: "And there shall come forth a rod out of the stem of Jesse and a branch shall grow out of his roots." [22.25 c Hewitt Fund]

58 Filippino Lippi. Italian, Florentine, about 1457–1504. *Two Male Figures: Study of a Saint Sebastian, and a Young Man Seated at a Desk.* Silverpoint and white wash on paper, 9¹¹⁄₁₆ x 8½″

These two silverpoint drawings of male figures, one of an aristocratic Florentine youth reading at his desk, the other an anatomical study, possibly for a future painting of Saint Sebastian, are the work of Filippo Lippi's son, an artist whose talents are often overlooked today, but who was very highly esteemed during his lifetime. The drawings from models have a freshness that is less apparent in Lippi's paintings, and show the close relationship of his style to that of Botticelli, his more famous teacher. [36.101.1 Dick Fund]

59 Michelangelo Buonarroti. Italian, Roman, 1475–1564. *Studies for the Libyan Sibyl.* Red chalk on paper, 11¾ x 8⅜″

This is one of the most beautiful of Michelangelo's studies in existence. The sketches are of particular interest in that they reveal this supreme artist's methods of work and emphasize his great knowledge of anatomy. In these powerful representations of the human figure Michelangelo's primary interest, as a sculptor, in the three-dimensional aspects of art is clearly indicated. They are studies for the figure of the Libyan Sibyl in the frescoes of the Sistine Chapel. Here he has used the clearer anatomy of a nude male model for the clothed female form he pictured in the fresco. [24.197.2 Joseph Pulitzer Fund]

60 Leonardo da Vinci. Italian, Florentine, 1452–1519. *Head of the Virgin.* Red and black chalk on grey paper, 8 x 6⅛″

Executed by the most versatile and inventive genius of the Italian Renaissance, this drawing displays a complete mastery of materials and technique. It is probably a fragment of a preliminary sketch for the painting of Saint Anne, the Virgin, and the Child that hangs in the Louvre. Leonardo not only modeled the face with great subtlety, bringing out its structural forms with clear and expressive understanding, but he has also sketched that mysterious smile of infinite tenderness and compassion found in other works of his, such as the *Mona Lisa.* [51.90 Dick Fund]

61 Jean Fouquet. French, about 1415/20–1481. *Portrait of an Ecclesiastic.* Silverpoint on paper, 7¹¹⁄₁₆ x 5⁵⁄₁₆″. Inscribed (upper right): Ung Roumain/ legat de nostre/St. Pere/en France

It has been suggested that this work is a portrait sketch of Teodoro Lelli, Bishop of the Italian city of Treviso, who in 1464 accompanied the Bishop of Ostia to France. The inscription in the upper right corner reads: "A Roman legate of our Holy Father in France." The exact details and delicate lines of the silverpoint technique bring out the calmness and quiet realism of Fouquet's art. He was one of the truly great artists of fifteenth-century France. [49.38 Rogers Fund and Exchange]

62 Jean-Antoine Watteau. French, 1684–1721. *Mezzetin.* Red and black crayon on white paper, 5⅞ x 5⅛″

No French artist so enchantingly conveys the spirit of the eighteenth century as Watteau, although he died, relatively young, early in that century. This appealing head is a study for the full-length painting of Mezzetin, a stock character of the Italian Comedy, playing his guitar (see figure 127). The sketch shows the same sure technique and basic vitality that are so apparent in the finished painting. [37.165.107 Rogers Fund]

63 Francisco José de Goya y Lucientes. Spanish, 1748–1828. *Portrait of the Artist.* India ink wash on paper, 6 x 3⅜″. Signed (on lapel): Goya

This self-portrait shows Goya in his fifties shortly after the serious illness which left him deaf. It is drawn with the same uncompromising honesty Goya brought to all his work. Here is a man, born to the poverty of a Spanish peasant's life, who fought protracted hardship and lack of recognition to become one of the world's most versatile and compelling artists, and one of the most celebrated. As a draftsman, etcher, lithographer, and painter, his reputation is secure in history. [35.103.1 Dick Fund]

64 Correggio (Antonio Allegri). Italian, School of Parma, 1489–1534. *The Annunciation.* Tempera on paper, 3¾ x 6¾″

This is a sketch for a fresco which Correggio executed in the Church of the Annunciation in his native city Parma. The composition, which compactly fills the paper, gives equal emphasis to both the angel, borne in on such clouds as the artist loved to paint, and to the mild-featured and lovely Virgin. It is considered one of the great sketches by the master. In its small area the artist has caught an impression of a large wall painting. The fresco for which it was a sketch has since been damaged. [19.76.9 Hewitt Fund]

65 Francesco Guardi. Italian, Venetian, 1712–1793. *Loggia of a Palace.* Pen and bistre wash on paper, 10¹³⁄₁₆ x 7⁹⁄₁₆″

In the Accademia di Belle Arti in Venice there is a painting of a similar composition by Canaletto, Guardi's master. Here the artist has given the airy grace of Venetian architecture a sense of firm structure, although the scene is drawn with Guardi's usual summary and broken line. In this quick and sure rendering of light and space, and the admirable suggestion of life and substance, Guardi was in fact a forerunner of the nineteenth-century Impressionists. [37.165.76 Rogers Fund]

66 Rembrandt Harmensz van Ryn. Dutch, 1606–1669. *Man Seated on a Step.* Pen and bistre, washed, on paper, 5¾ x 5⁷⁄₁₆″

Rembrandt, the towering genius of Dutch art, was a superb draftsman whose consummate skill is evident in his most casual sketches. He made numerous quick and perceptive drawings, such as this one, of men and women caught in informal moments at home or on the street. The fresh and spontaneous expression of a scene or an idea that he achieved in these

vivid drawings has rarely been equaled. [29.100.935 The H. O. Havemeyer Collection. Bequest of Mrs. H. O. Havemeyer]

67 Honoré Daumier. French, 1808–1879. *A Clown.* Charcoal and water color on paper, 14⅝ x 10". Signed (lower right): h. D.

This spontaneous drawing with its loose, quick technique, gives an immediate impression of enormous vitality and at the same time of great pathos. The clown, dressed in the traditional pierrot costume, is making a noisy oration. The work seems to be an expression of movement and sound rather than a two-dimensional representation of a scene. No interval of time seems to have elapsed between the artist's observation and this final description of what he witnessed. [27.152.2 Rogers Fund]

68 Jean Auguste Dominique Ingres. French, 1780–1867. *Study for the Portrait of Louis-François Bertin.* Chalk and pencil on paper, 13¾ x 13½". Signed (lower left): Ingres

This is a sketch for one of Ingres' masterpieces, a portrait of the artlover and publisher Bertin. It is one of numerous preliminary studies that reveal the artist's struggle for perfection in his work. Here he has finally caught and quickly recorded the pose he sought. It is a masterly example of his ability to suggest both texture and substance with an exquisitely drawn line. [43.35.485 Bequest of Grace Rainey Rogers]

69 Edgar Hilaire Germain Degas. French, 1834–1917. *Emile Duranty.* Charcoal and white chalk on bluish grey paper, 12⅛ x 18⅝". Stamped in red (lower left): Degas

Degas' drawing of Emile Duranty shows the artist's complete mastery of form and expression. It is a sketch for a portrait of the author and publisher in his library. Texture, line, and highlights have been rendered with certainty and with great power. A late sketch, no longer in the tradition of Ingres but closer to some of Degas' pastel works, it brings out the intellectual and thoughtful character of the sitter with penetrating directness. [19.51.9a Rogers Fund]

70 Workshop of Giotto. Italian, Florentine, first quarter of the fourteenth century. *The Epiphany.* Tempera on wood, gold ground, 17¾ x 17¼"

This is one of a series of scenes from the life of Christ, by some critics attributed to Giotto himself, six of which are known today. The example illustrated is unusual in that it combines the appearance of the angels to the shepherds and the Nativity with the Adoration of the Kings. Mary is pictured in a reclining position before the three kings, one of whom kneels and reverently lifts the Christ Child from the manger. Saint Jerome stands at the left, and in the background two hooded shepherds, attended by a dog, kneel before four hovering angels.

Through his own genius and his influence on his followers, Giotto may be said to have altered the entire development of western painting. He brought to the narration of religious history a combination of Franciscan humanity with a nobility of expression that has never been surpassed. [11.126.1 Kennedy Fund]

71 Pesellino (Francesco di Stefano). Italian, Florentine, about 1422–1457. *The Madonna and Child with Six Saints.* Tempera on wood, gold ground, 10¼ x 9⅜"

This painting is one of the small panels representing religious subjects for which Pesellino is best known. Here the Virgin and Child are surrounded by six saints, some of whom may be identified. Behind the Madonna stand two female saints. Saint Jerome, beating his breast with a stone, his cardinal's hat at his feet, is at the left. Next to him stands a saint who may perhaps be identified as Anthony the Abbot. On the right the bishop, holding a crozier, has been identified as Saint Bonaventure or Saint Louis of Toulouse. And beside him, in his characteristic armor, is Saint George.

Close to Fra Angelico in mood and figure types in his early painting, Pesellino worked intelligently with the new concepts of space and volume introduced into fifteenth-century art by Masaccio and Domenico Veneziano. His later paintings show the influence of Fra Filippo Lippi, with whom he worked. [50.145.30 Bequest of Mary Stillman Harkness]

72 Giovanni di Paolo. Italian, Sienese, 1402/1403–about 1482. *Paradise.* Tempera on canvas, transferred from wood, 18½ x 16"

This panel has been cut down on the right side; it once must have formed part of a *Last Judgment* (perhaps in the Church of San Domenico, Siena) with the blessed in Paradise on the left and the damned in Inferno on the right. The painting celebrates the Dominican order. A young monk, perhaps Saint Dominic, is being embraced by Saint Peter Martyr, identified by his bleeding head. Saint Thomas Aquinas appears at the left with the white dove at his ear. And it is possible that in this elegant representation of Paradise, Eloise and Abélard, Paolo and Francesca, are reunited. Dante and Petrarch also appear, and in the center of the panel Saint Catherine of Siena is greeted by Saint Augustine, Bishop of Hippo.

Giovanni di Paolo's early style was based on the Gothic tradition of Siena. Also, in such a work as *Paradise,* the sprightly elegance of the aristocratic figures give some of the flavor of the northern styles. His later works show the influence of Fra Angelico; the forms are stronger and the mood more ascetic. With this change of style and the death of Giovanni di Paolo, the great period of Sienese painting was brought to a close. [06.1046 Rogers Fund]

73 Fra Angelico. Italian, Florentine, 1387–1455. *The Crucifixion.* Tempera on wood, 13⅝ x 19¾", set in a panel 15¾ x 21¼"

Surrounding Christ in this representation of the Crucifixion are: to the left, the Virgin, Saints Augustine and Dominic (kneeling), Monica and Mary Magdalene; to the right, Saint John, Saint Thomas Aquinas (kneeling), Saint Francis, and another saint, perhaps Elizabeth of Hungary. *The Crucifixion* shows many similarities to Fra Angelico's early work, with its miniature-like quality and stylized forms.

Living at a time when Florence was bursting with new ideas and new approaches to art, Fra Angelico, a member of the Dominican order, was unable to resist some of the innovations resulting from the new search for the understanding of man. But he was unable to adapt the new methods and ideas completely, and his works still reflect the pure and devotional medieval concepts of art. [14.40.628 Bequest of Benjamin Altman]

74 Sassetta (Stefano di Giovanni). Italian, Sienese, 1392–1450. *The Journey of the Magi.* Tempera on wood, 8½ x 11⅜"

This representation of the Magi's journey is a fragment of a painting. It shows the three kings, one old and bearded, the other two young and gay, with their jester and courtiers leaving a medieval city and setting forth on their journey. The position, below them over the hill, of the star which directed them to the birthplace of Christ indicates that a representation of the Adoration of the Magi was directly beneath. This part of the painting is now in the Chigi-Saraceni Collection of Siena. Although we have only a part of the artist's conception, the story and composition here seem complete in themselves.

Sassetta takes his position squarely in the tradition of Sienese art. Without deviating from those traditions of style or purpose, he gives us a personality with a charmingly fresh and simple approach to life and art, an approach that is traditional yet individual, and that is certainly naïve. [43.98.1 Bequest of Maitland F. Griggs]

75 Andrea del Castagno. Italian, Florentine, 1423–1457. *Saint Sebastian.* Tempera on wood, painted surface, 53¾ x 23"

Saint Sebastian, a converted Roman soldier, was put to death by archers at the order of Emperor Diocletian for persuading his fellow Christians to give up everything for martyrdom. The painting of the martyred Saint was executed about 1445 and was intended as a votive image, an offering to the Saint for his protection against the plague. The worship of Sebastian as a plague saint was characteristic of the Renaissance in Italy and does not appear earlier.

The works of Castagno, a fifteenth-century artist of Florence, show the influence of the sculptors Donatello and Ghiberti. This can be seen in the realization of the human figure in fully plastic and rounded form, placed in three-dimensional space. Castagno's powerful and restrained figures stand between the monumental yet static ones of Masaccio and the sculptural and mobile figures in Michelangelo's paintings. [48.78 Andrews, Rogers, and Dick Funds]

223

76 Fra Filippo Lippi. Italian, Florentine, 1406?–1469. *The Madonna and Child Enthroned.* Tempera on wood, 48½ x 25"

The Madonna and Child Enthroned was once the central panel of an altarpiece. The side wings, representing the fathers of the church, Saint Jerome and Saint Gregory, Saint Augustine and Saint Ambrose, are in the Accademia Albertina in Turin. Seated on a pseudo-classic marble throne, the Madonna holds the Child who has the Book of Wisdom in his hand.

Fra Filippo Lippi was greatly influenced by Lorenzo Monaco, perhaps his first teacher, and by Fra Angelico among others. This painting was executed when the painter was under the influence of Masaccio (late 1430's), and it is this genius who seems to have impressed him more than anyone else. The effect can be seen in the large and monumental forms of the Mother and Child, which tend to fill the whole painted surface. Fra Filippo Lippi appears to be less interested in the idealization of his figures, for his figures are not sweet, but strong and powerful, than in a realistic and vigorous understanding of human beings as such. [49.7.9 The Jules S. Bache Collection]

77 Andrea del Verrocchio. Italian, Florentine, 1435–1488. *The Madonna and Child.* Tempera on canvas, transferred from wood, 26 x 19"

Verrocchio, like many other versatile artists of his time in Florence, worked in more than one medium or art form. It is through his sculpture that he is best known. Indeed, there are only two paintings which are definitely known to be by him. One of these is *The Baptism of Christ,* in the Uffizi in Florence, on which it is said his apprentice, Leonardo, also worked. The present painting so closely resembles one of Verrocchio's marble reliefs of a Madonna and Child that it is attributed to him. The rich and varied color of the painting is unusual in an artist whose major work was sculpture. The important and influential styles of Lorenzo di Credi, Perugino, and Leonardo were developed out of Verrocchio's incisive and vigorous drawing and the richly plastic character of his painting. [14.40.647 Bequest of Benjamin Altman]

78 Antonio Pollaiuolo. Italian, Florentine, 1433–1498. *Portrait of a Young Lady.* Tempera on wood, 18½ x 13"

Profile portraits of noblemen and noblewomen were very popular in Italy during the Renaissance. Here the richness of the jewelry and the brocaded dress are made subordinate to the direct outline and simplicity of background in the painting. While the representation of this fashionable Florentine lady is realistic, its simplification turns it into a lovely pattern of line and color. This work can be considered a masterpiece in the history of Florentine profile portraiture.

As both a sculptor and a painter, Pollaiuolo's importance in the history of art lies in his superb draftsmanship and his scientific approach to the representation of the human figure, particularly the figure in motion. In the steady growth in the second half of the

fifteenth century towards a more complete understanding and a more comprehending delineation of man, Pollaiuolo carried on the earlier efforts and investigations of Donatello, Castagno, and Uccello and helped bring about the final realization seen in the works of Leonardo and Michelangelo. [50.135.3 Bequest of Edward S. Harkness]

79 Carlo Crivelli. Italian, Venetian, active by 1457– died about 1495. *The Madonna and Child.* Tempera on wood, 14 x 9". Signed (lower center): Opus. Karoli. Crivelli. Veneti

Crivelli has created around the Madonna and Child the richness of the Byzantine heritage of Venice. This can be seen in the gold cloth, the fine brocade, and the jewels that he has incorporated into his composition. Festoons of fruit similar to the one in this painting were frequently introduced by Crivelli into his work.

A Venetian who for the most part painted outside of Venice, Crivelli remained closely tied to the flat, decorative style of the Byzantine East, which had determined the medieval and early Renaissance character of art in that city. In spite of his knowledge of the principles, techniques, and style of the Paduan School of Squarcione, Mantegna, and the Bellinis, Crivelli used their innovations only to enhance his own individual style. His paintings remained more Gothic than Renaissance in execution as well as in conception; he continued working in the restricting medium of tempera at a time when other artists were experimenting with the new technique of oil. [49.7.5 The Jules S. Bache Collection]

80 Fra Carnevale (Bartolommeo di Giovanni Corradini) (?). Italian, Umbrian, active by 1456– died 1484. *The Birth of the Virgin.* Tempera and oil on wood, 57 x 37⅞"

It was common in the Renaissance to clothe the figures in a Biblical scene in contemporary costume, but uncommon in Italian painting to find such elaborate architectural settings containing such elegant figures as are here shown. The scene of the birth with Saint Anne, her handmaidens, and the newly born Virgin takes place in the open loggia of a building designed in the classical manner, with classical subjects in the reliefs on the frieze. The scene in the foreground of the painting may represent the Visitation.

Fra Carnevale, an Umbrian and a Dominican monk, was an architect as well as a painter. He was influenced by Piero della Francesca, as can be seen in his figure types, and by the Florentine painters, as can be seen in his landscape. This painting, which emphasizes the architecture and its perspective and contains both Umbrian and Florentine characteristics, may plausibly be attributed to Carnevale. [35.121 Rogers and Gwynne M. Andrews Funds]

81 Francesco di Giorgio. Italian, Sienese, 1439–1502. *The Chess Players.* Tempera on wood, 13¾ x 16¼"

The game of chess played by a young gentleman against a young lady was a popular sub-

ject in art as early as the fourteenth century and was probably intended to be an allegory of the warfare of love. The key to the interpretation of this particular game of chess may be found in a French *chanson de geste* in which the hero, Huon de Bordeaux, demonstrates his skill in the game. He must forfeit his life if he loses; if he is successful he will win the king's daughter, his opponent. But having fallen in love with him, she loses on purpose.

Francesco di Giorgio, a master in depicting facial expression, was an artist of extreme versatility. He was better known in his time as an architect, military engineer, and sculptor than as a painter. His paintings were executed almost exclusively between 1469 and 1475. Unlike his scientifically advanced work in other media, they retained much of the graceful, fairy-tale quality of Sienese painting. [43.98.8 Bequest of Maitland F. Griggs]

82 Piero di Cosimo. Italian, Florentine, 1462–1521 (?). *A Hunting Scene.* Tempera and oil on wood, 27¾ x 66¾"

Probably commissioned by Francesco del Pugliese, this painting is one of a series, the others of which are still in existence, symbolizing the growth of civilization through the control of fire. *A Hunting Scene* depicts man's primitive life before he learned the use of fire. The theme, in which Vulcan is the mentor of man, is a Roman one, introduced into the Renaissance through the writings of Boccaccio.

Piero di Cosimo was greatly influenced by contemporary painters in Florence: Filippino Lippi, Leonardo, and Signorelli. His imagination led him beyond the knowledge of anatomy and the minute observation of details to create scenes with strange subject matter and a whimsical unreality in both figures and mood. [75.7.2 Gift of Robert Gordon]

83 Giovanni Bellini. Italian, Venetian, about 1430–1516. *The Madonna Adoring the Sleeping Child.* Tempera on wood, 28½ x 18¼"

The Virgin praying above the sleeping Child was a subject frequently painted by Venetian artists. This painting is perhaps the most successful of Bellini's early works. It was painted while he was still under the influence of the Paduan School, particularly of Mantegna, his brother-in-law, and of Jacopo Bellini, his father, and before he was accepted as the leader of the Venetian School in the late 1480's. The firmly outlined Madonna and the landscape with its twisting road are characteristics of Bellini's art in his early period. He developed in his later paintings, using oil with his pigment, a transparency of color and a rounder, softer, more gracious representation of the human form. This is true particularly in his paintings of the Virgin and Child.

Bellini stands as one of the great and influential figures in the history of Venetian painting during the Renaissance. He saw the change from a localized Eastern Byzantine style of painting to the coloristic tradition carried on by his famous pupils Giorgione and Titian, a tradition that continued into the baroque period. [30.95.256 Bequest of Theodore M. Davis]

84 Antonello da Messina. Italian, Venetian, about 1430–1479. *Portrait of a Young Man.* Oil on wood, 10⅝ x 8⅛"

This portrait, with its fine details yet simple and strong sculptural form, has been called a self-portrait; but the sitter seems too young to have mastered the mature style shown by the painting.

The artist was a Venetian by style but a Sicilian by birth. In his native country he came into close contact with Spanish artists. He had the opportunity of learning from them the Flemish technique of oil painting. Later in his life, when he spent some time working in northern Italy, in Venice and Milan, he introduced the new technique to painters there, who not only accepted the medium but also adapted it to their own techniques and styles of painting. These northern Italian painters developed even further the use of vital colors and transparent glazes. [14.40.645 Bequest of Benjamin Altman]

85 Andrea Mantegna. Italian, Paduan, 1431–1506. *The Adoration of the Shepherds.* Tempera on canvas, transferred from wood, 15¾ x 21⅞"

In *The Adoration of the Shepherds* the peasants appear as sturdy, rustic, even ugly types in contrast to Mary and Joseph, who seem noble and majestic, their drapery close to that of antique statues. Yet the painting is consistent in style. In spite of the many small, colorful details in landscape and figures, it achieves unity by the pyramidal composition whose apex is the figure of the Madonna.

Mantegna was one of the most influential northern Italian artists of the second half of the fifteenth century. He was adopted by and he studied with the Paduan master, Squarcione, who emphasized in his school the importance of antique architecture and sculpture as sources of artistic principles. Mantegna was also influenced, as can be seen in his later works, by the Florentine masters who came to Padua, such as Donatello, Uccello, and Filippo Lippi. In his turn, through his use of clear, flexible, precise line and perspective, he influenced the styles of the later northern painters Cosimo Tura, Crivelli, and Giovanni Bellini. [32.130.2 Anonymous Gift]

86 Vittore Carpaccio, Italian, Venetian, about 1455–1523/6. *The Meditation on the Passion.* Tempera on wood, 27¾ x 34⅛". Signed (lower right): vjctorjs carpattjj/venetj opus

A precise and observant story teller, Carpaccio has painted Saint Jerome with his lion and Job, a favorite saint of Venice, sitting on the left and right sides of the dead Christ. These two imposing figures from the Old Testament, who announced the Resurrection, are meditating on Christ's passion. Although the painter delighted in detail for its own sake, the dead tree, the living tree, and the panther, leopard, and stag are not included merely as details; they have a symbolic bearing on the religious subject of the painting.

Influenced in style and choice of subject by the northern Italian tradition of Gentile Bellini and the Paduan School, Carpaccio is best known for his legendary and historical paintings for the Venetian state. His work is closer in character to the Renaissance painters of the fifteenth century than to those of the sixteenth century. [11.118 Kennedy Fund]

87 Cosimo Tura. Italian, Ferrarese, active by 1451 – died 1495. *The Flight into Egypt.* Tempera on wood, diameter 15"

The Flight into Egypt is one of a series of five tondi which formed part of an altar in the church of San Giorgio fuori le Mura at Ferrara. The figures are small, but they are monumental in conception. Details of drapery and landscape have been simplified. The forms virtually fill the circular canvas, suggesting the new importance granted by Tura's generation to humans in relation to the universe.

From 1457 until his death Tura was the court painter at Ferrara. The strong influences on his painting, apparent in the vigorous drapery and the well-modeled forms, are derived from the Paduan master Squarcione, and from Tura's own contemporary, Mantegna. [49.7.17 The Jules S. Bache Collection]

88 Sandro Botticelli. Italian, Florentine, 1444/5–1510. *The Last Communion of Saint Jerome.* Tempera on wood, 13½ x 10"

This panel, one of Botticelli's later works, was executed when Florence was under the spell of the fanatical reformer Savonarola. The subject of the painting reveals a great change in Botticelli's art from the earlier lyrical and secular, if not pagan, subjects painted under the classical and humanistic patronage of Lorenzo de' Medici before the advent of Savonarola. *The Last Communion of Saint Jerome* shows the fervid and impulsive approach to religion shared by the artist and his later patron, Francesco di Filippo del Pugliese, for whom the scene was painted.

Botticelli was a pupil of Fra Filippo Lippi. He was influenced by the anatomical renderings of Verrocchio and Pollaiuolo and adapted their innovations to form a poetic and linear style of his own. Not an artist who greatly influenced the painters who succeeded him, Botticelli stands nevertheless as a genius who forged humanistic theories and religious fervor into a personal and subjective art. [14.40.642 Bequest of Benjamin Altman]

89 Domenico Ghirlandaio. Italian, Florentine, 1449–1494. *Francesco Sassetti and His Son Teodoro.* Tempera on wood, 29½ x 20½". Inscribed (at top): FRANCISCVS SAXETTVS THEODORVS QVE F.

Francesco Sassetti, a member of an influential Florentine family and a partner of Lorenzo de' Medici in his bank in Lyons, was a prominent citizen in the Florence of his day. His son Teodoro, born in 1460, appears here as a youth of eight or ten years old. This fact helps to date the painting between 1468 and 1470. Ghirlandaio painted a chapel for the Sassetti family as well as this portrait of father and son.

Ghirlandaio was influenced by his master Baldovinetti and by Verrocchio, and he worked with Botticelli. But he was neither a profound religious painter nor a great intellectual power. He delighted in paintings of a decorative and worldly nature. He introduced contemporary costume and architecture and used contemporary personalities as actors in his religious scenes which decorate many chapels in important Florentine houses and churches. Ghirlandaio's portraiture stands out as his most successful work. [49.7.7 The Jules S. Bache Collection]

90 Raphael. Italian, Umbrian, 1483–1520. *The Madonna and Child Enthroned with Saints.* Tempera on wood, 66⅝ x 66¾"

In this painting, the main panel of an altarpiece executed in Perugia after a journey to Florence about 1505, the artist combined the Umbrian and Florentine styles. The famous altarpiece was ordered, according to Vasari, by the nuns of the Convento di Sant' Antonio da Padova in Perugia. In the main panel the Madonna holds the Child, who blesses the Infant Saint John. Around them stand Saint Catherine and Saint Peter to the left, and Saint Cecilia and Saint Paul to the right.

The works of Raphael, a native of Umbria, particularly reflect the style of Perugino. This can be seen in his lovely female types with their heads inclined and in the clear, almost transparent skies. The dignity and monumentality of the male saints, however, have an affinity to the Florentine works of Leonardo and Michelangelo, a kinship realized more fully in Raphael's frescoes in the Vatican. His classical forms, his composition, and his use of proportion changed the character of early sixteenth-century painting, influencing the work of the later painters, Annibale Carracci and Guido Reni, and of the French painters, Poussin in the seventeenth century and Ingres in the nineteenth century. [16.30a Gift of J. Pierpont Morgan]

91 Hubert van Eyck. Flemish, died 1426. *The Crucifixion* and *The Last Judgment.* Tempera and oil on canvas, transferred from wood, each 22¼ x 7¾"

These two paintings were originally the wings of a triptych with a panel of *The Adoration of the Magi* in the middle. Of the two, *The Last Judgment* is more medieval in imagination and aspect with its hieratic grouping of Christ, the Virgin, and Saint John. Above them fly angels carrying the instruments of the Passion. Below them are the apostles representing both spiritual and temporal power, with angels and martyrs, welcoming the blessed. Saint George, astride the skeleton Death, keeps order among the damned in Hell. *The Crucifixion* is more realistic in detail, the emotions displayed more human, the costume of the people contemporary, the town a real Flemish town. This degree of naturalism is unexpected in a work produced at a time when medieval customs still strongly influenced the life and thought of Flanders.

For a long time the existence of Hubert van Eyck as a painter was disregarded. His works were ascribed to his brother Jan, or to other

225

contemporary artists. But now there are many facts which have been discovered to prove that Hubert was the elder of the two and worked on a large part of the famous Ghent altarpiece. The great tradition of Flemish painting stems in good part from the accomplishments of the two brothers Van Eyck. [33.92a, b Fletcher Fund]

92 Jan van Eyck and Helpers. Flemish, active by 1422 – died 1441. *The Annunciation.* Tempera and oil on wood, 30½ x 25⅝". Inscribed on doorstep: REGINA CELI LET

In the early fifteenth century the Annunciation to the Virgin was represented as taking place on the open porch of a building, as opposed to the later representation of a scene within the Virgin's bedchamber. In this painting of the earlier type many delicate and naturalistic details have been introduced as symbols of the Old and New Dispensations. The pair of Romanesque columns combined with the Gothic arched doorway and buttress carry out the contrast of the old and new. The same is found in the exquisite flowering plants on the crumbling wall behind the angel. The entire painting cannot be attributed to Jan van Eyck, but it has none of the characteristics of a copy and therefore is believed to be an early work by the painter with the help of his workshop assistants.

Jan, with his brother, Hubert van Eyck, was a founder of the important Flemish tradition of art. Although he perfected the technique of oil painting, a vital step in the development of European art, the spirit of his work remained largely medieval. He rendered each natural phenomenon with minute and sparkling precision and in glowing color both as an important element of his composition and as a perfect part of God's universe. [32.100.35 The Michael Friedsam Collection, Bequest of Michael Friedsam]

93 Petrus Christus. Flemish, active 1444 – died 1472/3. *Portrait of a Carthusian.* Tempera and oil on wood, 11½ x 8". Signed and dated (lower center): PETRVS . XPI . ME . FECIT . Aº 1446

This simple yet detailed painting of a monk in the habit of the Carthusian order is so realistic and describes so carefully a particular human being that it has been considered by many authorities to represent the monk Dionysius of Louvain, an important member of the Carthusian order. However, the halo is used only for saints and indicates that the artist was using the monk as a model for some patron saint of the order.

Christus continued working in the tradition of the great Flemish artists, Hubert and Jan van Eyck, and may have been an apprentice to the latter in Bruges. Many of his subjects and compositions are comparable to those of his master, but they seem heavier, less sensitive, more provincial in style and conception. They seem to be a simplification of the detailed and naturalistic works of Jan van Eyck, although in many instances Christus' art shows a highly personal imagination. [49.7.19 The Jules S. Bache Collection]

94 Dieric Bouts. Flemish, active by 1457– died 1475. *Portrait of a Man.* Tempera and oil on wood, 12 x 8½"

This painting, which has been cut off at the bottom, may have been part of one panel of a diptych. It is a simple, realistic, and straightforward portrait of a praying man who may have been a donor in a larger religious scene. The man seems unconscious of an outer world. This sort of profound introspection is characteristic of many of Bouts's portraits.

Although he is known as a Flemish painter, the artist received his early training in Holland, and the sturdy, substantial faces and figures in his paintings are Dutch in type. The trend of portraying the religious preoccupation and the psychological introversion of mankind, begun by Rogier van der Weyden, was furthered by Bouts. He, of all fifteenth-century Flemish artists, expresses the greatest intensity of feeling in his portrayals. [14.40.644 Bequest of Benjamin Altman]

95 Hugo van der Goes. Flemish, active by 1467 – died 1482. *Portrait of a Man.* Tempera and oil on wood, 12½ x 10⅛" (oval)

The man praying in such a steadfast manner beside an open window is undoubtedly a donor. This head has perhaps been cut from the left side of a diptych which had the Virgin on one side and the donor praying to her on the other. This was a subject frequently painted by the fifteenth-century Flemish artists. The ascetic and introspective mood of the portrait is also typically Flemish.

Hugo van der Goes, working in Ghent and Bruges, was one of the strongest adherents to the tradition represented by Rogier van der Weyden. His painting ranges from the strong, simple compositions executed early in his career for civic or court patrons to the emotionally uncontrolled compositions done after he entered a monastery, where he finally suffered a nervous breakdown and died. His greatest work, the altarpiece for Tommaso Portinari, sent to Florence about 1475, influenced the contemporary Italian painters and even those of succeeding generations. [29.100.15 The H. O. Havemeyer Collection, Bequest of Mrs. H. O. Havemeyer]

96 Rogier van der Weyden. Flemish, about 1400–1464. *Christ Appearing to His Mother.* Tempera and oil on wood, 25 x 15"

This scene of Christ appearing to his Mother was originally the right wing of a triptych which included also a Nativity and a Pietà. The scene in which Christ, before making himself known to others, came first to his mother on Easter morning has been described in detail in Pseudo-Bonaventura's *Mirror of the Blessed Life.* Through the open door of the Gothic building can be seen a traditional representation of the Resurrection. Old Testament scenes prefiguring the Resurrection are carved on the capitals of the building's supporting columns. On the left and right of the door are Saint Mark and Saint Paul, and above them are scenes from the Virgin's life after the Crucifixion. On the scroll held by the angel are the words, "This woman ful-

filled all things triumphantly; therefore a crown was given unto her," which celebrate the triumph of the Virgin Mary.

Rogier van der Weyden was the most influential artist north of the Alps and one of the most important masters of fifteenth-century Flanders. In the Flemish art of his time there were two definite trends in painting: one was towards the bright, naturalistic, and well-finished art of the Van Eycks; the other, towards the more linear and tense style used to portray the psychological and religious inversions of mankind. The artist was the leader of the latter style; his influence can be seen in the work of Memling, Dieric Bouts, and many other Flemish artists. [22.60.58 Bequest of Michael Dreicer]

97 Gerard David. Flemish, active before 1484 – died 1523. *The Archangel Gabriel.* Tempera and oil on wood, 30 x 24"

In this painting of the Archangel Gabriel, one of two panels (see figure 98) representing the Annunciation, the older means of presenting the Virgin on a porch with the angel approaching has given way to the more intimate interior setting favored by the detail-loving artists of the North. On Gabriel's robe is inscribed the Alpha and Omega, and also a portion of the text from St. Luke: "the power of the Most High shall overshadow thee."

The artist first worked in his native Holland, perhaps under Aelbert van Ouwater. After he moved to Flanders his work was influenced by the great Flemish masters. His work there reflects the emotional power of Rogier van der Weyden and the luminous color of Van Eyck and Memling. [50.145.9a Bequest of Mary Stillman Harkness]

98 Gerard David. Flemish, active before 1484 – died 1523. *The Virgin of the Annunciation.* Tempera and oil on wood, 30 x 24"

The panel of the Virgin of the Annunciation cannot be considered separately from the panel of the Archangel Gabriel announcing to her the birth of Christ (see figure 97). Perhaps a piece has been cut from the area where the two panels once were joined, which would account for the discrepancies in perspective and the discontinuation of the designs. The scene with Mary in her bedchamber kneeling before her *prie-dieu* on which rests a devotional book was a favorite subject of the Flemish painters. The dove, the canopied bed, the pitcher with lilies, and the precise details of interior decoration are characteristic elements. David has restrained his color and made the details subordinate to the solemn, aristocratic presence of the Virgin. The subtlety and strength of emotion, lacking in some of the artist's early works, are achieved in this example of David's mature style. [50.-145.9b Bequest of Mary Stillman Harkness]

99 Hans Memling. Flemish, active about 1465 – died 1494. *The Betrothal of Saint Catherine.* Tempera and oil on wood, 27 x 28⅝"

This painting shows Saint Catherine's vision of her betrothal to Christ and his Church.

Catherine, martyred by the Roman Emperor Maximianus because she tried to convert him, was a favorite saint of early Christian times. She sits at the left of the Virgin and Child with the symbols of her martyrdom, the wheel and sword, beside her. On the right Saint Barbara reads her breviary. Behind the holy group kneels the donor of the painting.

Memling, born in Germany, was a burgess of the Flemish city of Bruges. His religious and secular paintings express a more pronounced gentleness than do those of his contemporaries. It is probable that he worked under Rogier van der Weyden in Brussels at some period, for his style, figure types, and well-ordered compositions, in spite of a particular charm and grace, show a decided resemblance to the works of that master. [14.40.634 Bequest of Benjamin Altman]

100 Joachim Patinir. Flemish, active before 1515 – died 1524. *The Penitence of Saint Jerome.* Tempera and oil on wood, center panel 47⅞ x 32"; wings, each, 48 x 14½"

The central panel of the altarpiece shows the penitent Saint Jerome kneeling before a cross. Behind him is depicted a scene from the story of his faithful lion. The left wing represents the Baptism of Christ, and the right wing the Temptation of Saint Anthony. The painted exteriors of the wings, showing Saint Sebald, patron of Nuremberg, and Saint Anne, a German favorite, with the Virgin and Child, suggest that the altarpiece may have been ordered by a German noble. The influence of Gerard David is reflected in the left wing, the influence of Hieronymus Bosch in the right.

The interest of Flemish artists in the details of life and of landscape are united and subordinated in this painting to a larger conception of the earth and the universe. Patinir, though not actually the first painter to use landscape as a subject in itself, was the first to conceive and paint a receding landscape in which to unite more than one scene. The new preoccupation with landscape inspired many later Flemish painters, including Pieter Bruegel. [36.14a, b, c Fletcher Fund]

101 Hieronymus Bosch. Flemish, active by 1488 – died 1516. *The Adoration of the Magi.* Tempera and oil on wood, 28 x 22¼"

The Adoration of the Magi with its simple types and homely miniature-like details stands close to the early Dutch paintings. It is lyrical in treatment, in contrast to the later wild and satiric paintings of Bosch. The Virgin, the Child, and Saint Joseph are plain Flemish people; the three Kings are dressed up in exotic clothes and jewels as for a church tableau.

Although he inherited the Dutch and Flemish traditions of Geertgen tot Sint Jans and the Master of the Virgin among Virgins, Bosch developed an individual sort of fantasy which is unique and has never been equalled. In his later paintings Bosch peopled his heavens and his hells, his scenes of damnation and temptation, with fantastic creatures, part human, part beast. The large collections of his work in Spain and other foreign countries attest to his widespread appeal to the people of his own time. [13.26 Kennedy Fund]

102 Lucas Cranach the Elder. German, 1472–1553. *The Judgment of Paris.* Oil on wood, 40⅛ x 28". Signed (on rock, right foreground) with a crowned and winged serpent

This version of the judgment of Paris places the classical story in an enchanting German landscape with Paris, dressed as a German knight, awakened by Mercury, who is also represented in contemporary costume. The three goddesses, Juno, Minerva, and Venus, appear as three rather sophisticated nudes expectantly awaiting the presentation of the golden apple which will pronounce one of them the most beautiful.

Cranach, a prolific painter with an important workshop, was also a burgomaster of Wittenberg, the owner of a pharmacy and bookshop, and the architectural advisor to the Electors of Saxony. He was a friend of Martin Luther and a strong supporter of the Reformation. His scenes, particularly those of classical and mythological subjects, are some of the freshest, most winning and light-hearted paintings executed during the time of the German Renaissance. [28.221 Rogers Fund]

103 Albrecht Dürer. German, 1471–1528. *The Virgin and Child with Saint Anne.* Tempera and oil on canvas, transferred from wood, 23⅝ x 19⅝". Signed and dated (right center): AD (monogram) 1519

Several similar compositions by Dürer, including a drawing, depict Saint Anne, the mother of the Virgin, her head covered in white, beside Mary who holds the Child in her lap. The head of Saint Anne has been said to be an idealization of the head of Dürer's unpleasant wife, Agnes. Close to the style of his prints executed around 1519, the painting has the monumentality characteristic of his work at that period.

Dürer was one of the great figures, not only of the German Renaissance, but of the whole tradition of European art of the Renaissance and Reformation. He was primarily a graphic artist, who executed impressive wood cuts and etchings, some of them with a technical brilliance that has never been surpassed. He studied with the Nüremberg artist Michael Wolgemut, and was influenced greatly by Martin Schongauer. Having traveled in Italy, he introduced into the art of the North many southern innovations in painting. [14.40.637 Bequest of Benjamin Altman]

104 Unknown Painter. British, active in 1603. *Henry Frederick, Prince of Wales, and Sir John Harington.* Oil on canvas, 79½ x 58". Inscribed: (left) 1603/fe/Æ 11/ Sir John Harrington [sic]; (right) 1603/fe/ Æ 9/ Henry Frederick Prince of Wales Son/ of King James the 1st.

This double portrait of the Prince of Wales and his companion, both in hunting costume, was executed the year that James VI of Scotland, father of the prince, was proclaimed King of England, Scotland, and Ireland. The arms of England hang above the Prince and the arms of the Harington family hang above his friend, who holds a deer the prince has killed. This painting may have been executed to commemorate the visit of the king and prince to the Harington estate.

There were several Flemish painters in Elizabethan England who set the style for paintings of this sort. The exact painter of the present picture has not been determined. [44.27 Pulitzer Fund]

105 Pieter Bruegel the Elder. Flemish, active 1551 – died 1569. *The Harvesters.* Oil on wood, 46½ x 63¼". Signed and dated (lower right): BRVEGEL/LXV.

The labors and pleasures of the twelve months were popular subjects in medieval church carvings and illuminated manuscripts. July was usually represented as the month when the grain was harvested. *The Harvesters* by Pieter Bruegel is probably one painting from such a series. Four others from the same series also survive. In all five Bruegel has in realistic detail reported the doings of Flemish peasants during the several months of the year, setting his subjects in vast landscapes of great beauty.

In the artist's early work strange monsters similar to those painted by Hieronymus Bosch occasionally appear, and his people are portrayed with a witty acumen similar to Bosch's. His subsequent large landscapes are in the tradition of Patinir, but they benefit from his own travels in Italy and through the Alpine country. Bruegel, however, went beyond either in the depth of his understanding and in the skill with which he portrayed the world about him. [19.164 Rogers Fund]

106 Félix Chrétien. French, about 1510–1579. *Moses and Aaron before Pharaoh (the Dinteville Brothers before Francis I).* Tempera and oil on wood, 69½ x 75⅝"

The portraits in this allegory are those of the distinguished Dinteville brothers. François II de Dinteville, the Bishop of Auxerre, is represented as Aaron; Jean de Dinteville, as Moses; Guillaume and Gaucher de Dinteville, as attendants. Francis I, King of France, is presented in the guise of the Pharaoh.

Chrétien was a provincial painter whose work is not related to the great French tradition of the School of Fontainebleau. His artistic career remains obscure, and only a few paintings can definitely be attributed to him. In style, his portraiture is close to Holbein's. This painting was intended to be a companion piece to Holbein's *Ambassadors,* and for this reason, perhaps, was once falsely inscribed in the lower left corner, IOANNES HOLBEIN. 1537. [50.70 Catherine D. Wentworth Fund]

107 Hans Holbein the Younger. German, 1497/8–1543. *Portrait of a Member of the Wedigh Family.* Tempera and oil on wood, 16½ x 12½". Inscribed: Anno. 1532 ÆTATIS.

227

SVÆ 29.; on cover of book: H.H.; on side of book: HER[?] WID; on paper in book: Veritas Odiu[m] parit

The young man in this portrait by Holbein has been identified by the arms on his ring as a member of the Wedigh family of Cologne. Members of the family belonged to the Hanseatic League, which had special trade privileges in London. Living together in a quarter of the city called the Steelyard, they played an important part in the life of London. When Holbein went to England, his introductions in the Steelyard started him on his English career.

Holbein was not only one of the world's greatest portrait painters, but also an important international figure of his time. Although he became a citizen of Basel, Switzerland, his early work was influenced by the Italian-inspired Burgkmair. A close friend of the humanist Erasmus, Holbein was persuaded by the scholar to visit England, where he became the court artist for Henry VIII. He executed portraits of all the famous men and women of the times, from the king himself and his son Edward VI to the English courtiers and the visiting dignitaries of foreign countries. [50.135.4 Bequest of Edward S. Harkness]

108 Bronzino (Agnolo di Cosimo di Mariano). Italian, Florentine, 1503–1572. *Portrait of a Young Man*. Oil on wood, 37⅞ x 29½".

Although Bronzino was born and trained in Florence and spent most of his life there, he worked for two years, from 1530 to 1532, at the court of Urbino. This elegant portrait of an Italian noble may be that of a Duke of Urbino, possibly Guidobaldo II (1514–1574).

Bronzino is celebrated for his portraits of aristocratic Italian men and women, including numerous members of the Medici family. His work is executed in the mannerist style of sixteenth-century Florence, a style which he derived from his teacher Jacopo Pontormo and which he developed with conspicuous success. The muscular figures, painted with great sophistication, reflect the influence of Michelangelo in the intricate balance of their poses. [29.100.16 The H.O. Havemeyer Collection, Bequest of Mrs. H.O. Havemeyer]

109 Titian (Tiziano Vecelli). Italian, Venetian, 1477(?)–1576. *Venus and the Lute Player*. Oil on canvas, 65 x 82½"

The subject of Venus reclining in an open loggia with Cupid at her shoulder and an elegant and modish admirer by her side playing music to her was painted more than once by Titian. This particular composition is painted in the artist's late style with its characteristic subdued color and swift brush work; parts of it purposely have been left unfinished. The painting appeals to the senses with its rich color and textures, its atmospheric mountains, and the suggestion of pleasant music.

Titian, a giant in the history of European painting, had a very long life span. His work grew in power and conception from a gay, clear style to one deeper-toned and more pro-

found. He was a pupil of Giovanni Bellini and worked under that master and with Giorgione, learning from them the subtle use of color and the importance of paint in itself as a means of expression. He carried the coloristic tradition of Venetian art to new heights and influenced not only his contemporaries, Tintoretto and Veronese, but all later artists who were interested primarily in color. [36.29 Munsey Fund]

110 Tintoretto (Jacopo Robusti). Italian, Venetian, 1518–1594. *The Finding of Moses*. Oil on canvas, 30½ x 52¾"

In the foreground of the painting, on the left the Pharaoh's daughter with her jeweled crown, and on the right her companion, carefully tend the infant Moses. Hunters chasing a stag and ladies strolling beside the river can be found in the background. The artist, an energetic and prolific painter, left many of his canvases unfinished, and in this work the final rendering of certain details and all the glazes are missing. The gay colors and quick brush strokes indicate that it is an early painting of the master.

Tintoretto worked almost exclusively in Venice and for the Venetian state, decorating the Doge's Palace and the Scuola di San Rocco. He completed an extraordinarily large number of commissions for decorations and portraits. His work shows the influence of Titian, in whose studio he worked briefly. Tintoretto's art marks the turning point between the styles of the high Renaissance and those of the baroque period. His compositions have taken on a new and powerful movement and show an increasing interest in violent contrasts of light and shade, a dramatic aspect unknown in the classically and strictly composed art of the Renaissance. [39.55 Gwynne M. Andrews Fund]

111 Veronese (Paolo Caliari). Italian, Venetian, 1528(?)–1588. *Mars and Venus United by Love*. Oil on canvas, 81 x 63¾". Signed (lower center): PAVLVS VERONENSIS. F.

There is uncertainty as to the exact meaning of this painting. The subject has been interpreted as the adoption of Hercules by Juno and, also, as a marriage scene in which the principal figures are likenesses of contemporary people. It may rather represent Venus, queen of love and beauty, and Mars, god of war, being bound by Cupid. In any case, it obviously tells its story in terms of a goddess and hero of the pagan world.

While he was still in his twenties Veronese was established as one of the greatest painters of Venice. His style is closely related to the work of Titian, Tintoretto, and other Venetian painters of his day; in the sumptuousness of his decorative compositions, however, he enjoyed a particular eminence. He executed decorations for the Doge's Palace, celebrating the state and its important citizens. The religious scenes he painted for Venetian churches were so often freely cast in terms of the colorful and luxurious life of contemporary Venice, that the artist was rebuked by the Inquisition. [10.189 Kennedy Fund]

112 Anthony van Dyck. Flemish, 1599–1641. *James Stuart, Duke of Richmond and Lennox*. Oil on canvas, 85 x 50¼"

Van Dyck painted more than one portrait of James Stuart (1612–1655). The duke, a cousin to King Charles I, is here shown wearing the ornate costume of the court, with the jewel of the Order of the Garter about his neck and its star embroidered on his sleeve. This and other likenesses in the great series of portraits by Van Dyck of the English aristocracy constitute a survey of the British court in the first half of the seventeenth century.

After Rubens, his teacher, Van Dyck was the most famous Flemish painter of the century. He worked in Italy as well as in Flanders and in 1635 he was summoned to be court painter by Charles I of England, who lodged him and knighted him. Van Dyck learned much from Rubens and was technically as proficient as his master. However, he turned from Rubens's robust, vigorous style to a more delicate and elegant manner of presentation which flattered his courtly sitters. [89.15.16 Gift of Henry G. Marquand]

113 Peter Paul Rubens. Flemish, 1577–1640. *Venus and Adonis*. Oil on canvas, 77½ x 94⅜"

Venus, scratched by Cupid's arrow, left her former pastimes to follow Adonis in his pursuits, becoming a huntress herself. In this scene from the classical myth, Venus reverts to her role as goddess of love and tries to restrain her earthly lover from going forth to his last hunt. The painting shows the influence of the Venetian painters Veronese and Titian. The affinity to the painting of the same subject by Titian, in the Prado, may be plausibly explained by the fact that Rubens when in Spain made a copy of Titian's work.

Rubens was one of the great painters of his time and his work contains the full spirit of the baroque period. He was well known in cultural, learned, and political circles. He was commissioned by Marie de' Medici to paint scenes of her life and was sent on diplomatic missions to Spain and to England, where he was knighted by Charles I. He learned much from the art of the high Renaissance in Italy. His color is based on that of Titian and Veronese, his fluid and dramatic compositions on those of Tintoretto and Caravaggio. With the help of assistants his productivity was immense. Through his mastery of color, drawing, and design he influenced many succeeding artists, such as Van Dyck and Jacob Jordaens, as well as the Impressionists and the painters of the present day. [37.162 Gift of Harry Payne Bingham]

114 Nicolas Poussin. French, 1593/4–1665. *The Rape of the Sabine Women*. Oil on canvas, 60⅝ x 82⅜"

This is one of two versions by Poussin of the well-known legend from the beginnings of Roman history; the other is in the Louvre. Here, Romulus is shown standing on a platform at the left of the composition; with a wave of his mantle he signals to his countrymen to seize as their wives the Sabine women

228

who had been enticed to the newly-founded city to witness a religious ceremony.

A Frenchman who spent most of his years in Rome, Poussin studiously and ardently turned to classical history and ancient mythology for his subjects. From classical art and literature and from contemporary representations of the ancient world, he selected his material and synthesized it into a heroic style of painting. In his work seventeenth-century classicism found its outstanding exponent. In its time the ideal he formulated was original and new and had a decided influence on contemporary painting. His works, indeed, have been called a cornerstone of French painting. Later generations of French painters down through David and Cézanne in the nineteenth century have paid him the tribute of praise and imitation. [46.160 Dick Fund]

115 Jacob Isaacksz van Ruisdael. Dutch, 1628/9–1682. *Wheatfields*. Oil on canvas, 39⅜ x 51¼". Signed (lower right): J VRuisdael

This landscape is a justly celebrated work of Ruisdael's mature period. By masterful use of perspective the arched sky with its massive banks of clouds and the flat earth with its sweeping wheatfields have been wrought into a formal composition of compelling beauty. However, it is no artificial landscape in the earlier Italian tradition. It is the Dutch countryside as the artist saw it. The dramatic character of the painting, its unity and its coherence, was achieved through Ruisdael's keen awareness of the poetry in the real world immediately around him.

Ruisdael was one of the most famous of Dutch landscape painters. He painted nothing but land- and seascapes. Few were better qualified by nature and temperament than he to render on canvas the quiet, tranquil beauty of his own country, and this he did with lasting effect. His well-ordered, naturalistic panoramas, enriching the realistic tradition of Elsheimer and Van Goyen, laid foundations upon which later master landscapists, such as Constable in the nineteenth century, built their triumphs. [14.40.623 Bequest of Benjamin Altman]

116 Meindert Hobbema. Dutch, 1638–1709. *Entrance to a Village*. Oil on wood, 29½ x 43⅜". Signed (lower right): M. Hobbema

Like Ruisdael, his teacher, Hobbema also specialized in painting the Dutch countryside about him. This landscape is a fine and typical example of his art. Although it clearly belongs in the tradition so splendidly represented by the work of his master, Hobbema's panel—indeed, most of his painting—is conceived and presented with less poetic feeling. Both in his choice of subjects and in his technique Hobbema's work is remarkably consistent and, as a consequence, relatively easy to identify.

Most of the large number of paintings by Hobbema were executed while he was a young man, before his appointment to an official post in the government. Nevertheless, his masterpiece, *The Avenue of Middelharnis*, was painted in 1689. [14.40.614 Bequest of Benjamin Altman]

117 Johannes Vermeer. Dutch, 1632–1675. *A Girl Asleep*. Oil on canvas, 34½ x 30⅛". Signed (on wall at left): J. VMeer

The landscapes, still lifes, portraits, and genre scenes painted in Holland in the seventeenth century have left us with an almost complete pictorial record of the Dutch people of that period, of their customs, homes, and dress, and of the tidy land in which they lived. Vermeer's painting of a dozing girl is an exceptionally beautiful example of the detailed interior views so fondly painted by a number of Dutch artists of the seventeenth century. He has devoted loving care not only to the attractive sleeping model, but to each object in the room and to the room itself, without overemphasizing any detail. The photographically accurate diminishing perspective and the cool, pearly luminosity in which the scene is steeped characterize most of Vermeer's art.

The artist was a native of Delft, and was admitted to the painters' guild there. He studied under Rembrandt's master, Carel Fabritius. Vermeer, too, died a comparatively poor man. He worked with painstaking slowness and his known surviving works number barely forty. No one has excelled the technical brilliance with which he handled color, the faultless representations of his textured surfaces, or the exquisite manner in which he lighted the subjects of his brush. [14.40.611 Bequest of Benjamin Altman]

118 Gabriel Metsu. Dutch, 1629–1667. *The Music Lesson*. Oil on canvas, 24½ x 21⅜". Signed and dated (on paper): G. Metsu/1659

At one time the elegantly clad couple in this scene was thought to represent the artist and his wife, and the third person at the window to be Jan Steen, another famous painter of Dutch genre scenes. Whatever the substance of this belief, the subject itself is typical of Metsu's preoccupation with Dutch manners and society in his paintings. The gaiety and apparent contentment of the models, whoever they be, is also characteristic of Metsu's work.

Metsu was born in Leyden and moved to Amsterdam about 1657. He was a contemporary of Rembrandt, Jan Steen, and Vermeer, and while the influence of all three may be detected in his work, Metsu's genius developed in its own individual way. No other Dutch painter, possibly excepting Terborch, so devotedly and variously reported the solid, pleasant world of the Dutch bourgeoisie in the seventeenth century. [91.26.11 Gift of Henry G. Marquand]

119 Rembrandt Harmensz van Ryn. Dutch, 1606–1669. *Portrait of a Young Man*. Oil on canvas, 42¾ x 34". Signed and dated (on book): Rembrandt/F. 1658

This painting has been erroneously called a portrait of Thomas Haringh, the auctioneer who presided at the sale of Rembrandt's possessions in 1657 and 1658 when the artist was declared insolvent. The subject has also been wrongly identified as Rembrandt's son Titus, who was but seventeen years old at the time the painting was executed; this is a study of a more mature man whose name has been for-

gotten but whose essential human character has been memorably and profoundly recorded by the artist.

Rembrandt was born in Leyden where he got his schooling and the little formal training he had in the arts. By the time he was twenty-five, however, his success as a portrait painter encouraged him to move to Amsterdam with its greater opportunities. There he lived out his life. For some time he enjoyed considerable fame. His large studio attracted many pupils, among them Gerard Dou, whose work is often all but indistinguishable from work by Rembrandt's own hand. In spite of his successful accomplishments and his great reputation, the master's later years were troubled and sad, and he died in poverty.

It is interesting to note that the Metropolitan Museum has in its custody, aside from an important collection of his drawings and etchings, twenty-eight canvases by Rembrandt. [14.40.624 Bequest of Benjamin Altman]

120 Frans Hals. Dutch, after 1580–1666. *Yonker Ramp and His Sweetheart*. Oil on canvas, 41½ x 31¼". Signed and dated (over fireplace): F. HALS 1623

Yonker Ramp, or Lord Ramp as he might be called, must have been a well-known roisterer in Haarlem. He remains well known to us, for Hals painted several likenesses of him in various stages of tipsiness. This version of the happy, boisterous Hollander, shouting a drinking song as his good-humored sweetheart cuddles as close as Ramp's great hat permits, shows Hals's uncommon ability to capture a fleeting gesture and put it on canvas. The brush strokes seem to have been dashed on the canvas with furious speed, yet with perfect sureness.

Hals was the most successful Dutch artist of the early seventeenth century. He was honored and encouraged by the people of the thriving city of Haarlem at a time when many of his fellow artists were having a very hard go of it. No other artist so skillfully portrayed the hearty vitality and jolly humor of his countrymen as he did in his single and group portraits of Dutch citizens from all social classes. His rapid, broad technique which achieved an effect of spontaneity and vivid reality, is remembered in the works of the Impressionists two hundred years later. [14.40.602 Bequest of Benjamin Altman]

121 Rembrandt Harmensz van Ryn. Dutch, 1606–1669. *Flora*. Oil on canvas, 39⅝ x 36⅛"

Executed about 1650, this is one of Rembrandt's fanciful works in which he has painted his wife, Saskia, dressed as the goddess of Spring. Rembrandt was fascinated by the texture of materials and often dressed members of his family in costumes in order to paint them. This painting is gayer in mood and brighter in color than his more somber later works, in which he emphasized the interplay of light and shade to bring out dramatic effects.

Rembrandt, at a time when many of his contemporaries in Holland were specializing and working in only one field, painted, drew, and etched portraits, landscapes, and religious scenes. Standing as a universal genius in his

own period, he influenced many later painters profoundly. Rembrandt drew the material on which his art is based from many fields of art; from the landscape and genre painters in his own country, from Renaissance and baroque painters of the great Italian tradition, and from the picturesque and foreign paintings and miniatures of Eastern countries. From these, not copying but synthesizing, he formed a completely original style of great emotional penetration and sympathy. [26.101.10 Gift of Archer M. Huntington in memory of his father, Collis Potter Huntington]

122 Jan Steen. Dutch, about 1626–1679. *The Lovesick Maiden.* Oil on canvas, 34 x 39″. Signed (lower right): I. STEEN

This highly detailed genre painting with a girl and her two solicitous companions, the doctor and her mother, is typical of Jan Steen's humorous and perceptive record of middle-class Dutch life in the seventeenth century. The nature of the girl's complaint is indicated by the amused expression on the doctor's face and by the cupid loosing his arrow from his perch over the doorway. As in so much Dutch painting of this sort the texture of materials and the appearance of surfaces is lovingly and meticulously rendered, as in the girl's beautiful green skirt and in the group of objects in the lower left corner.

Steen was one of the best reporters of the Dutch school and an exceptionally talented figure painter. Born in Leyden, he studied under Jan van Goyen, the great landscapist whose daughter he married. While managing a brewery in Delft and a tavern in Leyden, which furnished the milieu for many of his pictures, Steen continued to paint, sometimes assisted by Metsu. He still had difficulty making ends meet; when he died he left five hundred pictures he had not sold. [46.13.2 Bequest of Helen Swift Neilson]

123 El Greco (Domenicos Theotocopoulos). Spanish 1541–1614. *Cardinal Don Fernando Niño de Guevara.* Oil on canvas, 67¼ x 42½″. Signed in Greek (on paper, lower center): "Domenicos Theotocopoulos made it"

Cardinal Don Fernando Niño de Guevara was a high ecclesiastic in the church of Spain and Grand Inquisitor. This portrait was painted by El Greco before the cardinal left Toledo for Seville in 1601. He is painted here in all the pomp and dignity accorded to his rank, and his complicated and dangerous personality has been brought forth with great perception.

El Greco, "the Greek," originally came from the island of Crete, but his style was based on the Venetian tradition of Titian and Tintoretto. When he finally went to Spain, his art became spiritually and emotionally Spanish. The characteristic mannered gestures, the elongated forms, and the dramatic use of light and shade, for which he is so well known, developed in that country. His method of distorting forms to create a mood and to express profound feeling has been contin-

ued even into modern times. [29.100.5 The H. O. Havemeyer Collection, Bequest of Mrs. H. O. Havemeyer]

124 Diego Rodríguez de Silva y Velasquez. Spanish, 1599–1660. *Christ and the Pilgrims of Emmaus.* Oil on canvas, 48½ x 52¼″

The scene in which Christ makes himself known to the two pilgrims at Emmaus by the act of breaking bread is depicted in this painting at the moment of recognition. The severe, sculptural treatment of textures and forms, the use of strong contrasts of light and shade which give emphasis to gestures and expressions, show that this is a work in Velasquez's early style, executed in Seville about 1620.

The work of Velasquez progressed from realistic paintings of still life and genre scenes, severe and clear-cut in treatment, to his later canvases with their subtle rendering of color, light, and shade, and an ease of brush work which enabled him to recreate the quality of the air enveloping the forms he depicted. After he left Seville he worked for Philip IV in Madrid, painting portraits of the royal family and the Spanish courtiers. During his travels in Italy, collecting works of art for Philip IV, he came under the influence of the Venetian masters of color and texture, particularly Titian. [14.40.631 Bequest of Benjamin Altman]

125 Jusepe Ribera. Spanish, 1591–1652. *The Holy Family with Saint Catherine.* Oil on canvas, 82½ x 60¾″. Signed and dated (at right): Jusepe de Ribera español/accademico Rono/F. 1648

The human rather than the religious aspect of this scene, with its simple and homely types, indicates that it is a late work of Ribera. The kneeling saint kissing the hand of the Child, although her attributes are missing, is probably Saint Catherine. Interest in a natural depiction of human beings is a Spanish characteristic in art and can be seen in the figures of Saint Anne, mother of the Virgin, and Saint Joseph, who are standing in the background.

Although he worked for most of his life in Naples, Ribera's art remained fundamentally Spanish. His early work with its subjects of martyred saints and his gentler later works can be called baroque because of their open compositions, the use of chiaroscuro, and expressionistic tendencies. He influenced not only contemporary Spanish art but also that of Italy and was greatly influenced himself by the Italian Caravaggio. The latter's use of contrasts of light and shade to enhance the drama of a scene can be seen in Ribera's canvases. [34.73 Samuel D. Lee Fund]

126 Francesco de Goya y Lucientes. Spanish, 1746–1828. *Majas on a Balcony.* Oil on canvas, 76¾ x 49½″

Goya frequently painted more than one variation of a subject, and there are other versions in existence of this painting of gay young Spanish women on a balcony with detached

and cloaked male figures behind them. With a broad brush and with few realistic details Goya has given a vivid actuality to his people. In its simple and decorative aspect the painting resembles his cartoons for tapestries.

Goya was one of the great individualists of Spanish painting. His psychological and technical approach to art anticipated the efforts of European artists in the next century. His range of subject matter, from portraits of the royal family of Charles IV to fantasies and to realistic descriptions of every human emotion and situation, has rarely been equaled by a single artist. He worked in many media: oil, fresco, pen and pencil, engraving, and lithography. He did not flatter the people whose portraits he painted. He could be satiric and bitter, he could depict the historical, the fantastic, or the imaginative, and in representing the suffering of others he was extremely perceptive and sympathetic. Delacroix and Manet among other artists were influenced by his methods and pictorial ideas. [29.100.10 The H. O. Havemeyer Collection, Bequest of Mrs. H. O. Havemeyer]

127 Jean-Antoine Watteau. French, 1684–1721. *Mezzetin.* Oil on canvas, 21¾ x 17″

Mezzetin was one of the stock characters in the plays, popular in Watteau's time, produced by the Italian *commedia dell' arte.* Appearing always in the same striped costume, he acted the sly agent, the lover who sang and played the guitar. Many authorities have tried to prove that this painting of the character represents a portrait of a particular actor, but Watteau seldom painted actual personalities or specific scenes.

The early work of Watteau, a native of the Franco-Flemish city of Valenciennes, was influenced by the genre painting of Flanders and Holland. In the 1710's he developed the *fête galante,* or courtly festival, a type of subject for which he became famous. In such scenes aristocratic people amused themselves in the gardens and villages of eighteenth-century France. He also painted many romantic fantasies based on scenes from the French and Italian theater.

At the end of the reign of Louis XIV a new poetic and emotional freedom found expression in the arts of France. In Watteau's intimate and wistfully lyrical canvases that freedom is joyfully proclaimed. In his work the grandeur of baroque gives way to the lighter grace of the rococo. The suggestion of sadness in Watteau's paintings may be attributed to his frail health. His followers, Lancret, Pater, and Fragonard, give a more gay and optimistic picture of the times. [34.138 Frank A. Munsey Fund]

128 François Boucher. French, 1703–1770. *The Toilet of Venus.* Oil on canvas, 42⅜ x 33½″. Signed and dated (lower right): F. Boucher 1751

Boucher's painting was commissioned in 1750 by Madame de Pompadour for the decoration of her Château de Bellevue. It was probably one of a series of subjects intended for her sumptuous bathroom. Elaborately conceived and rendered, but free from vulgarity, the picture represents the rococo style at its best.

Boucher, first painter to the king and director of the Royal Academy, exerted a powerful, almost dictatorial influence on the art and artists of France in his day. Under the patronage of Louis XV and Madame de Pompadour, he designed tapestries, directed the Gobelin factory, and executed decorations for many public and private buildings. His technique was all but perfect; his subject matter, often taken from classical mythology and abounding in nymphs and goddesses, and the tenor of his paintings reflect the sentimentality and lightness of mood characteristic of so much French art and thought in the eighteenth century. [20.155.9 Bequest of William K. Vanderbilt]

129 Jean Honoré Fragonard. French, 1732–1806. *The Love Letter.* Oil on canvas, 32¾ x 26⅜"

The piquant and elegantly turned-out young lady in this painting, once thought to be Marie Emilie Boucher, daughter of Fragonard's teacher, appears to be sending off a bouquet with a note addressed to *Monsieur mon Cavalier.* Such pleasantly sentimental scenes were well suited to Fragonard's gifts and his renderings were well received in the gay and artificial society of pre-revolutionary France. At the time the present picture was painted Fragonard had become established as a fashionable artist and was commissioned by Louis XV, Madame du Barry, Madame de Pompadour, and many other wealthy Parisians.

Fragonard studied with Chardin as well as with Boucher. Winning the *Prix de Rome,* he studied the contemporary and earlier Italian masters and, during these youthful days, painted small religious scenes, local landscapes, and views of ancient monuments. However, his reputation rests on the later decorative canvases of idyllic landscapes and romantic scenes that won him so many prominent patrons. [49.7.49 The Jules S. Bache Collection]

130 Jean Baptiste Siméon Chardin. French, 1699–1779. *Blowing Bubbles.* Oil on canvas, 24 x 24⅞". Signed (lower left): J. Chardin

Chardin painted a number of versions of this subject, two other known surviving examples also being in public collections in America—one in the National Gallery in Washington, the other in the William Rockhill Nelson Gallery, Kansas City. The Museum's picture may be the artist's earliest effort to record such a scene. Other artists, notably the seventeenth-century Dutch genre painters, had long since made the theme a familiar one. Chardin has reduced the subject to its simplest terms and stated it with the painstaking workmanship that is essentially characteristic of his art.

Chardin was one of the most serious, unpretentious, and individual French painters of the eighteenth century. Although he had academic training and in 1728 was elected a member of the Academy, his bourgeois origin ultimately directed his approach to painting. His fame was based and still rests largely on his paintings of still life. But in his own day his popular genre paintings were also highly regarded and won him the sobriquet of "the French Teniers." While he had few followers, the broad simplicity of his style lends a time-

less quality to his work that is clearly understood over the centuries. [49.24 Catherine D. Wentworth Fund]

131 Canaletto (Antonio Canal). Italian, Venetian, 1697–1768. *Scene in Venice: The Piazzetta.* Oil on canvas, 51½ x 51¼"

From the Piazzetta, looking across the entrance to the Grand Canal, one can see the Dogana and the Church of Santa Maria della Salute. Canaletto has faithfully represented them. At the right in his painting of the scene stands Sansovino's Libreria Vecchia, one of the finest secular buildings in Italy. The heavy shadows, the feeling of depth, the strength of composition, absent from his later works, indicate that this canvas was painted before the artist's trip to England in 1746.

Canaletto stands with Guardi as one of the best-known Venetian artists to celebrate the aspect of their city. Canaletto painted with great accuracy of detail, and his pictures have a clarity of construction and a solidity which become almost classical in design and monumental in conception. He was influenced by Pannini's imaginative views of Rome, and as his popularity increased he attracted many imitators. [10.207 Kennedy Fund]

132 Francesco Guardi. Italian, Venetian, 1712–1793. *The Rialto.* Oil on canvas, 21 x 33¾"

This painting of Venice is considered to be one of Guardi's early works. The view is of the Grand Canal at the point where it is crossed by the famous Rialto Bridge near the Camerlenghi Palace. The bridge and the vegetable market on the right are the bustling center of both water and land activity.

Guardi, now classed with Canaletto as the most famous of the many painters of views of Venice in the eighteenth century, was considered in his own time as merely an imitator of the latter. A pupil of Canaletto, influenced perhaps by Longhi and Tiepolo, Guardi also painted portraits, marine subjects, and imaginary landscapes. His work was less precise than that of his master, but brought out the picturesque quality of Venice. The shimmering light that plays over his views of the gay city was an innovation in rendering atmospheric effects which was barely noticed in his own day but which was furthered and perfected by the French Impressionists. [71.119 Purchase]

133 Thomas Gainsborough. British, 1727–1788. *Mrs. Grace Dalrymple Elliott.* Oil on canvas, 92¼ x 60½"

This lady, known in eighteenth-century London as Dolly the Tall, was the wife of the distinguished English physician, John Elliott. Gainsborough has very effectively recorded her elegance and natural grace, qualities he was quick to perceive and delighted to express in paint. The portrait was executed between 1770 and 1780, during the artist's highly successful stay in Bath. Not long after, the lady eloped to France, although she soon returned to England as the favorite of the Prince of Wales.

Gainsborough admired and was influenced by the work of Rubens and Van Dyck. He vied with Reynolds for the patronage of members of London's high society. Both had more commissions than they could execute. Both, too, were among the founders of the Royal Academy in 1768, Reynolds's more amiable disposition winning him the presidency. Gainsborough's glowing portraits constitute an impressive record of the English aristocracy. [20.155.1 Bequest of William K. Vanderbilt]

134 Joshua Reynolds. British, 1723–1792. *Colonel George K.H. Coussmaker, Grenadier Guards.* Oil on canvas, 93¾ x 57¼"

This portrait of a dashing officer was painted in 1782 when the colonel was thirty-three years old. As in so much English portraiture of the period, the artist appears as anxious to represent the social class of his subject as his individual character. It is a handsome example of Reynolds's work, however, and typical in the quiet self-assurance of this handsome aristocrat, posed so graciously by his horse, in the regalia of his fashionable regiment.

As the first president of the Royal Academy Reynolds's influence on English painting was somewhat greater than it might have been had he not held such a prominent post. His academic *Discourses,* however lightly they are often considered by modern critics, set standards that were highly regarded in their day. By his precepts and in his work Reynolds emphatically shaped the tradition of English portrait painting. With Gainsborough he painted a world of ladies and gentlemen whose serenity was untouched by the Industrial Revolution, the seeds of which were already being sown in the pleasant countryside around them. [20.155.3 Bequest of William K. Vanderbilt]

135 John Constable. British, 1776–1837. *Salisbury Cathedral from the Bishop's Garden.* Oil on canvas, 34⅝ x 44"

Constable visited Salisbury many times between 1811 and 1829, sketching and painting the thirteenth-century cathedral at almost every visit, in all weather and from every point of view. The present view, from the bishop's garden, showing the gray stone edifice in its typically English setting of arching trees, is a composition of idyllic beauty.

Constable was the first artist to give the native English school of landscape a European reputation. He had studied at the Royal Academy but his real school was nature itself and his real teacher his own eyes. He was one of the first painters to work out-of-doors in an effort to capture the movement of clouds across the sky and the fleeting effects of sunlight on a scene. The flecks of light pigment he so often used as a device were commonly termed "Constable snow." He had no immediate followers, but his technique and his approach to art laid firm foundations for the succeeding generations of realists. [50.145.8 Bequest of Mary Stillman Harkness]

136 Joseph Mallord William Turner. British, 1775–1851. *Grand Canal, Venice.* Oil on canvas, 36 x 48⅛"

Turner painted *Grand Canal, Venice* in 1835, a time when he was at the height of his career. His highly skilled draftsmanship is implicit here, as in all his work, giving a convincing sense of space, depth, and form to his composition. Beyond a row of palaces at the left rises the bell tower of the Church of San Marco, and at the right can be seen the facade of Santa Maria della Salute. But the artist is more concerned with re-creating a radiant impression of Venice than with representing the solid structure of its monuments. Turner's preoccupation with the problems of color, light, and atmospheric effect was leading him into far-reaching and rewarding experiments with paint. His later works, indeed, had a strong influence upon the French Impressionists—particularly Monet—in their later efforts to solve the same problems. [99.31 Bequest of Cornelius Vanderbilt]

137 Thomas Lawrence. British, 1769–1830. *Elizabeth Farren, Later Countess of Derby.* Oil on canvas, 94 x 57½"

Many artists painted likenesses of Elizabeth Farren, the spirited and well-known Queen of Comedy of the English stage; but few were as successful in capturing the lively beauty of the subject as Lawrence was in this full-length portrait. The actress appeared in Shakespearian parts, but it was her roles in Sheridan's and Goldsmith's plays at the Drury Lane Theatre that made her famous. In 1797 she retired from the stage and married the Earl of Derby.

This portrait, painted in 1790 when Lawrence was 21, marked the turning point in his career. It made his reputation and he was henceforth considered, not a student of the Royal Academy, but a master in his own right. He was one of Reynolds's most successful pupils and followers and, after his master's death, was made Painter-in-Ordinary to the King and became a portraitist whose work was in great demand. [50.135.5 Bequest of Edward S. Harkness]

138 Constance Marie Charpentier (?). French, 1767–1849. *Mlle. Charlotte du Val d'Ognes.* Oil on canvas, 63½ x 50⅝"

For many years this portrait of Mlle. Charlotte du Val d'Ognes was considered one of the most important and delightful works of Jacques Louis David, the leader of the neoclassical school of French art. However, it has been noted that many features of the painting are not characteristic of that artist's work. The mood is romantic as opposed to that of David's classical compositions with their bas-relief structure and neutral backgrounds; the anatomy is not perfectly drawn; and the details of costume, the realism of the broken window, and the complicated lighting of the scene are not convincingly in David's manner.

Constance Marie Charpentier, née Blondelu, was born and died in Paris. She was one of the many comparatively unknown yet talented French painters of the early nineteenth century. Her style was formed under the influence of minor painters and also the great masters and the leading French portraitists, David and Gérard. Only one of her many portraits and genre scenes exhibited at the Salons is known today. By the stylistic similarities of that painting to this portrait, and by other circumstantial evidence, it is possible to attribute the poetic likeness of Mlle. du Val d'Ognes to Madame Charpentier. [17.120.204 Mr. and Mrs. Isaac D. Fletcher Collection, Bequest of Isaac D. Fletcher]

139 Jacques Louis David. French, 1748–1825. *The Death of Socrates.* Oil on canvas, 51 x 77¼". Signed and dated (at left): L.D/MDCCLXXXVII; (at right): L. David

This is among the most successful of David's compositions. The scene depicts the philosophic and heroic Socrates, surrounded by his disciples, receiving the fatal drink that was his penalty for having criticized Athenian society. David copied Socrates' head from an antique bust of the sage, and invested the entire painting with a quality suggesting ancient sculpture. When it was painted Reynolds pronounced it "the greatest effort of art since the Sistine Chapel and the Stanze of Raphael . . . it is perfect in every respect." In later years Napoleon tried hard and unsuccessfully to buy the picture from its private owner.

David's paintings reflect with a very rare completeness and fidelity the emotional and intellectual strains of an epoch. It was an epoch of violent social and political change, and the artist participated actively and with partisan zeal in the affairs of the swirling world about him. He became the official painter and designer of Napoleon's Empire and was vastly influential in establishing the cult of the antique in art, a fresh interest in the past that culminated in the sweeping stylistic changes of the Classic Revival. [31.45 Wolfe Fund]

140 Jean Auguste Dominique Ingres. French, 1780–1867. *Madame Leblanc.* Oil on canvas, 47 x 36½". Signed and dated (at lower left): Ingres p. flor 1823

There are many preliminary studies for this portrait of Madame Leblanc and for the companion portrait of her husband (also in the Museum). Both portraits were painted by Ingres when he was in Florence, before he became a prominent figure among the French artists of his day. Here and in the companion piece can be seen that graceful line and simplicity of structure and modeling which are the very essence of Ingres' genius.

Ingres lived for many years in Rome, where he had gone as the winner of the *Prix de Rome* and where the classic works of Raphael and Mantegna deeply impressed him. He also studied ancient sculpture at the suggestion of David, his mentor. He usually painted from models, but modified natural forms to create more unified compositions, always using powerful, simple, and expressive lines to set the essential character of a painting. Ingres was the leader of the Classicists in the second quarter of the nineteenth century as David had been during the first quarter. [19.77.2 Wolfe Fund]

141 Gustave Courbet. French, 1819–1877. *Woman with a Parrot.* Oil on canvas, 51 x 77". Signed and dated (lower left): 66 Gustave Courbet

The woman in this picture was a titian-haired model whom both Courbet and Whistler painted a number of times. The unconventional and unlikely pose was no doubt chosen by Courbet to shock his public. The painting is, however, one of his most powerfully realistic canvases.

Courbet had little taste for the classicism of David and Ingres, and he reached back to the seventeenth century and the realism of Caravaggio, Ribera, and the Dutch masters. He was an energetic and exuberant person of enormous appetites, filled with the joy of life and the love of his work. Unfortunately he was embroiled in political strife, was imprisoned, and finally fled his native land. His realism exerted a wide influence on following painters and reached America through the work of Homer, Whistler, and Eakins. [29.100.57 The H. O. Havemeyer Collection, Bequest of Mrs. H. O. Havemeyer]

142 Honoré Daumier. French, 1808–1879. *The Third Class Carriage.* Oil on canvas, 25¾ x 35½"

This canvas is a study in oil for a larger painting of the subject. Daumier's sympathetic insight into the nature of common people and his keen interest in their world, so typical of his work, are here revealed with poignant directness. The unfinished portions of the canvas have more the character of line drawing than of oil painting, but one feels Daumier has already fully expressed the aloof intimacy of humble travelers in a cheap railroad coach.

Although he was one of the outstanding exponents of the naturalistic and realistic trends in the art of his day, Daumier belonged to no one school of painting. He was a distinctly personal artist, both in his ideas and in his manner of expressing them. Best known as a cartoonist and caricaturist, he devoted most of his effort to social and political commentary and satire. He once spent six months in prison for doing an unflattering cartoon of King Louis Philippe. On the other hand, he has left an unforgettable picture, drawn with immense understanding and pity, of the little people of Paris, of their workaday life, their enthusiasms, their follies, and their tragedies. [29.100.129 The H. O. Havemeyer Collection, Bequest of Mrs. H. O. Havemeyer]

143 Eugène Delacroix. French, 1796–1863. *The Abduction of Rebecca.* Oil on canvas, 39½ x 32¼". Signed and dated (lower right): Eug. Delacroix/1846

The subject of this lively, imaginative painting is taken directly from the pages of Scott's *Ivanhoe:* The lovely Rebecca is being carried off by the Norman noble Brian de Bois-Guilbert from the burning castle of Front de Boeuf, where she had been kept prisoner. A retainer has lifted Rebecca onto the back of a rearing horse ridden by a Saracen slave. Her abductor guards the rear. It is a violent, colorful episode of the sort so dear to the nineteenth-century romantics.

Delacroix, with his contemporary Géricault, was a leader in the artistic revolution against the classicism of David, Ingres, and their followers. For the most part his bold, nervous brush pictures an exotic or romantic world, and he drew his themes from history, legend, and poetry, as well as from the world about him. The rediscovery of the Middle Ages by Scott, Hugo, Goethe, and others brought forth rich new material to fire his imagination. The richness of colors in the paintings of Delacroix might be compared with that of the great Venetians of an earlier day, Tintoretto, Veronese, and Titian. In his treatment of color and light and in his belief in the freedom of the artist to express himself, Delacroix exerted a lasting influence on the development of painting. [03.30 Wolfe Fund]

144 Jean Baptiste Camille Corot. French, 1796–1875. *Woman Reading*. Oil on canvas, 21⅜ x 14¾″. Signed (lower left): COROT

Woman Reading in the Fields was painted when Corot was seventy-two years old. The artist himself painted out a willow tree which appeared at the left of the picture when it was first exhibited, in order to leave the figure of the woman less crowded and more impressive.

Corot's figure paintings are now more sought after than his feathery landscapes which brought high prices in his lifetime. He painted the former for his own pleasure from studio models early and then again late in his career. They are done with a rare simplicity and clarity of color.

The structure of Corot's composition recalls the classical works of Poussin; the interpretation of landscape, however, is romantic in spirit. Although he observed nature as realistically as any of the Impressionists, he did not follow their precepts. In his figures, at least, one recalls rather the austere realism of Ingres. [28.90 Gift of Mrs. Louise Senff Cameron in memory of Charles H. Senff]

145 Edouard Manet. French, 1832–1883. *Mlle. Victorine in the Costume of an Espada*. Oil on canvas, 65 x 50¼″. Signed and dated (lower left): éd. Manet/1862

This figure study is one of a number of Spanish subjects which Manet painted early in his career when he was studying the works of Velasquez and Goya. This enthusiasm lasted until he actually visited Spain in 1865. In this painting Manet was attempting to develop a new technique which involved contrasting broad, flat areas of color as a means of defining form without resorting to modeling.

The model for the painting was Victorine Meurand, whom Manet used many times. The painting was refused by the official Salon of 1863, but was exhibited in the Salon des Refusés of the same year. This second exhibition had been instituted by Napoleon III in response to the criticism aroused by the Salon jury's refusal of so many paintings.

Manet, a financially independent man of the world, was able to overcome the harsh criticism which met his early work. An avid student of the Old Masters, he learned from painters such as Goya and Hals many technical devices which he incorporated into his own style. When he joined the Impressionist movement in the early 70's, he had already achieved standing as a realistic painter, and having him in its ranks added prestige to the new movement. [20.100.53 The H. O. Havemeyer Collection, Bequest of Mrs. H. O. Havemeyer]

146 Claude Monet. French, 1840–1926. *Sunflowers*. Oil on canvas, 39¾ x 32″. Signed and dated (upper right): Claude Monet 81

The quick brush strokes, the juxtaposition of colors to catch the momentary light, and the effect of that light on form seen in this painting, are typical not only of Monet's work but also of the work of other Impressionist painters. It gives, as was intended, an impression of the flowers and vase, not their actual structure.

Monet studied under Boudin and was greatly influenced by Turner. He was prominent in the group called the Impressionists, among whose members were Manet, Pissarro, Renoir, and Sisley. Developing the realistic trend of Courbet, they tried to present an impression of reality by recording the momentary and accidental, and were interested primarily in the rendering of light. Monet often painted the same subject under the different conditions and the changing light of a single day. Never before him had an artist reproduced atmospheric effects or the light of a particular time of day so accurately, or observed so closely the laws of color. [29.100.107 The H. O. Havemeyer Collection, Bequest of Mrs. H. O. Havemeyer]

147 Edgar Hilaire Germain Degas. French, 1834–1917. *Rehearsal on the Stage*. Pastel on cardboard, 21 x 28½″. Signed (upper left): Degas

Degas, the most intellectual artist of his day, was a free spirit by nature and an ardent realist. At first he followed an academic style in the tradition of Ingres, but about 1865 he began to experiment both with subjects taken from everyday life and with the composition and the techniques of his renderings of them. He delighted in catching the movement and rhythm of figures in action; and the laundry, the ballet stage, the rehearsal room, the race track, and the boudoir furnished him with a never-ending variety of subjects which he interpreted with equal facility in oil, pastel, pencil, or lithographic crayon. His brilliant use of pastel is represented in *Rehearsal on the Stage*, a work probably executed in 1878 or 1879.

Although Degas had friends among the Impressionists and took part in their exhibitions, he was too much an independent to be classed with them or with any other particular group or movement. [29.100.39 The H. O. Havemeyer Collection, Bequest of Mrs. H. O. Havemeyer]

148 Pierre Auguste Renoir. French, 1841–1919. *Mme. Charpentier and Her Children*. Oil on canvas, 60½ x 74⅞″. Signed and dated (lower right): Renoir. 78

This portrait, an important milestone in Renoir's career, marks his first serious deviation from the practices of the Impressionists. While employing their small brush strokes and brilliant colors, he placed the figures in a traditional pyramidal composition and gave them solidity of form. In addition, he made copious use of black, which the Impressionists had banished from their palettes. By setting the group indoors, he established a precedent which was followed by such painters as Vuillard and Bonnard.

Through the influence of Madame Charpentier, the wife of an important publisher, this portrait was exhibited in the Salon of 1878. Up to this time Renoir had always exhibited with the Impressionists, the avantgarde group whose works were excluded from the annual exhibitions of the Academy. In Madame Charpentier's drawing room Renoir met important people, and through her support he obtained many commissions.

Renoir's love of color and his exuberant nature combined to make him one of the gayest and most lovable of painters. Although a great colorist, he was always interested in achieving solidity of composition and form. He made use of the Impressionists' color theories to achieve a sparkling, luminous paint surface. The greatness of his art lies in his ability to fuse a newly discovered means of expression with long established tradition. [07.122 Wolfe Fund]

149 Paul Cézanne. French, 1839–1906. *Landscape with Viaduct*. Oil on canvas, 25¾ x 32⅛″

This is but one of many views which Cézanne painted of the landscape near Mont Sainte-Victoire in the south of France. It is a splendid example of the artist's mature style. The colors still reflect the innovations of the Impressionists, but Cézanne has imposed an order on the scene and given his composition a solid structure in a manner that is inimitably his own. He painted from nature, but he chose to represent the unchanging forms that underlay the outward appearance of things.

Cézanne was a revolutionary painter who repudiated the established tenets of academy and salon, as in their different ways had Delacroix and Courbet. He was, too, a classicist in the sense that he gave great importance to the orderly architectural arrangement of shapes and figures within a scene, as had such masters as Raphael and Poussin before him. Beyond that he was an individualist whose personal vision and extraordinary talent has had a tremendous and increasing influence on the art of our time. [29.100.64 The H. O. Havemeyer Collection, Bequest of Mrs. H. O. Havemeyer]

150 Georges Seurat. French, 1859–1891. *An Afternoon at La Grande Jatte*. Oil on canvas, 27¾ x 41″. Painted in 1884

La Grande Jatte, an island park in the Seine on the outskirts of Paris, was a favorite place for Sunday afternoon strolls and outdoor recreation. It is here recorded by Seurat in a sketch made for the more formal and intricately planned canvas owned by the Art Institute of Chicago. The sketch combines Impressionist innovations and subject matter with

Seurat's own disciplined method and catches the atmosphere of a summer afternoon.

Seurat was an important member of the Post-Impressionists, a group including Derain, Cézanne, and Matisse, who turned away from Impressionism. Nevertheless he continued the Impressionists' study of color on a scientific basis and devised a new method of painting called pointillism. Paints were not mixed on the palette in pointillism, but were placed next to each other on the canvas in dots of pure color so that from a distance of several feet the forms and colors of the composition came into focus. This method enabled Seurat to create the shimmering effect —so strikingly achieved in the sketch for *La Grande Jatte*—of colored objects seen in sunlight and shadow. [51.112.6 Bequest of Samuel A. Lewisohn]

151 Vincent van Gogh. Dutch, 1853–1890. *L'Arlésienne (Mme. Ginoux)*. Oil on canvas, 36 x 29". Painted in 1888

Mme. Ginoux was the proprietor of a café often frequented by Van Gogh. This portrait of her, called *L'Arlésienne*, was painted in Arles at the peak of the artist's career and is considered his most beautiful portrait. It was executed at a time when Van Gogh was no longer bound by the technique of the Impressionists and their almost impersonal approach to painting. Here he has been able to identify himself completely with his subject. This intense love and sympathetic understanding of a person, a landscape, or an object found vigorous expression in Van Gogh's art.

Van Gogh was Dutch, but the influence of other painters on his art is almost exclusively French. In his early life he tried to work for the church as a missionary in the Belgian mining district, but painting soon absorbed more and more of his time until it became the sole passion in his life and his means of existing in a society from which he was estranged by temperament. He fought this estrangement by trying to form a society of artists with Gauguin as a leader, but was unsuccessful. We see him now as the genius on the edge of insanity, one who was misunderstood in his own time but whose sincerity and intensity of emotion burn through every canvas. [51.112.3 Bequest of Samuel A. Lewisohn]

152 Paul Gauguin. French, 1848–1903. *Ia Orana Maria*. Oil on canvas, 44¾ x 34½". Signed and dated (lower right): P. Gauguin '91; inscribed (lower left): Ia Orana Maria

Ia Orana Maria ("We greet thee, Mary") was one of the first paintings Gauguin made in Tahiti. It shows Tahitian natives with symbols of both their pagan traditions and their newly-learned Christian faith. This painting, the first successful work in the style Gauguin developed in Tahiti, combines the strong, rich colors of the islands with the flat, simplified forms of primitive art. Gauguin's interest in the exotic and the primitive—an interest shared by other romantic artists of the nineteenth century—led to the sojourns in Martinique and Tahiti by which he attempted to escape from European materialism.

In 1883 Gauguin, a prosperous stockbroker and a married man with a family, gave up both career and family to devote his life to art. His early work reflects that of the Impressionists. Later, in association with a group of painters in Pont-Aven in Brittany, he worked in the Synthesist style, in which symbolism plays an important role. In his Tahitian canvases, however, he turned from this intellectually planned method of painting to one that was more spontaneous, more immediately related to the awareness of the moment. [51.112.2 Bequest of Samuel A. Lewisohn]

153 Henri Rousseau. French, 1844–1910. *The Repast of the Lion*. Oil on canvas, 44¾ x 63". Signed (lower right): Henri Rousseau

A trip to Mexico was the high point of Rousseau's uneventful life. He subsequently painted many fantastic jungle scenes, such as this one, with wild animals placed in a tapestry of tropical flora. Models for the luxuriant foliage he found conveniently in the Paris Botanical Gardens.

Le Douanier, as Rousseau was called (he was a minor customs officer), started painting for his own enjoyment about 1880. He had no training in art and his work cannot be classified with any school of painting. He belongs among those painters known as "modern primitives," self-taught artists whose meticulous observations are recorded without benefit of professional training but with a fresh eye and uninhibited imaginative power. His work, discovered by Redon, particularly impressed Gauguin. The so-called Fauves, the group of French artists who favored spontaneous representation, were probably influenced by Rousseau's untutored art. [51.112.5 Bequest of Samuel A. Lewisohn]

154 Anonymous artist. *Christ Sitting by His Cross*. Woodcut from *Geistliche Auslegung des Lebens Jhesu Christi*, printed in Ulm, Germany, about 1485. 4" high

When paper became plentiful in Europe shortly before 1400, Italians and Germans began to print playing cards and sacred pictures from wood blocks, as the Chinese had been doing for some five hundred years. For about a century these first European prints were little more than outline guides for the painter to fill in with water colors. Most were probably designed by the hack illustrators of popular manuscript books. But now and then these Gothic woodcuts, like the one here illustrated, surprise with a pang of tenderness and tragedy. The great masters of painting may well have drawn on such designs for their more celebrated works. [32.68.4 Dick Fund]

155 Anonymous artist. *The Lovers*. Woodcut from *Storia di due amanti* by Pope Pius II, printed in Florence about 1490–1500. 4¼" high

The earliest big buyers of printed books were schools. Priests and lawyers followed. When those markets became glutted in the 1480's, many presses went bankrupt; but some printers, by making profusely illustrated books, opened a fresh market of common readers. Thus the 1490's produced a crop of wonderful woodcuts in Germany, Flanders, France, and Italy. From 1490 to about 1505 Florence created the first big lot of woodcuts, of which *The Lovers* is a splendid example, so rich in black-and-white color that they were never hand painted. Savonarola by his preaching and Botticelli through his art had aroused longings for the unattainable, and the eagerness of the dreams they stirred still trembles in these woodcuts. [25.30.17 Dick Fund]

156 Andrea Mantegna (1431–1506). *The Battle of the Sea Gods*. Engraving made in Mantua, Italy, about 1460–1500. 11" high

Mantegna was the first great painter who engraved a number of copperplates with his own hand and who hired other engravers to copy his drawings on metal. He drew with a graver on copper as freely and boldly as with a quill on paper. His engravings are the earliest prints that do not look in any way quaint or old-fashioned. As *The Battle of the Sea Gods* demonstrates, his work has the plastic quality of great monumental art. His prints were copied throughout Europe on embroideries, shields, and stone carvings. Dürer traced them to perfect his drawing, and both he and Rembrandt put some of Mantegna's figures into their prints. Mantegna's engravings made him the first Italian to affect art internationally. [18.12 and 20.88.1 Rogers Fund]

157 Domenico dalle Greche. Detail from a woodcut after Titian. *Pharaoh's Army Drowned in the Red Sea*. Venice, Italy. 1549. Detail 16" high

This is one of twelve sections made to be pasted together into a woodcut measuring about four by seven feet, a sort of poor man's tapestry. Titian drew for this expanse with the surge of an Italian whose ancestors have always covered walls with decoration. He was the only great Italian artist who often drew for the cheap and popular woodcut. No other woodcuts expand with so swinging a freedom except those that Rubens made following Titian's example. [22.73.3–131 Rogers Fund]

158 Master I. A. of Zwolle, Holland (active 1485). *Saint George and the Dragon*. Engraving made about 1475–1500. 8⅛" high

Goldsmiths have been engraving designs on metal cups and dishes for several thousand years, so it is natural that they should have been the first to think of inking engraved grooves and printing the design on paper. The first such engravings were probably printed along the lower Rhine around the 1440's. This *Saint George* was engraved in Holland, probably near Haarlem. It swaggers with the vitality of Dutch medieval art, most of which was burned during the religious wars. [33.54.6 Dick Fund]

159 René Boyvin (1525–1598). *Masquerade Costume*. Engraving made in Paris or Fontainebleau about 1540–1580. 12¾" high

The sack of Rome in 1527 disrupted the papacy and impoverished Italy. Many younger Italian artists found employment in building and decorating the palace at Fontainebleau for Francis I. There, in the northern forest, they developed the new Italian style called Mannerism into its Michelangelesque acrobatics and attenuations, its deliberate avoidance of emotion, and its gorgeous ornamentation. Mannerism was the first predominantly secular style for a thousand years, and could have occurred only at a moment when the Church had temporarily ceased to inspire and direct art. The diffusion of Italian influence in France was accelerated by such artists as Boyvin who reproduced many paintings by Italian Mannerists. [47.7.3 Dick Fund]

160 Giorgio Ghisi (1520–1582). *Ceiling Decoration*. Engraving after Primaticcio, made in Italy about 1550–1582. 11¾″ high

This engraving belongs to the school of Marcantonio Raimondi, the first great engraver who made a profession of copying other men's drawings and paintings. After Marcantonio, most engravers spent their lives reproducing paintings until photography took on the task in the later nineteenth century. Marcantonio and his followers engraved hundreds of designs by Raphael and his school. These cheap, portable engravings carried the Italian Renaissance style to its sudden triumph throughout Europe. [49.95.161 Whittelsey Fund]

161 Martin Schongauer (1440/5–1488/91). *Saint Sebastian*. Engraving made in Colmar, Germany, about 1480–1491. 6¼″ high

Schongauer's engravings are the earliest that survive in quantity because they have always been treasured. He is the first northern engraver who is also known as a painter. The Rhine, on which he lived, brought him the manners and the elegance of all Europe. He engraved and painted with the supple courtliness of the Flemish Rogier van der Weyden, and refined the Gothic style to its last dying delicacy. [51.516.2 Dick Fund]

162 Albrecht Dürer (1471–1528). *The Four Horsemen of the Apocalypse*. Woodcut made in Nuremberg, Germany, 1498. 15¼″ high

The Apocalypse series are the first woodcuts that have a black-and-white color as varied and shaded as engravings. They excite with a violence that Dürer never equaled afterwards, for he painfully worked away from his native Gothic agitation, so forcefully expressed in the cut illustrated, toward an acquired Italianate balance. He thus became the only artist who created great pictures in both the Gothic and the Renaissance manners. At every stage of his development he drew for woodcuts. His success induced most German painters of the 1500's to make woodcuts also. [19.73.209 Gift of Junius S. Morgan]

163 Rembrandt (1606–1669). *The Three Crosses*. Etching made in Amsterdam, Holland, 1653. 15⅜″ high

The young Rembrandt studied expression by drawing ham-actor grimaces that he made in the looking glass. As he matured he learned to express emotions with less and less outward show until he became the world's supreme master of the quiet statement. This etching illustrates Christ's last hour: "Jesus, when He had cried again with a loud voice, yielded up the ghost. And, behold, the veil of the temple was rent in twain from the top to the bottom; and the earth did quake, and the rocks rent; and the graves were opened; and many bodies of the saints which slept arose" (Matthew xxvii: 50-52). This print is one of the masterpieces of all Western art. Here is a climax of Rembrandt's mighty self-searching struggle for cohesiveness and unity —for ultimate simplicity—in the presentation of his thought. Few pictures made before or since surpass it in concentrated, undeviating dramatic intensity. [41.1.32 Gift of Felix M. Warburg and his family]

164 Peter Paul Rubens (1577–1640). *Saint Catherine*. Etching made in Antwerp, Belgium, about 1610–1640. 11⁵⁄₁₆″ high

Rubens advertised many of his paintings by having them reproduced in big engravings and woodcuts. He showed the engravers and woodcutters how to achieve a colorful sweep of line. This etching of Saint Catherine is probably the only print that he made with his own hands. It reproduces part of the ceiling (since burned) that he painted in the Jesuit church in Antwerp. It swings upward with a grander bulk than any other etching of its time. [22.67.3 Rogers Fund]

165 Eugène Delacroix (1798–1863). *Wild Horse Attacked by a Tiger*. Lithograph made in Paris in 1828. 8⁵⁄₁₆″ high

Artists have drawn and carved lions downing their prey since Mesopotamian art over four thousand years ago. Delacroix was certainly thinking of Greek works and of Rubens when he drew this superb lithograph. He was one of the greatest of the early lithographers (and also the greatest French Romantic painter) and he has here made an old subject as new and vivid as a fresh flame. [22.63.43 Rogers Fund]

166 Francisco José de Goya y Lucientes (1746–1828). *Ni por esas* ("Not even for these women"). Etching made in Madrid, Spain, about 1811. 6⁵⁄₁₆″ high

From 1808 to 1814 every Spanish man, woman, and child fought Napoleon's soldiers hand to hand. The stabbing reprisals, the breathless desperation drove Goya to etch and paint the most anguishing works of art that ever came out of any war. Though this etching shocks like a war snapshot, it is constructed with baroque erudition. Because Goya was educated in the eighteenth century, he drew with a reticence—even a seductiveness—that drives his visions home. [32.62.19 Dick Fund]

167 Moreau le Jeune (1741–1814). *Les Adieux*. Engraving made by Robert de Launay in Paris, 1777. 10″ high

The kings of France maintained a constant staff of craftsmen to furnish and decorate their palaces and theatres, and to supply them with clothes, books, and pictures. In time these craftsmen learned to collaborate so smoothly that one man's work blended without a break into another's. To make a print one artist sometimes drew the design on paper, a second etched the outlines on a copperplate, a third engraved the shadings, and a fourth added the lettering. Eighteenth-century French craftsmen contrived as delicate an urbanity as the eighteenth-century Chinese. Moreau's engraving here illustrated is one from a celebrated set, published "avec privilège du Roi," which was to serve as a history of the manners and costumes of France in the eighteenth century. [34.22.1 Purchase]

168 Honoré Daumier (1808–1879). *Peace*. Lithograph made in Paris March 6, 1871. 9¼″ high

Daumier taught himself to draw by sketching from Greco-Roman marbles in the Louvre. In the course of making about three thousand lithographs for daily papers he discovered pictures in the Paris sidewalks, the backstage of theaters, the kitchen, and the railroad station, and he handed on these subjects to Manet, Degas, Lautrec, and Bonnard. He learned to draw as powerfully as the greatest. Toward the end, he achieved a compassion so fundamental that his pictures fit any time of trouble. [22.61.275 Rogers Fund]

169 Pen drawing of mirror designs for Chippendale's *Gentleman's and Cabinetmaker's Director*, London, 1754. 11″ high

Chippendale's *Gentleman's and Cabinetmaker's Director* affected more furniture than any other book printed in English. Either half of this design might have suggested a frame to a carver in London, Boston, Lisbon, or Mexico City. Before factory production standardized a series of frames or lace collars, a craftsman would vary each frame or collar by borrowing ideas from designs engraved by professional designers. These so-called "ornament" prints show where and when styles originated, and how they traveled from place to place. Illustrated here is one of the original drawings from which Chippendale's plates were engraved. [20.40.1–2 Rogers Fund]

170 *Andiron Surmounted by a Figure of Mercury*. Attributed to Alessandro Vittoria (1525–1608). Italian (Venetian), late sixteenth century. Bronze, 36⅛″ high

A contemporary of the aged Titian and of Tintoretto, Alessandro Vittoria worked prolifically, producing sculptural monuments for the Venetian church and state, portrait busts of rare realism, and even smaller sculptures in bronze. Among the latter were utilitarian objects such as the magisterial bronze andiron capped by the figure of Mercury. With an-

other andiron which is surmounted by Orpheus, this notable bronze gives expression to the sculptural art of Venice's proudest epoch. [41.100.91a, b Gift of George Blumenthal]

171 Kunz Lochner. *Armor for Man and Horse.* German (Nuremberg), dated 1548. Steel. Knight's armor 5'5" high

The knight's armor belonged to a member of the Liechtenstein family, the horse armor to Johann Ernst, Duke of Saxe-Coburg. This is the finest horse armor in the Metropolitan Museum. The embossed letters on the peytrel may be read: *Ich traue Gott von ganzem Herzen, Johann Ernst Herzog zu Sachsen* ("I trust in God with all my heart, Johann Ernst, Duke of Saxony"). Both the knight's armor and the horse armor are dated 1548; both bear the Nuremberg guild mark; and both are thought to be the work of Kunz Lochner (1510–1567), the foremost armorer of the Renaissance, whose mark appears on the knight's armor. [Knight's armor, 29.151.2 Gift of Mrs. Bashford Dean] [Horse armor, 32.69 Rogers Fund]

172 Benvenuto Cellini. *Cup of Gold, Enamel, and Pearls* (the "Rospigliosi Cup"). Italian (Florentine), sixteenth century. 7¾" high

The maker of this fabulous cup was Benvenuto Cellini, whose autobiography describes his vivid career as goldsmith, sculptor, and adventurer. Like his bronze Perseus in Florence, his silver saltcellar (made for the French king, Francis I) now in Vienna, and his numerous medals designed for the papal mint, this piece, over-ornate perhaps to modern eyes, reveals the pagan splendor of the Renaissance. It is of gold with brilliantly colored enameled details in the supporting figures of tortoise and dragon and in the arabesques decorating the shell-shaped dish. Light reflects from the shell's gold interior, to play on the beautifully modeled and enameled sphinx with her three large pendant pearls. [14.40.667 Bequest of Benjamin Altman]

173 *Maiolica Dish Bearing the Emblem of the Visconti-Sforza Family.* Italian (Florentine), about 1480. Diameter 15"

This large armorial dish of Italian Renaissance maiolica was made in Florence for Milan's Visconti-Sforza family, art patrons like their friends the Medici of Florence. The porous earthenware is glazed with an opaque, white tin enamel against which a blue, ocher-spined serpent devouring a child rears up as the emblem of these noble rulers. The rim's whirling circle of diagonal leaves emphatically encloses the irregular central panel and its active occupant, echoing their spirit of animation. Touches of green and manganese purple and variations of scale contribute further to the effect of vitality. [46.85.16 Fletcher Fund]

174 *Harpsichord of Gilded Wood.* Italian (Roman), seventeenth century. 8'9" long

This harpsichord was once part of the collection of Michele Todini of Rome. In a catalogue written by him in 1676—one of the earliest published guidebooks of a private collection of musical instruments—it is called "la machina di Polifemo e di Galatea." Of the two flanking figures, Polyphemus holds a bagpipe and Galatea originally held a string instrument, probably a lute. These two instruments symbolize the two extremes of music: orgiastic wind music connected with Dionysos and music produced by strings based upon the mathematical ratios discovered by Pythagoras. [89.4.2929 Gift of Mrs. John Crosby Brown]

175 Jean Henri Riesener. *Secretary.* Ebony with panels of black and gold lacquer and gilt-bronze mounts. Made for the royal Château of Saint-Cloud and bears the cipher of Marie Antoinette. French, period of Louis XVI (1774–1793). 4'9" high

This resplendent piece of royal furniture once adorned the Château of Saint-Cloud, one of the elysiums where Queen Marie Antoinette whiled away the prodigal hours until the Revolution. The luxury and superfluity of the age are implicit in the richness of this desk; craftsmanship and taste have never been more refined. The queen enjoyed flowers, particularly roses and cornflowers, and here we find these and other varieties in ormolu swags and friezes exquisitely chiseled. The exuberance of the Louis XV style has quieted, and the style named after Louis XVI is here manifested in sobriety and great magnificence. [20.155.11 Bequest of William K. Vanderbilt]

176 Jean Antoine Houdon. *The Bather.* Marble statue made for the Duc de Chartres' gardens at the Château de Monceaux in Paris. French, period of Louis XVI (1774–1793), dated 1782. 47" high

The marble *Bather* superbly exemplifies the genius of Jean Antoine Houdon, France's leading sculptor during the late eighteenth century. It is a fountain figure, and was originally accompanied by a standing Negress in lead who poured water over her mistress's shoulders. It was made in 1782 at the order of the Duc de Chartres for the gardens of his Château de Monceaux in Paris. [14.40.673 Bequest of Benjamin Altman]

177 Aristide Maillol (1861–1944). *Female Torso.* French, 1929. Bronze, 47" high

The original model for this torso was an heroic full-length figure of a woman, *Chained Action,* designed by the contemporary French sculptor Maillol, as a monument to the nineteenth-century French revolutionist Louis-Auguste Blanqui and placed in the latter's native village of Puget-Théniers. This bronze with its green patina is one of three replicas of the figure's torso; the other two, one in the Tate Gallery, London, are of lead. [29.138 Fletcher Fund]

178 Antoine Sigalon. *Pilgrim Bottle.* Lead-glazed earthenware, bearing the arms of John Casimir of Bavaria, count palatine of Simmern (1543–1592), and his wife. French (Nîmes), 1581. 15" high

This French document of the Religious Wars bears the arms of a noble Bavarian Calvinist, John Casimir, whose ambassador was in southern France in 1581, when the Reformed Churches of Languedoc met at Nîmes. The Nîmes decorator, Sigalon, himself a Huguenot deacon, satirized Catholicism in the two grotesque figures holding rosaries and maniples, substituting them for the usual heraldic supporters of coats of arms. The mask handles, the scroll and foliage designs, and the colors—yellow, white, green and orange on a blue ground—reflect contemporary Italian maiolica styles; but Sigalon's satire is as French as that of Rabelais. [41.49.9a, b Lee Fund]

179 *Artist and Scholar Being Presented to the Chinese Emperor.* German, about 1765. Porcelain group, 15⅝" high

Under the patronage of the Elector Emmerich Joseph, the factory at Höchst produced porcelain rivaling that of the better known factories at Meissen and Sèvres. This composition of draperies, scrolls, and oriental figures was originally a table decoration, produced when porcelain, long made in China but only recently discovered in Europe, was still a new and costly luxury at European courts. Such imaginary compositions reflect the elegant "chinoiserie" then fashionable throughout Europe. Subtly balanced scrolls express the lively, witty rococo spirit which was as popular in porcelain as in Mozart's music. [50.211.-217 Gift of R. Thornton Wilson in memory of Florence Ellsworth Wilson]

180 Jean Baptiste Lemoyne. *Louis XV of France.* Marble bust, once in the possession of Madame de Pompadour. French, dated 1757. 34¼" high

Both the glories and the tragedies of the French Bourbon kings are inherent in this marble bust of Louis XV by his favorite sculptor. This was one of many royal portraits by Lemoyne, who also furnished garden sculpture for Versailles. The king's coiffure and armor, his Orders of the Saint-Esprit and Golden Fleece, and his sweeping drapery all lend regal dignity to realism. Politically, Louis' long reign (1715–1774) continued the turmoils which culminated in the French Revolution. Stylistically, it encompassed first the frivolous rococo style, then the new classicism of Paris' Place de la Concorde (then called Place Louis XV), and of Versailles' Petit Trianon. [41.100.244 Gift of George Blumenthal]

181 *Intarsia Paneling* in the private study of Federigo da Montefeltro, Duke of Urbino, from the ducal palace at Gubbio. Italian, about 1479–1482. Paneling 9' 7" high

Perhaps the most complete and telling example of Italian Renaissance art in America, this small study or *studiolo* would be almost unique even in Italy. There is indeed only one other like it, a room which is known as its twin and which is still preserved *in situ* in the

236

ducal palace at Urbino. This Urbino room and the Metropolitan's *studiolo,* which was made for the ducal palace of near-by Gubbio, were actually ordered by the same man, a celebrated man of the Renaissance, a condottiere and humanist, Federigo da Montefeltro, Duke of Urbino.

As a thorough-going son of his times, Federigo was interested in rare manuscripts, the arts, and the sciences, as well as in military affairs. All his multifarious interests are still reflected in the cupboards of the *studiolo,* which are inlaid in intarsia work (marquetry) in a manner calculated to preserve forever the appearance of the study just as it was when Federigo was using it. [39.153 Rogers Fund]

182 The Angel of the Annunciation. Matteo Civitali (1436–1501). Italian (Lucca). From a terracotta group. Second half of the fifteenth century. 51½″ high

The Angel of the Annunciation is by general agreement considered to be a major work by Matteo Civitali (1436–1501). On the other hand, only a very few Italian sculptures of the fifteenth century are signed or unquestionably documented. It is not surprising, therefore, that there is no certainty that *The Angel* is indeed by this master.

Civitali worked chiefly in the Tuscan city of Lucca; and the Metropolitan's *Angel* conforms to the sculptor's style as it is known through researches in the field of art. If it is by Civitali, it is surely a great example of his work. Yet it first came to light a number of years ago in Florence, and it recalls in various ways the work of the celebrated Florentine master Donatello. Among the latter's most famous creations is the stone relief of the Annunciation in the Florentine shrine of Santa Croce. There is an undeniable resemblance between *The Angel of the Annunciation* from the Santa Croce relief and the *Angel* in the Metropolitan attributed to Civitali. The latter could of course have been made by Matteo Civitali after the Donatello model. There is also the possibility that it could have been the work of a Florentine master possessed of a talent even greater than that of Civitali. In any event, it is an extraordinary example of early Renaissance sculpture and we can do no wrong in valuing this sculpture solely on its own very conspicuous merits. [11.97 Hewitt Fund]

183 The Virgin and Child. Terracotta relief, painted and gilded, by Andrea del Verrocchio (1436–1488). Italian (Florentine), fifteenth century. 30½″ high

Andrea del Cione, called Verrocchio (he would have been called Andrew True-Eye in England), was one of the leading Florentine artists of the second half of the fifteenth century. Like his eminent colleague, the sculptor Antonio Pollaiuolo, Verrocchio had first been a practicing goldsmith. Interestingly enough his works in painting and sculpture continued to reflect the goldsmith's point of view, just as those of the modern French painter Rouault reflect his early training as a stained-glass worker. In Verrocchio's relief of *The Virgin and Child,* a work in painted terracotta, the refined manner in which the smallest details are executed, and the delight with the representation for its own sake of subordinate parts of the composition, such as the robe of the Virgin, proclaim the goldsmith.

As one of the progressive leaders at a time when Florentine art was uniquely conceived as a scientific study, Verrocchio was ever involved with the problem of the correct anatomical rendering of the human figure. In this respect, note the skillful yet sensitive treatment of the Child's body and the Virgin's hands. Verrocchio was also the contemporary of such painters as Botticelli and Ghirlandaio, whose Madonnas bear a more than coincidental likeness to the lovely figure on the Metropolitan's relief. [09.215 Rogers Fund]

184 The Crucifixion. Tapestry woven in silk, wool, and metal threads, probably after a design by Bernard van Orley (1491/2–1542). Netherlandish (Brussels), about 1515–1525. 8′ 3″ high

When Charles V of the Holy Roman Empire (he was Charles I of Spain) ascended the throne in 1519, the Netherlands for more than a century had been weaving Europe's finest tapestry wall hangings. This characteristically northern art throve mightily under the patronage of the Hapsburgs. For tapestries were then considered to be part of the paraphernalia of royalty and served a very real purpose in the days when the monarchic principle was a mighty force. Many tapestries, richly woven in wool, silk, and silver and gold threads, were commanded for Spain, where Charles, and later his son Philip II, maintained his court. As a result the Spanish national collection, created in this manner by Hapsburgs, is now rivaled only by the collection in Vienna; and that too was a Hapsburg foundation.

Eminent artists such as Bernard van Orley were commissioned to supply designs for the tapestries, and famous weavers such as Van Aelst and Van Pannemaker were called upon to manufacture them. Van Orley was the designer of the *Crucifixion* tapestry, which is as fine and as rich an example as any of the period. Significantly enough, it too was made for Spain. It belonged not to royalty, however, but to Spain's most illustrious ducal family, that of Berwick and Alba. [41.190.136 Bequest of George Blumenthal]

185 Summer. Embroidered hanging from a series representing the seasons and elements. French, period of Louis XIV; executed about 1685 at the Maison des Filles de la Providence in Paris. 14′ 6″ high

French art of the period of Louis XIV revolved without any deviation about the person of the Sun King. Louis, who said, "L'Etât c'est moi," could have as truly proclaimed, "L'Art c'est moi." The result was the development of an official style of the highest competence, always impressive, on occasion majestic, and frequently dull.

He pressed into his service all the arts, even that of the embroiderers. The needlework hanging of *Summer* is an example; it is one of a series of eight panels of the four Elements and the four Seasons made to honor the King, Mme. de Montespan, and their six children. The panel of Summer represents their daughter Mlle. de Nantes in the guise of Ceres. The three other panels in the Museum are of Louis XIV himself as Air, Mlle. de Blois, another daughter, as Spring, and a young son, the Conte de Vexin, as Fire. Apparently the entire series was made about 1683 or 1684 in the Community of Saint-Joseph-de-la-Providence, a school for the training of poor girls of which Mme. de Montespan was founder and patroness. The work itself is done in petit-point and other stitches and may be after designs by Charles Le Brun, the king's director of fine arts. [46.43.2 Rogers Fund]

186 Bedroom from the Palazzo Sagredo, Venice. Italian, about 1718. The stuccowork decoration of putti, etc. is probably by Carpoforo Mazzetti and Abondio Statio

Eighteenth-century Venice was the Monte Carlo of Europe. Most of the city's year was then given over to the celebration of Carnival, an elastic institution that could be revived for any occasion on a moment's notice. The Venetian "tourist season," for such it was, was indeed an unending affair, and joy was unconfined, except among the masses who for a century had been suffering from an ever-increasing decline in trade. Many of the great families existed on a diminishing reservoir of wealth that had been accumulated during the earlier days of Venice's political and economic power. Perhaps encouraged by the false atmosphere of Carnival, these families continued to spend lavishly.

This bedroom from the Palazzo Sagredo, which faced on the Grand Canal, is an example of the brilliant, extravagant style to be found in that fabulous city during the final century of its freedom. For those with an eye for details: the stuccowork, which figures so prominently in the decoration, was probably made in 1718 by Carpoforo Mazzetti of Vissone and Abondio Statio of Massagno; and the painting of Dawn on the ceiling is believed to be the work of Gasparo Diziani of Belluno. [06.1335.1a-d Rogers Fund]

187 Armoire of walnut, painted and gilded. In the style of Hugues Sambin (about 1520–1602). French (Burgundian School), mid-sixteenth century. 97″ high

As late as the beginning of the sixteenth century France was still wedded to the Gothic style. Then in a few short decades the Gothic gave way to the Renaissance, which surged like a conquering invader from its birthplace, Italy. The French quickly took to the Renaissance, and their enthusiasm for it was ever stimulated by the example of their rulers, Francis I and his successor, Henry II, who, as well as they could, made over France in an Italianate manner.

The Metropolitan's armoire shows how completely the spirit of the Renaissance left its mark on even the decorative arts. Was there ever a Renaissance cabinet in Italy that was so richly decorated? Sculptured classical motives occupy every available space: satyrs, nymphs, Roman warriors, sphinxes, and all the rest of the horde with which Renaissance dreams were peopled. Where there is an area

on the exterior of the armoire not carved in relief, the painter has added ornament details to keep the object from seeming the least bit undecorated. Even the interior is painted, and most skillfully, with classical and allegorical figures in the Italianate Fontainebleau style. The armoire is said to have been made in honor of the marriage of Diane de France, the natural daughter of Henry II, and the Italian soldier Orazio Farnese, Duke of Castro; ciphers which seem to be theirs are found on it. It is truly a noble enough piece for such a gift, and may well be the work of Hugues Sambin, the chief cabinet maker of the Burgundian school. [25.181 Rogers Fund]

188 *An English Ecclesiastic,* said to be Saint John Fisher, Bishop of Rochester. Painted terracotta bust, probably by **Pietro Torrigiano** (1472–1528). Italian (Florentine), early sixteenth century. 24¼″ high

Pietro Torrigiano, the sculptor to whom this painted terracotta bust of an English Ecclesiastic is generally attributed, was one of the Italian artists who did so much to bring the Renaissance to all of Europe. But even before he had made a single important piece of sculpture, he did a thing which gave him more fame than any of the sculptured works of his mature years. During his student days in Florence he had got into a fight with another student, Michelangelo Buonarotti. The mark of that encounter, a shattered nose, was to remain with Michelangelo throughout his life.

Torrigiano's career was that of a wanderer. He resided in Spain and Portugal, leaving in both places sculptures of respectable quality in the Renaissance manner. He spent a number of years in England, where among other monuments, he made the tomb of Henry VII in Westminster Abbey.

The bust is presumed to be that of Saint John Fisher and is one of three sculptures said to have come from the famous Holbein Gate in Whitehall. A second portrait, that of Sir Henry Guildford, is also in the Metropolitan Museum. A third, the portrait of Henry VII, is in the Victoria and Albert Museum in London. [36.69 Dick Fund]

189 *Buddhist Altarpiece.* Gilt-bronze. Chinese, sixth century. 23¼″ high

A large number of miniature images of Buddhist deities, cast in bronze and usually plated with gold, have survived from the sixth and seventh centuries, but complete or nearly complete altarpieces such as the one shown here are exceedingly rare, only three having been discovered to date. Two of these are in the Metropolitan Museum; the third is in the Museum of Fine Arts, Boston.

Although made of heavy metal, these altarpieces are so cleverly wrought as to give an impression of ethereal lightness. The fluttering scarves and draperies of the figures and the upswept flames of the halo suggest a moment of time caught and transfixed forever. [38.158.2 a-g Rogers Fund]

190 *Buddhist Traveler's Shrine.* Wood. Chinese Turkestan, T'ang Dynasty, 618–906 A.D. 14¼″ high

This serene and youthful representation of the Buddha owes much of its charm to the medium in which it was carved, which now has the quality of a great ivory. The sculpture is the central part of a traveler's shrine found in Central Asia. The style of the figure is strongly Hellenistic, and it has been suggested that this treatment may have originated in northern India, where Graeco-Roman influence was prevalent.

One can imagine that the sculpture was a symbol of faith and courage to its owner during lonely travels through the Central Asian deserts. [29.19 Fletcher Fund]

191 *Head of a Buddha.* Stucco. Chinese Turkestan, T'ang Dynasty, 618–906 A.D. 7¼″ high

Modeled in stucco and coated with gesso, this appealing little head of Buddha has, through the centuries, taken on a texture more gleaming and more lovely than ivory.

The head comes from an area in Central Asia where the influence of Gandhara (a district in northern India) was prevalent, an influence which was strongly touched with Hellenism. It is considered to be one of the finest works of art as yet discovered in Central Asia. [30.32.5 Rogers Fund]

192 *Pottery Vase.* Tz'u Chou ware. Chinese, Sung Dynasty, 960–1280 A.D. 12½″ high

Although not one of the famous "classical" wares made during the Sung dynasty for imperial use, Tz'u Chou pottery constitutes one of the largest and most decorative ceramic categories of the period. It is usually characterized by bold, incised and painted designs in black, brown, or rust-red on a white or cream-colored ground. Semi-conventionalized floral patterns similar to that of the jar illustrated here were popular with the Tz'u Chou potters, but many of the smaller pieces have enchanting bird and animal designs which add variety to this distinctive ware. [25.65 Rogers Fund]

193 *King Peroz I* (457–483) *Hunting Ibexes.* Silver dish, partly gilded, with niello inlay. Persian, Sasanian period, fifth century. Diameter 8⅝″

The vitality of Sasanian pictorial art is evident in this hunting scene. King Peroz sits majestically on his galloping horse, wearing his massive crown, surmounted by a crescent and a celestial globe symbolizing the divinity of the royal person. He is thus, in oriental fashion, glorified as the supreme hunter. In accordance with the conventions of Near-Eastern art, front and side views are sometimes combined; for example the horns of the ibexes are shown front view while the animal itself is in profile. [34.33 Fletcher Fund]

194 *Detail from a Wall Hanging.* Wool tapestry on linen. Coptic, about 400 A.D. Found at Antinoë. Detail 10″ high

Themes from Graeco-Roman mythology were common in Coptic art of the third to the fifth century. Three rows of medallions set with busts of figures from a Bacchanal and framed by interlacing vines appear in this wall hanging from Antinoë. The Bacchante illustrated and other figures in this hanging are rendered in naturalistic colors derived from the Hellenistic style. Its technique, particularly the method of shading colors, foreshadows the medieval tapestries of Europe. [31.9.3 Gift of Edward S. Harkness]

195 *Egrets in a Landscape.* Detail from a Marsh Scene with Birds. Handscroll painting in ink on paper. Attributed to Shên Chou (1427–1509). Chinese, Ming Dynasty, 1368–1644 A.D. 11½″ high

The snowy egrets seen here are but a pair of bystanders in a lively convocation of birds. Paired pheasants and ducks, wagtails, kingfishers, and wild geese soar in the air or disport themselves among the reeds in characteristic fashion; an angry goose swooping down on a startled crab provides a bit of humor in this otherwise placid nature study.

The subject is treated in a calligraphic kind of painting which is executed at top speed in order to achieve an unbroken rhythm and which is therefore less concerned with exquisite detail than with the dynamic liveliness that is here apparent. [47.18.7 Fletcher Fund]

196 *Enameled and Gilded Glass Bottle.* Syrian, Mamluk period, about 1320 A.D. 17⅞″ high

This large bottle, formerly in the Imperial Hapsburg collection in Vienna, is one of the masterpieces of medieval Islamic glass. Its surface is almost entirely covered with enameled decoration in jewel-like colors or delicate gilt tracery. Intricate arabesques on a lapis-lazuli blue ground fill three large medallions on the shoulder. The broad band of equestrian warriors probably represents a battle between the Mamluks and the Mongols. [41.150 Rogers Fund]

197 *Bronze Ewer.* Decorated in relief, engraved and inlaid with silver. Persian (Khurasan), Saljuk period, early thirteenth century. 15½″ high

The shape and style of decoration of this fine ewer, formerly in the J. P. Morgan collection, are characteristic of the twelfth- and early thirteenth-century work of the province of Khurasan in eastern Persia. The all-over design of interlacing, the animals' heads used as endings for letters in inscriptions, and the bands of signs of the zodiac are typical of Saljuk art. [44.15 Rogers Fund]

198 *Incense Burner in the Shape of a Feline.* Bronze, with openwork decoration. Made for the Amir Saif ad-din Muhammad al-Mawardi by Ja'far, son of Muhammad, son of 'Ali, and dated 577 A.H. (1181–1182 A.D.). Persian (Khurasan), Saljuk period. 33½″ high

Bronze bird and animal incense burners were very popular during the Saljuk period. A mag-

238

nificent example is this feline, which once spread clouds of incense through the Amir's palace. It is comparable in size to the bronze griffin in the Campo Santo at Pisa. Cast in several sections, then welded together but with the head left removable, it is pierced and engraved with beautifully designed ornament and inscriptions. [51.56 Rogers Fund]

199 Carved Panel from a Wooden Door. Egypto-Arabic, Fatimid period, eleventh century. 13¾" high

The decorative quality of this beautifully drawn symmetrical arabesque pattern and its deep cutting are typical of the Fatimid art of Egypt. The horses' heads form an integral part of the abstract design. Rounded beveling gives variety by softening some of the contours, and delicate chiseling and punchwork ornament the surface. This panel and similar ones were set in a door of the palace of one of the Fatimid caliphs. [11.205.2 Rogers Fund]

200 Kuan Yin. Polychromed wood. Chinese, late T'ang Dynasty, 618–906 A.D. 43" high

Although sculpture in China has always been anonymous and the expression of religious fervor rather than a purely creative art, many of the early Buddhist sculptures are highly accomplished and have a direct emotional appeal comparable to that of the famous medieval church sculptures of the West.

The earliest religious sculptures of China are in or from the great Buddhist rock temples of Kansu, Shansi, and Honan provinces. There, working in the living rock, Chinese sculptors of the fifth and sixth centuries gradually progressed from relief carvings to semi-round, and eventually mastered the full-round technique, a technique hitherto alien to the linear tastes of Chinese artists.

In the T'ang dynasty, free-standing sculpture came to full maturity, the figures of the Buddhist deities becoming well-articulated, the scarves, draperies, and jewelry imbued with easy grace. Some of the loveliest sculptures of this period, such as the ninth-century figure of Kuan Yin shown here, were carved in wood, then painted in glowing colors highlighted with gold. Only faint traces of the original polychromy of our figure have survived the centuries, but the serene and noble bearing of this great deity, the Bodhisattva of Compassion, is as appealing today as it must have been eleven centuries ago. [42.25.5 Gift of Mrs. John D. Rockefeller, Jr.]

201 Bronze Ceremonial Vessel (kuang). Chinese, Shang Dynasty, 1523–1028 B.C. 12" high

The bronze vessels used in ancient China for ceremonies in honor of ancestors, in commemoration of great events, and in propitiation of the forces of nature, vary greatly in shape, size, and style of decoration. Such variation was, however, in no wise accidental or the result of a bronze-caster's whim. Within a given period each vessel for food, wine, or water was created according to a prescribed formula, and its function was perfectly understood by those who participated in the sacrificial ceremonies.

Western scholars who have studied the language and early literature of China have added greatly to our knowledge of these bronzes. Many of the vessels have inscriptions cast in the bronze, and although these inscriptions rarely include specific dates, they frequently name families or events which can be identified, thus providing clues to the dating. Using the inscribed bronzes as key pieces, scholars have been able to assign tentative dates to most of the known vessels on a stylistic basis.

One of the simplest and grandest in the whole galaxy of Chinese bronzes is the wine vessel illustrated here, but because of its simplicity it is difficult to date on stylistic grounds. The almost primitive rendering of the animal-head cover has no known parallel, but the fact that the vessel was found in or near Anyang, the site of the Shang capital, strengthens the impression that this is one of the earliest ceremonial bronzes yet discovered. [43.26a, b Rogers Fund]

202 Covered Jar. Famille noire porcelain. Chinese, early K'ang Hsi period, 1662–1722 A.D. 25" high

Color, it has been said, is the master quality which distinguishes Chinese porcelain from the ceramic wares of other countries. To the admittedly prejudiced specialist in Far Eastern art, this would seem to be understating the artistic merits of Chinese ceramics. Surely no country in the world has ever achieved more beautiful shapes, more luscious glazes, or conceived more enchanting bird and flower themes with which to decorate their wares. Two or three centuries ago European potters began to copy and adapt every trick of the Chinese ceramist, and they have, over the years, created beautiful things galore, but rarely have they attained that quintessence of perfection that distinguishes the work of China's great potters.

The elegant porcelains of seventeenth- and eighteenth-century China, of which this stately jar is a fine example, represent the culmination of more than a thousand years of constant experimentation with colors and glazes. Tall, slender vases decorated in vivid colors with birds and flowers and small, exquisitely modeled pieces rendered in monochrome, which came from the imperial factories by the thousands, caught the European fancy to an extraordinary degree during the eighteenth century. In fact, the pretty names by which many of these wares are now known originated in the drawing rooms of France, where proud owners chattered happily about their fine famille verte, famille noire, famille rose, famille jaune, their evanescent clair de lune, their delicately mottled peachbloom, and their flamboyant sang de boeuf. American museums are now avid collectors of these wares, and the group in the Metropolitan Museum is one of the finest in the West. [14.40.60a, b Bequest of Benjamin Altman]

203 The Tribute Horse. Detail from a painting on silk. Chinese, Sung Dynasty, 960–1280 A.D. 32⅜" high

Closely guarded by armed outriders and by two warriors whose helmets, banners, and

richly caparisoned mounts proclaim them to be Tatars, this magnificent snow-white charger from the steppes of Central Asia moves proudly through rocky mountain gorges toward his ultimate destiny, the service of an emperor.

The majestic landscape which provides an austere and splendid background for this glittering procession is, by traditional Chinese standards, an unusual setting for a scene such as this. In their great landscape paintings, early Chinese artists usually demonstrated the relative unimportance of man by reducing him to a pinpoint, yet here, the procession shares equal interest with the immortal hills. Nor is this the only unusual feature of the painting. The shaft of sunlight which illumines the tribute horse and the cliff behind him is obviously intended to focus attention sharply on this detail of the painting. Highlighting of this sort is so untraditional with Chinese artists as to be almost inexplicable, unless we assume that we have here a painting of an emperor's favorite charger, executed at his command by a talented and tactful court painter. Like many of the early paintings of China, it is unsigned, but that it is the work of one of the great Sung masters is apparent in every brush stroke. [41.138 Rogers Fund]

204 Spring Morning at the Palaces of Han. Detail from a handscroll painting on silk. Chinese, Sung Dynasty, 960–1280 A.D. 6⅜" high

Although monochrome ink landscapes, that is, landscapes painted in myriad variations of black, have from earliest times been highly esteemed by the Chinese, paintings in full color have had an equally long and honorable tradition in China. In particular, blue and green landscapes—an arbitrary classification invented by the Chinese for landscapes in which these colors predominate—became popular as early as the seventh century A.D. Thereafter many of China's greatest artists became famous for their blue and green landscapes, their biographers taking care to note this fact for posterity.

Such an artist was Chao Po-chü (active 1130–1160), to whom the miniature scroll Spring Morning at the Palaces of Han is attributed. The intrinsic loveliness of this little picture of terraced lake palaces, red with blue roofs outlined in gold, set against misty blue and green hills also outlined in gold, and enlivened by tiny figures moving along galleries and bridges—this is a loveliness not translatable in words. Chao Po-chü also painted large and showy blue and green landscapes, several of which are in American museums, where they are highly prized. The Palaces of Han scroll, though similar in style to these Chao Po-chü masterpieces, is a more intimate creation, a gemlike world-in-miniature that only a great artist could have painted. [47.18.4 Fletcher Fund]

205 The Thunder God. Detail from the Tenjin Engi (The Story of Sugawara Michizane). Handscroll painting on paper. Japanese, Kamakura period (1186–1334). 11¾" high

As recorded in the text of the written and painted story of Sugawara Michizane (deified

as Tenjin), Michizane was a poet, Buddhist scholar, and statesman who in the year 900 A.D. became the chief minister of the Japanese Emperor Go Daigo. Intrigue against Michizane began almost at once, and within a matter of months the young emperor had been prevailed upon to banish this eminent man to a distant province.

Michizane spent his few declining years composing sorrowful poems and in prayerful contemplation. Shortly after his death, he was deified as Tenjin, and a shrine was erected in his honor at Kitano in 947.

The thirty-seven scenes of the Tenjin scroll (which is in three parts) depict the principal events of Tenjin's earthly life and subsequent episodes in which his supernatural powers played a part. Thus, in the detail illustrated here, a thunderbolt is seen bringing destruction to the palace and violent death to several of those who had intrigued against the blameless Michizane.

Both the calligraphy and the painting of the scroll are beautifully executed, and are believed to be the work of a thirteenth-century artist. [25.224 Fletcher Fund]

206 Jonah and the Whale. Painting from a manuscript of the Universal History (Jami at Tawarikh) by Rashid ad-Din. Persian, Mongol period, Tabriz school, end of the fourteenth century. Tempera on paper. 12⁹⁄₁₆″ high

The Old Testament story of the prophet Jonah occurs also in the Koran, the sacred book of the Muhammadans. The story was frequently illustrated in Persian histories of the prophets, especially in copies of the Universal History by Rashid ad-Din. The author of the work was not only a historian but also a physician, a public benefactor, and a powerful prime minister at the Persian court. Large copies of this history were illustrated in the art school which he established near the capital city, Tabriz. In our painting "the great fish" carries Jonah in his mouth before casting him on the bare shore. Jonah reaches eagerly for the garment being brought by a swiftly flying angel. The size of the painting shows the influence of Mongol wall painting, and its style is an interesting mixture of Chinese and Persian elements. The figures and the colors are Persian, while the large carp and the landscape are derived from Chinese art. [33.113 Pulitzer Bequest Fund]

207 The Birth of Zal. Painting from a manuscript of the Book of Kings (Shah-nama) by Firdausi. Persian, Safavid period, second half of the sixteenth century. Tempera on paper, 18½″ high

One of the most popular of the books illustrated by Persian painters was the Shah-nama

or Book of Kings written in 1010 by the celebrated poet Firdausi. This great epic poem is based partly on history and partly on ancient legends of Iran. Among the episodes recounted is the story of Zal. Born with white hair, he was left by his father Sam on bleak Mount Alburz to perish. He was brought up by the Simurgh, an enormous bird with magical properties, and was returned to his repentant father to become a great hero and the father of the greatest Persian hero, Rustam.

In the sixteenth century in Persia the art of miniature painting was highly developed and reflected the sumptuous tastes of the court. The rich palette, the great elegance of design, and the decorative quality exhibited in the miniature illustrated here are characteristic of this type of Persian art. [34.72 Dick Fund]

208 Krishna Holding up Mount Govardhan. Painting from a manuscript of the Mahabharata (called in Persian translations, as in this one, the Razm-nama). Indian, Mughal school, period of Akbar (1556–1605). Tempera on paper, 11½″ high

In 1569 the Emperor Akbar started the building of his new capital city, Fathpur Sikri, which became a great center of learning and art. In it was established his personally supervised atelier of more than a hundred artists. The heads of the school and many of its painters were Persians, but the majority were Hindus. The great Hindu epic, the Mahabharata, was translated into Persian and beautifully illustrated in this school. An incident in which Krishna showed his supremacy over Indra, the ancient rain god, is represented in figure 208. When Krishna persuaded the people to worship Mount Govardhan and himself as a mountain god, the angry Indra sent down torrents of rain upon the people of Braj. But Krishna, while in bodily levitation, lifted the mountain in one hand, so that the people were sheltered under it.

The miniature, painted by a court painter of Akbar, shows the developed style of the Mughal school. The colors and the drawing of the rocks are derived from sixteenth-century Persian miniature paintings, but the landscape and the people of Braj are Indian. [28.63.1 Gift of Edward C. Moore, Jr.]

209 Horseman Leading a Mongolian Captive. Detail from a silk brocade. Persian, Safavid period, second half of the sixteenth century. Detail 16½″ wide

The richness and beauty of the brocaded silks and velvets of the sixteenth century matched

the elegance of the carpets and other furnishings of the Persian palaces of the Safavid rulers. The courtiers and nobles were dressed in rich garments made of such brocades as this one. Kashan and Yazd were the great silk centers of Safavid Persia. Many of the beautiful patterns were floral, but a large number were figure subjects in landscapes so closely resembling the miniature paintings of the time that they must have been designed by the painters themselves. The motive or "repeat" of the silk brocade illustrated is composed of a prince on horseback, with a child mounted behind him, leading a Mongolian captive; between them is a plane tree in which a long-tailed pheasant is perched. [52.20.12 Pulitzer Bequest Fund]

210 Silk Animal Rug, detail. Persian (Kashan), Safavid period, mid-sixteenth century. Detail 36½″ high

The finest Persian carpets ever made were woven in the sixteenth century in the court manufactories established by the rulers of the Safavid dynasty for the use of the court and the nobles. The finest ones were made of silk in the city of Kashan. On many occasions they were given as presents to foreign rulers. Among the gifts brought by the Persian ambassador to Constantinople on the occasion of the accession to the throne of Selim II (1566) were twenty large and many small silk carpets decorated with birds, animals, and flowers. The Altman silk rug is decorated with animals single or in combat, placed in a mountainous setting. Pheasants perch in the trees and frame the varied and beautifully drawn palmettes of the border. [14.40.721 Bequest of Benjamin Altman]

211 Bowl with a Painting of a Saljuk Prince. Pottery with overglaze painting partly in relief and gilded. Persian, Kashan, early thirteenth century. Diameter 8¹⁄₁₆″

Under the Saljuks Persian potters of the twelfth and thirteenth centuries created a great variety of ceramic wares which are among the most beautiful ever produced. Many ceramic techniques were perfected by Persian potters. Rayy and Kashan were famous ceramic centers of great importance. The fine bowl in this illustration is a product of Kashan kilns of the beginning of the thirteenth century. The technique employed here, known as "Minai," is overglaze painting in polychrome. In this technique the pottery, after being painted over an opaque glaze, was placed in earthenware containers and fired a second time for half a day. Some of the vessels were decorated with figure compositions recalling miniature paintings; others, as is this bowl, were decorated with large, single figures. [51.53 Dick Fund]

240